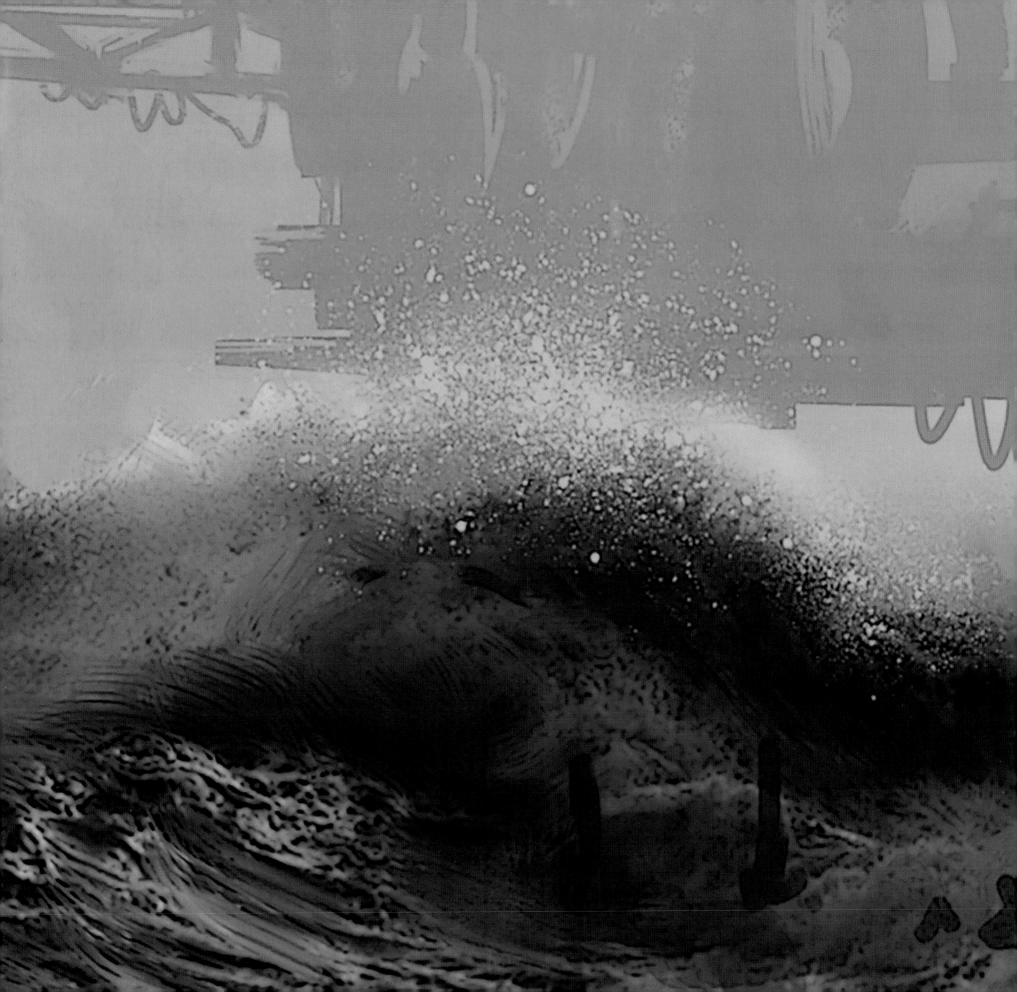

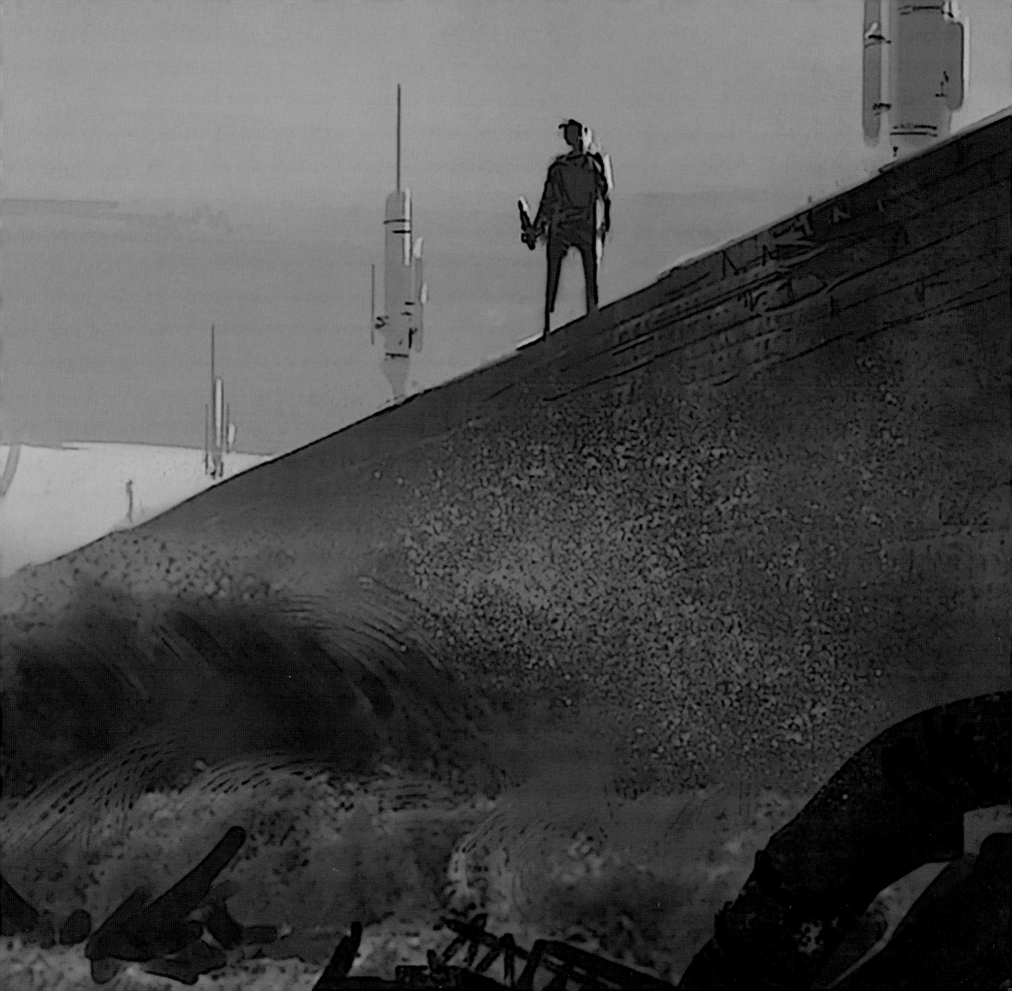

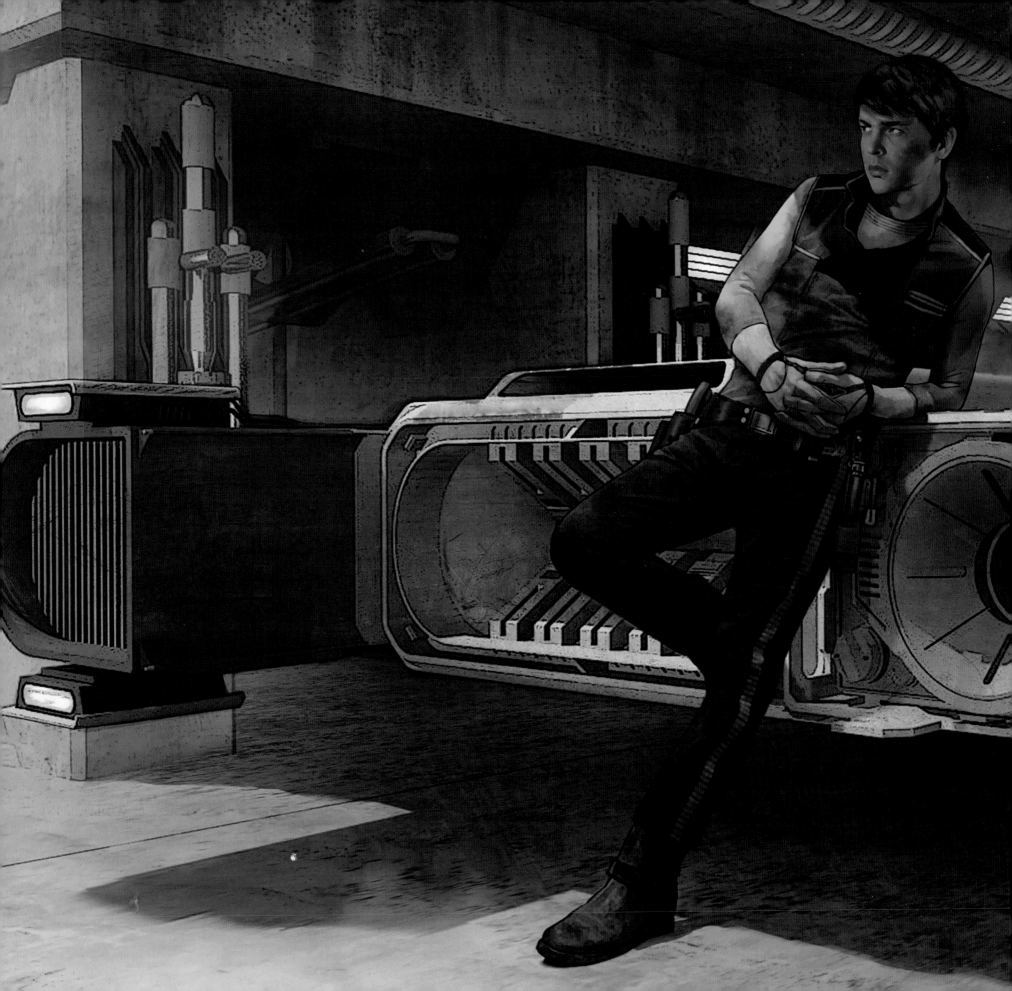

THE ART OF

SOLO

A STAR WARS STORY™

Written by Phil Szostak

Forewords by Neil Lamont and James Clyne

Abrams, New York

CONTENTS

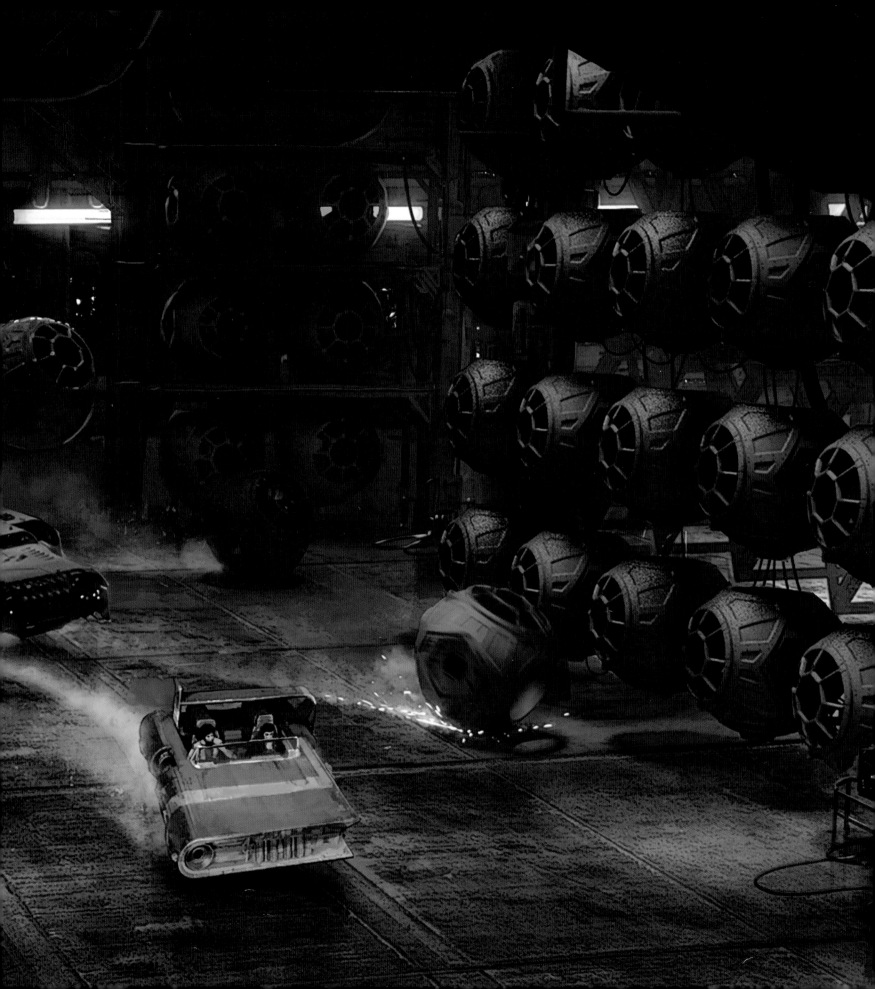

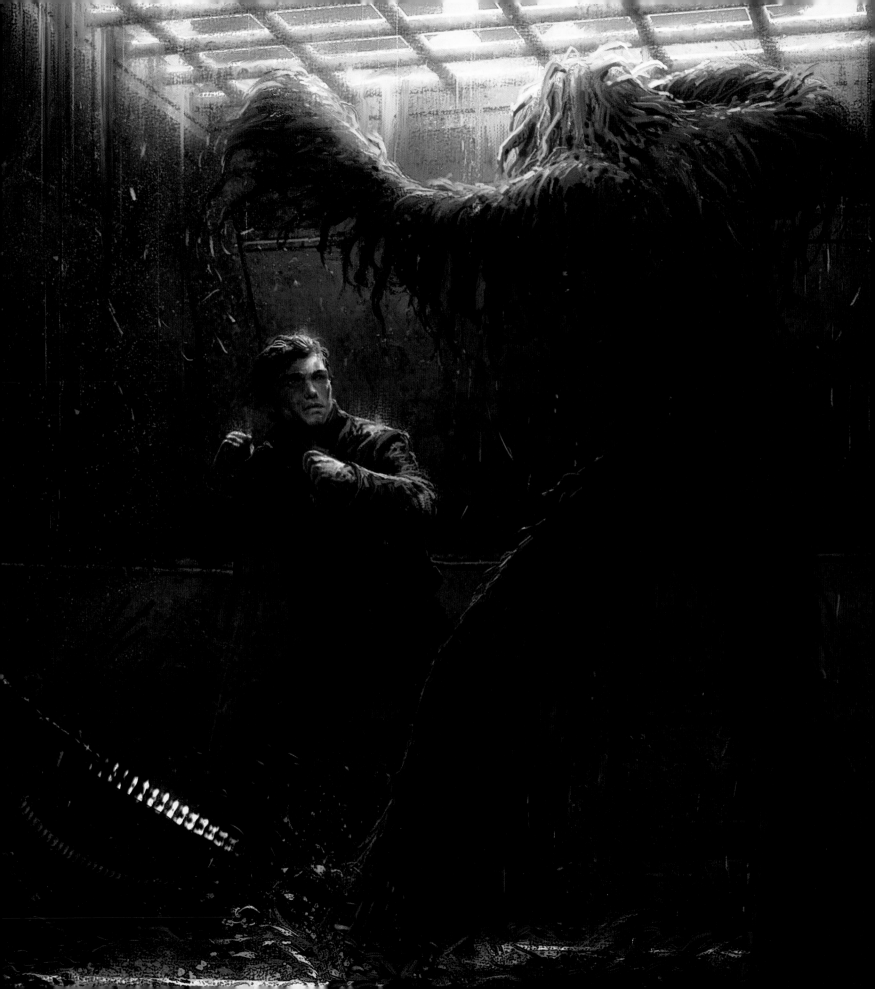

Foreword by Neil Lamont

Solo: A Star Wars Story—what a great idea, and what an amazing opportunity for me to be involved from the ground up, having joined the production just after the first draft of the script was completed. *Solo* is the film every film lover has wanted to see since the release of *A New Hope* in 1977, finally answering the question, "Just how did Han and Chewie meet?"

This is a period film set in the late sixties, drawing inspiration from a wealth of sources and feelings: cool, hip, retro, lo-fi, muscle cars, *Shaft*, Route 66, travelling east to west across the United States, Jimi Hendrix, a boy's dream (back then), the height of the Cold War, the arms race, *2001: A Space Odyssey*, *McCabe & Mrs. Miller*, *Planet of the Apes*, and *The Driver*.

In this book, you will see the passion—our hearts on our sleeves—in every artwork, each piece showing invention, skill, desire, and creative genius. We tried to embody the period through what we felt and remembered . . . or what we could reference, for artists on the younger end of the spectrum. People from all departments (art, set decoration, costume, creatures, and props) are showing off their talents: from concept, innovation, design, and manufacturing to the ultimate process of camera rolling.

The early blue-sky concept phase was led by Lucasfilm/ILM lead concept designer James Clyne, alongside the UK concept team and a group from the San Francisco Lucasfilm team. But there was another department starting the film at this stage that greatly contributed to this phase and onward to help bring the reality, scale, and scope to the vision of the film: the locations department.

The script has many new environments, some of which we have heard of in *Star Wars* legend but never seen: Corellia, Mimban, Vandor, Kessel, Savareen. All need to be set in an environment, whether real or conceptual. A location search for all new planets is necessary, as the information found will be used either for reference or a potential real location we may shoot at some stage during the shooting schedule. We aim to get to see the selected initial locations as soon as possible, to inform all groups and the overall production.

Corellia: Fawley Power Station, an electricity-generating plant built in the early to mid-1960s, the height of innovation at this time. This location has a large amount of roadway through and around the generation factory and the ancillary areas. Perfect for Corellia. The original control room in the plant is very cool, cutting edge design for the period, great consoles painted in a grey/blue color. This room was inspiration for the droid control room, as well as the underbelly color of the industria, in our Kessel sets (exterior and interior). We went to Tilbury docks, too—the grain terminal—becoming the model for our bridges and connective tissue between the Corellian industrial islands.

Mimban: Mud planet, battlefields, trenches, gloomy, smoke. We decided early on that this environment should be stage-bound, built in a controllable space: the 007 Stage at Pinewood Studios.

Vandor: It needs to be mountainous and snowy, like crossing the Rockies. We looked at Torres del Paine in Chile (online), and the Dolomites in northern Italy (which are absolutely stunning). We settled on northern Italy, the visual effects department (VFX) was able to scan the relative chosen loations, enabling departments to use this topographical information in pre-visualization, concept, and design.

Kessel: A huge inspiration for the spice mining planet were the sulfurous yellow pools in Dallol, Ethiopia—an unearthly scenery. The region could be a complete environment for VFX to use as the basis for Kessel if it had been possible to shoot there, but the gases from the pools proved too corrosive. We never went, just internet research, the Kessel environment dependent on the talent of concept and matte artists.

Savareen: We chose Fuerteventura, Canary Islands, after a long search across the world, looking for extraordinary sea cliffs. In one part of this volcanic island, a band of sand crosses the whole island, four miles or so, east to west, with spectacular sand cliffs on the west coast. The art department and concept team, aided by scans of the location from VFX, produced the designs and models, with location and set concepts.

Filmmaking is a collaborative process. We share, push boundaries, laugh, cry, criticize, admire, and support one another to attain the best design possible. There are many departments involved in making a movie, but, from a design point of view, the concept team is the frontline.

This book is a tribute to amazing teamwork. Thank you, everyone.

Foreword by James Clyne

At the beginning of this project, *The Force Awakens* had not yet been released, *Rogue One* was shooting, and *The Last Jedi* was in pre-production. *Star Wars* fever was at an all-time high. The *Star Wars* universe had once again been reestablished, and our challenge was to create worlds that hadn't yet been surveyed, but still fit in with everything that had come before us. "New and a bit dangerous, but the same," were our marching orders, along with, "Oh, and you'd better not tarnish the mystique of the ever-aloof Han Solo!"

Working in the film industry, I'm used to abstract and seemingly impossible requests. This time felt different—almost intangible. I wanted to clear my brain and go back to a time when all of *Star Wars* was new. So I pulled out a book I've had since I was eight: *The Empire Strikes Back Sketchbook*, a small companion to the original Art of *Star Wars* series. The sketchbook is unique in that it specifically explores the early development of production design. It's simple, yet exposed. There is nothing flashy about it. Sure, there are still the same walking tanks in the snow and floating cities in the clouds, but they are not evocative in the same way a typical illustration sets a scene. These vehicles and environments were depicted in the hand of an engineer and displayed with a type of draftsmanship I had never seen before. No color, no photo manipulation, no slick 3-D programs at work here. They are not of far-flung technological futures, but lived-in, human experiences of our past. Flipping through the pages and running my fingers over my own sketches scrawled in the margins, I was reminded that my job is not to design something that comes to life on-screen, but to design something that feels real in the imagination of an eight-year-old.

The visualization of the pre-*New Hope* worlds inhabited by Han Solo—specifically Corellia, the fabled Kessel mines, and Vandor—began in September 2015. I was asked to work closely with the directors and to lead a small group of artists. We knew going in that Han Solo was a scoundrel, a smuggler, a gambler, and a scruffy-looking nerf herder. We also knew these new worlds would need to complement his rebellious nature.

As the script evolved, so did the work, and things changed over the course of production but those early sessions were creatively abundant. Both L3's confident strut and the way Han's Corellian speeder drifts around a high-speed corner as though driven by rally driver Ken Block played into this new narrative.

Seventies pop culture was a natural source of inspiration. Hard-hitting music from the Ramones or Iggy Pop and the early street artists of New York City were part of the conversation. *McCabe & Mrs. Miller* and the 1978 film *The Driver* were both examined as we laid the tracks for new roads. There are flickers of pre-*Star Wars* America in everything from the industrial wasteland of the Corellian shipyard to Han's animal-skin Vandor winter coat. We established cultural and visual ground rules to fuel the imagination, but always kept our art tethered to the original Sagas. This established boundaries. It kept us honest. It inspired.

Simple, old-school, street-corner grunge music gave us a needed pump of creative adrenaline to get started, but to make something fresh we needed to "get uncomfortable." We needed to look at the material from a different point of view, and we used every high school art-class rule in the book: We flipped our work over. We turned it backward and upside-down. We absent-mindedly sketched as we talked about music, movies, and art. And then, like teenagers, we looked back at those sketches and took them seriously. In fact, the first image you would see in our early collection of work was an image I had done (badly) where I turned the *Star Wars* logo 180 degrees (essentially an upside-down *Star Wars* poster). Flipping that world on its head seemed like the right way to go. It was a subjective—and a bit subversive—narrative we could all cling to. It didn't work as an abstract idea alone, but it became a metric we used to define the work.

Every production hits the ground running, and ours was no exception. In 2016, production designer Neil Lamont and his art department came on board abroad and things really started moving. I moved my family to London. The design work was far from complete, and its pace dictated our process. Thankfully, as the pressure needle rose, Neil kept us sane. The sense of speed became a ubiquitous part of the visual storytelling. Han pushed himself to the limits of what was possible, and we would, too. Han was fast. He cut corners. He never tripped, he slid. He "made the Kessel Run in less than twelve parsecs" and luck had nothing to do with it. He was that kid down the street spending nights and weekends rebuilding a muscle car. We re-watched *American Grafitti*, inspired by the American car obsession, which borders on religious. Most days it felt like the Pinewood art department was redlining, the engine running hard, but everyone was on board and enjoying the ride. Muscle cars have always been nouns and verbs: Cars define a person, and they transcend them. We wanted that spirit reflected in the vehicle design. For example, Lando Calrissian's new *Millenium Falcon* with its sleek nose jutting forth like an Italian supercar, or, equally so, a Ford Mustang Mach One's blunt rear end mirrored in Moloch's speeder.

The road from production to film is incomplete without dead ends and U-turns. The process leads to many scrapped ideas. Thanks to the foresight of George Lucas, many of the original

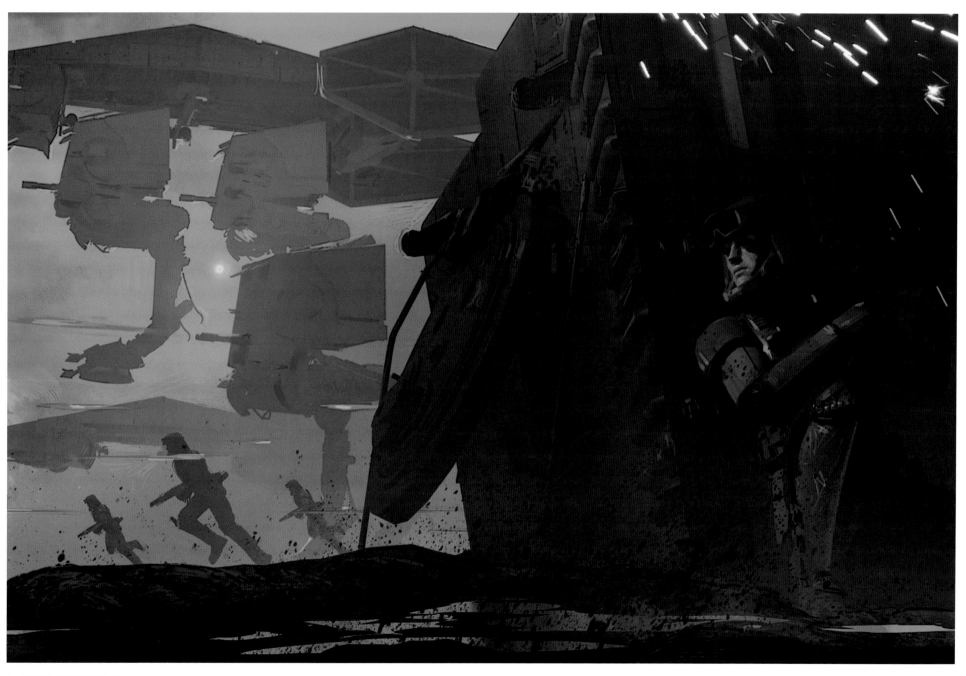

▲ **MIMBAN EXTERIOR 09** Clyne

drawings are meticulously preserved in the Lucasfilm Archives. I peruse that treasure trove whenever I can. The zenith of *Star Wars* design is still held by Ralph McQuarrie and Joe Johnston; their work is in everything we do today. Look closely and you'll find the influence of Harry Lange and Colin Cantwell. It's all over the *Millenium Falcon*'s interior design and a new Imperial ship. Although these artists did not work on this project, it would feel sacrilegious not to give them credit as it is due.

 The Han Solo project was exciting, nostalgic, sometimes crazy-making, and thankfully, very richly collaborative. Most of the artwork seen here comes from those early pre-production sessions and Pinewood's art department, but each image embodies the work of hundreds of artists. This work could not have been done without Glyn Dillon's and David Crossman's costume department, Neal Scanlan's creature crew, and Rob Bredow's and Pat Tubach's VFX [visual effects] team. Hopefully the audience will find a rich, authentic world filled with familiar and new environments and characters worthy of the *Star Wars* visual universe. My hope is that this latest edition of the Art of *Star Wars* books will find a comfortable place on the shelf next to the dog-eared copy of *The Empire Strikes Back Sketchbook* that I own to this day.

Introduction by Phil Szostak

In early 1973, a twenty-eight-year-old George Walton Lucas Jr. found himself six months out from the release of his second film (and first box office hit) *American Graffiti*, unable to sell any studio on his follow-up, *Apocalypse Now* (a very different, darkly comedic film than the *Apocalypse Now* later directed by Lucas's mentor Francis Ford Coppola) and therefore deeply in debt. Out of desperation, Lucas turned to a backup project—an unnamed *Flash Gordon*–inspired science-fiction film—and began developing it.

The name "Han Solo," then simply "leader of the Hubble people," was first mentioned in a list of characters written by Lucas in those early months of 1973. A complementary list of potential locales included Yavin, a jungle world inhabited by eight-foot-tall Wookiees, later featured in Lucas's May 1973 ten-page treatment entitled *The Star Wars*. The word "Wookiee" was inspired by Bill Wookey, a friend of actor Terry McGovern. (McGovern had portrayed a robot cop in Lucas's financially unsuccessful but visionary directorial debut *THX 1138*, improvising the line, "I think I ran over a Wookiee back there.")

Han Solo was recast as a "great pilot" in Lucas's two-page *Journal of the Whills I* outline and then a "huge green-skinned monster" in May 1974's *The Star Wars* rough draft. By late January 1975, Lucas had synthesized elements of *THX 1138* (the "force," from a deleted scene, and an oppressive faceless Empire), *American Graffiti* (akin to Luke's life with his Tosche Station friends on Tatooine and the ragtag young Rebellion), Lucas's *Apocalypse Now* (a rebel force fighting a much larger superpower), and many other literary, philosophical, and artistic influences into a screenplay called *Adventures of the Starkiller Episode I: The Star Wars*. In that second-draft script, "farm boy" Luke Starkiller meets a Humphrey Bogart–like "young Corellian pirate" named Han Solo and his "savage-looking" Wookiee companion Chewbacca in the Mos Eisley spaceport cantina, as in the finished 1977 film, *Star Wars*: Episode IV *A New Hope*.

Lucas always had a particular fondness for dogs, specifically the Alaskan malamute breed. While writing *A New Hope*, he often drove his station wagon around the San Francisco Bay Area with his mammoth malamute Indiana (later inspiration for both Indiana Jones's name and the in-world origin of that name) in the passenger seat, drawing strange looks from fellow motorists. Eventually, Lucas incorporated Indiana's "co-piloting," physical stature, and doggy demeanor into his Wookiee character Chewbacca, moving him away from the more monstrous "bushbaby-monkey" Lucas had imagined in his second draft.

Mythologist Joseph Campbell's monomyth or "hero's journey"—the narrative thread common to stories across all human cultures and epochs—was a massive influence on George Lucas's final conception of *Star Wars*. And the hero's journey always begins with a departure: crossing a threshold from the known and ordinary (usually the protagonist's childhood home) to the unknown and extraordinary. George Lucas's own hero's journey began upon his departure from Modesto, his sleepy hometown in the Central Valley of California, for the University of Southern California's School of Cinematic Arts in Los Angeles, over three hundred miles away. Similarly, in *A New Hope*, a teenage Luke Skywalker leaves his backwater homeworld of Tatooine aboard Han Solo's freighter, the *Millennium Falcon*, for Alderaan. And, as we will see in *Solo: A Star Wars Story*, teenage Han Solo's escape from Corellia, the only home he's ever known, kicks off his own journey into the unknown.

But one would be remiss not to mention the ways in which facets of George Lucas himself shine through in his characters. When the central hero of Lucas's rough draft, Captain Annikin Starkiller, was bifurcated into Luke Starkiller and Han Solo in the second draft, Solo received Lucas's love of fast cars (or starships), sarcastic sense of humor, and aspirational swagger, becoming the sort of dashing swashbuckler every kid dreams of being. Luke Starkiller (eventually Skywalker) embodied Lucas's more introspective, spiritual side—a young man who longs for adventure but is trapped equally by circumstance and fear. "George is Luke," actor Mark Hamill said. "He is. I always felt that way."

In many ways, Han Solo embodies the teenage dream: a relatively carefree life of perpetual adolescence, a boy and his dog bopping around the universe, defying authority, who eventually transition (not without resistance) into a more responsible and respectable existence encompassing duty and family. Luke Skywalker is the harsher reality: an innocent who, in reaching beyond the humdrum safety of home, is forced to confront his inescapably cyclical personal and familial demons, which, by their very nature, make for a more contemplative but lonely life.

Young Solo's flight from Corellia's mazelike industrial cityscape takes him deeper and deeper into the frontier of *Star Wars*'s Outer Rim, to wild worlds like Vandor, Kessel, and Savareen. It is a voyage that intentionally but subtly mirrors the path west across the North American continent, from the industrial east, over the mountainous continental divide, and through land's end at the Pacific Ocean.

Lucasfilm design supervisor James Clyne mused, "Conquering another world is a very fantasy/*Star Wars*/science-fiction

idea of conquering the frontier. America was really one of the last frontiers on Earth." One could argue that the real-world Age of Exploration concluded with the westward survey across the North American continent, specifically of the newly acquired Louisiana Purchase territory, by groups such as Meriwether Lewis and William Clark's Corps of Discovery. That fearless, bold, and some would argue foolhardy spirit of exploration is not the exclusive domain of American culture, but it is certainly one of its defining characteristics. "Whatever it is, it's very American, and it still flows in our blood," Clyne continued. "And it's a reason why Silicon Valley exists, why Hollywood exists. It's that cowboy in us that isn't afraid to fail and wants to keep trying new things and exploring new avenues—which gets us in trouble sometimes, but is a very American thing."

Han Solo embodies and celebrates that American fantasy of the rugged individual who needs no other man or woman: the explorer/astronaut, the cowboy, the swashbuckling hero ever-present in the children's books, radio dramas, comic books, films, and television shows of the twentieth and twenty-first centuries. A life lived boldly, confidently, and in the case of Han Solo, without much consequence or depth. In *A New Hope*, the limitations of such a shallow life were thrown in sharp relief by the raw, selfless heroism of Luke Skywalker and Princess Leia Organa and particularly Ben Kenobi's ultimate sacrifice, forcing Solo to reach deeper, to find his inner hero, his truer self.

With *Solo*, an international crew of veteran *Star Wars* filmmakers and artists likewise reached deep, pushing the limits of what constitutes a *Star Wars* film. From the outset, Lucasfilm president Kathleen Kennedy's mandate for *Star Wars* Stories, the stand-alone spinoff films released between the episodes of the sequel trilogy, was that they would "expand the mythos and depths of the *Star Wars* universe in previously unexplored ways." That expansion began with 2016's *Rogue One: A Star Wars Story*, telling the heretofore unknown tale of the theft of the Death Star plans desperately exploited by the Rebellion in 1977's *A New Hope*.

But *Solo* is an even further step beyond the tones and genres that *Star Wars* fans have come to expect, beyond even what George Lucas envisioned in those early 1970s treatments and drafts. Filmmakers and artists in every department at Pinewood Studios, from costumes to creatures to props, made calculated risks, like jumps into hyperspace. They ventured into uncharted territory that still stays true to the feeling and aesthetic established forty years ago by Lucas and original trilogy concept artists like Ralph McQuarrie, Joe Johnston, and Colin Cantwell. *Solo: A Star Wars Story* and the artwork in this volume are an invitation to filmgoers and fans to join Han Solo and Chewbacca in their journey into the unknown.

"Here's where the fun begins."

▲ **T-SHIRT ART VERSION 1A** Clyne

▸▸ **HAN CHEWIE RUN VERSION 1J** Dudman

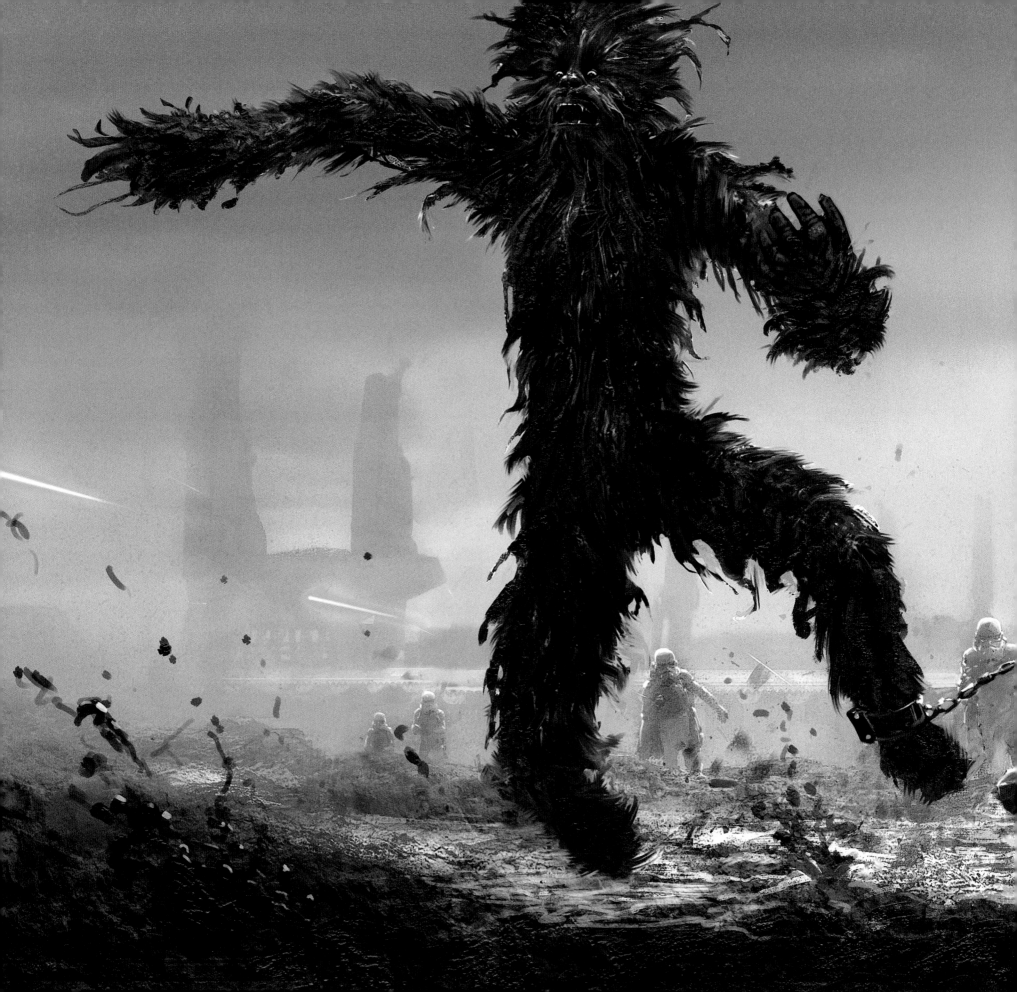

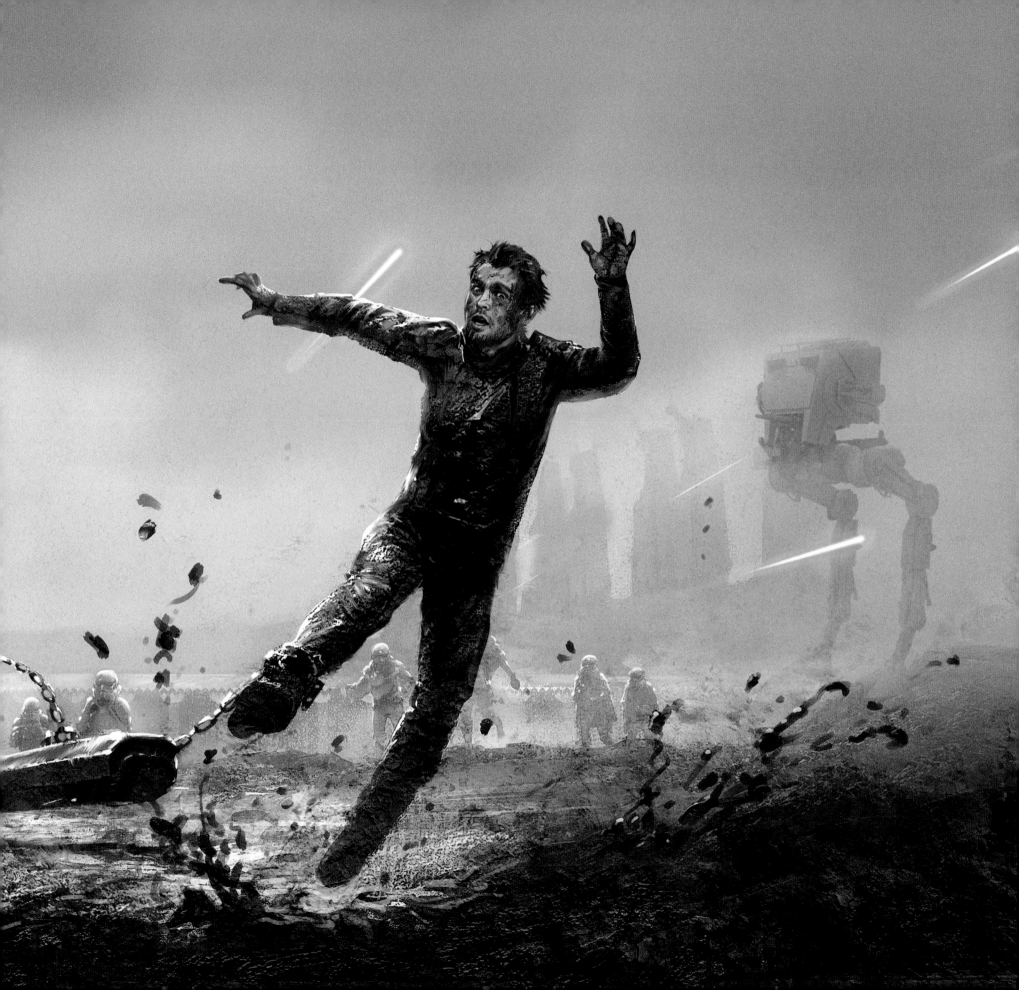

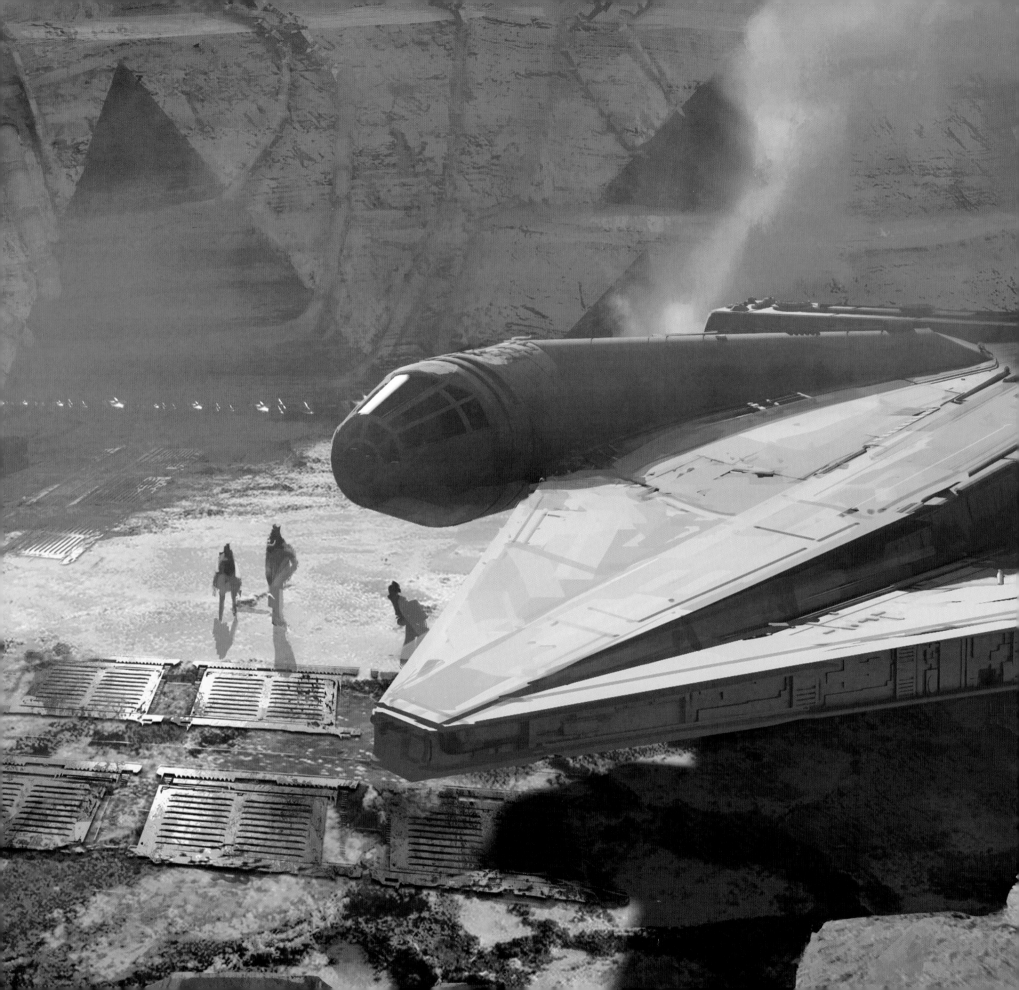

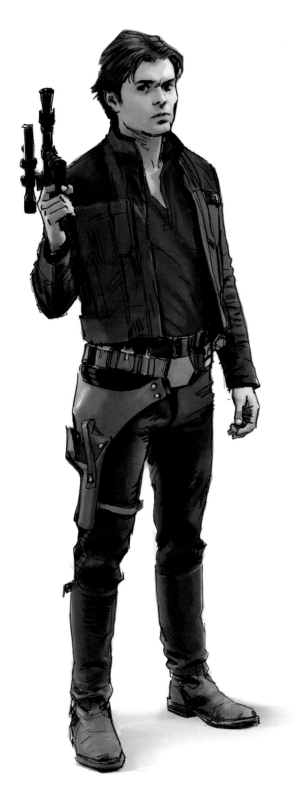

Who's Who

Will Allegra
Co-producer

Matt Allsopp
Concept artist

Alex Baily
Art director - Fuerteventura

Andrew Booth
Computer graphics supervisor: BLIND LTD.

Rob Bredow
VFX supervisor

Adam Brockbank
Costume concept artist

Al Bullock
Supervising art director

Chris Caldow
Prop/set decoration concept artist

Julian Caldow
Concept artist

Candice Campos
Lucasfilm vice president of physical production

Colin Cantwell
Star Wars: Episode IV *A New Hope* spacecraft designer

Luis Carrasco
Concept artist

Oliver Carroll
Digital art director

Doug Chiang
Lucasfilm vice president Executive creative director

Ryan Church
Lucasfilm concept design supervisor

James Clyne
Lucasfilm design supervisor

Jim Cornish
Storyboard artist

David Crossman
Co-costume designer

Glyn Dillon
Co-costume designer

Laura Dishington
Lead graphic designer

Peter Dorme
Art director

Jack Dudman
Concept artist

Yanick Dusseault
ILM senior art director

Neil Ellis
Concept model maker

Simon Emanuel
Producer

Patrick Faulwetter
Concept artist

Luke Fisher
Creature concept designer
Senior sculptor

Colin Fix
Concept artist

Liam Georgensen
Assistant art director

André Gilbert
Creature sculptor

Kiri Hart
Co-producer
Lucasfilm senior vice president of development

David Hobbins
Concept artist

Jason Horley
ILM art director

Will Htay
Concept artist

Alex Hutchings
Junior concept model maker

Colin Jackman
Creature senior sculptor

Vincent Jenkins
Concept artist

Joe Johnston
Original trilogy ILM art director

Lawrence Kasdan
Executive producer
Co-screenwriter

Jon Kasdan
Co-screenwriter

Kathleen Kennedy
Producer
Lucasfilm president

Matt Kerly
Standby art director

Ashley Lamont
Art director

Neil Lamont
Production designer

Harry Lange
Original trilogy art director
Set decorator

George Lucas
Star Wars creator

Jake Lunt Davies
Creature concept designer

Ivan Manzella
Creature concept designer
Senior sculptor

Paul Marsh
Senior concept modeler

Aaron McBride
ILM senior art director

Iain McCaig
Concept artist

Jon McCoy
Concept artist

Jason McGatlin
Executive producer
Lucasfilm senior vice president of physical production

Ralph McQuarrie
Original trilogy production illustrator
Concept artist

Ian McQue
Concept artist

Craig Mullins
Concept artist

Matt Naish
Art department assistant

Masa Narita
ILM senior hard surface modeler

Brett Northcutt
ILM senior concept artist

Kris Pearn
Storyboard artist

Chris Reccardi
Concept artist

Martin Rezard
Creature concept designer
Senior sculptor

Robert Rowley
Costume concept artist

Lee Sandales
Set decorator

Matthew Savage
Prop concept designer

Paul Savulescu
Draughtsman

Neal Scanlan
Creature and droid effects creative supervisor

Tyler Scarlet
Junior concept artist

Allison Shearmur
Producer

Dominic Sikking
Graphic designer

Molly Sole
Junior concept artist

Henrik Svensson
Creature paint finish designer

Stephen Swain
Art director

Thom Tenery
Concept artist

Justin Thompson
Concept artist

Matt Tkocz
Concept artist

Gary Tomkins
Senior art director

Patrick Tubach
ILM VFX supervisor

Chris Voy
ILM senior concept artist

Andrée Wallin
Concept artist

Thomas Weaving
Art director

Tom Whitehead
Art director

Jamie Wilkinson
Property and weapons master

Louis Wiltshire
Creature senior sculptor

Bradford Young
Director of photography

Shaun Yue
Screen graphics designer

Stephen Zavala
ILM concept artist

Tonči Zonjić
Costume concept artist

Harry and the Boy

In October 2012, veteran scribe Lawrence Kasdan (*Star Wars: Episode V The Empire Strikes Back*, *Raiders of the Lost Ark*, *Star Wars: Episode VI Return of the Jedi*, *The Big Chill*) was invited by Lucasfilm Ltd. President Kathleen Kennedy to Skywalker Ranch in Marin County, California to meet with *Star Wars* creator George Lucas. The trio discussed Kennedy's yet-to-be-revealed plans for additional *Star Wars* films beyond the original and prequel trilogies.

"I went up, and George had sort of roughed-out many movies—not just the new trilogy, but other movies, the spinoffs and things," Kasdan told the *Los Angeles Times* in December 2015. "I wasn't sure I wanted to do anything, but I said, 'I could do the Han Solo movie'—because he's my favorite character. He's reckless. He's feckless. He's cynical. He's tough. He's pragmatic. He's not that smart. I like that. He's the most fun."

A little more than three months after The Walt Disney Company acquired Lucasfilm and unveiled their plans for a sequel trilogy of *Star Wars* films starting with *Star Wars: The Force Awakens* in 2015, two new spinoff films were announced on February 5, 2013. One would be authored by screenwriter-producer Simon Kinberg (*Sherlock Holmes*, *X-Men: Days of Future Past*, *Star Wars Rebels*). The other, the aforementioned Han Solo film then codenamed "Harry and the Boy," was to be penned by Kasdan. While crafting their standalone films, both Kinberg and Kasdan would consult part-time on *The Force Awakens* alongside screenwriter Michael Arndt (*Little Miss Sunshine*, *Toy Story 3*) and recently-announced director J.J. Abrams (*Mission: Impossible III*, *Star Trek* [2009], *Super 8*), at Abrams's Bad Robot Productions in Santa Monica, California.

In April 2013, Lucasfilm Senior Vice President of Physical Production Jason McGatlin reached out to Lucasfilm VP/Executive Creative Director Doug Chiang (*The Polar Express*, *War of the Worlds* [2005], *Rogue One: A Star Wars Story*), then a concept artist in the earliest days of *The Force Awakens*'s development, regarding Kasdan's Han Solo project. "Larry was already deep into his writing process when I got involved," recalled Chiang.

"I was still working on *Star Wars: The Force Awakens* when Jason asked me to assemble and oversee a small team of part-time artists to help inspire Larry. Although I didn't get a full story brief, Larry gave me enough information to start development for several key characters and environments. At that time, the plan was for "Harry and the Boy" to be the next *Star Wars* film after *The Force Awakens*." That honor eventually went to *Rogue One*, after Kasdan was pulled onto *The Force Awakens* as a full-time co-screenwriter in late October of 2013 and forced to temporarily shelve *Solo*. Lawrence Kasdan's son Jon Kasdan (*Freaks and Geeks*, *In the Land of Women*, *The First Time*) recalled, "Laying out Episode VII took up more of Larry's time than he had initially anticipated. Then, when J.J. came on and they decided to write Episode VII together, it became a full-time job and Harry and the Boy was put on hold for more than a year."

"I enlisted as many Industrial Light & Magic [ILM] artists as possible," Chiang continued. Those artists included Ryan Church, Yanick Dusseault, and Iain McCaig, all of whom were working full-time on *The Force Awakens*, as well as fellow ILM Art Department designers Chris Bonura, Thang Le, and Aaron McBride. "I wanted to include some of the guys who didn't get an opportunity to work on *The Force Awakens* because of scheduling conflicts. During that time, most of us were doing double duty on both films."

From April to December 2013, Chiang and Lawrence Kasdan were in contact every two weeks. "He would call me after he reviewed the latest batch of artwork to give me notes," Chiang said. "This rhythm worked well given the part-time nature of the team. At other times, he would spontaneously call if he had a new idea." By the end of 2013, still-nebulous *Solo* story elements included a younger Han Solo and his girlfriend Kura (later Qi'ra)—a "femme fatale–type character in the tradition of Jane Greer in *Out of the Past*," according to Jon Kasdan—on the run through the Dickensian cityscape of his homeworld, Corellia, and Solo's oft-bragged-about, less-than-twelve-parsec Kessel Run, mentioned in *A New Hope* and *The Force Awakens*.

"I found Larry to be focused and clear in his direction. He wasn't afraid to push the boundaries and be bold," remembered Chiang. "And once he locked in on an idea, he didn't waver."

◄ **YOUNG HAN VERSION 01** Iain McCaig

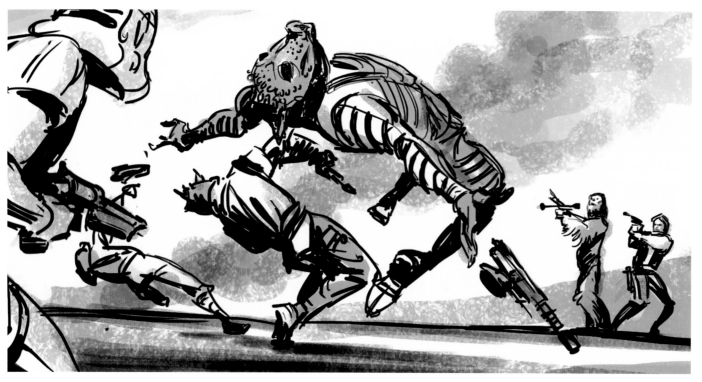

▲ HAN AND CHEWIE KEYFRAMES VERSION 04 McCaig

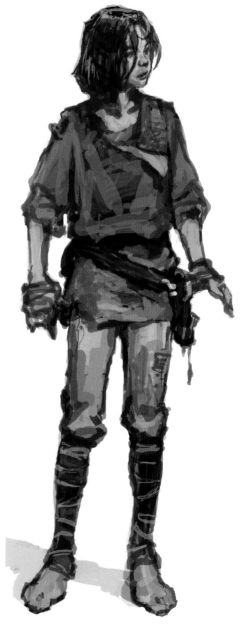

▲ HAN SOLO McCaig

In January 2003, during preproduction for *Star Wars:* Episode III *Revenge of the Sith*, early drafts of George Lucas's script included an appearance by an adolescent Han Solo on the forested Wookiee world of Kashyyyk. In these drafts, Solo is revealed to have been raised by Chewbacca and, in one of the final battles of the Clone Wars, Solo would help Jedi general Yoda locate Separatist General Grievous. Concept artist Iain McCaig designed the grubby young Solo, not knowing he'd get the chance to illustrate the character again, more than a decade later, for *The Force Awakens* and *Solo*.

◄ HAN LANDO BET VERSION 1C Colin Fix

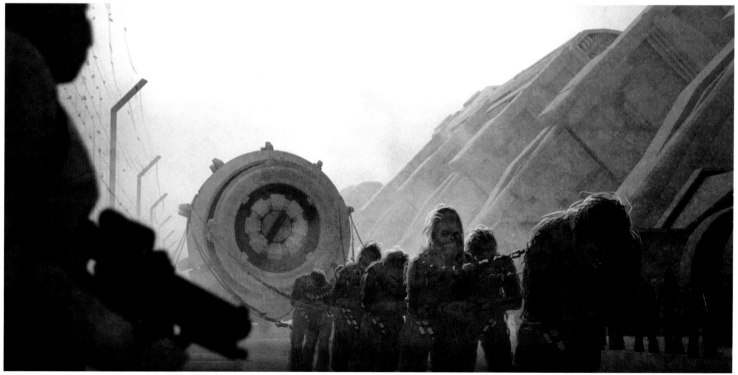

▲ **FALCON PRIZE** Yanick Dusseault

"In Kasdan's early notes, Han and Chewie's first ship was even more of an eyesore than the *Falcon*. I figured that if the earliest *Millennium Falcon* design, which eventually became the blockade runner, was considered a Corellian corvette, then the ship before it would be an even more embarrassing piece of crap, like a Corellian motorhome. Han would swoon that much more when he first sees the brand-new *Falcon*." **Aaron McBride**

▶ **SLAVE CAMP** Dusseault

In Lawrence Kasdan's "Harry and the Boy" story, Wookiees are enslaved by the Empire on the mining planet of Kessel.

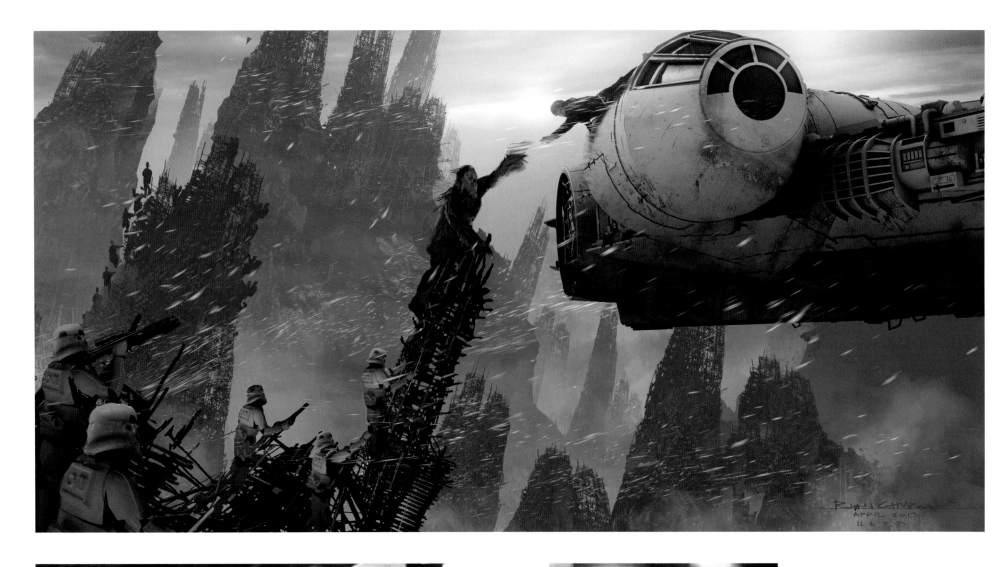

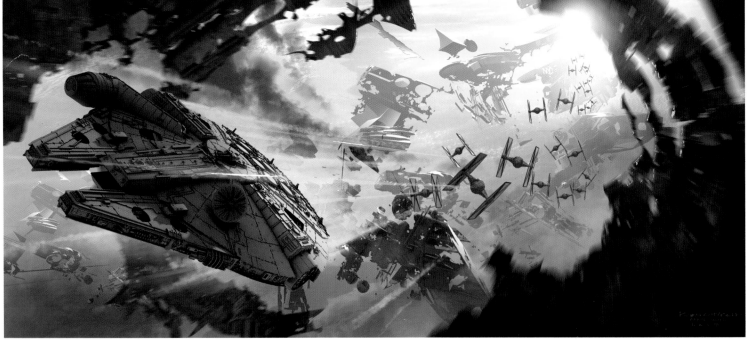

▲ **KESSEL CHEWIE SAVE** Ryan Church

◄ **KESSEL RUN 01** Church

Han Solo stages a daring rescue of
Chewbacca aboard the *Millennium
Falcon*, leading into the famous Kessel
Run—with Imperial TIE fighters in hot
pursuit. The story elements of enslaved
Wookiees on Kessel, and Han and
Chewie's flight from the Empire, would
both end up in the final film.

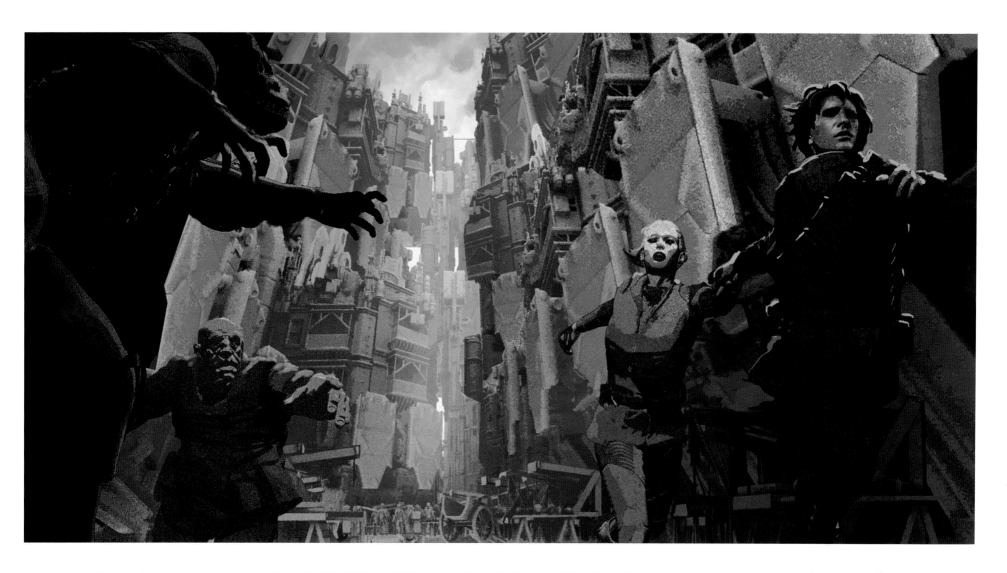

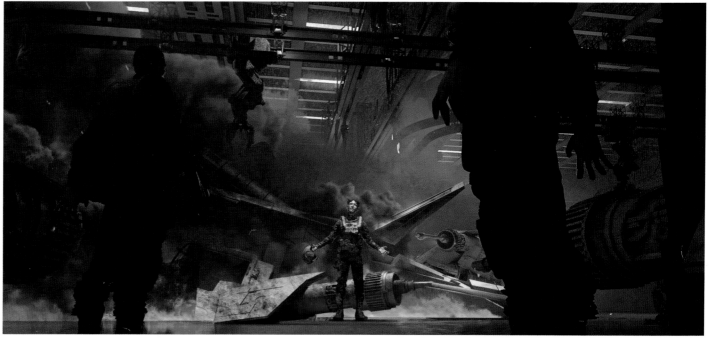

▲ **STREET DESIGNS** "Originally, Kasdan's story started with prologue when Han was about twelve: a street rat on Corellia, much like Oliver Twist. He was working for a crime boss—a Fagin or Bill Sikes-type alien. Early on, Corellia was more like nineteenth-century Dickensian London, overcast with a lot of industrial factory smoke.

"Doug suggested very narrow, crooked streets and tall building facades that you couldn't see over the top of, so Han would feel trapped in his surroundings—buried in those narrow streets. The first piece I did was Han and Kura 'running the gauntlet' through a narrow alleyway teaming with all sorts of the most dangerous and unsavory aliens in the galaxy. This was long before casting, so I illustrated Han as a young Harrison Ford. Kasdan wanted Kura to be a Grace Kelly type that Han was trying to impress." McBride

▶ **HANGAR CRASH VERSION 03** "At some point, Han would become a pilot in a fleet resisting the Empire. There was to be a scene inspired by *Top Gun* where he crashes his damaged fighter into a hangar. Han is brought before a tribunal to be court-martialed, which would've perhaps led him to Mimban." McBride

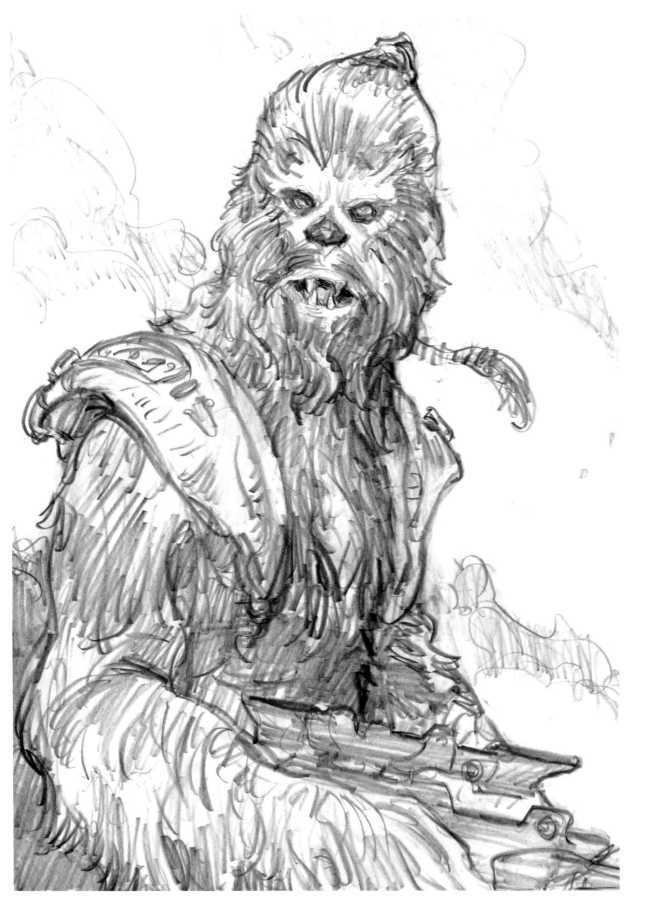

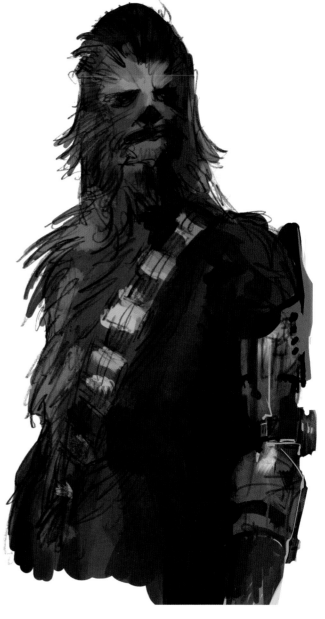

▲ **CHEWIE VERSION 06** McCaig

◄ **YOUNG CHEWIE VERSION 01** McCaig

▸ **BATTLE RESCUE** "I did a lot of versions of Han and Chewie's first meeting. For Kasdan's notes, it was Chewie saving Han in the battlefield. I thought this to establish a 'life debt,' so they would be reluctantly paired together." McBride

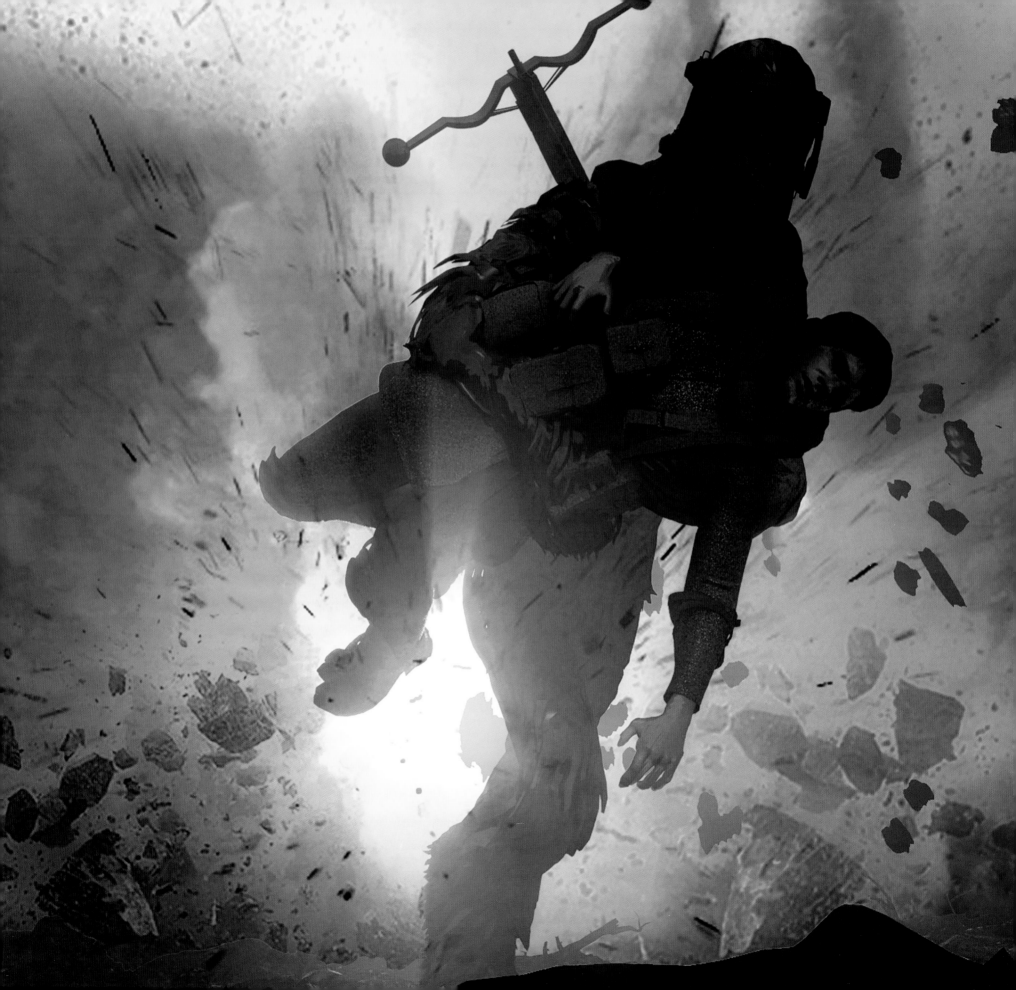

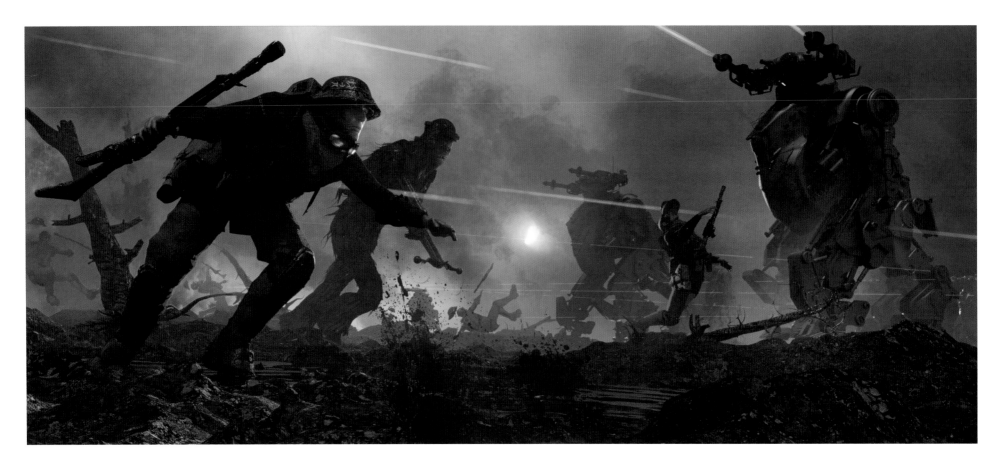

△ **BATTLE** "In Kasdan's early story notes, Han wasn't serving in the Empire but rather in an army—a faction made up of many different aliens—fighting against the Empire. Kasdan and Doug had mentioned that it should feel like World War I trench warfare: bleak muddy battlefields, burnt broken trees, and a sky overcast with smoke. I tried giving Han a McQuarrie-esque pith helmet and mud spats. Doug mentioned that Han and Chewie, who were forced into service together, would be fighting these Imperial mech walkers." **McBride**

◁ **HAN AND LANDO VERSION 01** "Doug said the *Falcon* would first be shown mostly under a tarp, with little glimpses of the signature features of the *Falcon*, as a tease for the audience. But the parts that were visible should be shiny and new. I imagined Lando cleaning the *Falcon* like guys who preciously wash their Trans Am in the driveway." **McBride**

▲ **LANDO FALCON SKETCH VERSION 05** McCaig

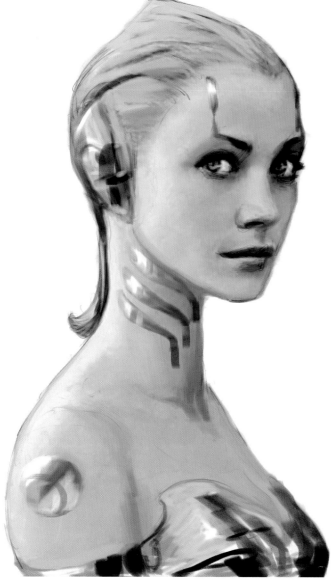

▲ **LOVE INTEREST VERSION 02** McCaig

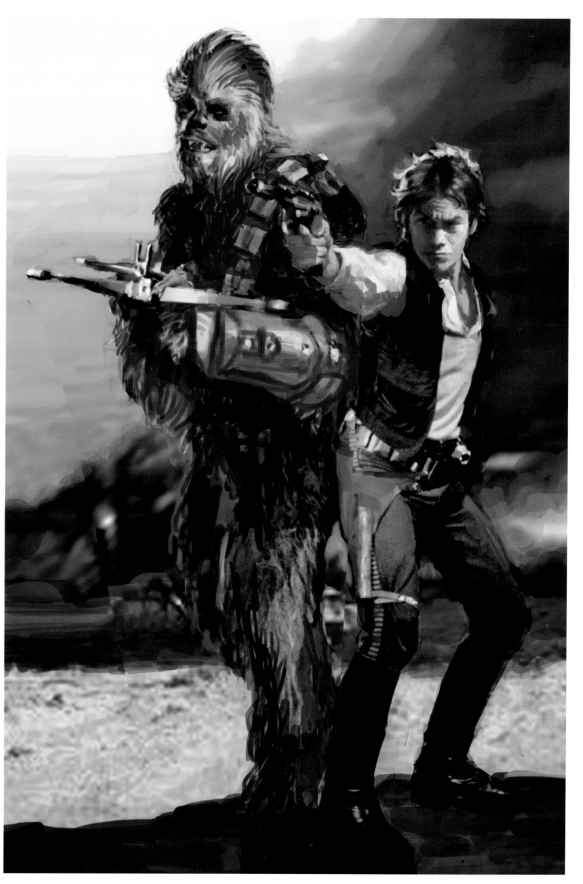

▲ **HAN AND CHEWIE VERSION 04** McCaig

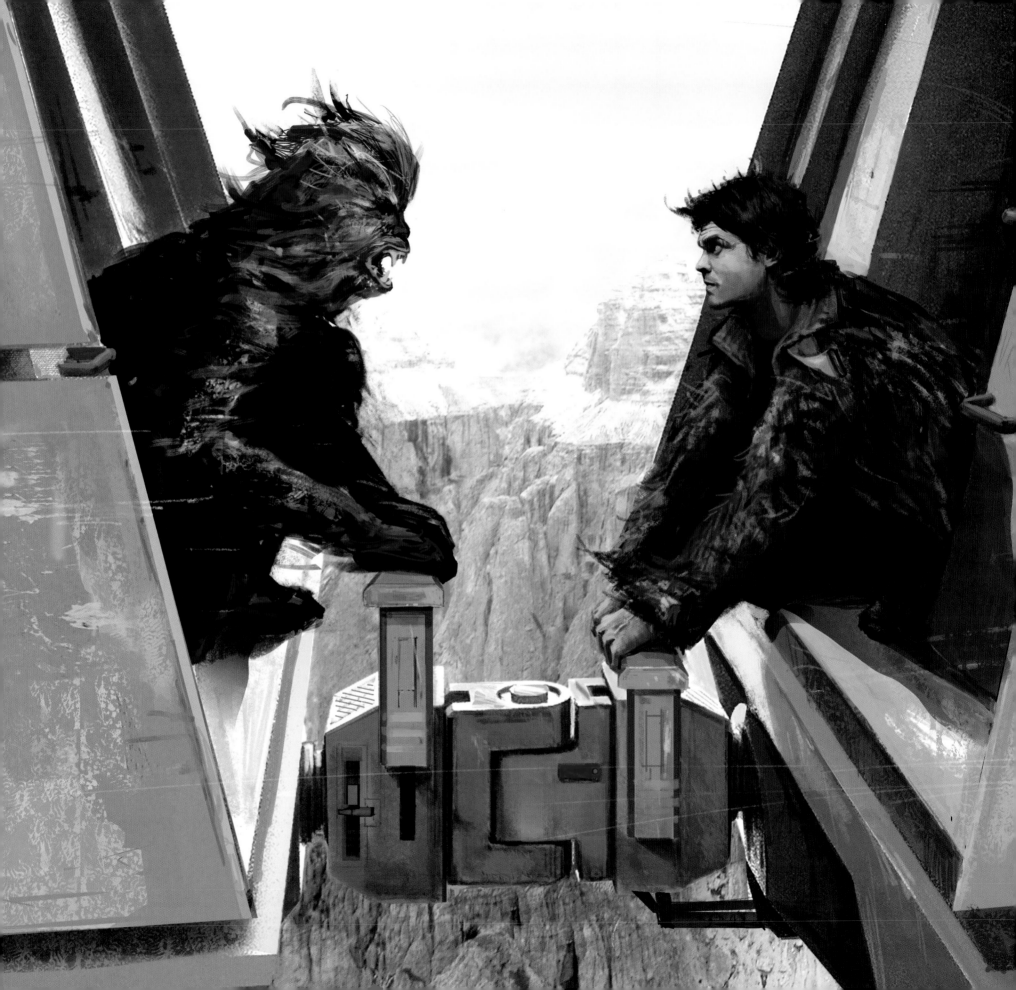

Han Solo

Upon completion of his co-screenwriting duties on *Star Wars: The Force Awakens* in late 2014, Lawrence Kasdan asked his son Jon if he would co-write the as-yet untitled Han Solo film with him. The second *Star Wars Story* after Gareth Edwards's *Rogue One*, would be centered on a young Han Solo (played by Alden Ehrenreich, whose casting was announced in May 2016) and was scheduled for a May 24, 2018, release, only five months after director Rian Johnson's *Star Wars: The Last Jedi*. "Larry did not feel he could write another Star Wars movie from scratch, on his own, after having just completed Episode VII," Jon recalled. "I was ambivalent about doing it with him because I was skeptical there was a good movie in the story of Han's youth. I don't tend to like prequels because there's little to no suspense about whether the hero will survive; of course he will. We see him later."

But an earlier Star Wars collaboration with his father changed Jon Kasdan's mind. "At the time we started working in earnest on Han Solo, we were both familiar with and had actually collaborated on writing Han's death scene," Kasdan revealed. "Personally, I would not have been excited to work on a young Han Solo movie had the character not died in Episode VII. It's hard enough for a new actor to be compared to Harrison Ford ever, but to be compared to him while he's still playing the part in other movies being made simultaneously, that seems like an unfair burden to put on any actor or any movie."

"So his death was, for me, essential to going forward. Not only that, but there are thematic undercurrents in this movie that point very directly to his inevitable fate forty years later. If character is destiny (and both Larry and I believe it is) Han's was written long before the moment his son stabbed him through the heart with a lightsaber. It's that essential humanism in him that is at once his greatest strength and his undoing." Films such as *Thief* (1981), *Heat* (1995), *Charley Varrick*, *The Wages of Fear*, *Sorcerer*, *Out of the Past*, *The Getaway* (1972), *The Wild Bunch*, *Only Angels Have Wings*, *The Magnificent Seven* (1960),

The Godfather: Part Two and *The Treasure of the Sierra Madre* had direct story and style influence on Lawrence and Jon Kasdan's final *Solo: A Star Wars Story* screenplay.

As with Luke Skywalker before him in 1977's *A New Hope*, *Solo* sees the wet-behind-the-ears title character embarking on his own Joseph Campbell–esque Hero's Journey, from the relative safety and familiarity of Corellia into the wider frontier worlds of Mimban, Vandor, Kessel, and Savareen. All the while, Solo and his compatriots chase treasure in the form of coaxium: rare, priceless but volatile hyperdrive fuel, a small nugget of which buys Han his freedom from Corellia. But unlike young Skywalker, Solo does not seek adventure. "The story always revolved around Han Solo, this lone character who really only wants to get enough cash together to buy his own ship and be his own man," Clyne recalled. But along the way, Solo finds more than he bargained for amid the wildness and danger of the intergalactic fringe. "The Han we meet in *A New Hope* is a fully formed, if somewhat simple guy," said Kasdan. "He wears the mask of the heartless, jaded cynic, and really believes he is one, but is actually a compassionate, vulnerable hero. We wanted dramatize how Han became the prior and how the later always reared its ugly head. We wanted to make a movie about a Han who is more trusting, eager to please and open to the people around him. And we wanted to see that character experience heartbreak and betrayal as well as loyalty and devotion."

Solo's journey—from petty thief to Imperial grunt to the "stuck-up, half-witted, scruffy-looking nerf herder" we all know and love from the original *Star Wars* film trilogy—also had to be reflected in a devolved design progression of the costumes and props so closely associated with the character, and without defying filmgoers' expectations too much. "Throughout the film, we're trying to build up a story of Han's look," said co–costume designer David Crossman (*Saving Private Ryan*, *Lincoln*, *Rogue One*). "We start in Corellia, with the red Corellian stripe on his trousers. As the story progresses, more things are added to his costume. It slowly evolves into that classic Han Solo look."

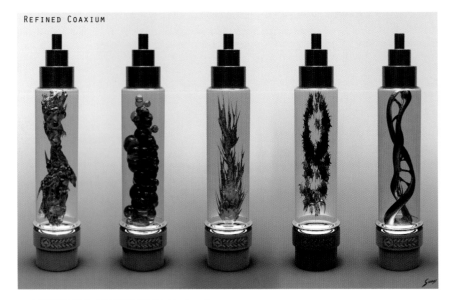

REFINED COAXIUM

▲ **REFINED GOLD VIALS VERSION 38** Matthew Savage

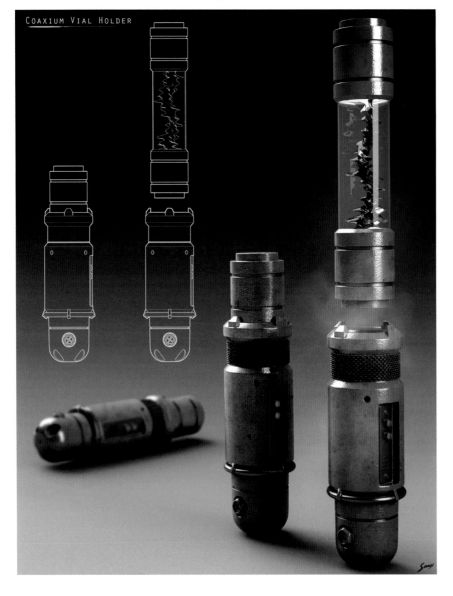

COAXIUM VIAL HOLDER

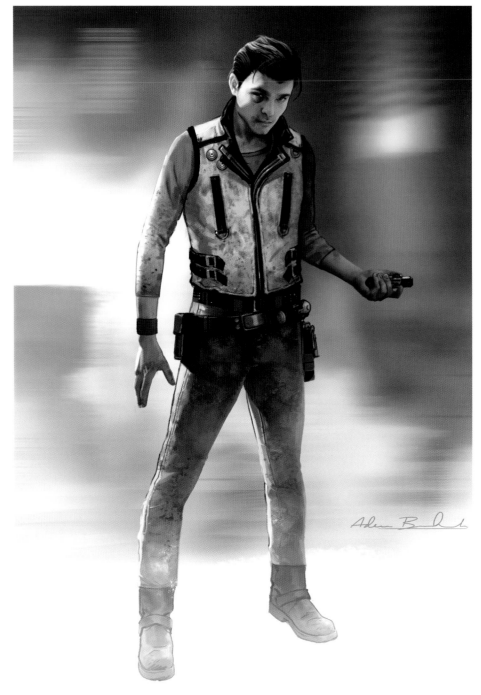

◄ **REFINED GOLD VIALS VERSION 97** Savage

"Unrefined coaxium was inspired by ferrofluid, which is put into real-world spacecraft fuel. Ferrofluid is full of iron filings. Since there's no gravity in space, it's magnetically, instead of gravitationally, pulled into the engine. The fact that coaxium powers hyperdrives makes ferrofluids a really lovely idea. When you put ferrofluid into a magnetic environment, it becomes very spiky. The more magnets you get around it and the further away those magnets are, the more refined and sea urchin–like the spikes become. The idea is that when you refine coaxium, it becomes a solid jewel." **Jamie Wilkinson**

▲ **YOUNG HAN VERSION 4B** Brockbank

"Before the White Worms themselves came into it, we knew we were costuming teen Han. So we worked up mood boards inspired by a lot of stuff from the band the Clash—that kind of eighties punk look—and *The Outsiders*, a 1950s gang." **Dillon**

"By October 2016, there was talk of white residue in the White Worms' lair. That residue went into all of the costumes. That's when Han gradually started moving over to a whiter jacket, so he could belong in that gang. We also found a nice vintage punk jacket that had been painted, so we did a similar thing." **David Crossman**

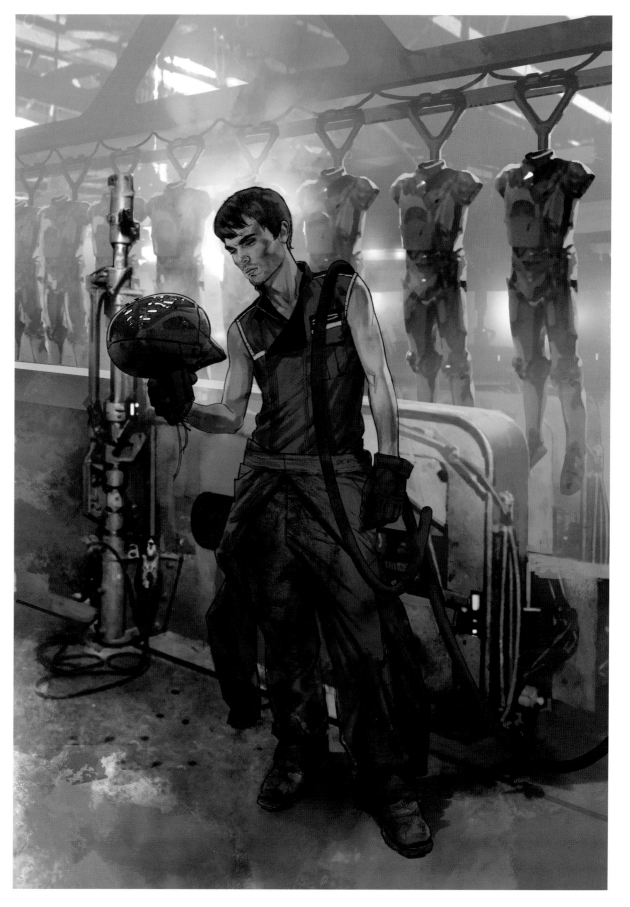

▲ **PRISON UNIFORM VERSION 1A** Brockbank

"Han is a street kid who imagines a more exciting, freer life beyond the slum he lives in. He's also naturally rebellious and resists all authority. That impulse gets him into trouble constantly." **Jon Kasdan**

In early exploratory work, Han Solo worked in the Imperial factories of Corellia before being imprisoned by the Empire and becoming cellmates with Chewbacca. Co-costume designers Glyn Dillon (*Kingsman: The Secret Service*, *The Force Awakens*, *Rogue One*) and David Crossman, along with costume concept artist Adam Brockbank, iterated on those designs until late June 2016 when Solo was reimagined as a member of the White Worm gang who doesn't meet the enslaved Wookiee until being conscripted and sentenced to a tour of duty on the mud world of Mimban.

▶ **FACTORY SUIT RED VERSION 1A** Brockbank

▶▶ **BUSHWHACKED VERSION 1A** Brockbank

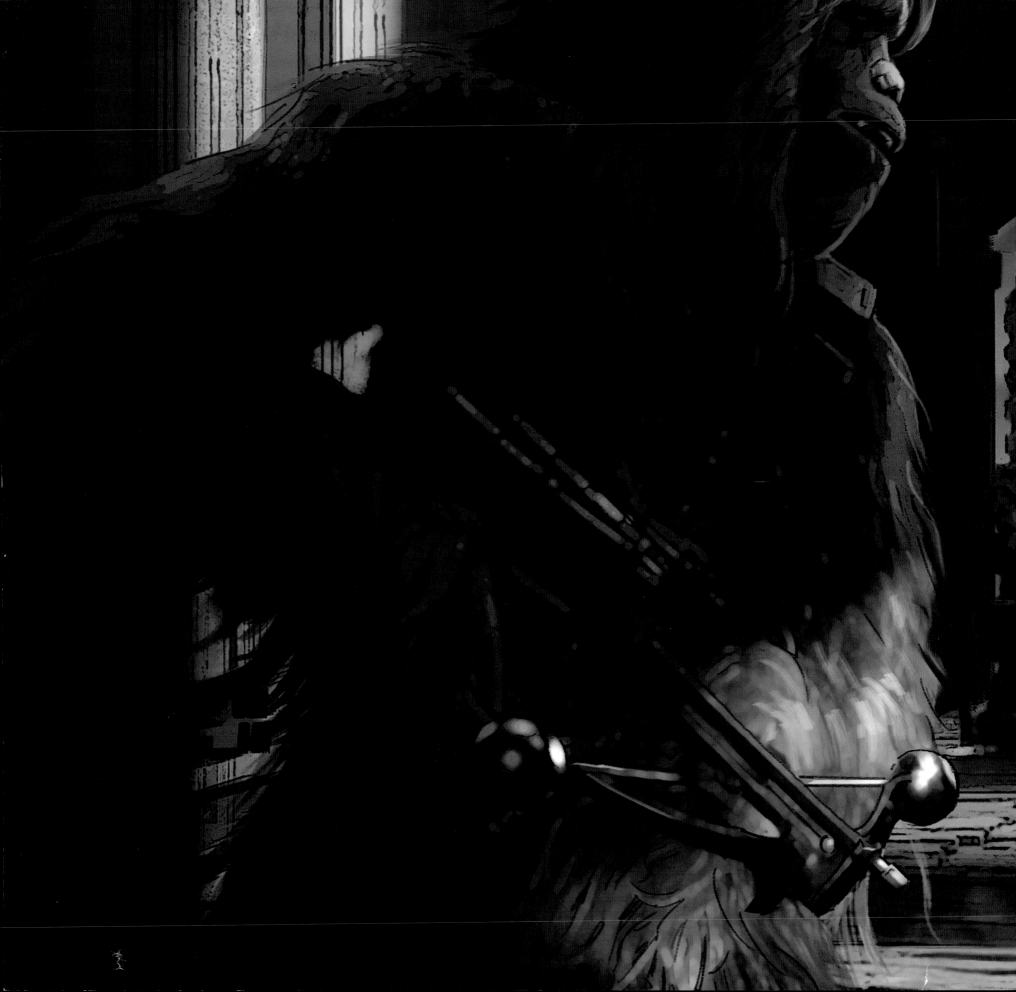

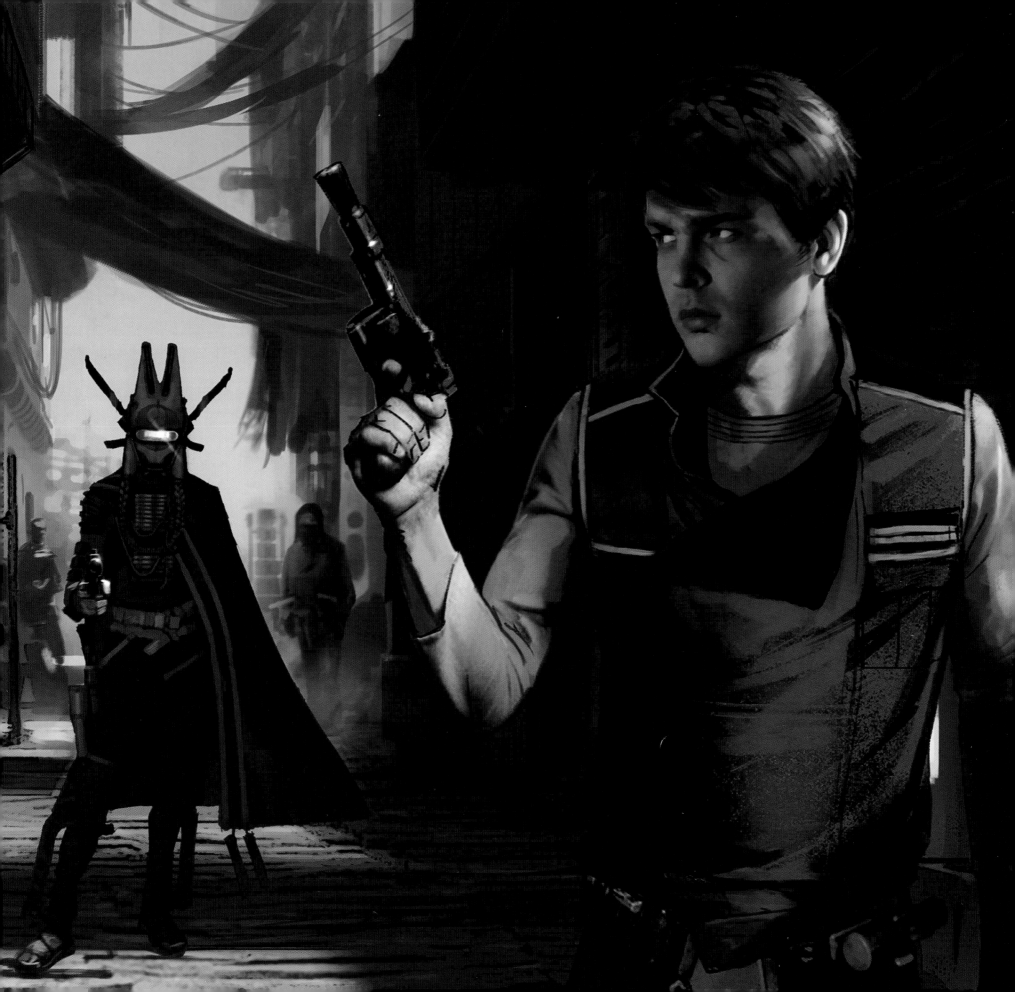

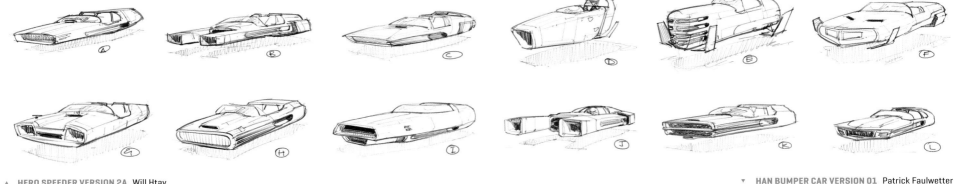

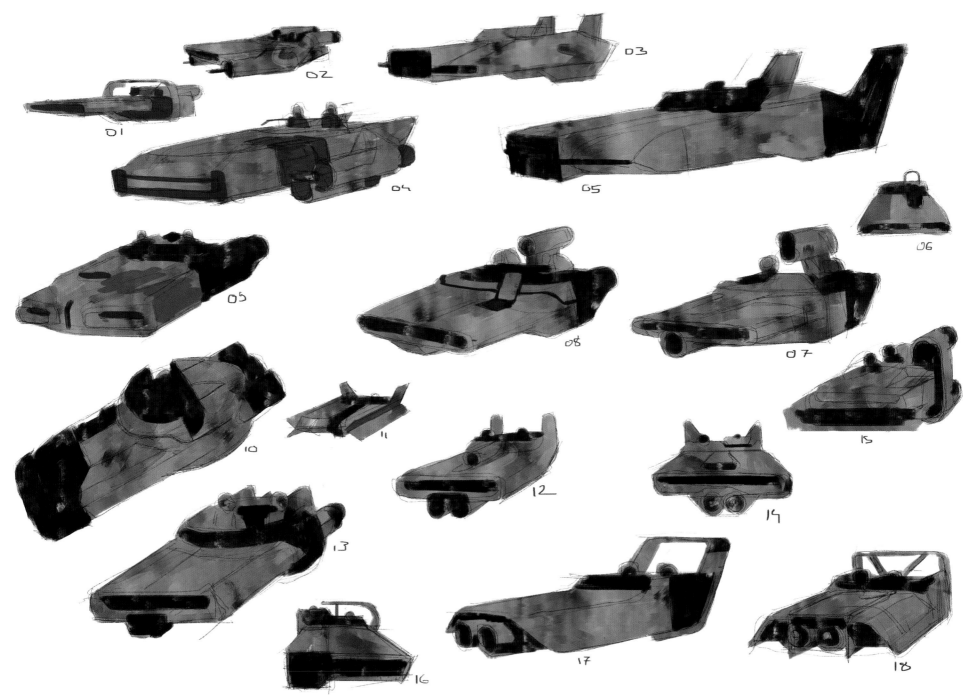

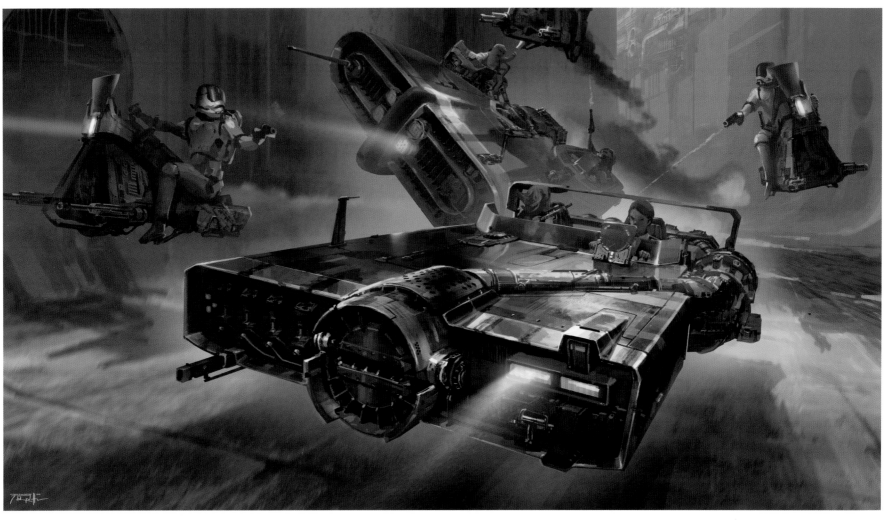

▲ **CHASE VERSION 01** Faulwetter

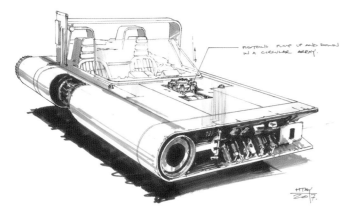

▲ **CAR BONNET VERSION 02** Htay

▶ **SPEEDER VERSION 02** Faulwetter

"In the early meetings for Han's speeder, for inspiration I showed a lot of reference of Dodge Chargers and Chevy Malibus. We loved that idea of a seventies, planar approach to it. One of my artists, Patrick Faulwetter, nailed what it became: It's just a big slab. I showed this photograph of this seventies car that somebody had Photoshopped the wheels out of and made it into a speeder. That always stuck. We liked the idea that Han steals the coolest car on Corellia." Clyne

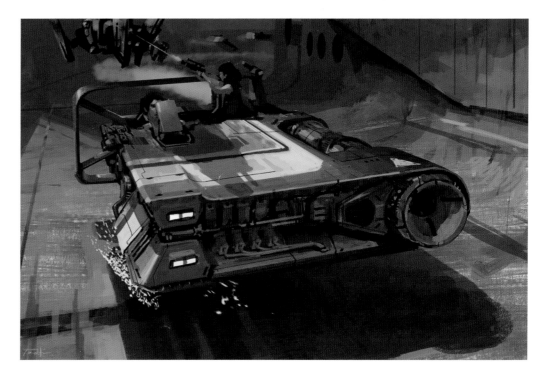

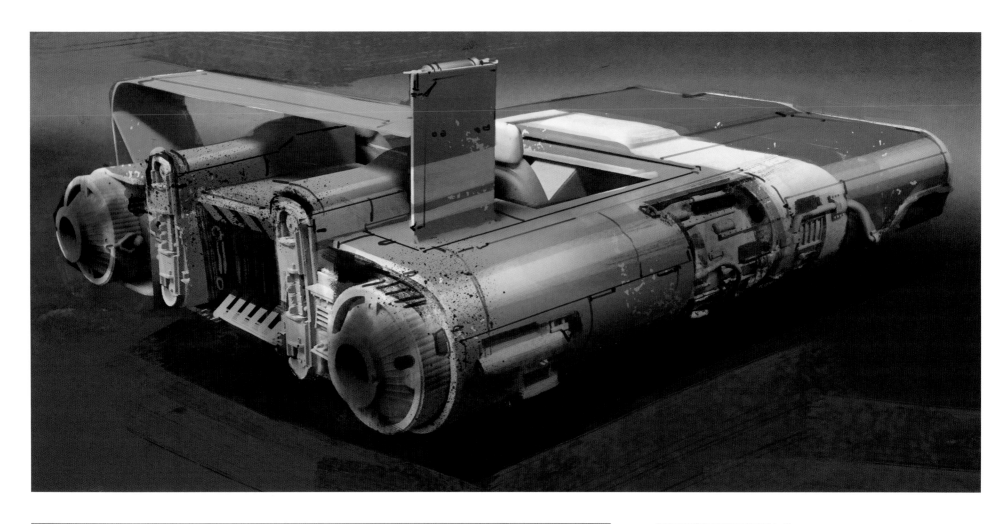

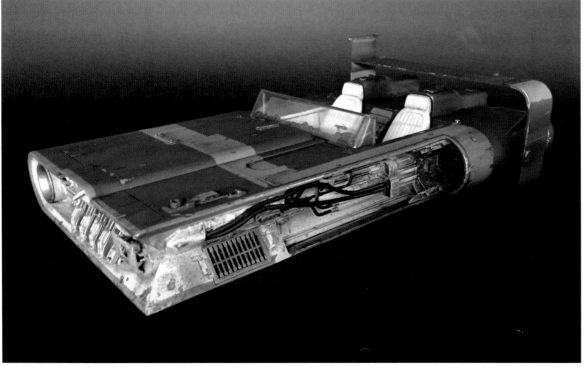

▲ **HAN BUMPER CAR VERSION 1A** Clyne

"Han's speeder looks like the Bible! That was something that James and his guys drew a long time ago, and it stuck. At one point, I tried to introduce more symmetry back into it. And I finally got my way on the back of the car, where we've got two engines that push it completely correctly; it's not going to drive in a circle. But asymmetry has always been a big part of its design. We've tried to understand the asymmetry by saying that maybe it's part of a removed cowling."
Neil Lamont

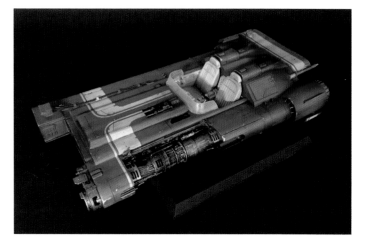

▲ **HAN BUMPER CAR 03** Ellis

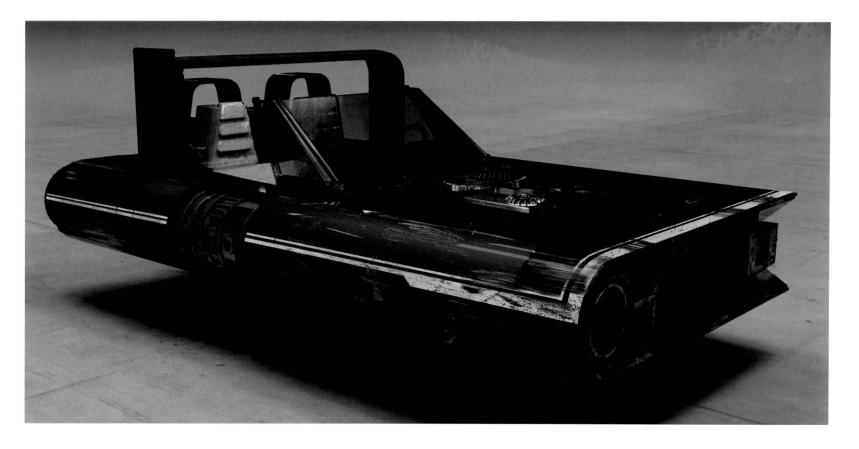

▲ **HAN'S SPEEDER STRIPE VERSION 65**
Paul Savulescu

"The irony, of course, is that that Han's speeder *is* a muscle car. It's got a V8, four-wheel-drive drift car under there, basically. That's been a massive part of the development of the speeders: to make sure they don't react like a car. So when Han's speeder rounds a corner, it floats a bit." **Lamont**

▶ **DASHBOARD TUNNEL AMBIENT** Andrew Booth and BLIND LTD.

"The speeder has to work driving at eighty miles an hour. Originally, we thought all of the graphics would be ambient loops, since we don't have access to the car on set. But we had the idea that maybe we could tie a smart phone's compass into driving the actual graphics. So we have an old-looking graphic, but it's driven by the technology of the smart phone. We had it programmed so that you can press the buttons and change what sort of map you're looking at, and, when they are actually driving, it moves around, so it has a little bit of interactivity and dynamism. Maybe Lucasfilm could make this into an app [*laughs*]." **Shaun Yue**

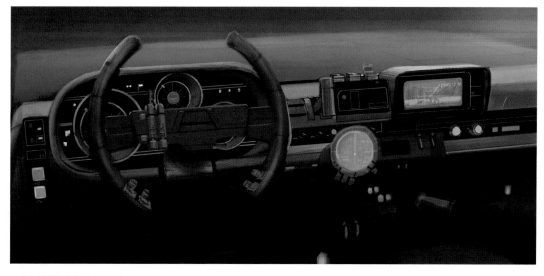

▲ **DASH VERSION 3A** Jenkins

▲ **DASHBOARD SPEED** Booth and BLIND LTD.

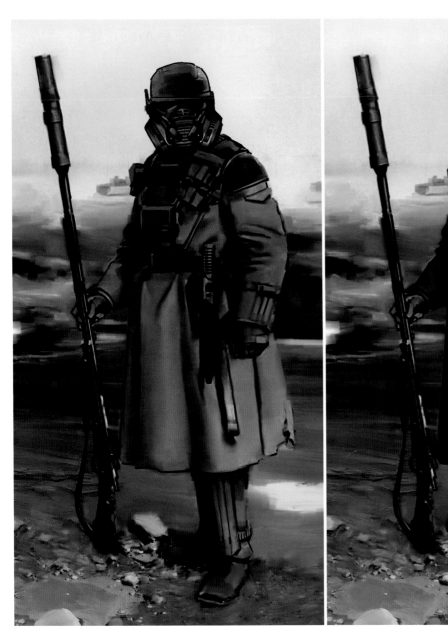

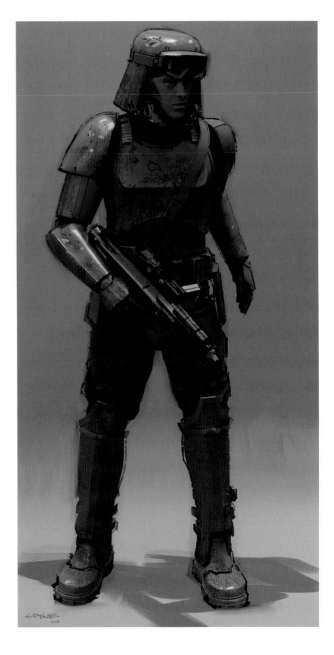

▲ **MUDTROOPER VERSION 2A** Dillon

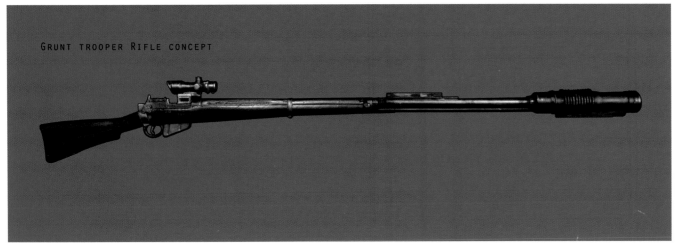

Grunt trooper Rifle concept

▲ **MUDDY BOOTS VERSION 01** Clyne

"I did a really early rendition of a mudtrooper. Our desire was a guy who didn't look too dissimilar from the AT-ST pilot, mainly because they didn't have a face mask," Clyne recalled. To allow Han Solo to be distinguished from his fellow mudtroopers necessitated a helmet design through which the audience could see Alden Ehrenreich's face.

◄ **MUDTROOPER LONG RIFLE VERSION 12** Savage

"This was going to be for the Imperial officers. Because the scene in the trenches got cut down slightly, we just stuck to the one mudtrooper blaster build. The long gun was what they used to go over the top of the trenches in World War I. That was probably the fourth or fifth design we hit on before the direction changed. It was so simple, especially being inspired by a Lee-Enfield rifle, which the Jawa gun from *A New Hope* was also inspired by. They literally cut it down and added a grenade-launcher cup." Wilkinson

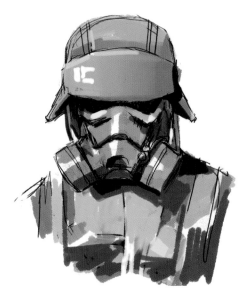

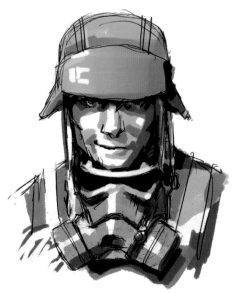

▲ **GAS T VERSION 01** "As it progressed, we—
including Glyn Dillon in costumes—were playing
with these ideas of early World War I helmets. They
liked this idea of the goggles that come down and
the gas mask that comes up. It almost starts to
mimic a stormtrooper, which is fun." **Clyne**

▶ **NEW HAN MUDTROOPER VERSION 30** **Dillon**

"The mudtroopers started with the AT-ST helmet
and a World War I vibe, but they evolved gradually.
We made a helmet like the original Glyn pictures
and tried that on Alden. Then we made one more like
the General Veers helmet from *Empire*. It ended up
somewhere between the two. Then Glyn drew these
proto-stormtrooper goggles, which we fabricated
in chrome, and which worked very well with the
helmet. A lot of the discussion was around the mask,
because Han was going to be revealed wearing a
mask and goggles." **Crossman**

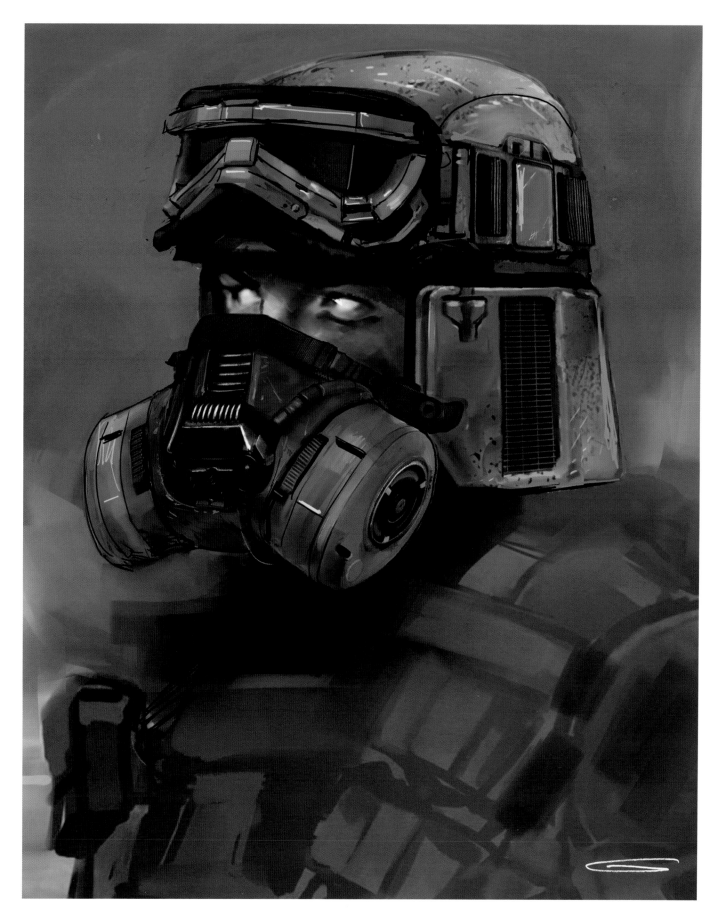

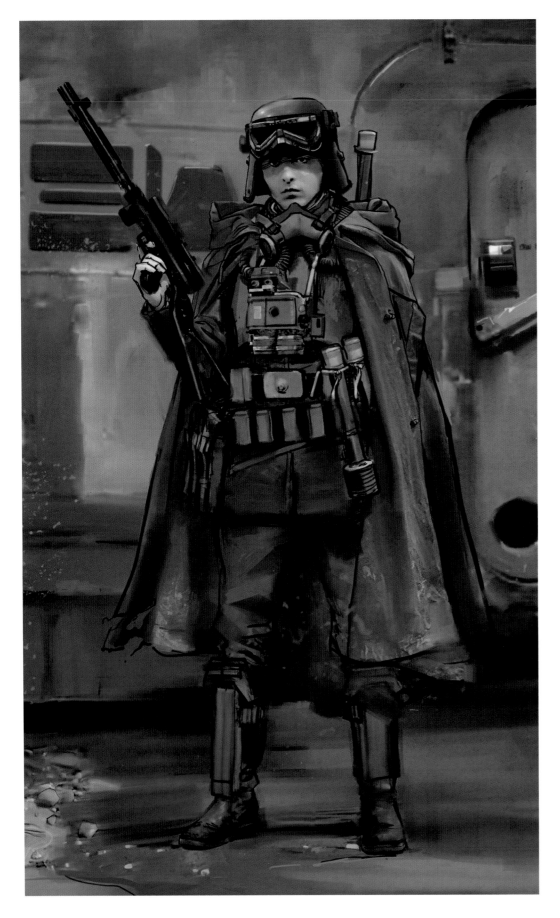

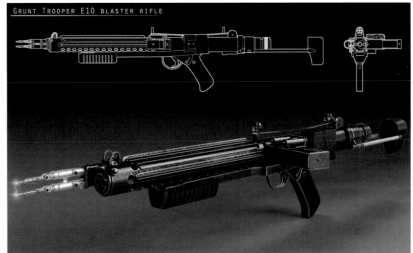

GRUNT TROOPER E10 BLASTER RIFLE

▲ **MUDTROOPER BLASTER VERSION 27** Savage

"The blaster had to be simplified because the mudtoopers are supposed to be the grunts. So we took the Sterling, a British submachine gun also used for the standard stormtrooper E-11, and added a taser at the end of the barrel that pushes forward. It's almost like a World War I bayonet. They're going to have a lovely green barrel flashes, giving a slightly alien feel." **Wilkinson**

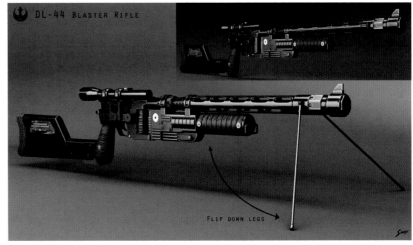

DL-44 BLASTER RIFLE

FLIP DOWN LEGS

▲ **RIFLE VERSION 07** Savage

"We thought, 'Wouldn't it be nice if the first time you see Han's DL-44, it's in a different state?' Like Jyn and Krennic's blasters in *Rogue*. On the Mauser C96, a German semiautomatic pistol that the DL-44 is inspired by, there's a wooden stock that goes on the back that you can use as a holster for the gun. You can take the gun out of the stock and slide the stock into this slot in the grip, and it becomes a long-range pistol. That's where it all started." **Wilkinson**

◄ **HAN TROOPER VERSION 23** Dillon

"We cut the cape in a curved way, giving it a waterfall effect, and burned holes in it so he had one side that's heroic. Alden looked good in it. The cape is a Russian World War II groundsheet. Those capes were always blowing in the wind in Soviet photos of World War II—a very iconic romantic image. We were able to buy some originals and some 1950s ones, which were then dyed black and distressed, adding our gray mud of Mimban." **Crossman**

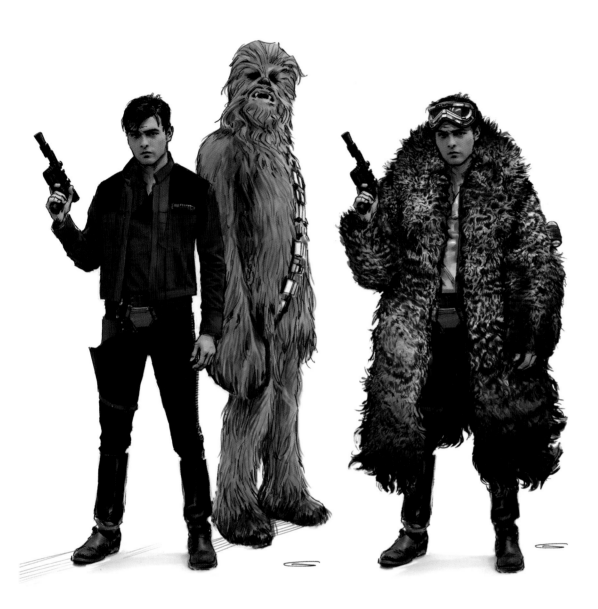

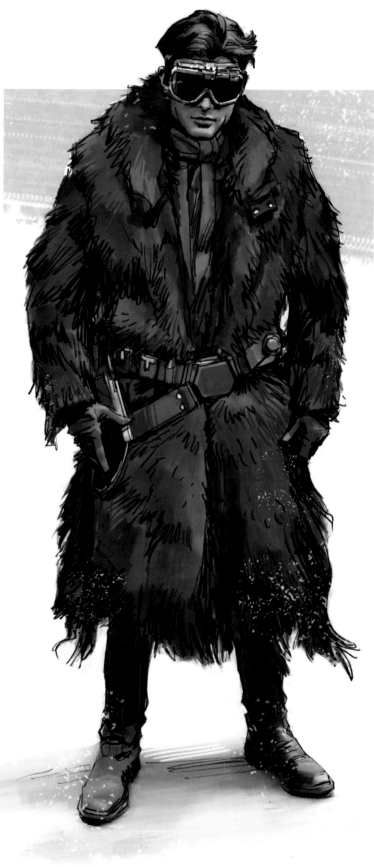

▲ **HAN SHORT JACKET VERSION 06** "The one that Dave Crossman and I liked at the very beginning is the one that we ended up with: that Steve McQueen, early-seventies suede leather look. It felt very 'Han Solo' straight away. Adding the black yoke on the shoulders and a little bit of *Star Wars* detailing didn't feel too challenging. That was a good hit for your hero look." **Dillon**

"We saw an exhibition at the V&A [the Victoria and Albert Museum] in London. I can't remember which exhibition it was, but in it there was a nice combination of brown and black suede. As soon as we saw that, we put the black panels onto the jacket. The next thing was playing with Alden's height and physicality to carefully work out the length of the jacket and how slim it looks on the arms, so he looks heroic enough. When you look at old Han Solo photos, everything is cropped and seventies—super short. So we shortened the sleeves. We kept the belt pretty much the same. That's Alden's favorite costume." **Crossman**

▲ **HAN VANDOR JACKET VERSION 1A** "We had a screening of *McCabe & Mrs. Miller* for the whole crew. They wanted a big fur coat for Han, akin to the one Warren Beatty wears when he rides into town with his little bowler hat. It's a fantastic look—really big and dramatic. We scoured the world for fake furs, because we don't want to really use fur unless it's a by-product. We ended up using buffalo on that one. The shorter, curly parts of the hide took a bit of processing to get to the right shape and the right look." **Dillon**

▶ **HAN FUR COAT VERSION 02** **Dillon**

"There was a worry about the volume of the coat on Alden and whether it should be paler—it went though many iterations. We were trying to arrange all of the pelts in a certain way to get a heroic look, but also keep a wild element. It was a very difficult thing to put together and make repetitions of. Buffalo is a very thick, hard-to-sew hide, so the coat was sewn by hand. And it doesn't smell great [*laughs*]. Finally, we got this semi-fitted look. We had the belt over the coat like Han had over his parka on Hoth. That seemed to work." **Crossman**

Qi'ra

Rogue One co–costume designers Glyn Dillon and David Crossman reunited to serve the same role on *Solo*, gathering reference for remote costume design reviews in late 2015, with concept art creation in full swing by July 2016 in preparation for the commencement of principal photography in January 2017.

Prior to July, Dillon was putting the finishing touches on costumes for the *Rogue One* reshoots that began at Pinewood Studios, Buckinghamshire, England, in June 2016. Crossman wrapped his work as costume supervisor under costume designer Michael Kaplan on *The Last Jedi* in June, as well, having met costume needs for the Crait mine interiors and Resistance ski speeder pilots. When available, both Crossman and Dillon contributed sporadic sketches and paintings in the months between the winter and summer of 2016, supplemented by work from James Clyne, Aaron McBride, Karl Lindberg, and Luis Carrasco in the ILM Art Department, based in Lucasfilm's San Francisco offices.

"There's a lot more costume variety in the *Solo* script, compared to *Rogue One*," Dillon realized. "Once again, you're trying to push to do something new, but at the same time keep it feeling like it is *Star Wars*. You want to have respect for the franchise but not complete reverence, where you're too scared to do anything."

In July, Crossman and Dillon were joined by returning costume concept artist Adam Brockbank, following his stint designing sets in *The Last Jedi* production designer Rick Heinrichs's art department. "No one else was available. Adam was down on his luck [*laughs*]," Crossman joked. "His main background in the film world is with the art department, doing environments. But I think he enjoys his forays into costume." Dillon opined, "Adam has amazing stuff, hasn't he? He likes to mix it up a bit, having done comic book work. So he's really great at doing characters. It keeps everything fresh. When Adam gets bored with us, he goes to the art department. And then when he's sick of them, he comes back."

The Last Jedi costume concept artists Tonči Zonjić and Robert Rowley also returned briefly to contribute to *Solo* in late 2016. "Tonči was back in Canada by then," Crossman recalled. "So he did the whole thing remotely. Usually, working remotely isn't successful. But this time it was very helpful. There's some of Tonči's work in the film. Rob, who did some great work on *The Last Jedi*, also did a little bit for the yacht."

One of the very first characters the costume department would be tasked with attiring is Qi'ra (also known as "Kura" in early script drafts), first introduced as "Head Girl" in Proxima's Corellian White Worm gang and, to a much lesser extent, Han's would-be girlfriend. But for the first seven months of 2016, the idea that Qi'ra could be a beautiful humanoid alien was entertained, with both Neal Scanlan's creature department and the costume department proposing design ideas. "There aren't many characters in *Star Wars* that are a mid-ground between an alien and a human," Scanlan realized. "That is a territory owned by other franchises. We came to the conclusion that we should just let the actress be the actress, and that was exactly the right choice."

Qi'ra (played by Emilia Clarke) would be unlike any previous *Star Wars* heroine to date—not a queen nor a princess, neither a military nor spiritual warrior, and about as far from a naïve desert scavenger as they come—which presented another design challenge for Dillon and Crossman. Ultimately, Han and Qi'ra's Corellian attire would have more in common with fellow young inner-city roughnecks like 1970s New York and London punk pioneers Blondie and the Clash, as well as 1950s rocker gangs as depicted in films such as *The Outsiders* and *Grease*, than the well-heeled denizens of other *Star Wars* metropolises like Coruscant and Cloud City.

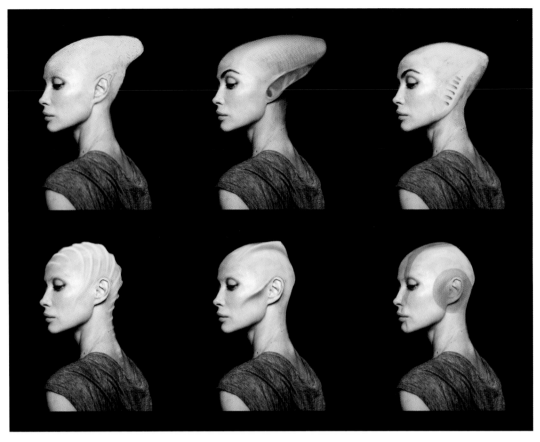

▲ **K-2 VERSION 01** Fisher

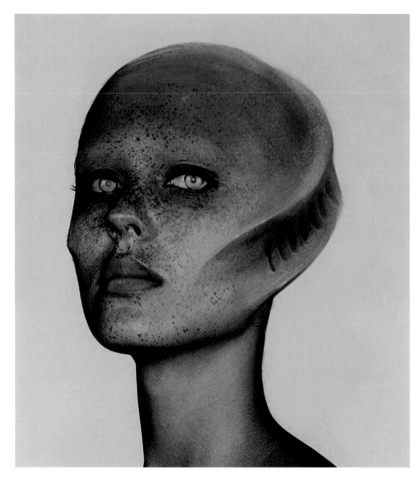

▲ **K-1 VERSION 01** Luke Fisher

"We explored Qi'ra being an alien in the early days. When you look at all of the characters that have been created over the years—for instance in the *Star Trek* franchise—you learn that you don't want to cover the actor or actress's beauty or emotional range. Every time we touched upon the human form, it fell into some sort of fashion niche or *Trek*-like genres, like steampunk. It is a very tough gray area. One needs to go all the way or not at all." **Neal Scanlan**

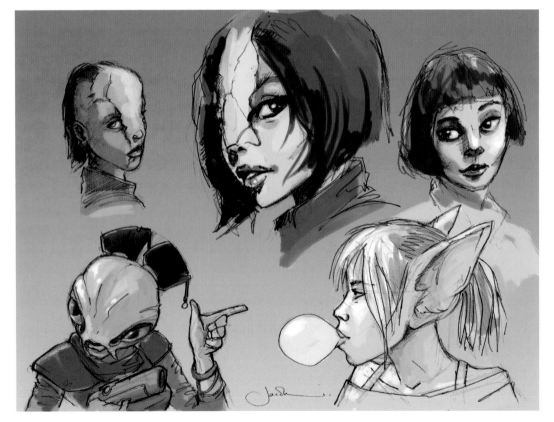

▲ **KURA VERSION 10** Jake Lunt Davies

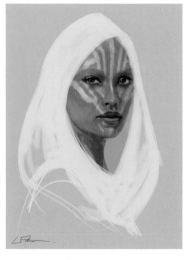

▲ **KURA VERSION 01** Fisher

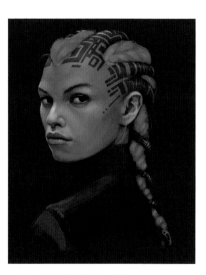

▲ **KURA X3 VERSION 1A** Fisher

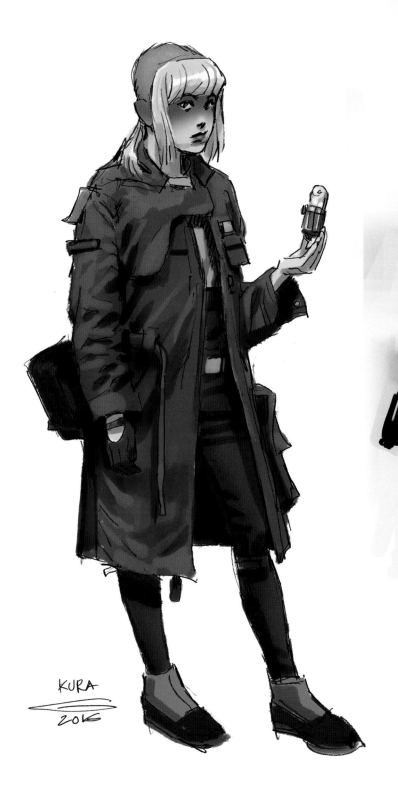

KURA
2016

▲ **TEEN K PARKA VERSION 02** Dillon

"Glyn did the very early Qi'ra picture with a shaved head, red ombre face, and a chunky feather-cut haircut. I love that picture. It's one of my favorites. There were similar makeup tests done on background people, but never in that way on Emilia Clarke. She was shooting *Game of Thrones*, so her availability was pretty much nil. It has to be the right person to make all of those things work; it probably wouldn't work on Emilia. Sometimes, ideas are better in a drawing." Crossman

▶ **OLDER KURA VERSION 23** Dillon

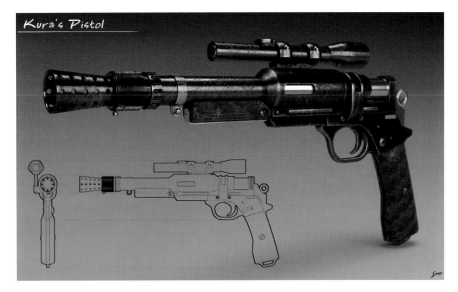

Kura's Pistol

▲ **KURA PISTOL VERSION 01** Savage

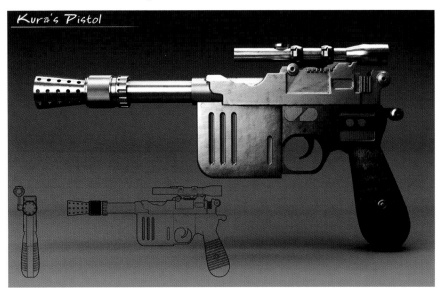

Kura's Pistol

▲ **KURA PISTOL VERSION 02** Savage

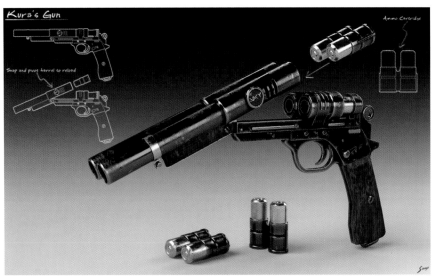

Kura's Gun

Snap and pivot barrel to reload

Ammo Cartridge

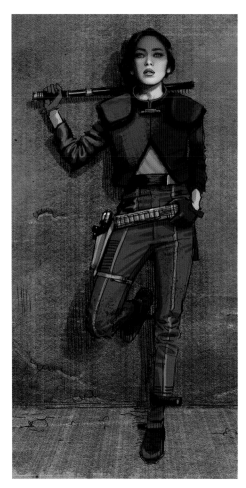

▲ **KURA MAIN VERSION 01** Dillon

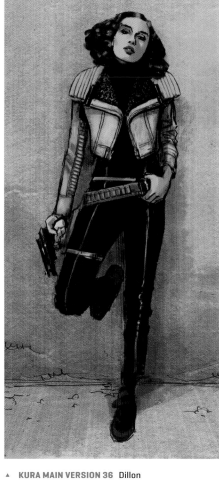

▲ **KURA MAIN VERSION 36** Dillon

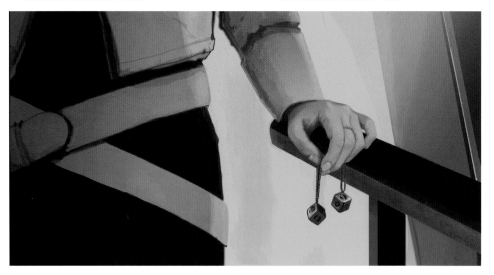

◄ **KURA PISTOL VERSION 04** Savage

"Qi'ra's blaster was the first gun that got signed off on. It's really feminine and petite—a fantastic gun, and one of my favorites. It's not that far removed from the slightly obscure World War II pistol, the Mannlicher M1905, that it's inspired by. We just added the second barrel, like a mini-shotgun." Wilkinson

▲ **DRYDEN MAIN DECK VERSION 6C** Sole and Clyne

"They are the exact same dice that were in *The Last Jedi*; we haven't changed them at all. It was a real shame that the scene where Han hangs the dice up in the *Falcon* in *The Force Awakens* got cut. It would have been a nice link among all three films." Wilkinson

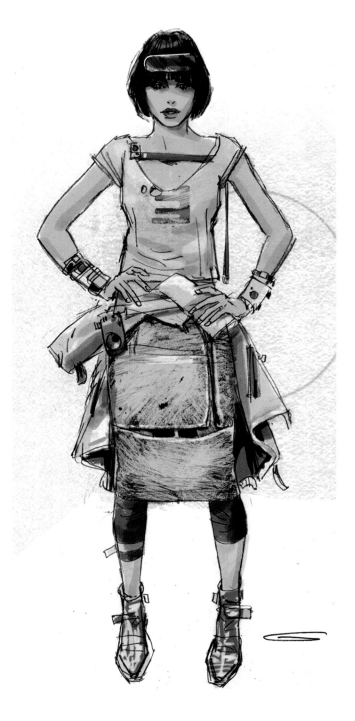

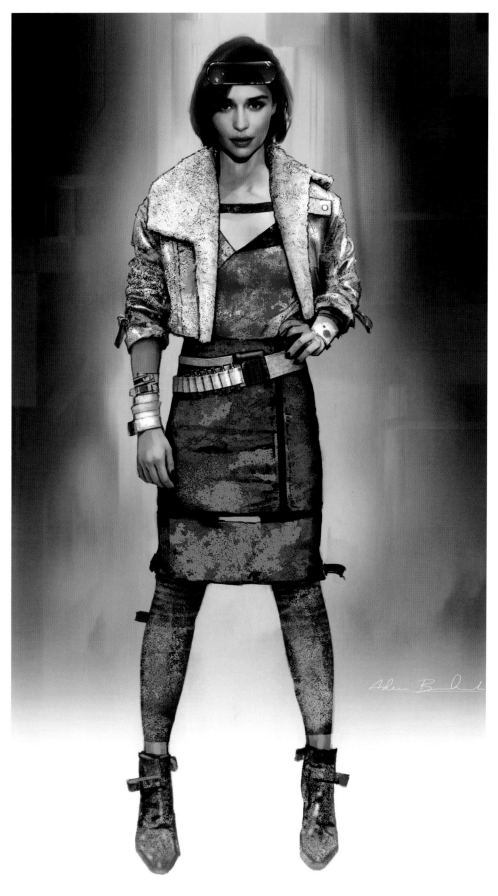

▲ **KURA TEEN VERSION 55** Dillon

"Some of the references for teen Qi'ra were Blondie and the early-eighties punk scene. There was a nice Debbie Harry yellow T-shirt, which we started out with. When you get the actors in for fittings, you realize some colors work better than others. We went for red, because Emilia can wear strong colors really well. So there was a bit of experimentation in development." **Crossman**

▶ **QI'RA VERSION 1A** Brockbank

"For Qi'ra's jacket, we started with a base pale-silver nylon color that we could add residue to, with a strong shirt color coming through. Han and she stood out from the rest of the gang—that slight notch above those kids." **Crossman**

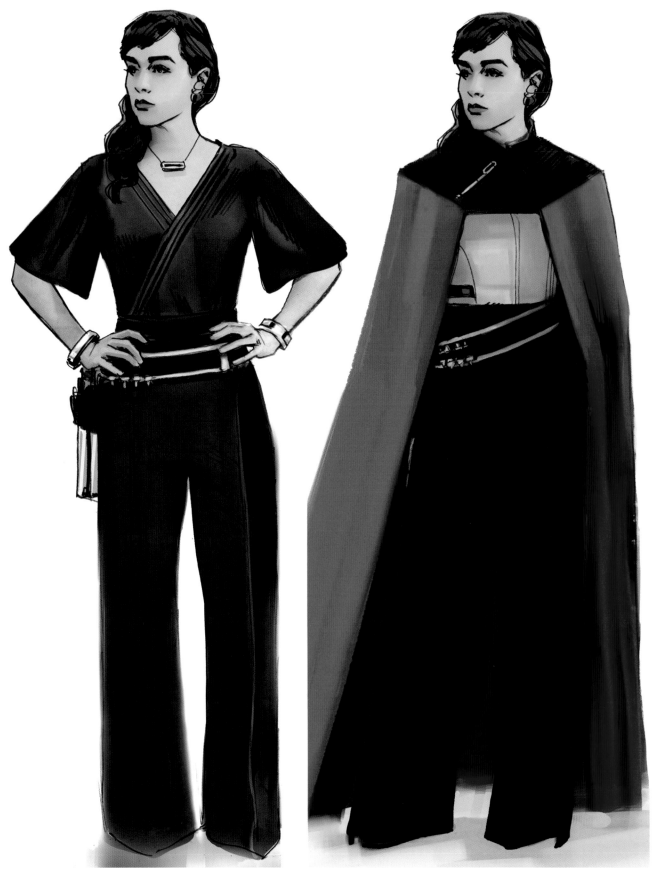

▲ **KURA YACHT VERSION 01** Dillon

"We made a couple of options for Qi'ra's dress. Emilia's really lovely, and she knows what suits her. It's always going to be led by what makes her feel comfortable. We make various shapes of dresses and see what really works for her figure. Whatever wins that round then goes on to drive the next version of the dress. Then you commit to the fabric and the color." Crossman

◄ **QI'RA DISGUISE** Dillon

▲ **QI'RA VERSION 13** Dillon

▲ **KURA VANDOR VERSION 01** "There's an amazing shot of Emilia entering the bar with Alden where she fills the frame. It's almost like *Casablanca*." Dillon

◄ **KURA YACHT VERSION 10** Dillon

"Our favorite one had more of a Japanese aesthetic, with this transparent Habutai silk top layer, which would give it a formality— but, with being so transparent, you would still see her figure," Crossman recalled. "Then we worked on various shapes that would suit Emilia, with shoulders and plunging necklines. The transparent layer gave it some gravitas, because she wasn't just any person at the party. We added the gold belt and some tech to that. So she was still formidable and beautiful."

▲ **YACHT DRESS VERSION 05** "Knowing it was to be the first time we would see Qi'ra since she was a teen on Corellia, we wanted there to be a big difference. There had to be an impact. And the character had to have an edge now, an element of danger. She was a femme fatale." Dillon

"We did alternate versions of the dress but finally, the elegance of the black gown won out. Our cutter Jenny Alford, produced a beautiful dress which complimented Emilia's best features. The construction and the fabric became one of the most important aspects of the costume being able to work." Crossman

▶▶ **DRYDEN MAIN DECK VERSION 1C** Thom Tenery and Clyne

THOM TENERY

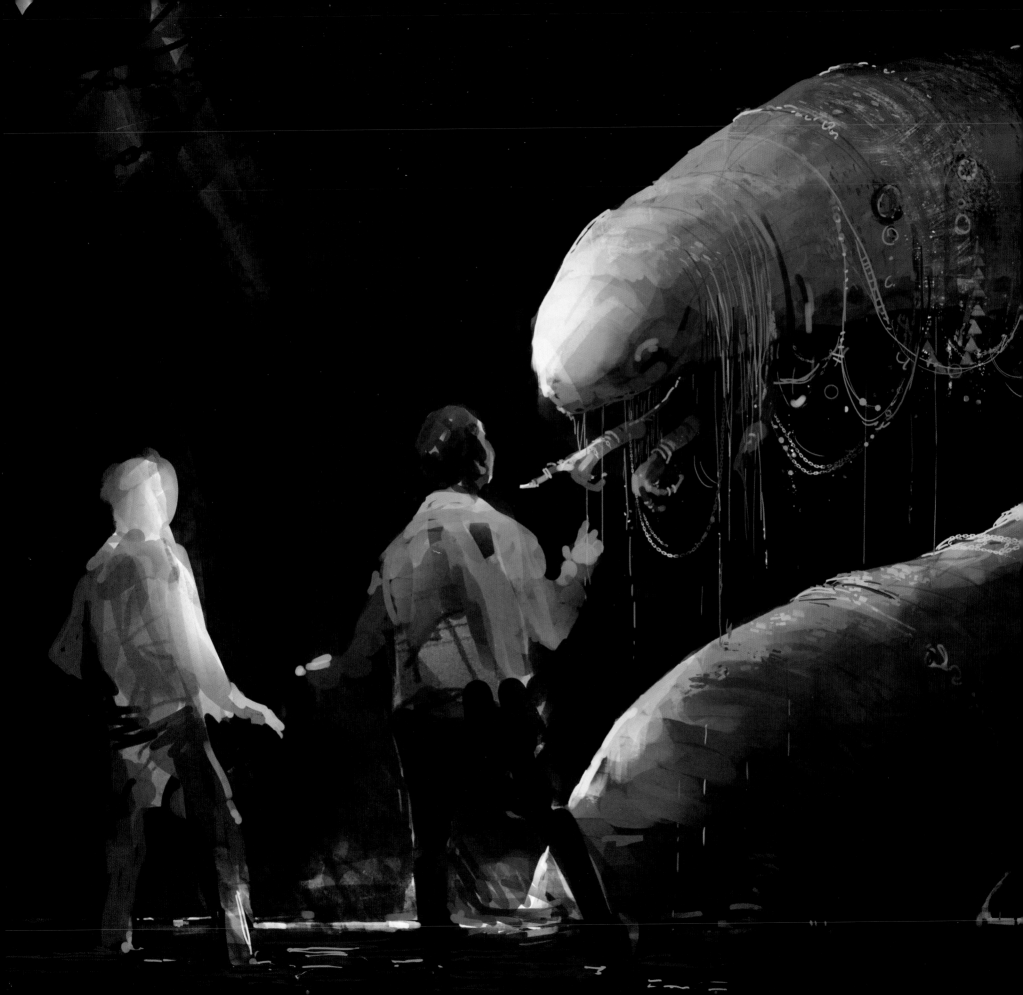

The White Worms

Creature effects creative supervisor Neal Scanlan (*Babe*, *The Golden Compass*, *Prometheus*), along with his core team of creature concept designers and senior sculptors Jake Lunt Davies, Luke Fisher, Ivan Manzella, and Martin Rezard, as well as paint finish design supervisor Henrik Svensson, returned for their fourth collective *Star Wars* film in a row starting in October 2015.

In spite of *The Last Jedi* production crew's hectic ramp-up to the commencement of principal photography at Pinewood Studios in February 2016, Scanlan and team prepared dozens of preliminary concepts for Rio Durant; Qi'ra/"Kura"; Enfys Nest; a then-unnamed alien crime boss; mine workers; and a gaggle of random aliens and droids for their first remote design presentation on October 22.

"I think we are getting into the groove, as far as how the creature department operates and how we interface with and get to know our directors," Scanlan said. "The biggest change and initial challenge that I felt from *The Last Jedi* to *Solo* was stepping back in time. I imagined Ralph McQuarrie and George talking about where *A New Hope*'s production design should be: 'Let's look at Buck Rogers and Flash Gordon.' And 'Let's look at this bygone era: the fifties.' Where do *we* go? It was quite exciting."

Reflecting on his impression of *Solo: A Star Wars Story*'s aesthetic and how they impact creature effects in the film, Scanlan recalled, "It feels like there is a visual curve in the film, in the sense that the film starts quite dark and monochromatic. As Chewie and Han's relationship grows, there would be a visual change. But we would also go slightly more 'weird'—a little bit more edgy and off-center, to a place we haven't been able to go yet. And that idea gained some traction. It certainly became our compass."

Scanlan said, "The filmmakers want the characters to become a part of the storytelling process at the time of filming, which is a great compliment. That has driven a lot of our decision making, not only in how the puppets and animatronics might work, but also in how they look." Scanlan's career began in the era immediately following *The Dark Crystal*'s 1982 theatrical run, with Scanlan constructing and mechanizing creature characters for productions both within and without the Jim Henson Creature Shop, founded in 1979 in the Hampstead Village area of London for *The Dark Crystal*. Those productions included *Return to Oz*, *Labyrinth*, *Little Shop of Horrors*, and Henson's *The Storyteller* TV series.

Although they weren't among the very first creatures Scanlan's team was tasked with designing, Proxima's White Worms ultimately found inspiration with early and previously passed-over concept art from across the creature effects team. "We were drawn to an old design of Ivan Manzella's which, aside from the face and posture, also contained a suggestion of jewelry and costume. There were also a couple of Luke Fisher's images from last year which influenced the direction for jewelry. Ivan then sculpted a maquette that the filmmakers picked up on, whilst Luke and Jake Lunt Davies explored the jewelry and costume application.

The den of the White Worms sequence was shot from September 4 to 8, 2017, on Pinewood Studios' purposefully flooded 007 Stage. *Solo*'s second unit filmed the chase among Han, Moloch, and the Imperial Patrol Troopers' speeders from May 15 to 17 at Hampshire's decommissioned Fawley Power Station, a two-hour drive from Pinewood Studios.

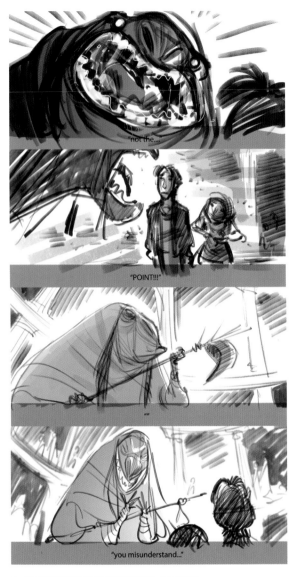

"not the...."

"POINT!!!!"

"you misunderstand..."

▲ STORYBOARDS KEY FRAME PASS Kris Pearn

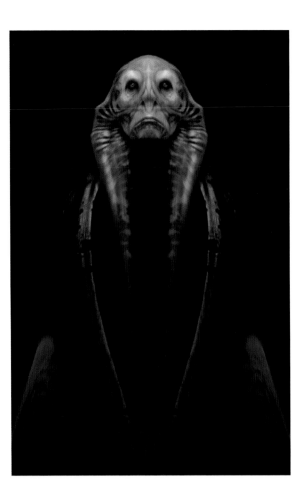

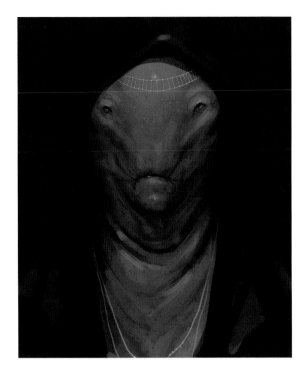

▲ PROXIMA VERSION 3A Fisher

"We took the normal approach with the White Worms: We knew they lived in total darkness, so there was going to be some element of albinism to them—a pigment-less creature." Scanlan

◀ PROXIMA VERSION 13 Manzella

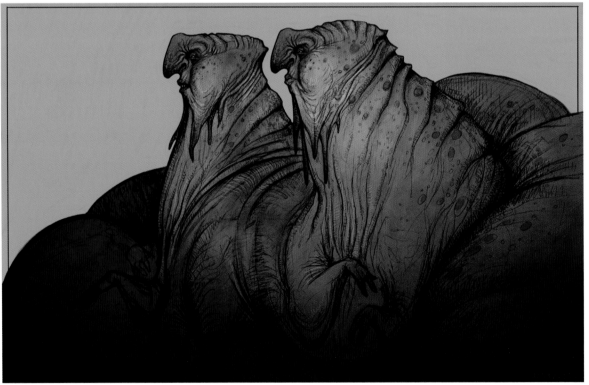

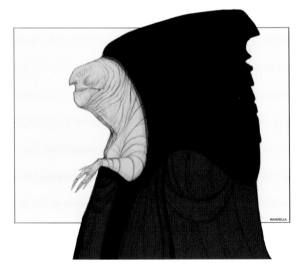

▲ PROXIMA VERSION 20 Ivan Manzella

▲ PROXIMA VERSION 1A Manzella

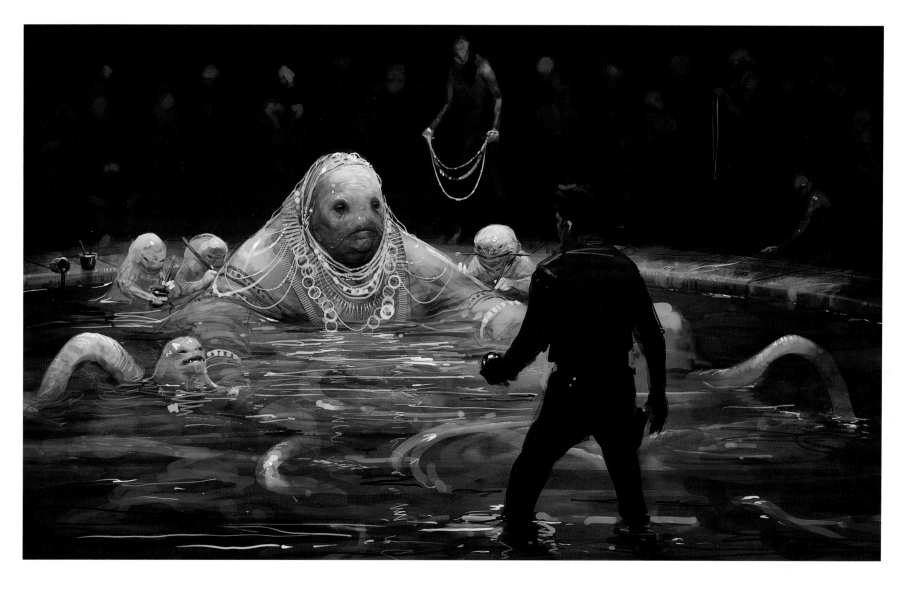

PROXIMA VERSION 1A Fisher

"I love the *A New Hope* trash compactor-esque psychology of Han walking into this water and not really knowing what is beneath his feet. Every step he takes, there is some form of organic life. Proxima is like some sort of plant with roots growing out—all-consuming. Everything is feeding off of everything, including her aides and these tiny pod-like babies that are being spawned off of her. It's a great concept." Scanlan

WORM 02 Manzella

"We felt that something octopus- or snakelike had been done so often before, so during the sculpting process, we began to look at these creatures as being more plant- or treelike in structure and texture, with tentacles like the roots of a tree. This also fit in with an early idea that somehow Proxima, her attendants, and Moloch were all symbiotically connected by a submerged and unseen root system." Lunt Davies

WHITE WORM 08 Lunt Davies

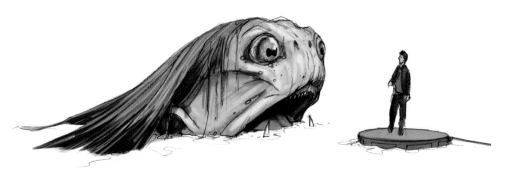

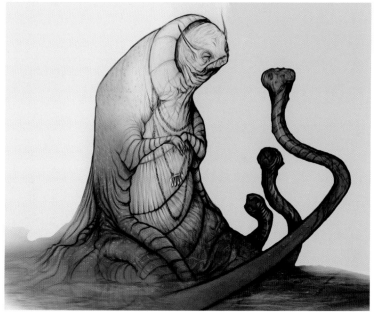

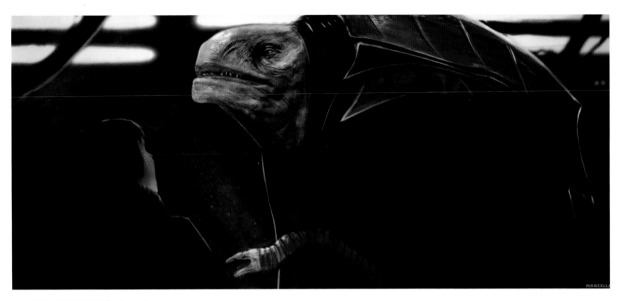

▲ **PROXIMA VERSION 11** Manzella

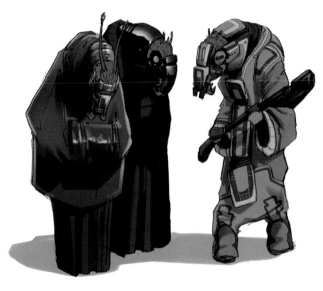

▲ **MOLOCH BG 04** Lunt Davies

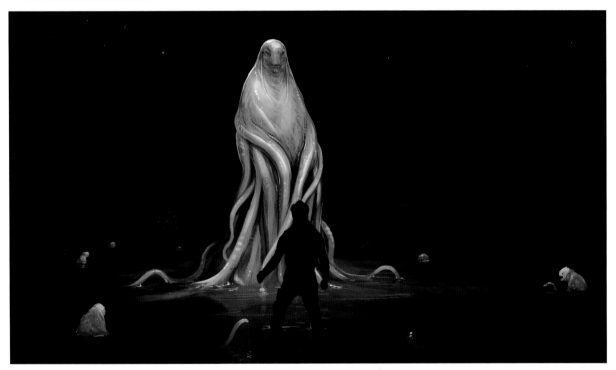

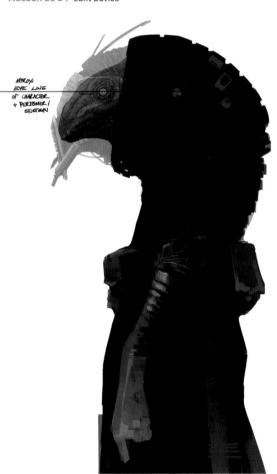

APPROX EYE LINE OF CHARACTER + PERFORMER / STUNTMAN

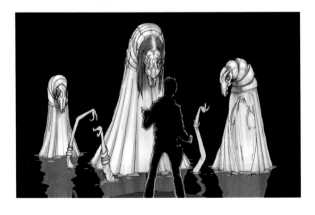

▲ **PROXIMA VERSION 1A** Fisher

"We wanted Proxima to be tall and imposing, and we really liked the serpentine feel of her looming toward and over Han. The idea of having the tentacles of her lower body submerged in the water had been likened to noodle soup." **Jake Lunt Davies**

"We were able to approach the design of the puppet in a way that would really enhance the fluidity of her body movements. The face controls were remotely operated while the head was supported on a pole-arm with the body suspended below, down to the water. This allowed the head to lead the body and lend it a more snake-like movement. Some puppeteers were required to be submerged in the water to operate the base of Proxima's body." **Scanlan**

◄ **WHITE WORM 03** Lunt Davies

▲ **MOLOCH OVERLAY 01** Fisher

"Luke Fisher came up with a tremendous design for Moloch's exterior protective outfit. But what we didn't have was what Moloch looked like on the inside. Our stunt performer who is playing Moloch, Harley Durst, is pretty well hidden in that costume. It's quite a successful distortion of the human figure." **Scanlan**

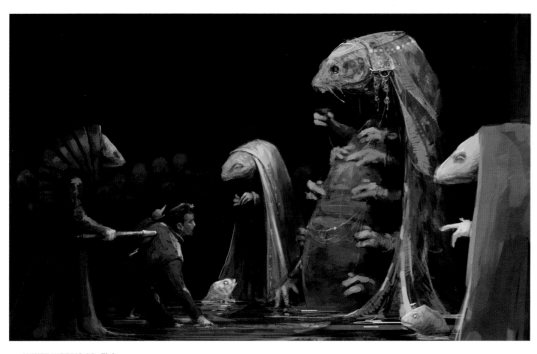

▲ **WHITE WORMS 10** Fisher

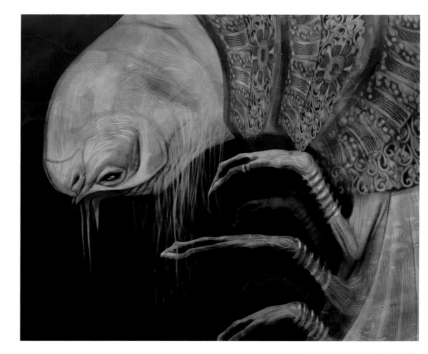

▲ **PROXIMA CONCEPT** Manzella

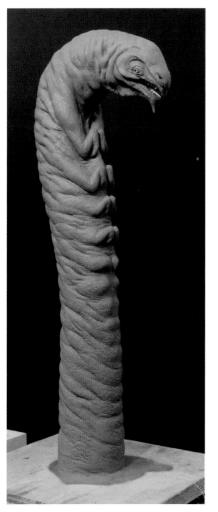

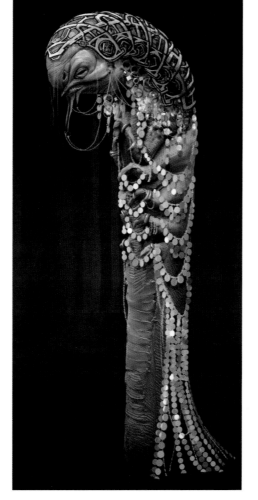

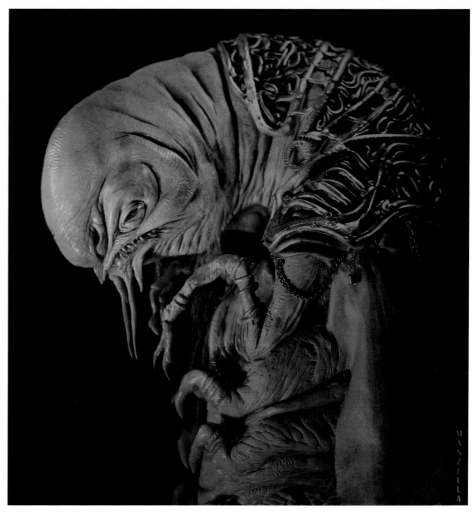

▲ **ATTENDANT M055** André Gilbert

▲ **PROXIMA COSTUME** Lunt Davies

▲ **PROXIMA MAQUETTE VERSION 01** Manzella

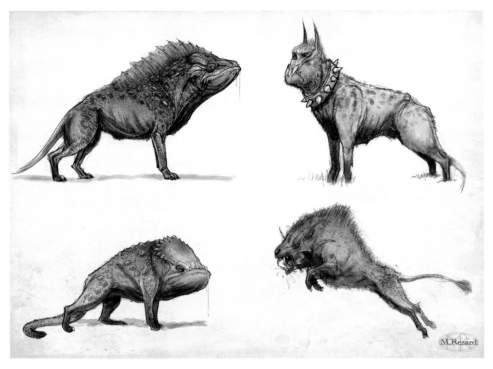

▲ HELL DOGZ 02 Rezard

▼ ROBOT DOG 05 Rezard

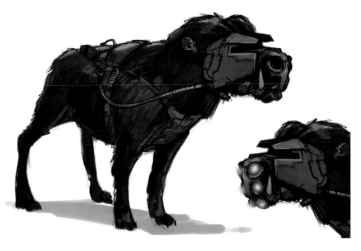

▲ DOGS 03 Lunt Davies

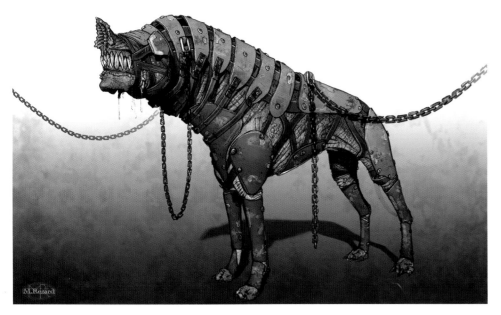

▼ PIRANHA 01 Rezard

▼ DOG 08 Rezard

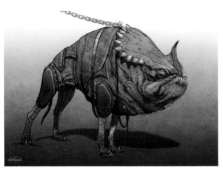

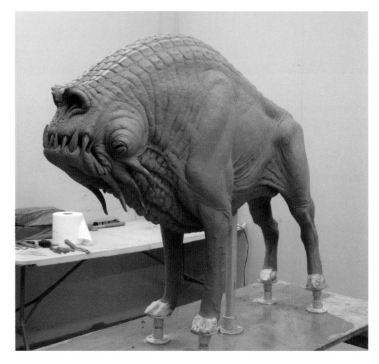

▲ DOG SCULPT Martin Rezard

"The feeling was that the dogs spent most of their time inside the den with Proxima. So the design had that same pigment-less skin. And they follow the DNA of Proxima. Suiting up actual dogs for Moloch's dogs was my idea. Madness. They loved it so much they actually put their own prosthetic heads on. All you had to do was hold the creature head, and they walked up and put their heads in it. You start with the animal first: What's required for them to be fully sensory aware? Like a puppeteer or a performer, you can then begin to change their shape. They're quite complicated little muscle suits underneath; very lightweight, stretch net, with very high foam pieces. There's a lot of breathability and ability for the animal to move unrestrained. There are mistakes in the random analog movement of an animal that work for you, like when the dog decides to do something that isn't quite right; you would never possibly conceive of that when puppeteering or CG-animating a creature. The bantha in *A New Hope* [performed by female Asian elephant Mardji in early 1977] set that whole thing up for me. It's our responsibility to carry that magic forward." Scanlan

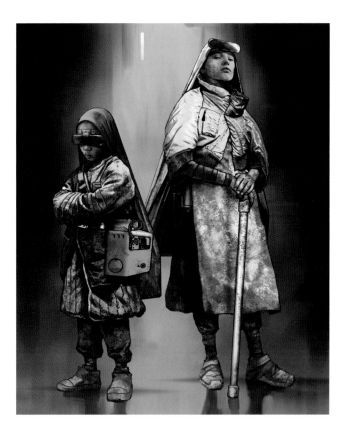

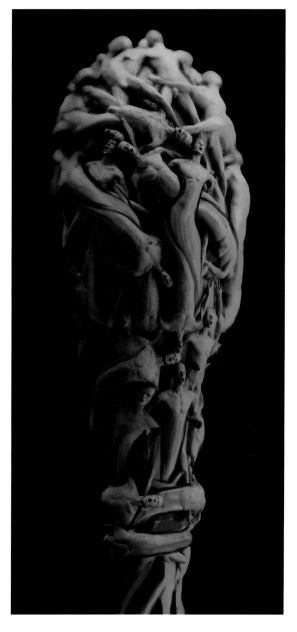

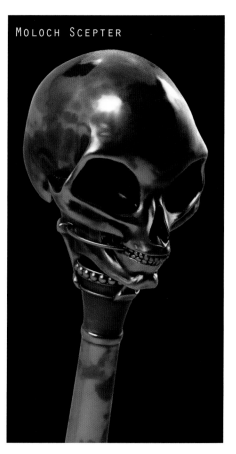

▲ SCEPTER VERSION 03 Savage

▲ **WHITE WORM KIDS 03** Brockbank

"There are about seventy-five White Worm gang outfits. You settle on a number of shapes and techniques that you like. Then you can start subdividing them into dye batches. Then you subdivide them again into different ways to break them down. It's all about the treatment that it goes through in our aging and breakdown department. They will dye it to different colors so you will have colors coming through. Then they coat this wax and powder on it. Gradually, you get an individual look, but something that's unified as well." Crossman

▼ **MOLOCH PISTOL VERSION 10** Savage

"Prop concept artist Matt Savage, whom I've worked with a lot over the years, and I are always looking at fantastic existing guns. We added an extra barrel above, changing the design, but Moloch's pistol is inspired by a snub-nosed Colt Python. We actually designed it a couple of films ago; we have all these unused designs in a bank, in case we need them. There are a lot of areas on the pistol that light up red. When he pulls it out in the dark, it's already illuminated." Wilkinson

▲ **SCEPTER RAMEN VERSION 08** Savage

"This was a dream prop for me to work on; there are about forty-eight souls on this [laughs]. It has an old elegance about it, like an antique. There's one figure on the staff that has glasses on. I think that's supposed to be me [laughs]. We got a very talented sculptor, Peter Sellars, in, who sculpted it in a week. I was away, and they kept on sending me pictures of how it was coming along. By the end of the fifth day, the detail was incredible. Every face of these tortured souls tells a story." Wilkinson

▶ **SCEPTER VERSION 02** Savage

"I've always loved William Blake and John Martin, painters of Armageddon and the end of the world. After I read, in the script, about all of the captive children on Corellia, we started pitching the idea of Moloch's staff being carved out of bone, depicting all of these captives. This was one in-between when the figures still had legs. In the following one, everything became more snakelike." Wilkinson

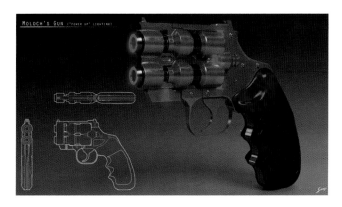

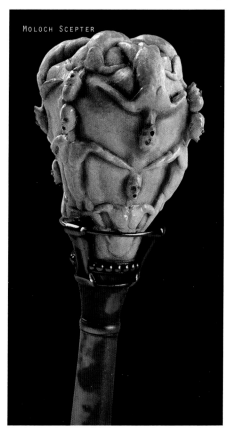

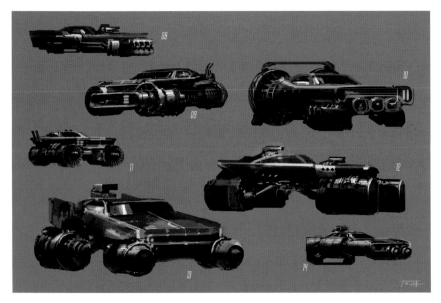

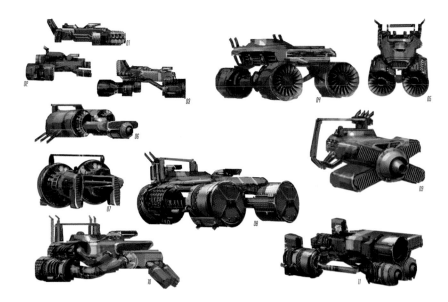

▲ **TROPHY CAR VERSION 07** Faulwetter

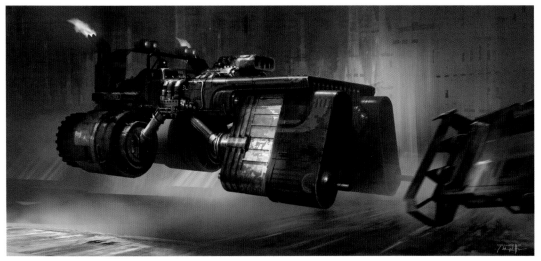

▲ **HAN CHASE VERSION 04** Faulwetter

▲ **MOLOCH BUMPER CARS VERSION 01** Faulwetter

"The inspiration for Moloch's speeder started with monster trucks and went through massive iterations. When we first met action designer and second unit director Brad Allan and he mentioned monster trucking, I, being an Englishman, thought of Bigfoot or something like that. But he didn't mean that; he meant more of the Baja off-road trophy trucks, with incredible suspensions."
Lamont

▼ **MONSTER SKETCH VERSION 7A** "We were circling seventies muscle-car aesthetics for all of the speeders in this film, but Moloch's speeder in particular went through dozens of iterations in which I referenced everything from sixties to seventies Lincolns and Cadillacs to period industrial design, like CRT [cathode ray tube] televisions, clock radios, Polaroid cameras, early gaming consoles—just about anything clunky from that era. Other early versions were huge and aggressive looking, like eighties monster trucks and Baja racing trucks." Tenery

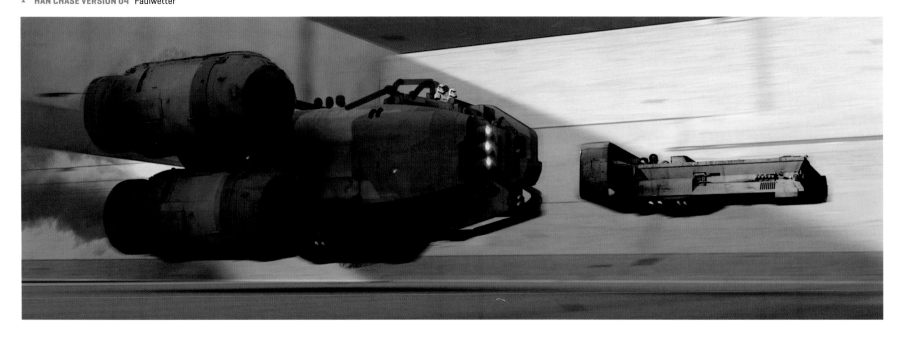

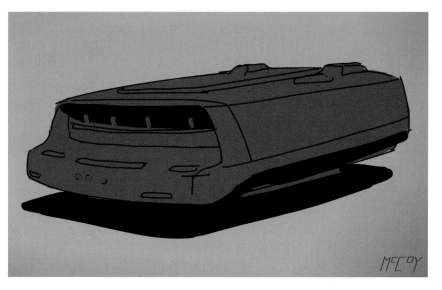

▲ MOLOCH SPEEDER SKETCH 1A McCoy

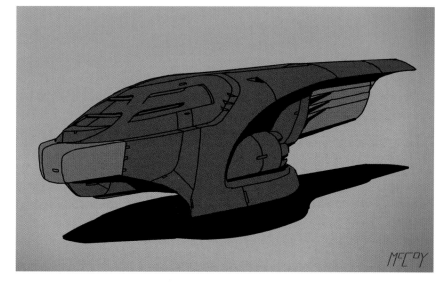

▲ MOLOCH SPEEDER SKETCH 1D McCoy

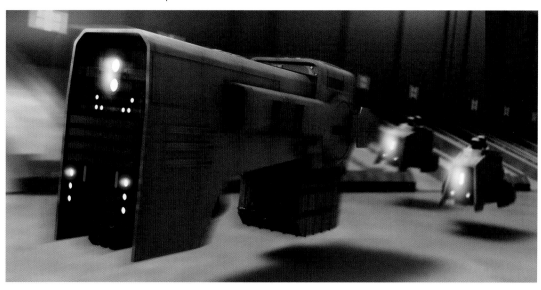

▲ MOLOCH TRUCK A Julian Caldow

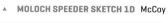

▲ SPEEDER SKETCH VERSION 1A Tenery

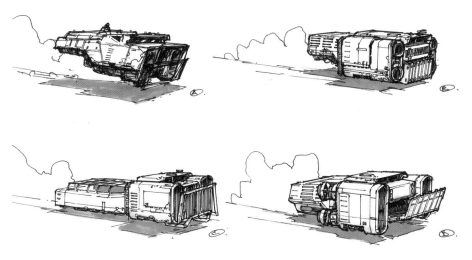

▲ BLUE SKIES 1A Htay

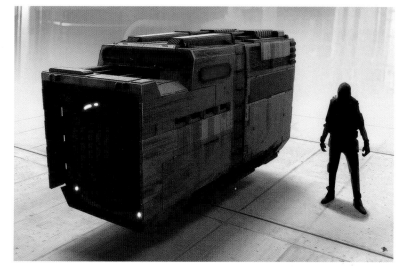

▲ MOLOCH BUMPER VERSION 5A Dudman

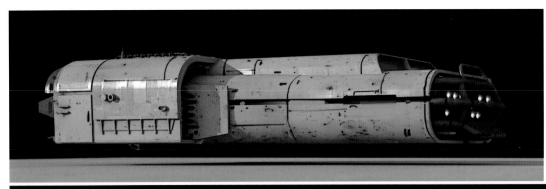

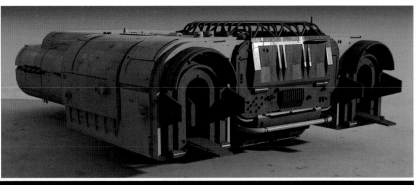

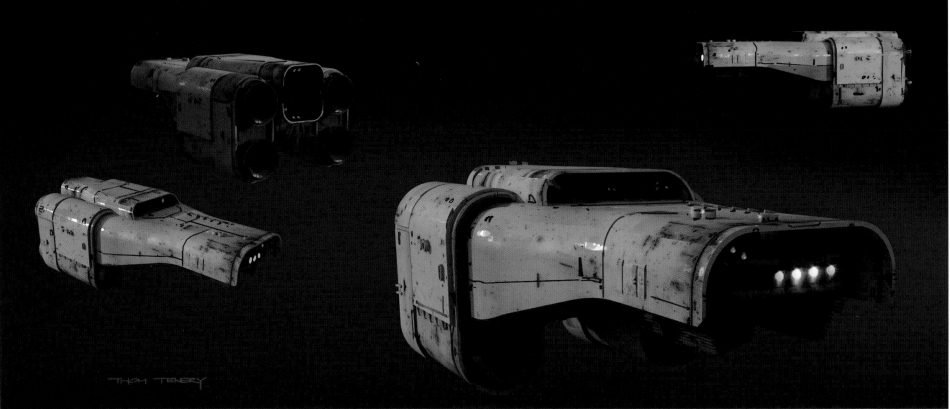

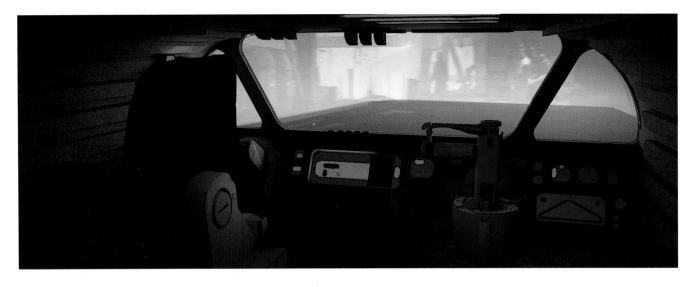

▲ **MONSTER SKETCH VERSION 1A** "The boxy, radiused look grew out of a design where I was referencing the '55 Chevy that Harrison Ford's character drives in *American Graffiti*, as well as that red '51 Mercury. That initial concept had a meaner brow, a chopped-top look, but there were stunt driving considerations that necessarily pushed the proportions into its final silhouette, which is a bit clunkier and toylike." Tenery

◄ **SPEEDER COCKPIT VERSION 3A** Tenery

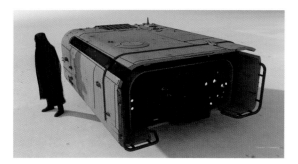

▲ **SPEEDER MOD VERSION 2B** Tenery

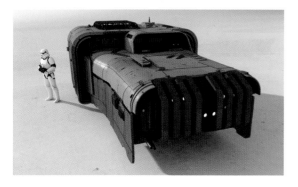

▲ **SPEEDER VERSION 2A** Tenery

▶ **SPEEDER MOD VERSION 2B** "The dog cages were introduced fairly late in the design process. But that narrative element began to quickly influence overall styling decisions, and the speeder took on canine characteristics." Tenery

▼ **CHASE VERSION 1A** Tenery

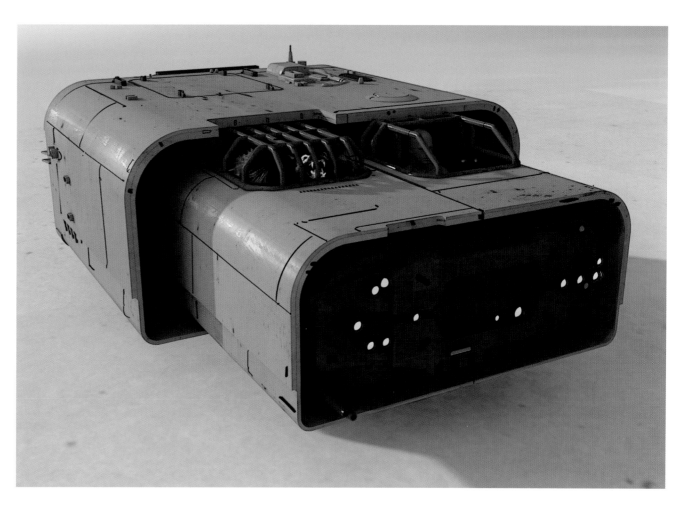

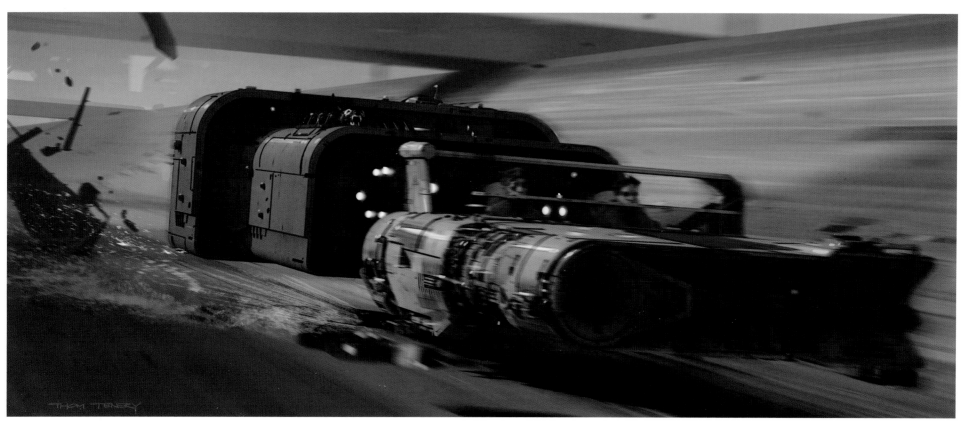

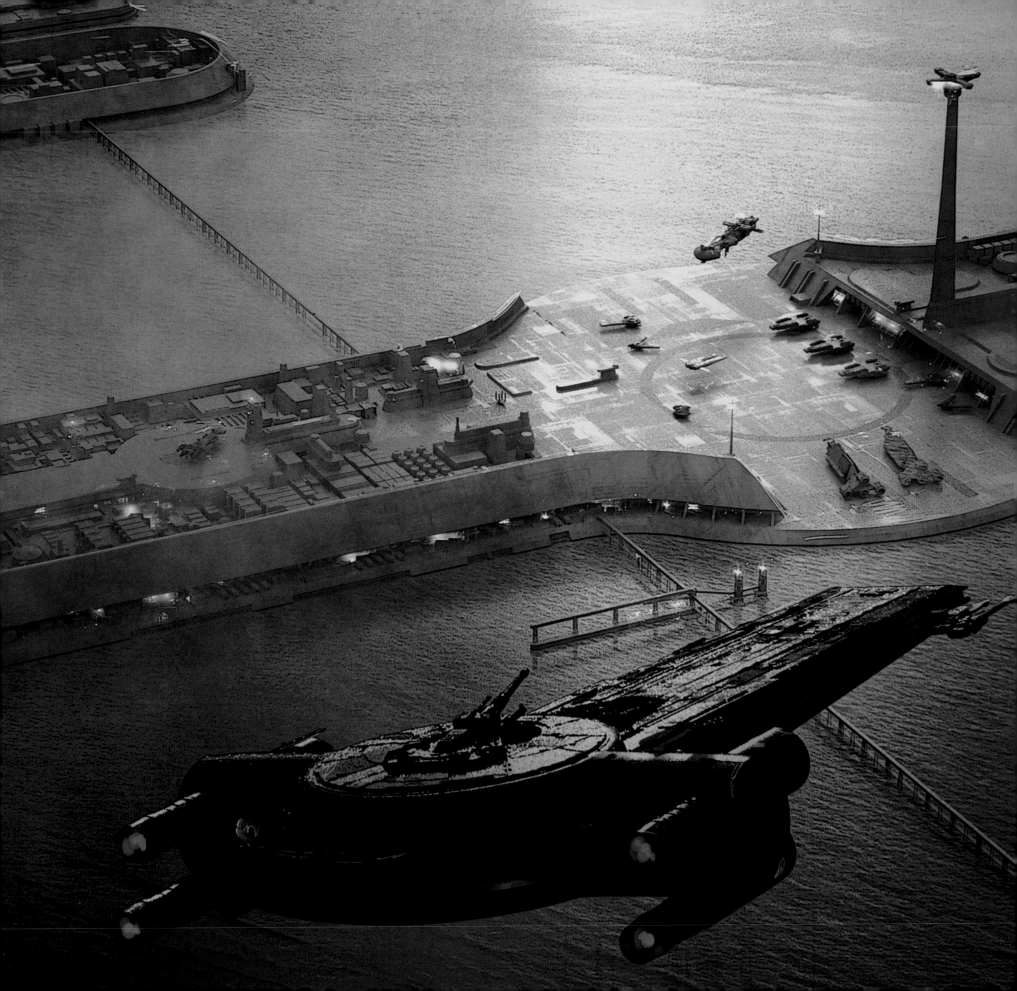

Corellia

In July 2015, as Neal Scanlan's creature department and Michael Kaplan's costume department shifted into full preproduction on *The Last Jedi*, and with *Rogue One* just weeks away from the start of principal photography, *The Last Jedi* ILM VFX art director James Clyne received a tempting offer from Jason McGatlin and Lucasfilm Vice President of Physical Production Candice Campos. "They were like, 'Hey, we're doing *Solo*, and we'd like to give you an opportunity,' " Clyne recalled. " 'You're not going to be the production designer, but you're going to oversee all of the visuals, especially as we jump into development. You've got a small budget. You can hire your own crew. And we'll just see where it goes.' I was torn between really being entrenched in *The Last Jedi*—and in getting to know director Rian Johnson and production designer Rick Heinrichs—and this great new opportunity. We were really in our stride on *The Last Jedi*."

Despite his initial hesitancy, Clyne soon jumped at the chance. "Until December 2015, it was just me running a small team: Ian McQue, Patrick Faulwetter, and Thom Tenery, who were all part-time, like me," Clyne said. "No one was really available. Ian lives in Scotland. Thom and Patrick live in Los Angeles. There was no *Solo* production office in LA. It was all remote. All the while, I was getting on the ringer with Rian and Rick to continue work on *The Last Jedi*. It was quite a juggle! In a way, both projects being *Star Wars* made it a little easier; because I was still in the universe, I was able to keep my mind in both worlds and not have to detach from one or the other."

Clyne continued, "So much of it was just wet cement at that point. From the beginning, the big things that we knew were going to be in the film were Corellia; the train sequence; a vehicle

that they would steal one of the train cars with; and a world that was described as a Colorado Rockies environment, which became Vandor. Taanab and the Kessel Run were also a part of it."

"Corellia was a world that was going to be explored simply because it was a part of the canon," remembered Clyne. "Han comes from Corellia. The *Millennium Falcon* is Corellian. At the time, Corellia was somewhere between a Dickensian kind of city and this punk rock, seventies, urban-decay New York City—but the beauty behind urban decay."

The very first *Solo* world Clyne and company envisioned was Corellia. "We knew it was a shipyard, so we were basing it on New Jersey, New York, even Bethlehem and Allentown, Pennsylvania—all of those steel work yards. That started to really inform us. I started to pull imagery of Brutalist concrete forms, but they didn't want to make it so ugly that we start our movie in this really depressing area. The hope is that we still bring color to it, a little life to it. People live there. They work there. Modesto in *American Graffiti* is still colorful. We didn't want to lose that," Clyne said.

The Corellian spaceport was constructed on Pinewood Studios' cavernous Albert R. Broccoli 007 Stage, the largest soundstage in Europe, with a set prep and rehearsal week from February 13 to 17, 2017, and shooting from February 20 to 24, with over three hundred twenty extras—including twenty-four classic Imperial stormtroopers. From March 17 through 19, second unit director Brad Allan captured Han Solo's stolen speeder racing down Corellian streets and bridges, both prior to and after picking up Qi'ra, on location at the Port of Tilbury's grain terminal in Essex County, England. The subsequent foot chase through the Corellian fish market was shot by the second unit at Fawley Power Station on May 18, with the exterior of the White Worms' den shooting nearby on the following day, May 19.

◀ **SPACEPORT ESTABLISHING VERSION 1A** Clyne

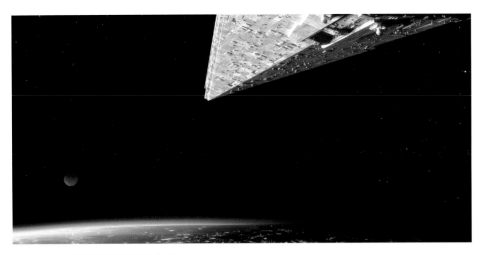

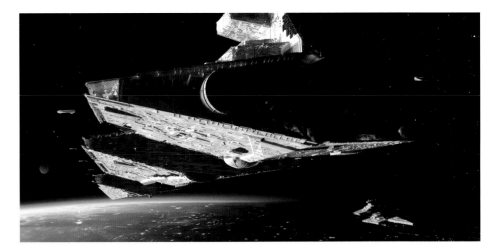

▲ **OPENING DESCENT VERSION 4B** Dudman

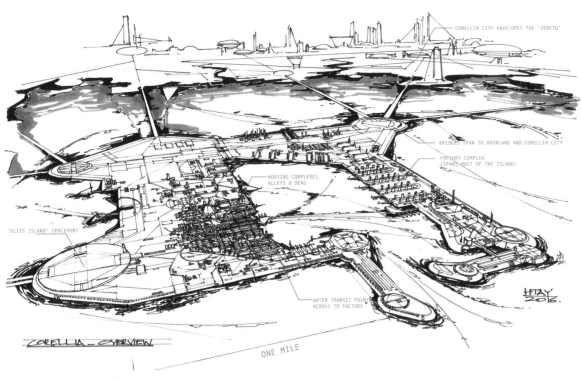

Labels on sketch:
- CORELLIA CITY ENVELOPES THE "VENETO"
- BRIDGES SPAN TO MAINLAND AND CORELLIA CITY
- FACTORY COMPLEX (SPANS MOST OF THE ISLAND)
- HOUSING COMPLEXES, ALLEYS & DENS
- "ELIIS ISLAND" SPACEPORT
- WATER TRANSIT POINT ACROSS TO FACTORY
- CORELLIA - OVERVIEW
- ONE MILE
- HTAY 2016.

▼ **CITY VERSION 01** Matt Allsopp

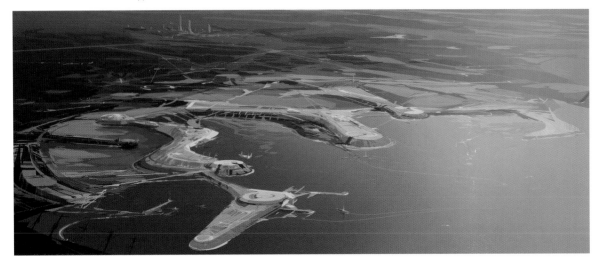

▲ **OPENING DESCENT VERSION 2B** Dudman

"I pitched this idea for the opening shot: You do a pullback through space above Corellia, and you see the nose of a Star Destroyer appear, just like in Episode IV. 'Here we go again!' But you realize that the Star Destroyer is segmented in pieces. It's a little tongue in cheek, but still true to it. I love that all three of the original movies also started with a Star Destroyer." Clyne

◄ **DEADWOOD OVERVIEW VERSION 1A** Htay

"There was no context for that image of Han standing at the water's edge. But it tells a story. The sea setting was painted in because it was evocative of a mood. There was no discussion of water. But then, talking about water and talking about dockyards, those elements became a really big part of Corellia. So we did a lot of this monochromatic, black-and-white sketching. None of it was really hitting or becoming a really identifiable thing." Clyne

▼ **CORELLIA PLANET VERSION 10** Brett Northcutt

"We don't even know if Corellia's landmass is all man-made yet. In true *Star Wars* fashion, it doesn't really matter. From pole to pole, the moon of Endor is just forest. And Yoda lives on a planet that's all swamp. I don't know why it works. It just works." Clyne

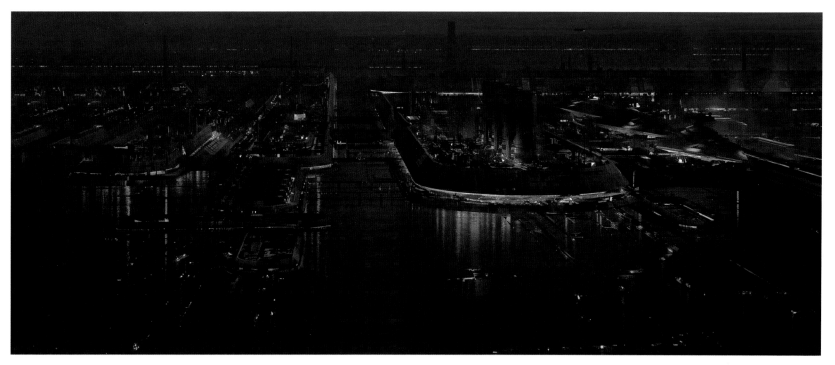

▲ **AERIAL ESTABLISHING VERSION 8F** McCoy

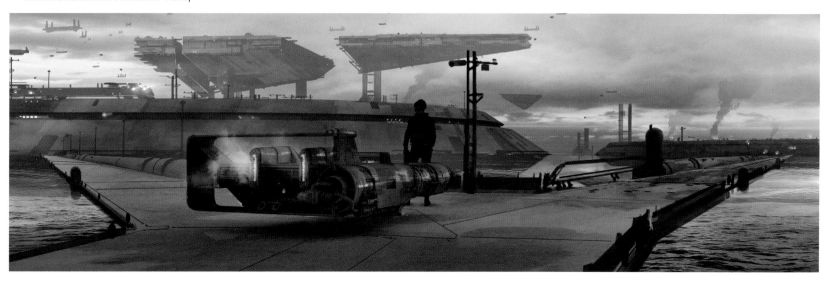

▲ **CROSSROAD VERSION 1A** Tenery

▶ **DEADWOOD PLANET VERSION 02** "The best worlds in *Star Wars* had the most identifiable iconic imagery; simple shapes, like George Lucas's original drawing of the X-wing, TIE fighter, and Death Star. So I literally drew an X-wing, TIE fighter, and the Death Star, and then I drew Bespin. How the hell do I do a Corellia that is just as identifiable? I was sitting at my desk, and I had a little scale model of the *Falcon*. I turned it upside down, and I imagined another *Falcon* pointing at it. I painted over it, and it created this weird pill shape. And I thought, 'Well, a pill in water is a pretty iconic shape. It seems as good as anything.' You can see how the pill shape progressed. There's also this weird fort-turned-prison, the French version of Alcatraz called Fort Boyard, with big concrete slabs that go down to the water. That became an inspiration too." Clyne

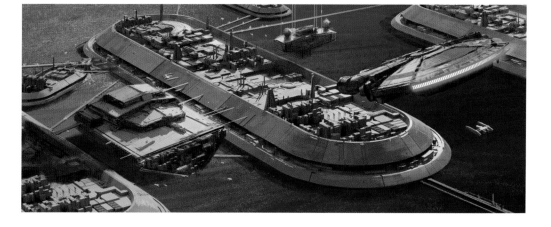

▲ DEADWOOD VERSION 1B Jenkins

▲ STREET CONCEPT ROUGHS VERSION 04 Ian McQue

▲ DEADWOOD REVISION 02 McQue

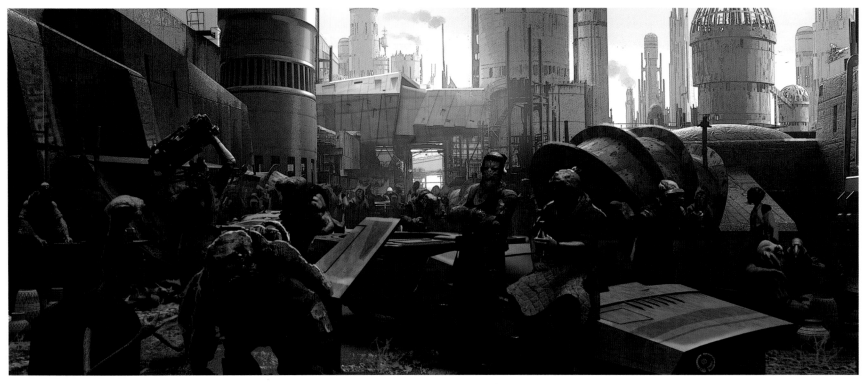

▲ STREET VERSION 02 McBride

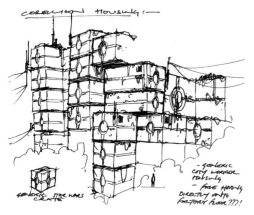

Htay

CORELLIAN HOUSING!

- GENERIC CITY WORKER HOUSING
- FACE HAVING DIRECTLY ONTO FACTORY FLOOR ???!

GENERIC STAR WARS CRATE

▲ **HAN HOME SKETCH VERSION 1A** Htay

▶ **FACTORY VERSION 1A** Htay

In early iterations of the script, Han Solo was a worker in the Imperial factories of Corellia, dwelling in blocky Brutalist/Metabolist housing inspired by the Nakagin Capsule Tower in Tokyo, Japan. "We are saying that all of these workers on Corellia live in this Japanese/Brazilian favela-esque housing," production designer Neil Lamont recalled. In June 2016, concept artist Will Htay proposed that the housing blocks physically intersect with the factories, with some capsulated rooms looking out over the factory floor. When Solo's occupation shifted, the favela idea was adapted for the White Worms gang's inhabitation of the sewers beneath a housing island.

▼ **DEADWOOD STREETS VERSION 1B** Faulwetter and Clyne

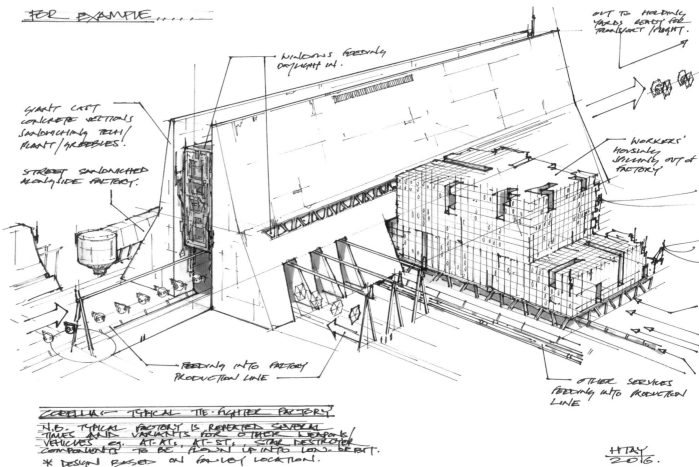

FOR EXAMPLE......

OUT TO HOLDING YARDS READY FOR TRANSPORT/FLIGHT.

WINDOWS FEEDING DAYLIGHT IN.

GIANT CAST CONCRETE SECTIONS SANDWICHING TECH/ PLANT/GREEBLES!

STREET SANDWICHED ALONGSIDE FACTORY.

WORKERS' HOUSING SPILLING OUT OF FACTORY

FEEDING INTO FACTORY PRODUCTION LINE

OTHER SERVICES FEEDING INTO PRODUCTION LINE

CORELLIA:- TYPICAL TIE-FIGHTER FACTORY
N.B. TYPICAL FACTORY IS REPEATED SEVERAL TIMES AND VARIANTS FOR OTHER WEAPONS/ VEHICLES eg. AT-ATs, AT-STs, STAR DESTROYER COMPONENTS TO BE FLOWN UP INTO LOW-ORBIT.
* DESIGN BASED ON FAWLEY LOCATION.

Htay 2016.

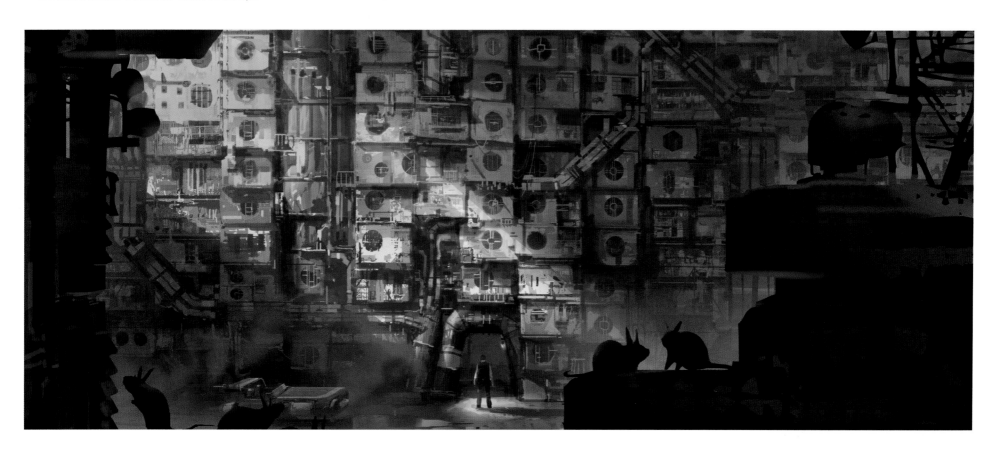

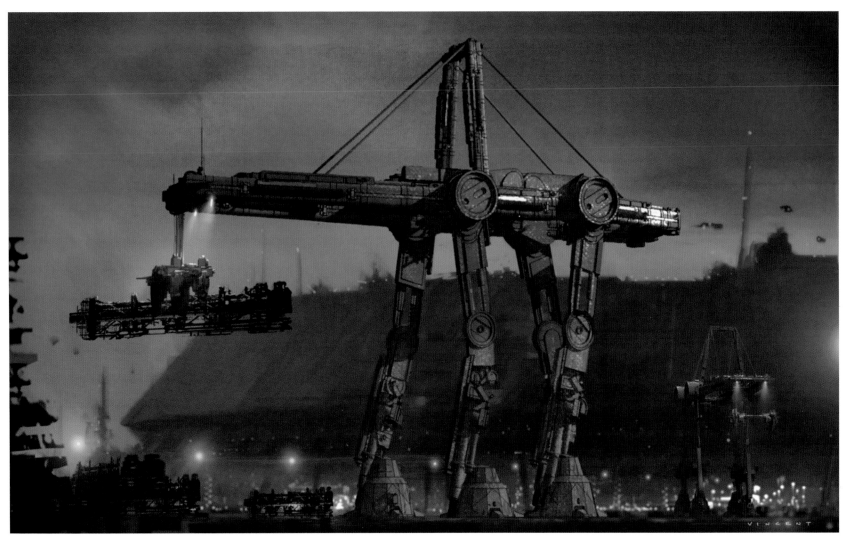

▲ **CRANE WALKER VERSION 17** Jenkins

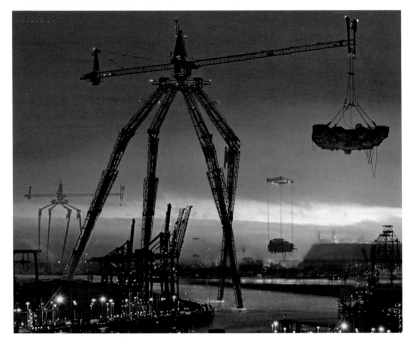

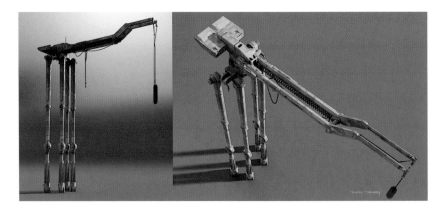

▲ **CRANE WALKER DEV VERSION 1B** Tenery

"One of Kathy's notes, early on when we showed her Corellia stuff, was, 'Let's make sure we have innovative and new ideas in there.' So I've been pitching these walker cranes. It's obviously a direct reflection of the snow walker—imagining George driving by the Oakland docks and seeing those shipping-container cranes." Clyne

◄ **CRANE WALKER VERSION 10** Jenkins

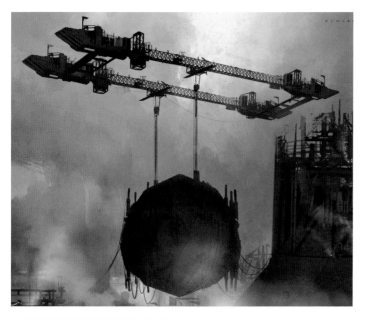

▲ **SUPER HAULER VERSION 2A** Jenkins

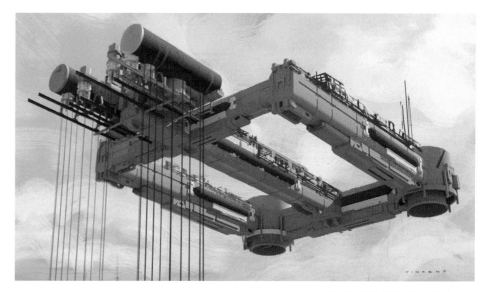

▲ **SUPER HAULER VERSION 15** Jenkins

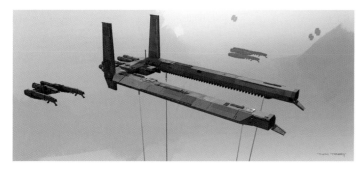

▲ **SUPER HAULER VERSION 4A** Tenery

"The AT-hauler was something that Beckett's (Han Solo's mentor figure, played by Woody Harrelson) gang was always going to steal. Where they stole it from fluctuated. Originally, they were going to take it from Corellia and meet Beckett there. It was a little tighter in that we didn't jump to another planet. They steal the AT-hauler and fly directly to Vandor. The AT-haulers carry cargo, shipping containers, so they are justified in being on Corellia." Clyne

▼ **CORELLIA CONCEPT VERSION 05** Northcutt

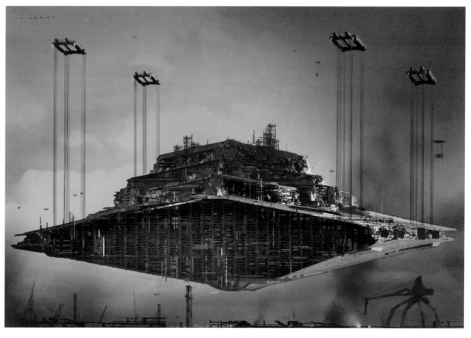

▲ **SUPER HAULER VERSION 16** Jenkins

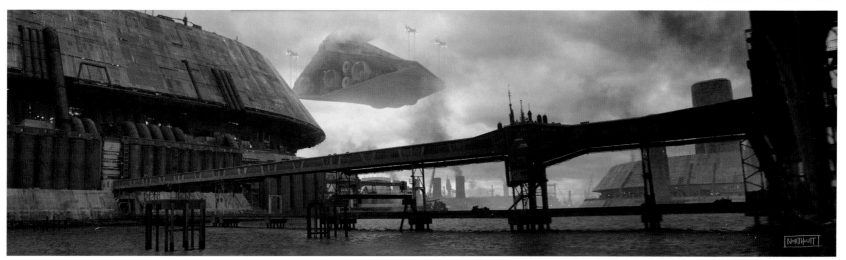

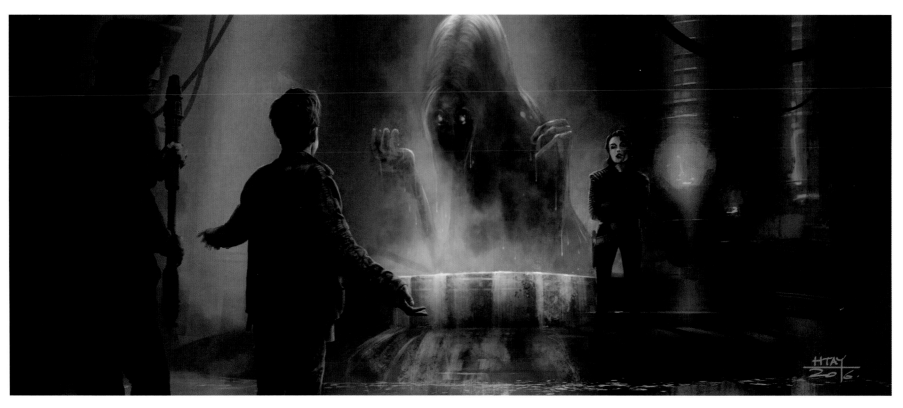

▲ **WHITE WORM INTERIOR VERSION 01** Htay and Clyne

▲ **KURA STEPS IN MOLOCH'S WAY** McCoy

▲ **HAN SMASHES WINDOW** McCoy

◄ **BLUE SKY DEN VERSION 02** Htay

"In this set, we wanted to feel that we were in the bowels of one of these islands, with these pipes and within a concrete framework. But at the same time, we wanted to feel connected to the outside, particularly when Han smashes the window. This happens to be a housing island, so Han smashes a favela window. And when he smashes the glass, if you have a really close look, it's a broken profile of the *Falcon* [*laughs*]. It's so dark in there. We rely on a lot of changing textures: mosses and texture in our concrete, and trying to be quite strong in our aging—making the whole place feel oily and industrial." **Lamont**

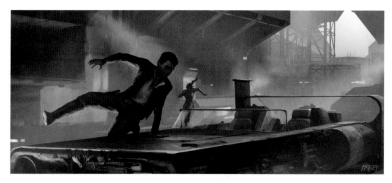

▲ **BONNET JUMP VERSION 2B** McCoy

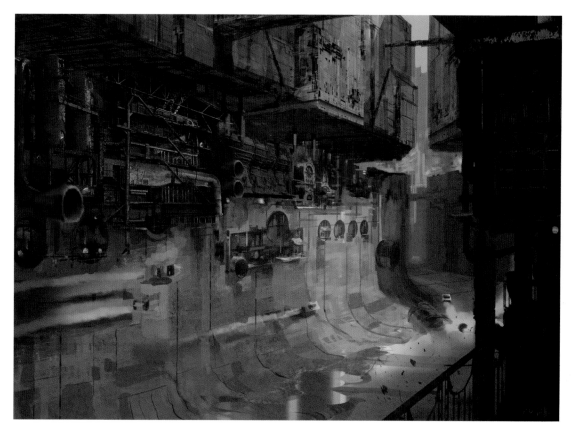

▲ **CHASE VERSION 06** Craig Mullins

▲ **DEADWOOD VERSION 03** Faulwetter

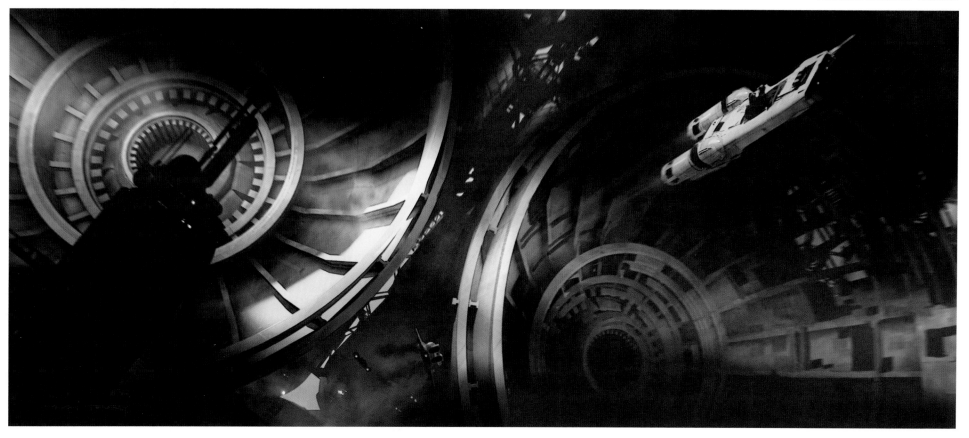

▲ **DEADWOOD CHASE VERSION 02** Tenery

▶▶ **VISTA VERSION 1E** Jenkins

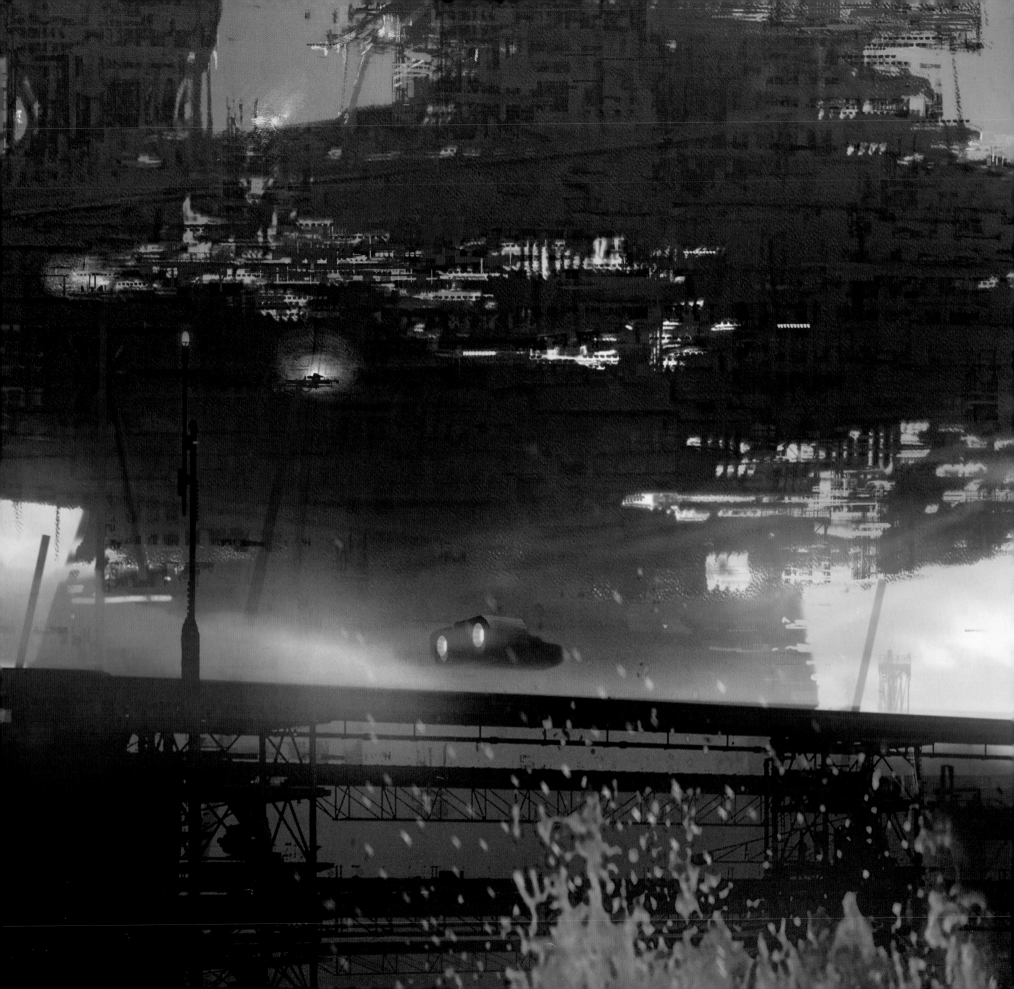

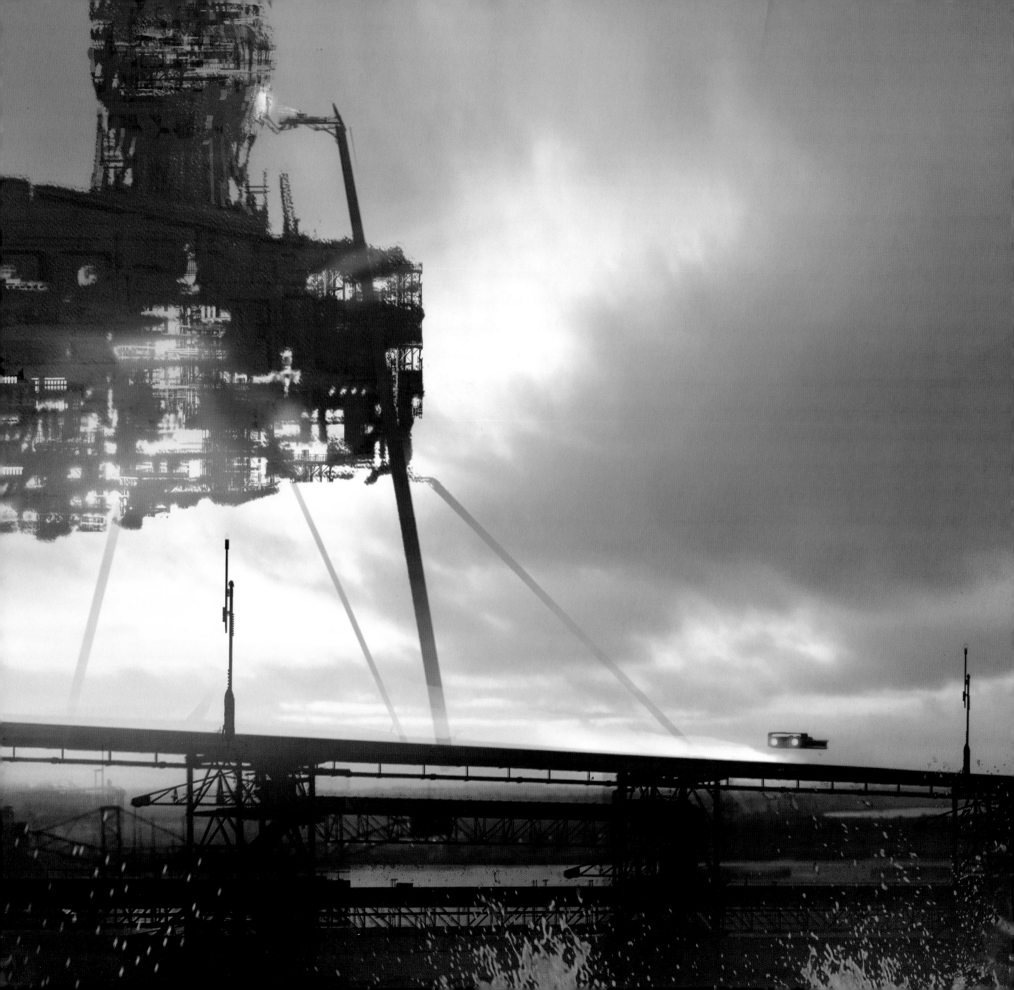

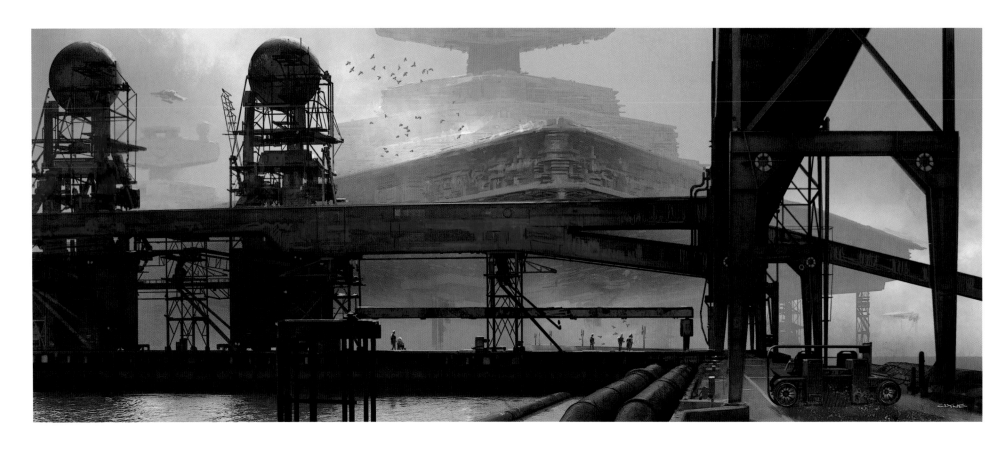

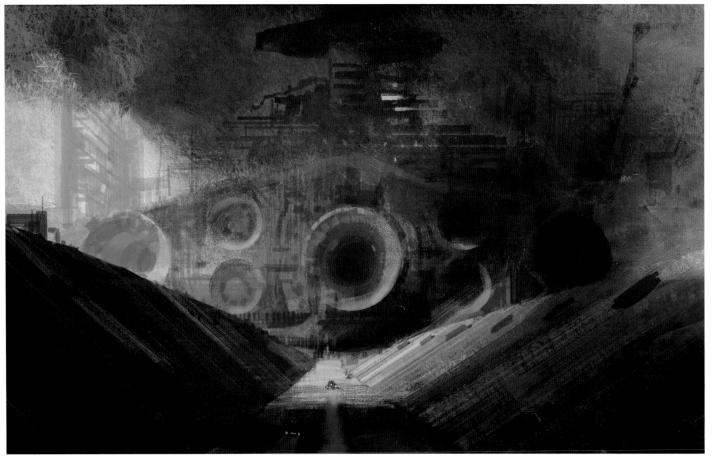

"The car chase has very simple lighting, very naturalistic. All you may end up having to do, in some of those shots, is put something tall and spindly with flashing lights on it, and it will hopefully be totally believable. It transported all of us when we looked at the footage. Everyone was really excited." Lamont

▲ TILBURY 02 Clyne

"James and I had spoken about bridges spanning and connecting our manufacturing islands of Corellia. By that time, we had gone to see the grain store at Tilbury. Tilbury comes alive at night because you've got all of the twinkling lights of the southern side across the Thames and the twinkling lights of the terminal and port of Tilbury. It's just incredible. It opens up Corellia from this narrow road that we initially see Han hotwiring his car on, to driving out across these expansive bridges." Lamont

◄ CHASE PAINT 06 Mullins

"I'm pitching Corellia as all water, with massive amounts of industry—like Long Beach, California. We knew there was a speeder chase, so I showed an image from the movie Grease for inspiration: the two cars racing in the LA River basin, which is almost like a huge dry dock. We knew that Star Destroyers were going to be built on Corellia. I thought, 'How fun would it be to do a 'Thunder Road' kind of thing?'" Clyne

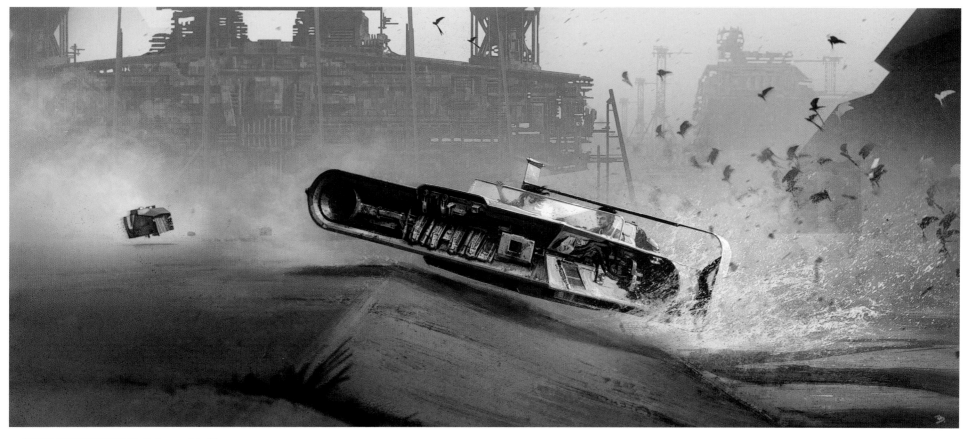

▲ **SPEEDER CHASE VERSION 3D** Dudman and Jenkins

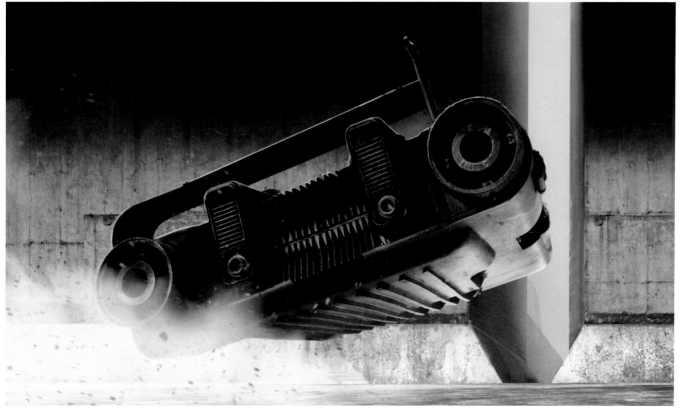

▲ **I CAN MAKE IT VERSION 11** Jenkins

▲ **SPEEDER STUCK VERSION 8B** Jenkins

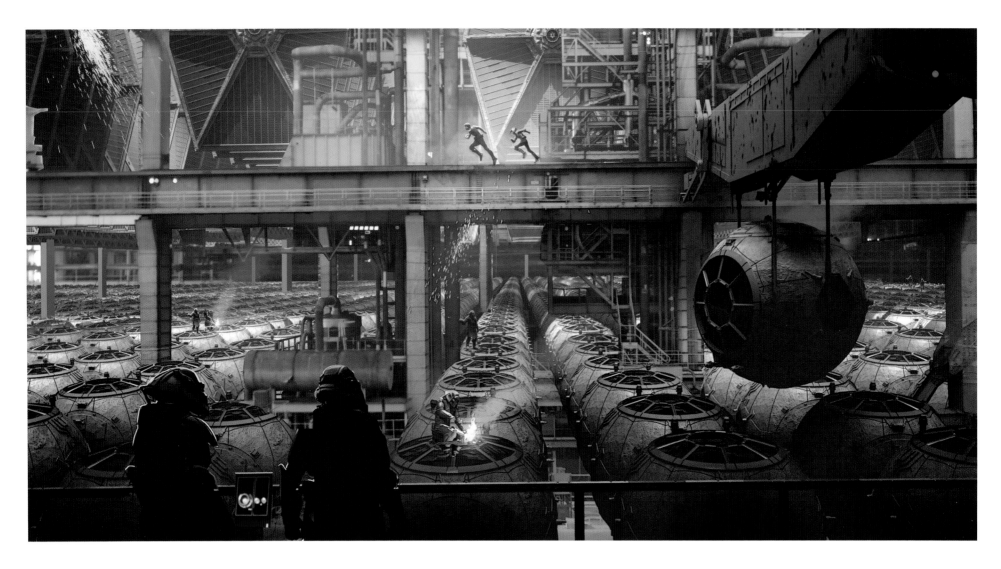

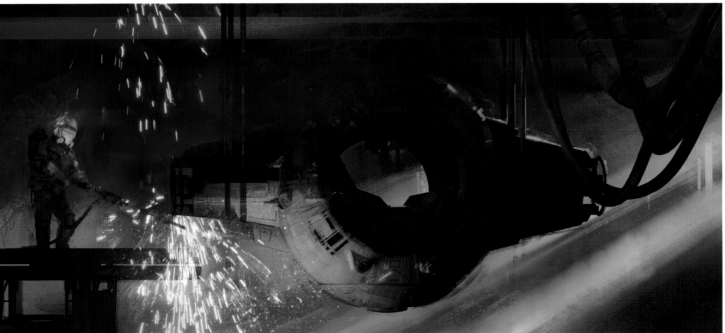

"In *The Force Awakens*, Fawley Power
Plant was potentially going to be the
interior of Han and Chewie's freighter that
gobbled the *Millennium Falcon*. It was
also briefly considered for the exterior of
Starkiller Base. They decided not to use it;
instead, we did something on stage—very
practically, very simply. We looked at
Fawley again on *Rogue One*, for the Ring of
Kafrene, but again, they decided not to use
it. It's an electricity-generating station,
now defunct, built in the mid-sixties.
It's relatively simple to change British
industrial into what we were trying to
channel as Corellia." **Lamont**

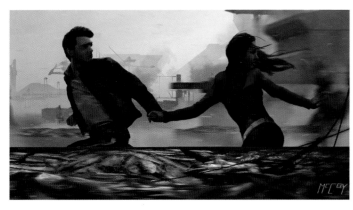

▲ **FISH MARKET ESCAPE VERSION 10** McCoy

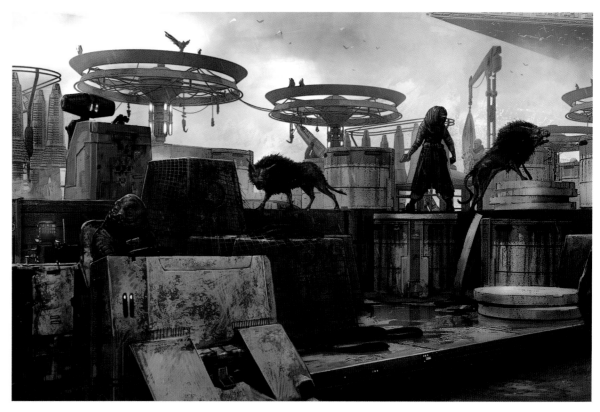

▲ **CHASE FISH MARKET VERSION 8C** Dudman

▲ **BARREL INTERIOR VERSION 1D** Mullins and Clyne

"Designing alien fish is actually one of the harder tasks, and one that I'd already attempted on *The Last Jedi*. The problem is that terrestrial sea-life can be so exotic and alien-like, and we are often being presented with newly discovered oddities from the depths of the oceans. It's hard to create something believable that doesn't look that it might already exist in our world." **Lunt Davies**

▶ **FISH MARKET FAWLEY VERSION 1B** Dudman

"The fish market is at Fawley Power Station too, but not on their waterfront. Their harbor ended up being too big an area for us to dress, so we chose part of the factory that we thought we could build it in; Rob Bredow will deal with the water via visual effects. We built it in a place that we could use for Han's alley, where we are first introduced to him. Each set will be the background for the other, but without saying they are next to each other. We are just cheating a little to get as much out of what we are building at Fawley." **Lamont**

"Sitting down with Neil, we would think, 'Well, what is this world on a set level?' Another identifiable part of the *Falcon* is a 'gak band' on the side, that midsection of dense and random technological bits and bobs. It's all over *Star Wars*: the blockade runner, the Star Destroyer. What if that became part of the architecture? So I pitched this idea of big flat surfaces of concrete. And everywhere we would see this band of gak. You see it in the White Worms. You see it in the spaceport. Hopefully, we will see it in the streets. In *Star Wars*, you don't want everything to be super busy or super clean." **Clyne**

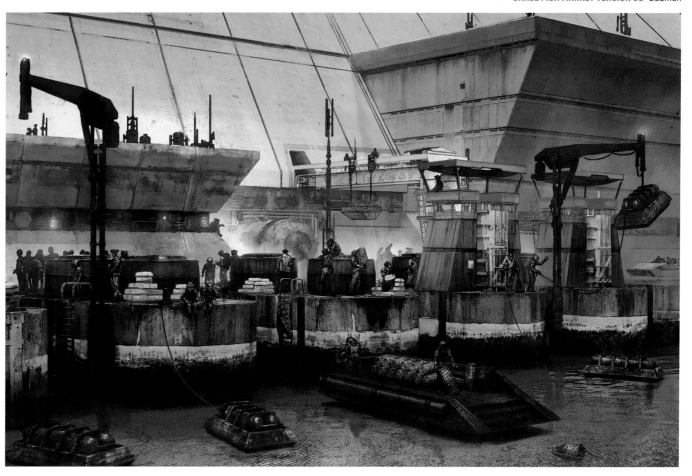

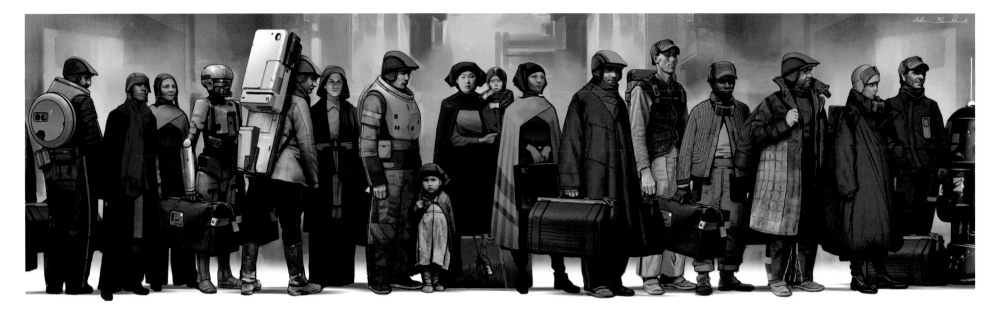

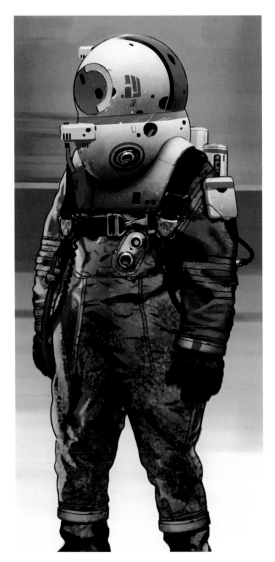

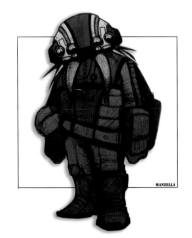

CORELLIAN EMIGRANTS VERSION 1A Brockbank

MAVERICK 021 "This is based on a sketch by my daughter Eloïse, who would have been eight at the time. Ever since *The Force Awakens*, she has occasionally given me drawings of aliens she has designed, which I would interpret. Some made it quite high in the selection process with various directors, and this design was nearly approved for *The Last Jedi*. On *Solo*, however, it was finally chosen and went through to being made and shot. In interpreting her sketch, I saw the horns as being part of its respiratory system, as the tubes were connecting them to a mouthpiece. I looked at squash and gherkin for the texture of the skin, while the eyes are based on amber and precious stones. And the green/red color scheme harkened back to aliens on lurid, 1950s pulp sci-fi covers." Lunt Davies

"The tone of these particular aliens felt right for Corellia: They weren't too weird, they weren't too crazy, but they weren't boring. This is the prologue, and we're establishing this environment. We knew that the cantina-like showcase of aliens was going to come later, in the saloon. It was a case of holding the best and craziest for later." Scanlan

MAVERICK 024 VERSION 1A Brockbank

"When you have a giant crowd scene to do, one way both to make it feel real and to help you with your numbers is to design a costume that represents a job. Say you've got several factory workers. Even though it's the same costume, when you put it on different people, everyone still looks like an individual. That way, you get to feel the variety without having to design three hundred fifty individual costumes." Dillon

BANDOLERO VERSION 7A Manzella

"We start designing stuff and it's like, 'That's a Warwick.' We design for Warwick. The concept guys feel the same. And then we give him a hard time if he's not available [*laughs*]." Scanlan

BOBBLE HEAD VERSION 11 Brockbank

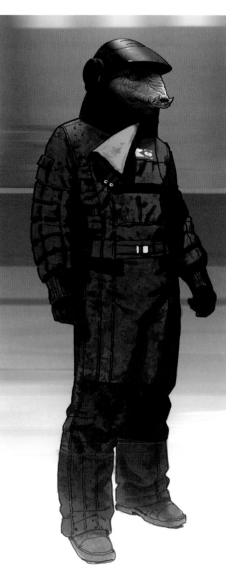

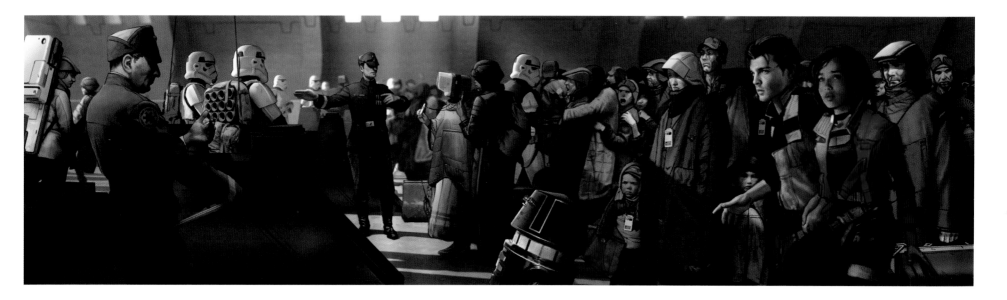

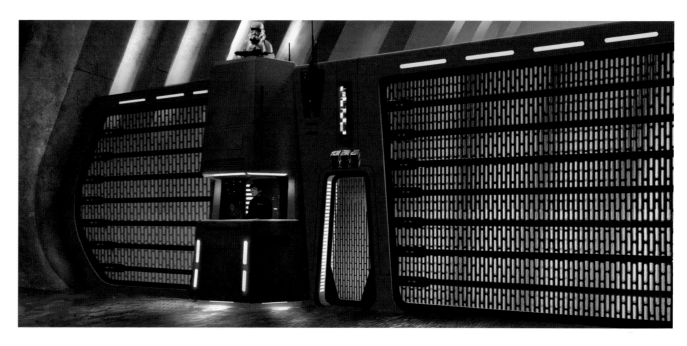

▲ **CHECKPOINT VERSION 3C** Brockbank

"The spaceport set was on 007 Stage. We wanted to feel 'them and us': Corellia, Imperial, Checkpoint Charlie, East and West. It all ended up looking great with Director of Photography Bradford Young's lighting—that whole natural vibe in that big hall, with shafts of light coming into it." **Lamont**

"I think the Corellia spaceport is one of the biggest crowds ever on *Star Wars*. We made around three hundred fifty costumes. It was similar to the process of dressing everyone in *The Last Jedi* casino. We really felt the sheer volume of costumes to complete, even more so with this film. The first twelve weeks were relentless compared with other *Star Wars* films that we've done. We were really up against it to complete things—very busy." **Crossman**

▶ **GATE VERSION 56** Jenkins

"Boy, did we go through a lot of iterations of that fence. But on the eighth or ninth we designed out of about fifty, we came around to something very close to the finished set—and not far from one of those first designs. You felt that the Empire had come in and gone, 'Here's the fence. This is ours. That's yours. If you want to come through here, you've got to have the right information.'" **Lamont**

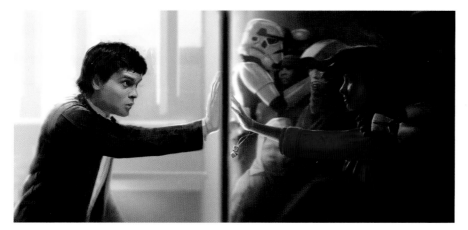

▲ **CHECKPOINT VERSION 1I** Brockbank and Clyne

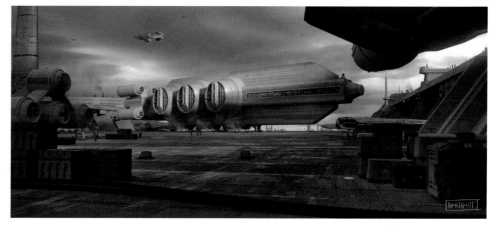

▲ **STARSHIP ON SPACEPORT PILL VERSION 02** Northcutt

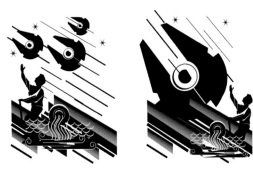

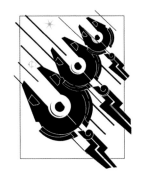

▲ **SPACEPORT MURAL VERSION 04** Laura Dishington

▲ **SPACEPORT MURAL VERSION 05** Dishington

▲ **RECRUITMENT VERSION 1A** Jenkins

▲ **WALL MOTIF VERSION 45** Dishington

"We tried to tell a little bit of the story of Corellian manufacturing through some murals in this set. They're quite Soviet in style. In the end, we didn't settle on anything too colorful because it just complicated the background and simplicity of the set. They're meant to be bas-relief carved into the stonework. Our scenic artists painted it in trompe l'oeil: It's all in one plane and has no actual depth, so they painted in the shadows. Very clever. That whole set was shot right to left, pointing in the physical direction you want to go if you want to be free of this world, toward the security gate. There are spacecraft flying from where these people are pointing, symbolizing hope. And the freighters are very *Falcon*-esque. That certainly wasn't an accident." Lamont

◀ **DEADWOOD SPACEPORT CHECK SOLO**
Booth and BLIND LTD.

"We had this recruitment-desk design, which was a retinal scan in a *Star Wars* world. Then he types in 'Han . . . Solo.' But you select a name by sliding in elements. There are no keyboards. Keyboards in the seventies were typewriters in an office typing pool. In *Star Wars*, they are pushing buttons or flicking switches." Booth

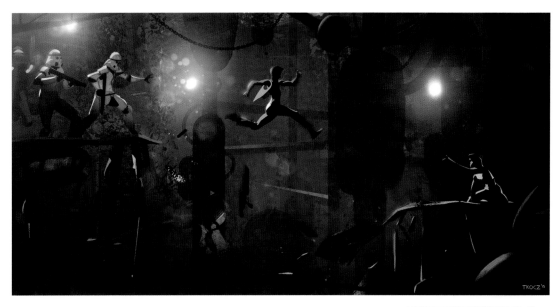

▲ CATWALK CHASE VERSION 03 Tkocz

▲ CATWALK CHASE VERSION 03 Tkocz

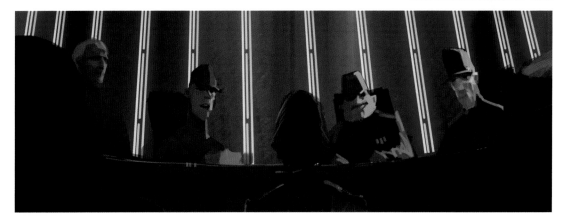

▲ CATWALK CHASE VERSION 02 Matt Tkocz

▲ COURT INTERIOR VERSION 01 Mullins

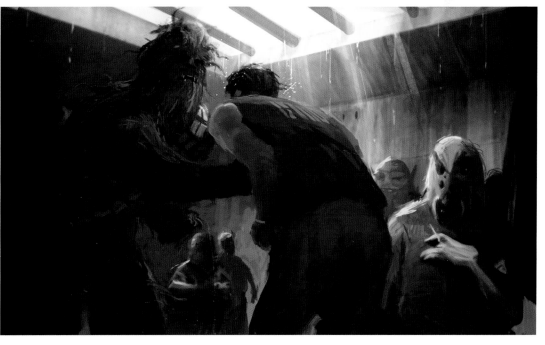

In an early iteration of the script, circa June 2016, teenage factory worker Han and his girlfriend Kura are on the run from Imperial stormtroopers on Corellia. They are caught, and Han is sentenced to jail. He's locked up in a cell inspired by a 1978 Cloud City prison painting by Ralph McQuarrie, which also featured early iterations of Lando Calrissian and the prototypical white-armored Boba Fett. "At one point, Han met Chewie on Corellia in a prison yard," recalled Clyne. "A fight was going to break out. Han and Chewie were also going to meet Beckett on Corellia, and they steal our AT-hauler there. Mimban was always in play, but it came out and went back in quite often."

▲ CORELLIA REC YARD VERSION 2A Allsopp

▶ CORELLIA REC YARD VERSION 1B Allsopp and Faulwetter

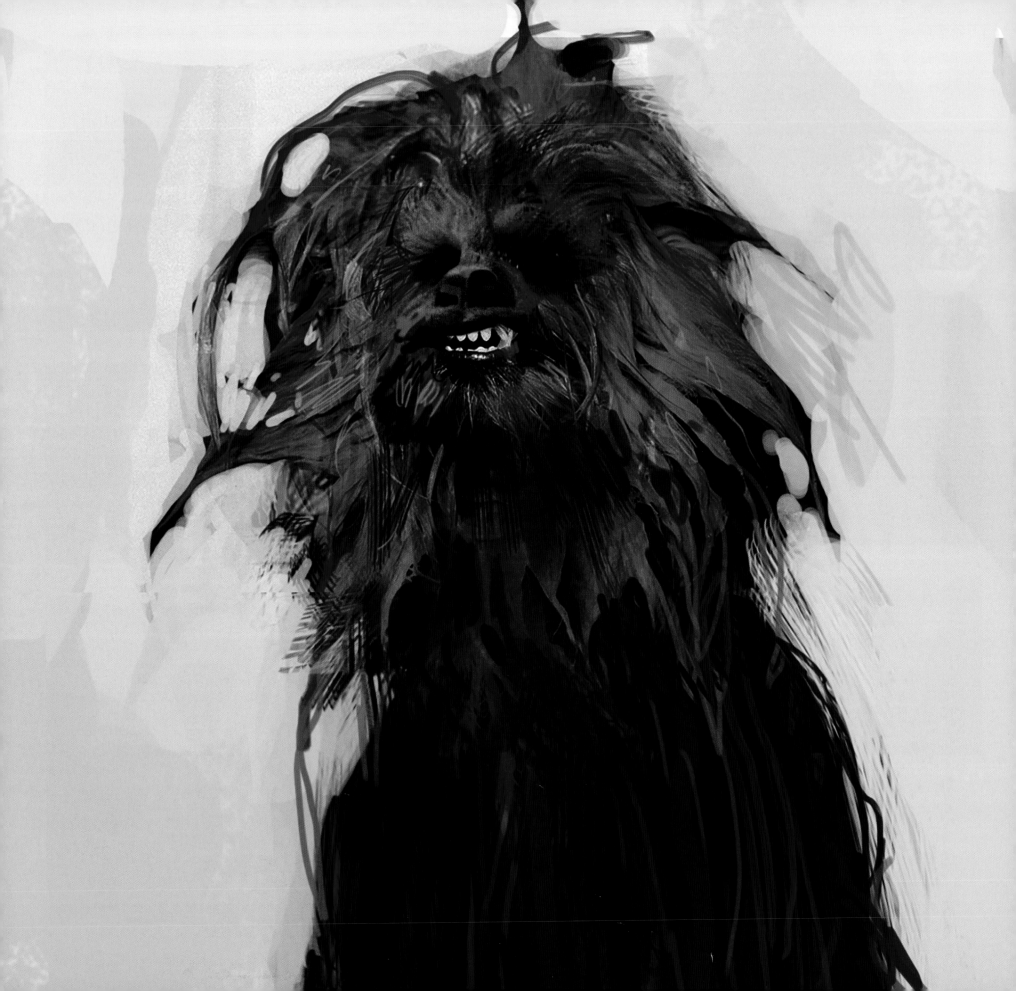

Chewbacca

A precise and faithful reproduction of the beloved "walking carpet" that makeup artist and special creature designer Stuart Freeborn and team handcrafted in 1976 was paramount for Neal Scanlan's creature effects team on *The Force Awakens* and *The Last Jedi*. "We absolutely take with us the Chewbacca that Stuart created," said Scanlan. "We are all there as guardians of this character's legacy. But Chewie in *The Force Awakens* was a little too well groomed. We were paranoid about any hair that fell out of place."

But the broadening and deepening of the character in *Solo*, through the exploration of his roughshod origins as "the Beast," a malnourished, feral Imperial prisoner, enabled Scanlan and team to take chances and push the hirsute copilot of the *Millennium Falcon* into previously unexplored territory. Scanlan recalled, "This is the first film where we've been given the opportunity to go somewhere on our own with Chewie. We realized that it doesn't matter that Chewie doesn't look like this perfect version that we have stamped in our mind. The whole point is that he shouldn't look like that. So if we don't clean the suit and it looks a little ragged, knotted, and mangy, that's treated as a positive."

The question as to whether Scanlan's yak hair Wookiee suits would hold up, given the demands of the story, was a major source of concern that the creature team tackled head-on. "The time that goes into producing each suit is so long and labor-intensive," Scanlan said. "They are such precious entities. But it was going to happen, so it was, 'Folks, here we go. Let's do it.' The first thing we did was to get an old Chewie suit, put some poor, unsuspecting performer in it, and then throw water over him, throw mud all over him—just generally abuse him. It brought out this feral realness to a Wookiee that we've never seen before: a sort of undernourished, captive, slightly wild version of Chewie. So we just built more of the suits. There have always been two suits sitting in the safe that we could bring out, just in case. The rest are being washed each night, reset the next day; the slow degradation is in tune with Chewie's journey through the movie."

Solo also afforded actor Joonas Suotamo the opportunity to put his own stamp on the character. "It's been a huge challenge, but also a long overdue opportunity for Joonas to define himself as Chewie." Scanlan realized. "Both in *The Force Awakens* and *The Last Jedi*, he's very much playing the role that Peter Mayhew has defined. Peter Mayhew's range of performance on Chewie must be very tough to emulate. Chewie is Peter. To always have to work within that performance bubble is tough. You either succeed or you fail."

"But no one has ever seen Chewbacca in this film's circumstances. So this time around Joonas can bring his skills to Chewie. Two other players, a stunt guy and picture double, are also in Chewie suits, in order to service the amount of shots that the character is in. But Joonas is zealously protective of any shot with Chewie. And if he can get from one side of the studio to the other, he's going to get over there and make sure he is in the shot [laughs]. There's been a little bit of healthy Chewie competitiveness, which has worked to the film's advantage," Scanlan concluded.

◄ **POOR WET CHEWIE VERSION 02** "In early talks about Chewie we thought, 'What if when we first see him on Corellia, he was like a street dog? What if he is malnourished?' I found a photo of this Chihuahua. This isn't even Chewie's head [*laughs*]. I Photoshopped the dog head right on top of this painting. This was the first painting of Chewie that everyone really responded to. He doesn't look like this in the film, per se. But it informed some of the makeup and hair that they eventually backed into." **Clyne**

"The idea to have Chewie be a sort of punishment for disobedient soldiers on Mimban and that he would be like an abuse mutt, covered in mud was something Larry and I both immediately loved."
Jon Kasdan

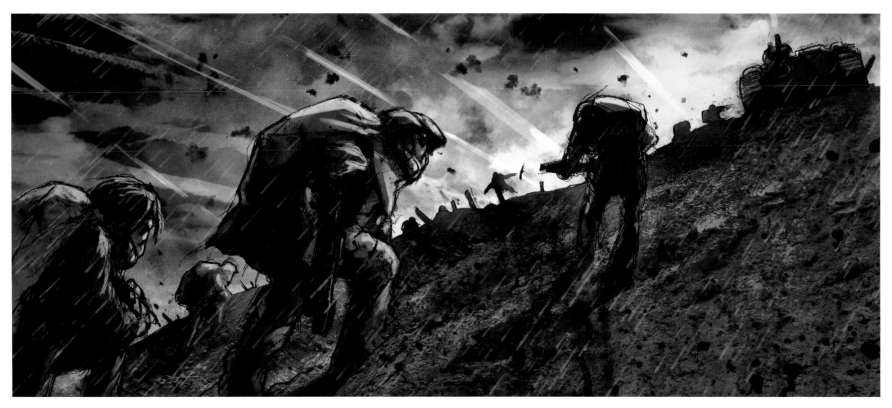

▲ **MUDTROOPERS VERSION 02** Lunt Davies

In March 2016, the Kasdans' evolving screenplay depicted Chewbacca and his fellow enslaved Wookiees on the planet Mimban, fighting on the side of the Galactic Empire. The partial stormtrooper armor the Wookiees wear would help hide their faces, allowing the creature effects team to not have to build quite so many articulated Wookiee faces.

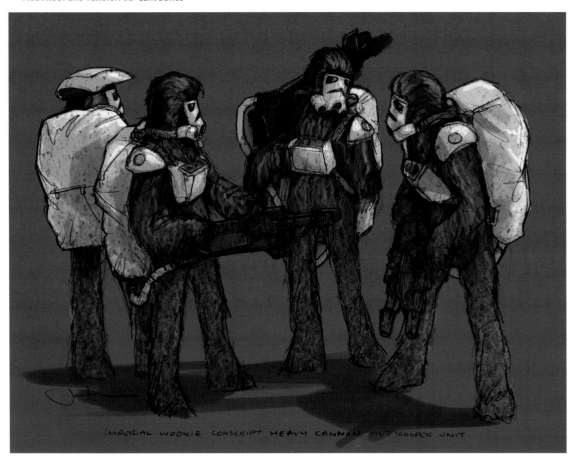

IMPERIAL WOOKIE CONSCRIPT HEAVY CANNON MUDTROOPER UNIT

▲ **WOOKIEE TROOPERS VERSION 1A** Lunt Davies

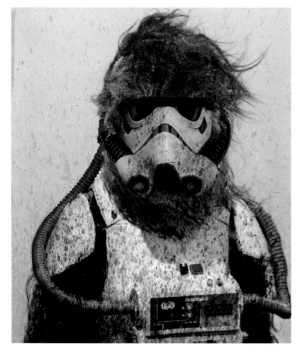

▲ **CHEWIE TROOPER VERSION 1A** Lunt Davies

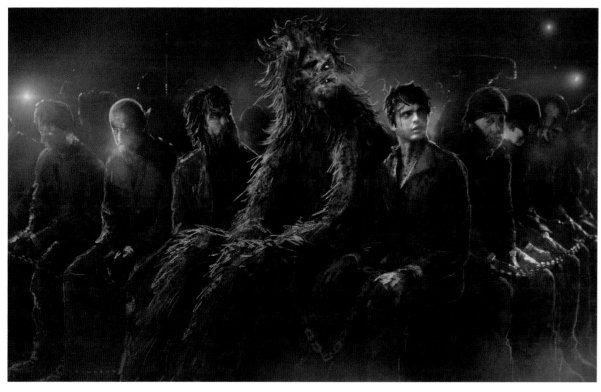

▲ **CHAINED VERSION 1A** Jenkins

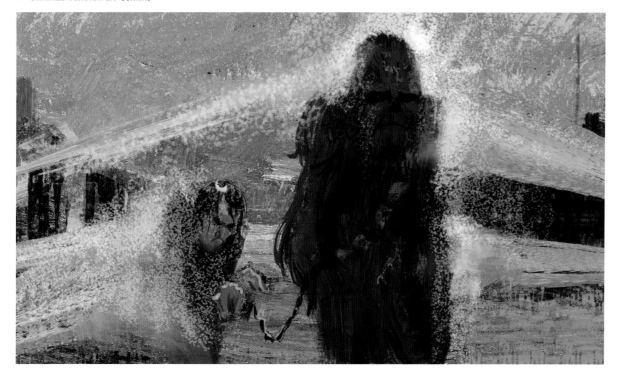

▲ **MOUNTAIN SHOWER VERSION 01** Mullins

▶ **CHEWIE VERSION 1A** Fisher

"Chewie starts really awful, isn't great for a while, and gets slightly better. He has a shower at some point. Eventually, he'll start to look pretty and lovely. By the end of the film, he'll tiptoe into the twilight with Han looking like the Chewie we've always loved before [*laughs*]." Scanlan

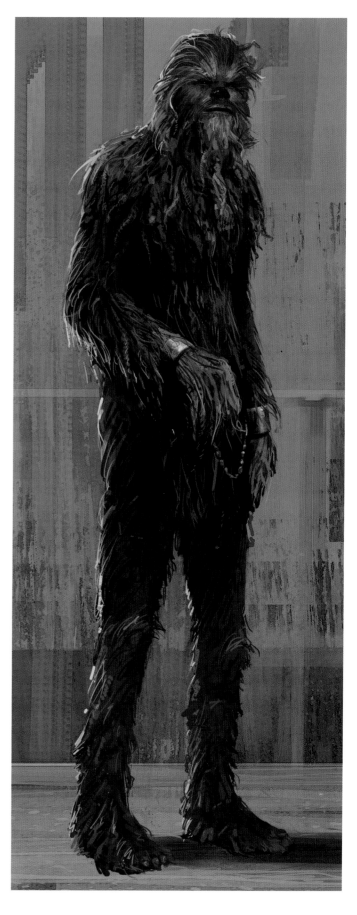

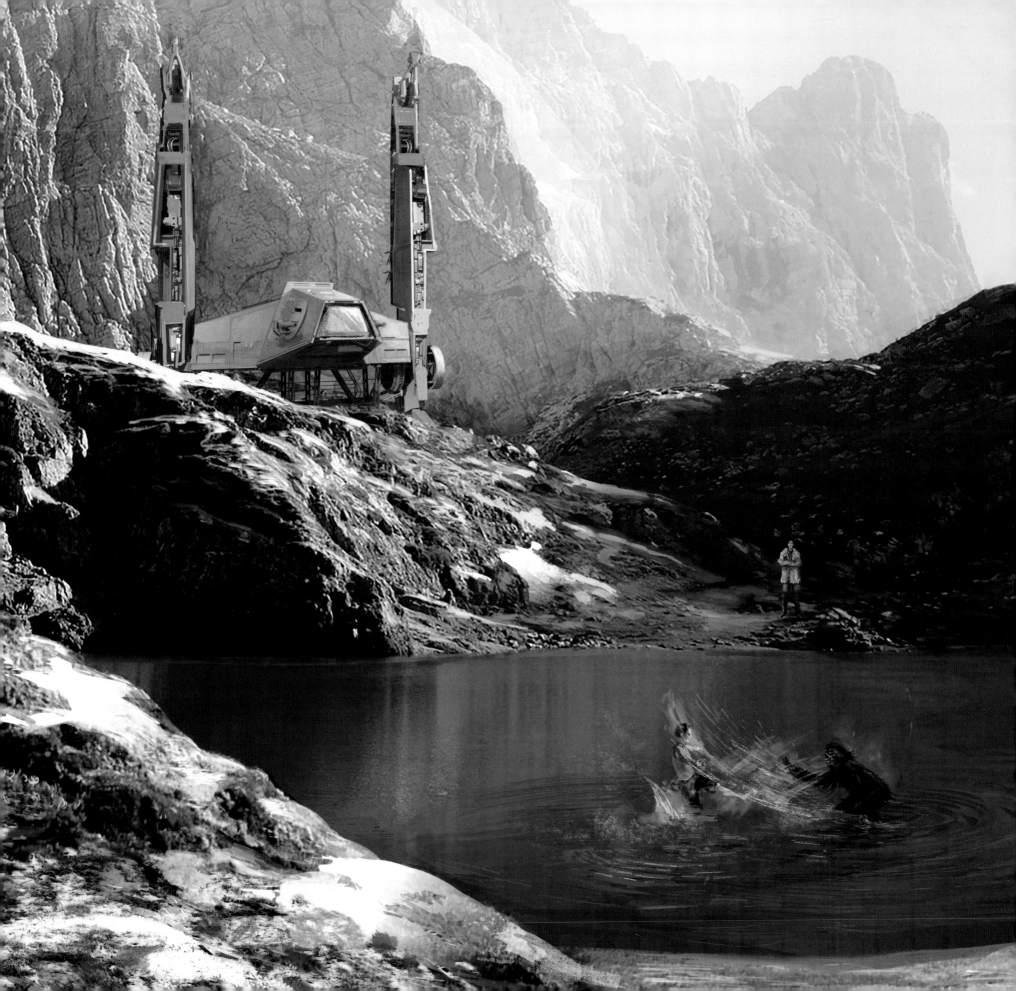

▲ **SAWED OFF RIFLE VERSION 01** Savage

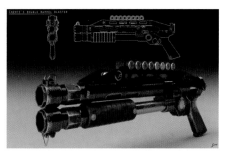

▲ **SAWED OFF RIFLE VERSION 06** Savage

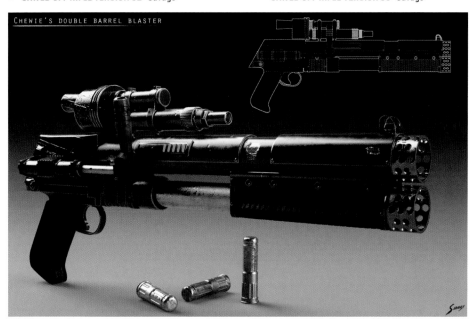

CHEWIE'S DOUBLE BARREL BLASTER

▲ **BELT 01** Tonči Zonjić

◄ **WASHING WOOKIEE VERSION 12** Sole

▲ **SUPERCHARGE DETAIL VERSION 10** Savage

"When they initially said a pump shotgun, I thought, 'That's going to be cool.' But the prototype kept on developing. We looked at Remingtons, first of all, because they kept mentioning that classic pump-action shotgun where you can load it with one hand—like in *The Terminator*. At one point, we cut the stock off. But because of all of Chewie's hair, the gun was getting lost. Now it's got a super-charge that he takes out of his bandolier, and a big red glow comes out of the end. It fires one big mega-shot out of both barrels, which he will use on top of the train." Wilkinson

▶ **CHEWIE BANDOLIER 02** Brockbank

"They wanted Chewie to have a new weapon other than the crossbow. Once that was decided, Chewie's new weapon drove his new bandolier design: If it's more of a shotgun-style weapon, then maybe it should be more of a cartridge-based bandolier. We did a few versions of that, and the chosen Y-shaped design by Tonči was an instant hit." Dillon

▶▶ **STATIC VERSION 1E** Clyne and Jenkins

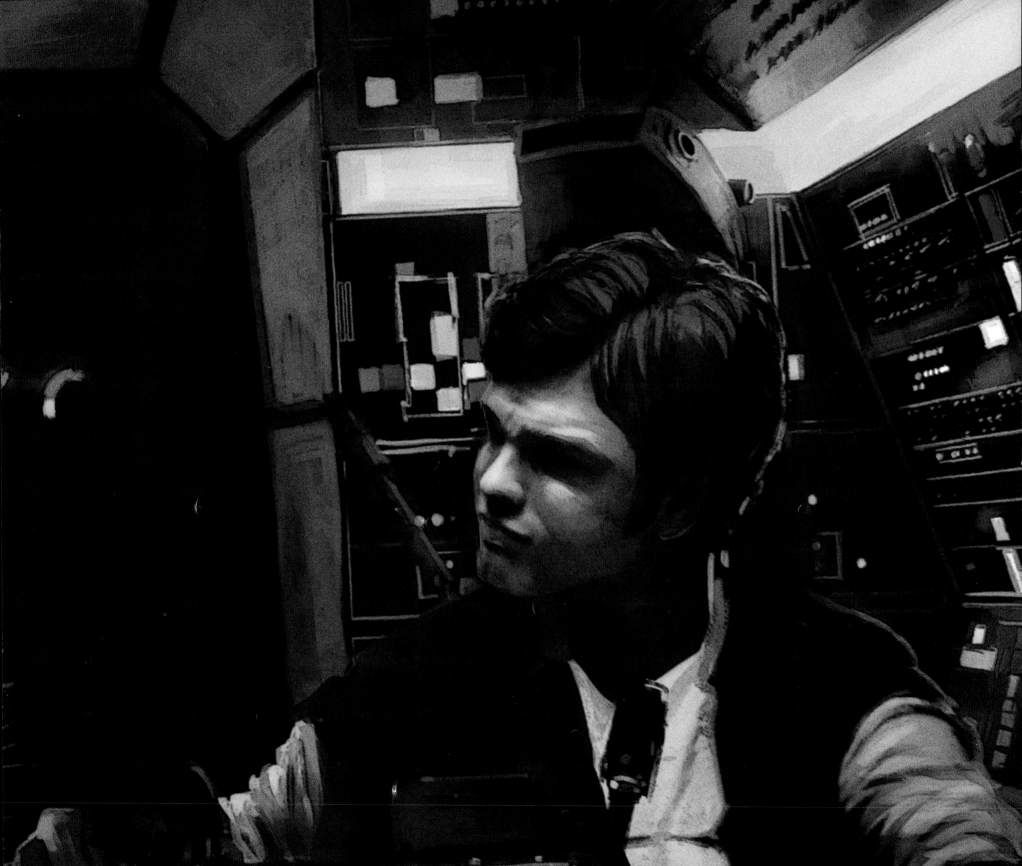

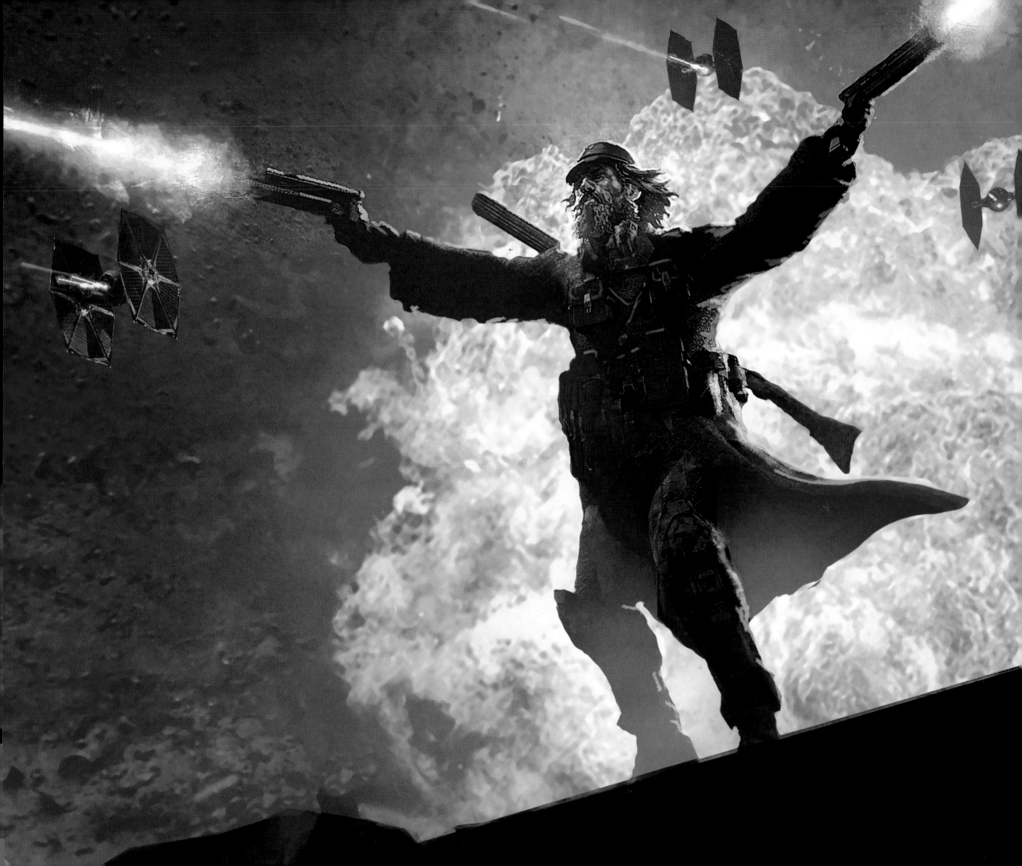

Beckett

Like the creature effects crew, property and weapons master Jamie Wilkinson (*The Dark Knight, Alice in Wonderland* [2010], *Skyfall*) and his veteran team, including prop concept designers Matthew Savage and Chris Caldow, returned for their fourth consecutive *Star Wars* film with *Solo*. But this film's sheer volume and diversity of characters, factions, and worlds within the *Star Wars* criminal underworld, and away from the mass-produced weapons of war between the Empire and Rebellion, meant that Wilkinson's crew had challenges above and beyond any of the previous films in the storied franchise. "When you walk around our prop display, you can see that this is a massively prop-heavy and weapon-heavy film," Wilkinson declared. "You've got the train sequence, which is very prop-heavy. We introduce Enfys Nest's gang. We have zip-lines, comms units, and a lot of factions with unique props and weapons sets. And the demand for props is very front-end, with most of those sequences shooting early in the schedule."

To meet those challenges, Wilkinson drew inspiration from his experience on the previous *Star Wars* standalone film. "*Rogue One*, with Gareth Edwards, was the first period *Star Wars* movie," Wilkinson remembered. "I wanted to go right back to the source, to the work that art director Roger Christian pioneered on *A New Hope*. So I got a lot of prop weapons from Bapty & Co. Bapty was our armory, the European equivalent of Independent Studio Services [ISS] in Hollywood. They did a lot of the original weapon makes, back in the day. We just bought a load of period weapons and said, 'Gareth, is this the way we should keep going?' And he was completely into it, which was fantastic, leading us to the shoretroopers' E-22, for example. When the E-22

fires, you get simulated barrel flashes. Even though it wasn't a real weapon, we were trying to keep it really close to what you see in *A New Hope*. On *The Force Awakens*, we went with a flashing red light, simulating the laser blast. But we stripped it right back for *Rogue*."

Solo is likewise a period *Star Wars* film, only this time five to ten years earlier than *Rogue One*. "We're right in the middle of an Imperial war on Mimban. So it's that whole world again," Wilkinson noted. And instead of leaning into a military caper film, as *Rogue One* did, *Solo* would be more akin to a Western. "We used a lot of imagery from Westerns, and the themes of morality and friendship associated with gunfighters, as well as gangster movies," Jon Kasdan said. "These are lawless times in the galaxy, as was certainly the case in late nineteenth century American frontier, the Caribbean of the late seventeenth century, or the gangster world of twenties Chicago. Our characters have to deal with brutality and violence and lawlessness then decide how they'll respond to it, and how they'll maintain their humanity in the face of it." Wilkinson concluded, "The good thing about that brief is that it gets you thinking in a particular direction. We started heading in that direction and eventually veered away from a strictly Western look. But it gave us a sense of which way to go."

One character within this period film with a particular penchant for *Star Wars* weaponry is Han Solo's mentor figure, the gunslinging scoundrel Mattias Beckett. Wilkinson recalled, "The asymmetry of Beckett's pistols was decided early on, from two designs that Matt Savage did way back. And both of them were such great stand-alone designs. They are as on the nose for the Western genre as you get in this film, that sort of cowboy character with his double holsters. We embraced the idea. How we made the guns different is that one is a side-loader and the other's a front-loader. Beckett's gunslinging bit is all a part of the action."

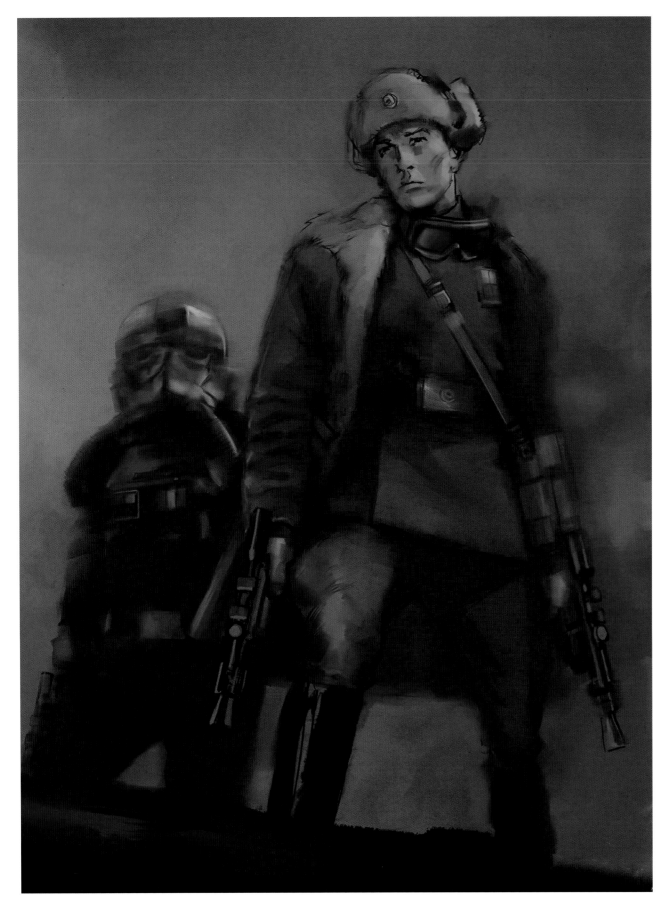

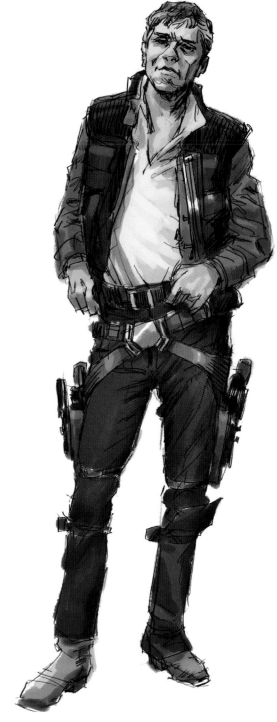

▲ **BECKETT VERSION 3A** Dillon

◄ **BECKETT RIO VERSION 03** Dillon

"Beckett had a Russian fur hat for a while because Mimban
was supposed to be this tough muddy world. We were always
looking at James Coburn in *Cross of Iron*, that kind of German/
Russian Eastern Front feeling. But Woody Harrelson doesn't
wear leather or fur. Once casting happens, restrictions apply.
In some way that drives his final look because there are
certain things you can't do." **Crossman**

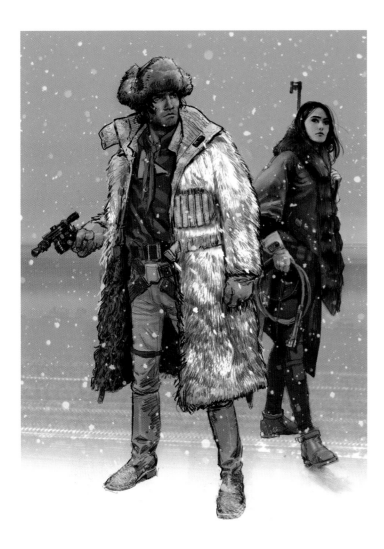

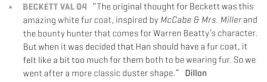 **BECKETT VAL 04** "The original thought for Beckett was this amazing white fur coat, inspired by *McCabe & Mrs. Miller* and the bounty hunter that comes for Warren Beatty's character. But when it was decided that Han should have a fur coat, it felt like a bit too much for them both to be wearing fur. So we went after a more classic duster shape." **Dillon**

▸ **BECKETT VANDOR 3A** Brockbank

"The idea with Beckett is that he's Han's mentor, and it's very much a cowboy movie—the classic cowboy duster coat fulfills that. We added the familiar *Star Wars* greeblies, bits of random technology, on his shoulder to bring it into that world. For a while, we were thinking of having canvas on the outside and fur on the inside of his coat. But once the casting came through, we had to adjust. We tried to embrace those restrictions with things like his holsters, which we made from a paler canvas and are actually really nice." **Dillon**

"I'm glad we got to keep the duster so pale. There's more costume changes on this film, especially with Han, than usual. Most of the time with *Star Wars*, you try to keep the lead characters on a simple line of changes. Woody's duster coat seems to suit all occasions [*laughs*]. He's meant to have the look of Han's mentor. There's something there for Han to emulate." **Crossman**

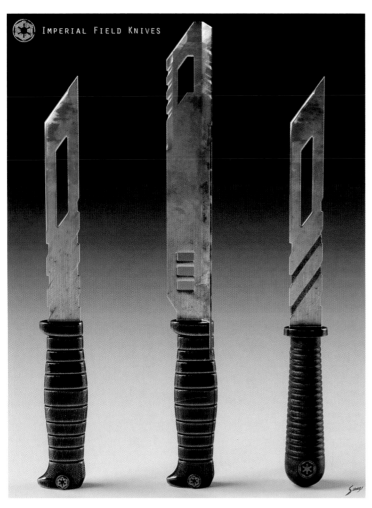

IMPERIAL FIELD KNIVES

▲ **FIELD KNIVES VERSION 01** Savage

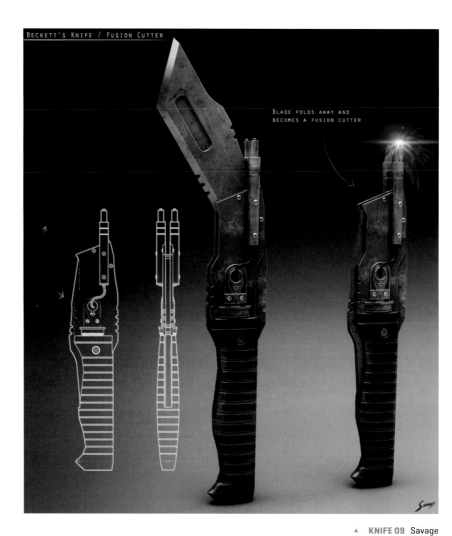

BECKETT'S KNIFE / FUSION CUTTER

BLADE FOLDS AWAY AND
BECOMES A FUSION CUTTER

▲ **KNIFE 09** Savage

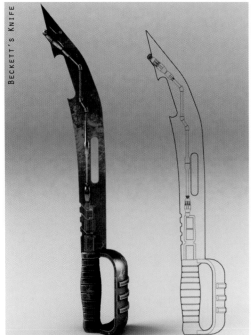

BECKETT'S KNIFE

▲ **KNIFE VERSION 06** Savage

BECKETT'S KNIFE BEING USED
AS A FUSION CUTTER

▲ **KNIFE VERSION 08** Savage

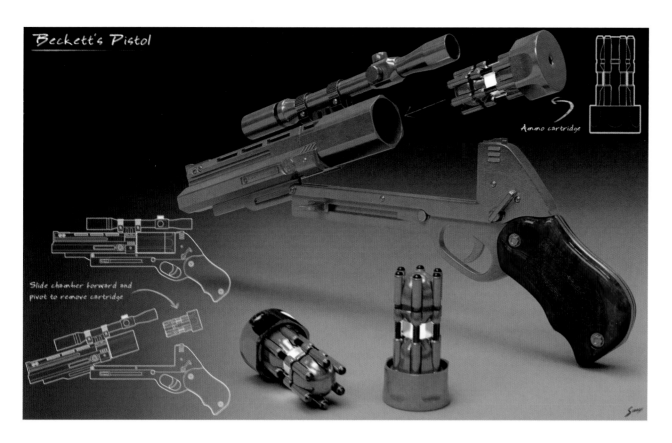

Beckett's Pistol

Ammo cartridge

Slide chamber forward and pivot to remove cartridge

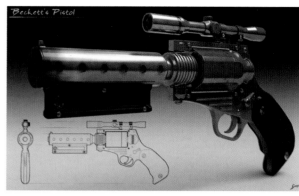

▲ **PISTOL VERSION 03** Savage

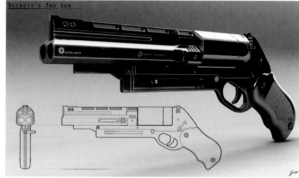

BECKETT'S 3RD GUN

▲ **THIRD PISTOL VERSION 11** Savage

▲ **PISTOL VERSION 09** Savage

"The loading blaster idea, reintroduced with Director Krennic in *Rogue One*, is very much akin to a Western revolver. But the first intended use of the idea was in the back of the First Order stormtrooper's F-11. I've always said that you never really run out of ammo in a *Star Wars* film. But on *The Force Awakens*, when Finn and the stormtroopers are heading down to the village, at one point, J.J. Abrams wanted to see them locking and loading. So we did a couple of our black-and-white F-11s with a cartridge in the back that twists and pops out. Blasters don't go on forever. They have a 'battery pack,' as we are wont to say. And this cartridge is the ammo." Wilkinson

▶ **PISTOL VERSION 06** Savage

"Beckett pushes the barrel to the side, the chamber pops out, and he changes the cartridge and pops it back in. It's really well engineered; it literally goes with just the touch of a button. Same with the other one: You release a button and the barrel goes forward, right up on the blaster, and pops up." Wilkinson

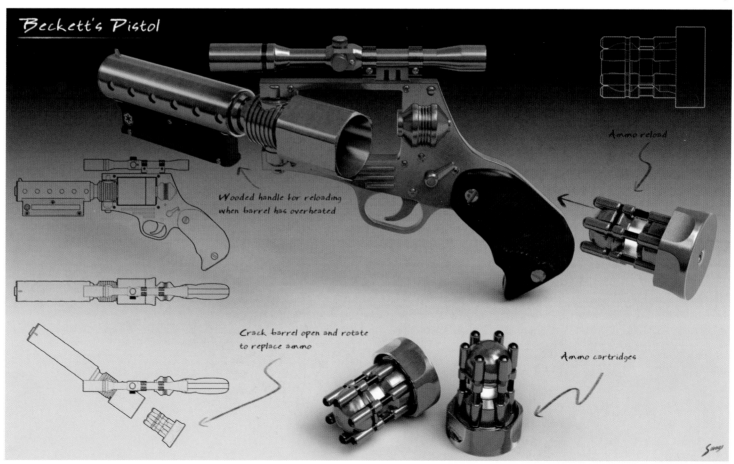

Beckett's Pistol

Wooded handle for reloading when barrel has overheated

Ammo reload

Crack barrel open and rotate to replace ammo

Ammo cartridges

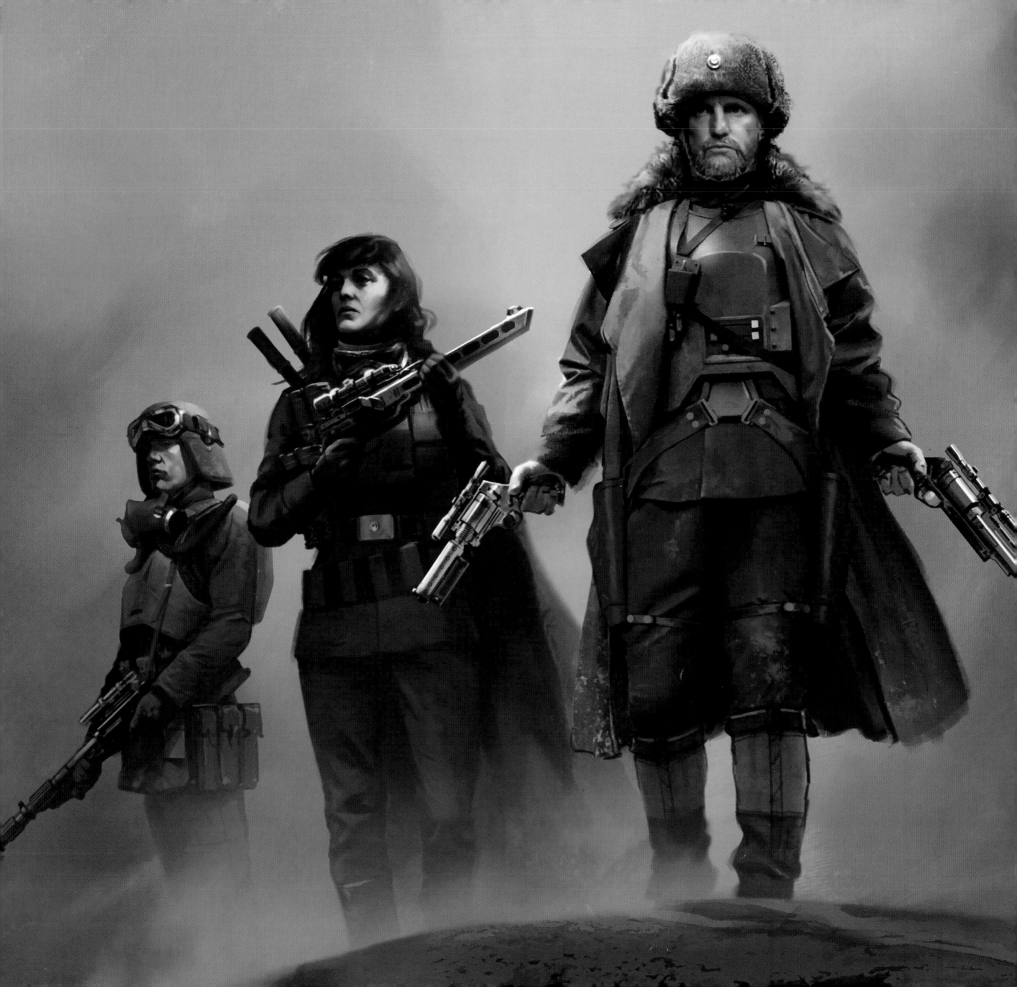

Beckett's Gang

One of Lucasfilm design supervisor James Clyne's principal tasks on *Solo* was, in concert with the filmmakers and department heads, defining the visual language of this particular *Star Wars* film. "I started to dig into the three or four inspiration points that I felt George Lucas had pulled from: First with the obvious influence, the Flash Gordon/Buck Rogers classic science-fiction adventures. Then the samurai films of Akira Kurosawa. Then the John Wayne/*The Searchers* influence. Maybe this is our opportunity to really embrace the Western? In one of the early meetings, I said, 'If we do nothing else, wouldn't it be wonderful to do a love letter to the Western?' So we asked, 'Well, what does that mean?' A lot of it was just a conversation."

As 2015 drew to a close, a small, unassuming preproduction office for *Solo*, by then code-named "The Red Cup," was set up on Jefferson Boulevard in Culver City, California, as had been done for *The Last Jedi* a little over one year earlier. Clyne recalled, "I would fly down to LA once every other week or so and explore

◀ **BECKETT'S GANG VERSION 2A** Brockbank

"Beckett's gang had to be in disguise; they had to have elements of all of the other mudtroopers. But there needed to be something off about them, something not quite right. We made these rubberized Imperial officer's coats on *Rogue One*, which served as a good coat shape for Woody Harrelson. Then we put some Imperial armor in the style of General Veers from *The Empire Strikes Back* on him. We kept Beckett in his hero-look holster set and boots, which had to be faux leather. Then we played around with various styles of headwear that would suit Woody. Woody would tell us if it looked good or bad. 'Negative! Negative!' [*laughs*] So we settled on the classic Imperial officer's cap, adding goggles to them." **Crossman**

"Thandie Newton was dressed more like a mudtrooper, but they all needed their character coming through the uniforms. We liked an image that I had found of a Viet Cong girl with an upside-down pistol hanging around her neck, tied on with a piece of string. So we added Val's red ropes and the pistol around her neck. Instead of wearing a man's costume, we thinned out the legs and sleeves and gave her a slightly shapely silhouette. We took away the mudtrooper leg armor, so it was just boots and dark legs. All that plus her hair and the armor, and she looked quite cool. She was quite into that costume." **Crossman**

where things were going. A small story department had been started up with some great storyboard artists that they had known for a long time: Phil Keller and Dave Lowery, who worked on *Jurassic Park*. And they pulled a couple guys who had worked on *Cloudy with a Chance of Meatballs*. There wasn't any concept art coming out of that office. Their goal was to lay out the whole movie in an animatic [a preliminary edit of a film or television episode made using storyboards and temporary sound]. It was great to go down there and see what those guys were developing, feeding them ideas as we were designing them. Their work would also inform me in coming back and plugging away in San Francisco."

"Until January 2016, all of the concept art that was being generated was by my small team. I'd bring in a couple artists like Craig Mullins, who is this giant in the concept art world, for a couple of months. It was crazy to work with Craig. Sometimes I'd pull in Aaron McBride, who worked with us for a while. And I'd try to pull in other people here at ILM. But it was a pretty ragtag group of artists. I like working small, being pushed on that level. But yeah, for the first six or seven months, it was just a small concept team and myself," said Clyne.

From the outset, Clyne and his design team recognized that out of all of *Solo*'s new vehicles, the idiosyncratic nature of the Imperial AT-hauler would most impact its visual conception. "The AT-hauler is one of the most complex things I've art directed on the film because it required so many different abilities," Clyne recognized. "It had to have a cockpit that fits at least six or seven crew because it had to carry not only Han and Chewie, but also all of Beckett's gang. It had to be Imperial. And it had to be able to pick up a train car. The AT-hauler is not just a flying vehicle that gets people from point A to point B; it's this utilitarian Swiss Army knife ship that needs to do so many things—a lot like the U-wing from *Rogue One*. So the design had to service that story and required a lot of back and forth. We talked so much about what it had to be. And all that complexity eventually boiled down to arms—arms to pick something up. If only someone had blurted that out from the beginning!"

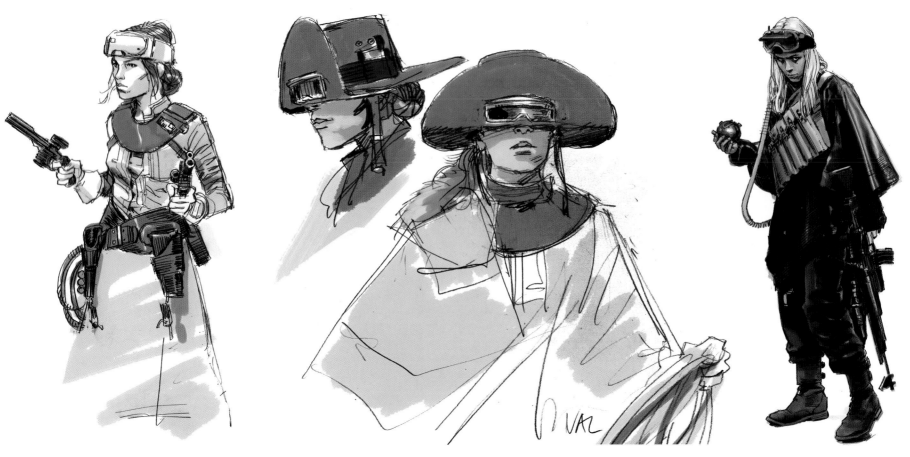

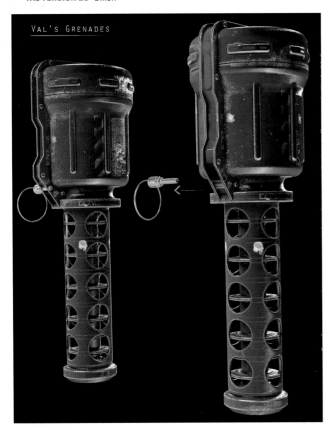

VAL'S GRENADES

MAG CHARGE AND DETONATOR

◄ GRENADES VERSION 03 Savage

"These grenades are from Mimban, part of Val's kit. We added some yellow to them, just to bring them out." Wilkinson

▲ MAGNETIC CHARGE VERSION 04 Savage

"We are working on a magnetic bomb that she is setting on the bridge. Then she activates the detonator as she is falling." Wilkinson

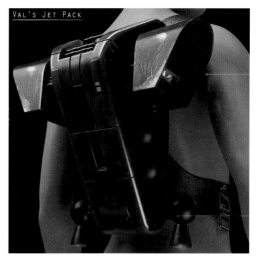
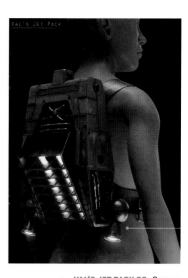

▲ VAL'S JET PACK 01 Savage ▲ VAL'S JET PACK 03 Savage

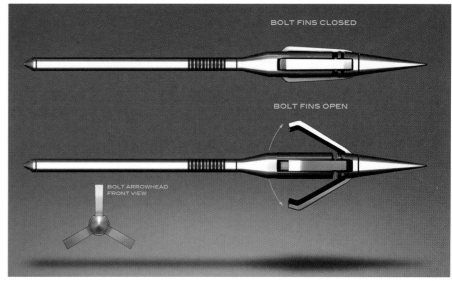

BOLT FINS CLOSED

BOLT FINS OPEN

BOLT ARROWHEAD
FRONT VIEW

▲ VAL'S GRAPPLE BOLT VERSION 01 Savage ▼ VAL'S GRAPPLE GAUNTLET VERSION 03 Savage

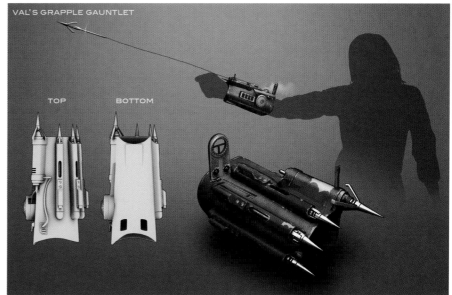

VAL'S GRAPPLE GAUNTLET

TOP BOTTOM

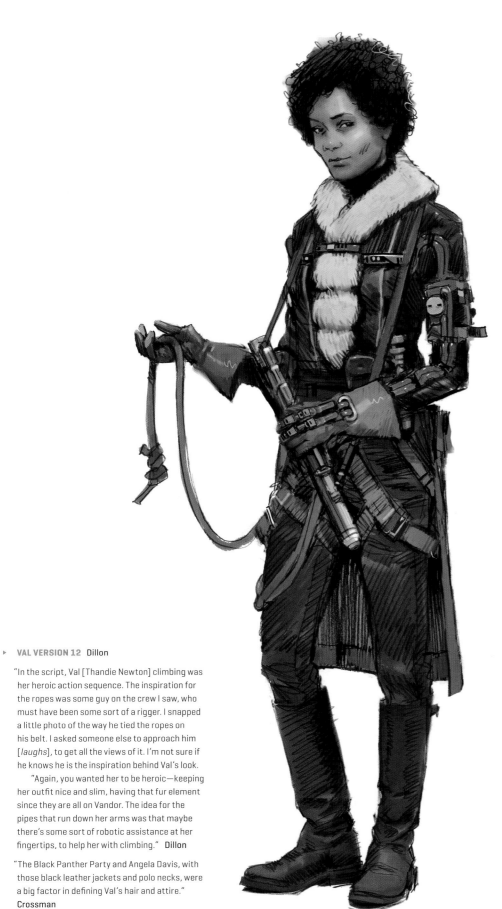

▶ VAL VERSION 12 Dillon

"In the script, Val [Thandie Newton] climbing was
her heroic action sequence. The inspiration for
the ropes was some guy on the crew I saw, who
must have been some sort of a rigger. I snapped
a little photo of the way he tied the ropes on
his belt. I asked someone else to approach him
[laughs], to get all the views of it. I'm not sure if
he knows he is the inspiration behind Val's look.

"Again, you wanted her to be heroic—keeping
her outfit nice and slim, having that fur element
since they are all on Vandor. The idea for the
pipes that run down her arms was that maybe
there's some sort of robotic assistance at her
fingertips, to help her with climbing." Dillon

"The Black Panther Party and Angela Davis, with
those black leather jackets and polo necks, were
a big factor in defining Val's hair and attire."
Crossman

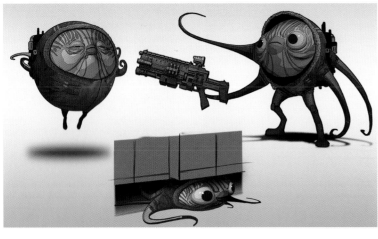

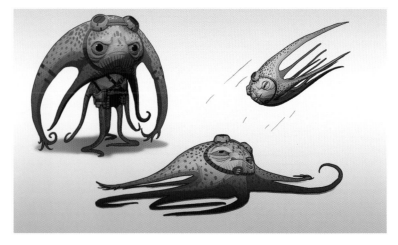

▲ SQUID MONKEY VERSION 02 Carrasco

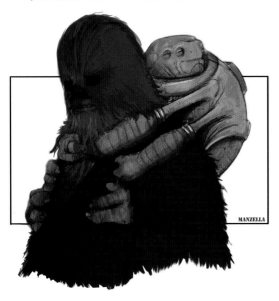

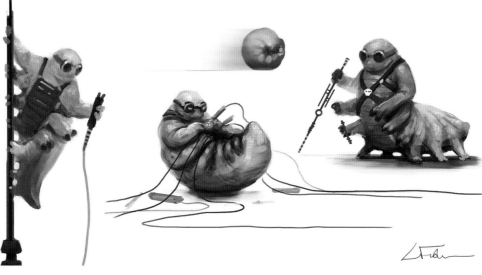

▲ RIO VERSION 01 Fisher

▲ RIO VERSION 5A Manzella

▲ QUICKDRAW VERSION 01 Manzella

▲ ZAPF VERSION 1A Manzella

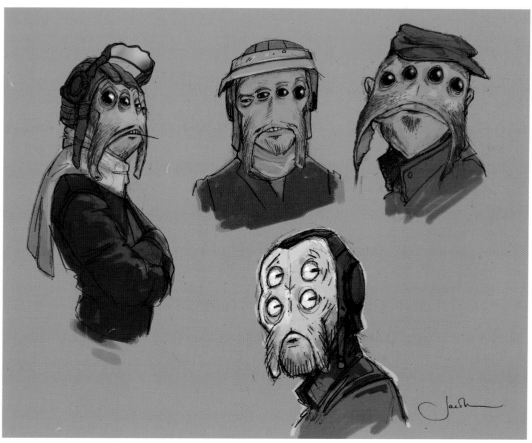

▲ QUICKDRAW VERSION 01 Clyne

▲ QUICKDRAW SKETCH VERSION 02 Tyler Scarlet

▲ RIO 15 Manzella

▶ RIO 09 Lunt Davies

In early drafts of the script, Rio Durant and Zapf were both aliens in Beckett's crew, Rio being a gruff humanoid alien with multiple eyes, based in part on actor Wilford Brimley, and Zapf the "squid-monkey." Rio was an ace pilot with the natural advantage of seeing more than the average aviator. "We all spent a lot of time finding this guy," remembered Jake Lunt Davies. "He is an amalgamation of ideas for two characters that were resolved into one."

▲ **RIO ZAPF VERSION 3A** Lunt Davies

▲ **RIO SCALE VERSION 1A** Lunt Davies

"With Rio, one of the things we want to do is to purposefully play with the audience's mind. And you will get the idea that Rio is the greatest pilot that ever lived. He can get around in this spaceship in a way that Han could never possibly do. The idea is, 'Let's use a person in a suit.' You might cut to our performer, Katy Coleman—aka Katy Kartwheel—in a suit, grabbing the top of a switch. Cut to Katy's feet catching the side of another switch. Cut back to this thing in reverse that she does [*laughs*]. You end up with this frenetic, dynamic character." Scanlan

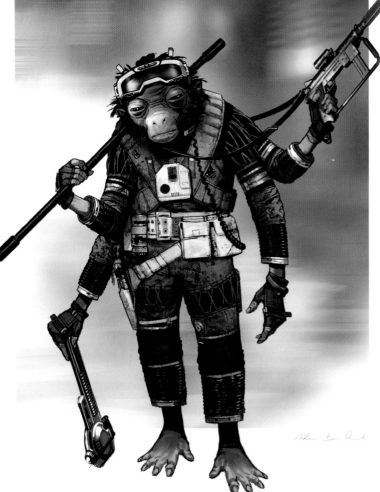

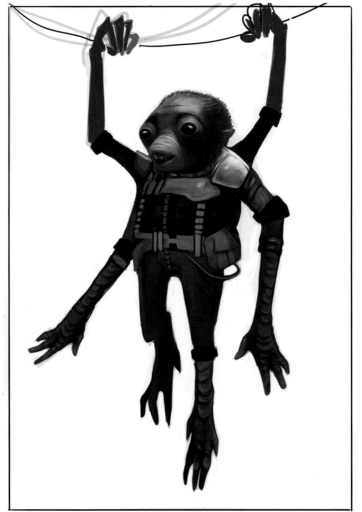

▲ **RIO ZAPF VERSION 6A** Lunt Davies ▲ **RIO VERSION 5B** Brockbank

▲ **RIO HANGING VERSION 01** Manzella

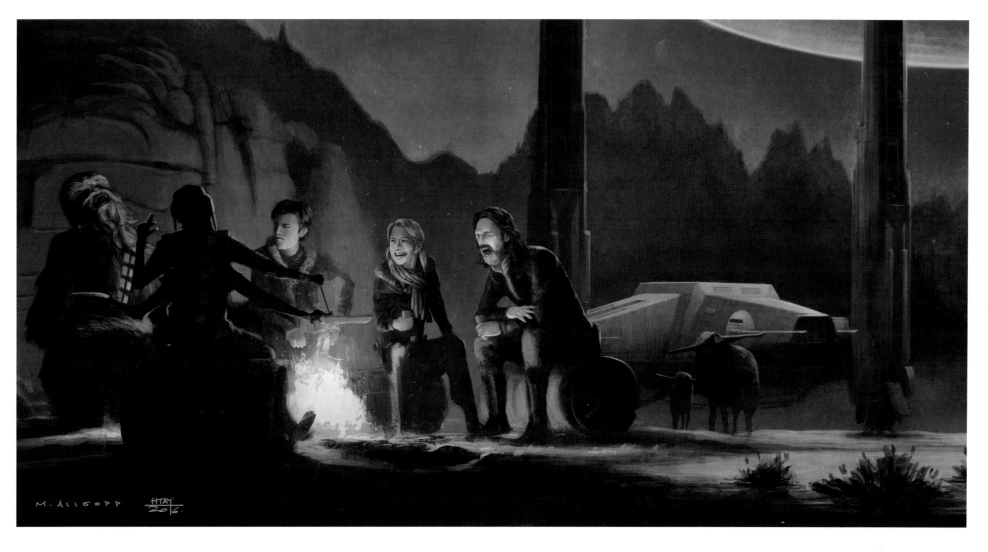

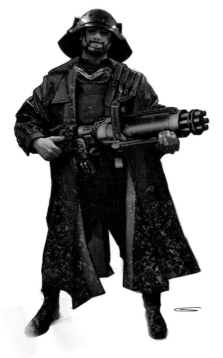

▲ **MOUNTAIN PLANET CAMPSITE VERSION 09**
Allsopp, Htay, and Clyne

◄ **KORSO VERSION 03** Dillon

"Korso was great fun. We gave him an
overlong, rubberized coat, but in black with
a big Imperial Navy helmet and this huge
gun. Because of his broad shape, he could
carry all of that off." **Crossman**

► **KORSO GUN VERSION 01** Savage

"We've always wanted to put a minigun into
a film. In *Rogue One*, Moroff's blaster was
an M-60 with a minigun barrel, but it didn't
function practically. This is the first time
we made one that worked. It has a sixteen-
pound drill in it—literally the cheapest
drill you can buy—to spin the barrels. You
push the handle of it, and it spins. We put
a single flashlight down here so every time
the barrels rotate, it lights up. It's a simple
build but really effective." **Wilkinson**

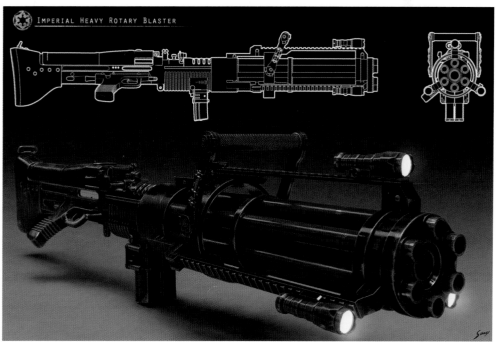

IMPERIAL HEAVY ROTARY BLASTER

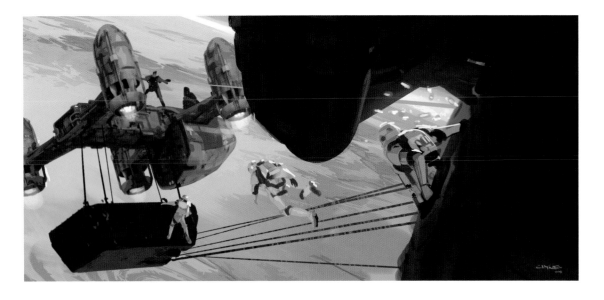

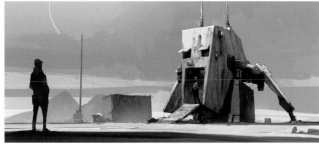

▲ **CARGO LIFTER VERSION 02** McQue

◄ **QUAD LIFT FIGHT VERSION 1A** "The AT-hauler quickly became an Imperial thing. I didn't know it was Imperial at first. I didn't know what it was. We called it a 'Quad Rotor' at first. So maybe it had four engines. But we always knew it was going to be something of that size." Clyne

▼ **QUAD VERSION 02** McBride

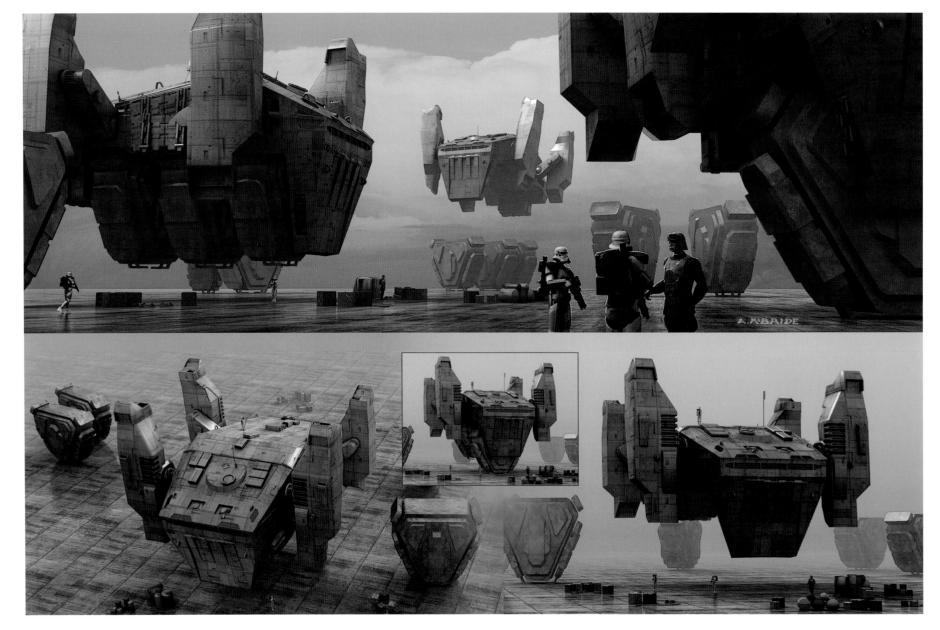

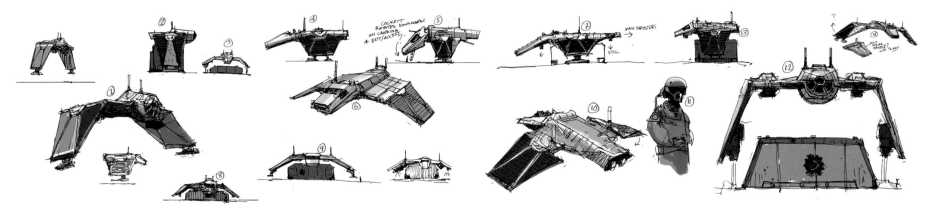

▲ **CARGO LIFTER ROUGH 01** McQue

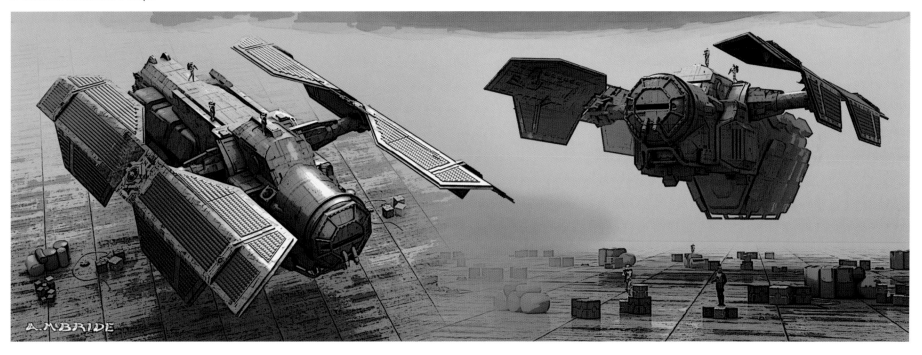

▲ **QUAD VERSION 04** McBride

"Everybody on my team jumped in on this one. Some versions were inspired by a vehicle from *TRON*. But the thought process was always, 'How do we create something that's simple and iconic, just like a TIE fighter, but that also has a lot of function?' We tried out stuff that was very TIE fighter–like, but a hauler TIE fighter. Whatever its function was, the directors wanted to make it very obvious, very simple, so that the audience would get it right away. We did a lot of exploration." **Clyne**

▶ **QUAD VERSION 4B** McBride

"We knew that the Hauler was going to have to pick up this cargo, and we knew there was going to be a fight for it. I developed this idea of it having this exterior cage. I spent a lot of time with Oliver Carroll, our art director, on the AT-hauler, sitting with him every day. I pitched to the guys, 'What if you have an Indiana Jones moment: fisticuffs outside the vehicle?' The action shouldn't always be on the inside." **Clyne**

"When we first see these sky-cranes on Mimban, there's a little bit of interactivity. You can see people adjusting things on the outside and walking down a gangway to access another part of the vehicle. That's how the gantry stuck. And then it became a necessity: a good way for Han and various people to be able to get onto the ship during the train heist." **Lamont**

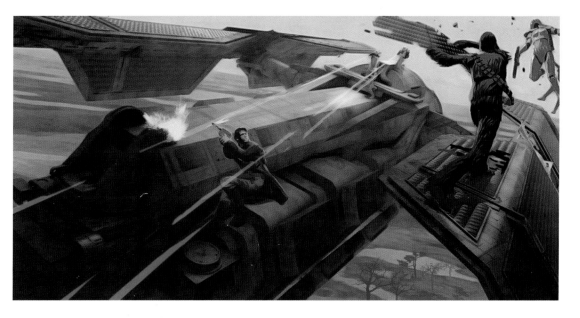

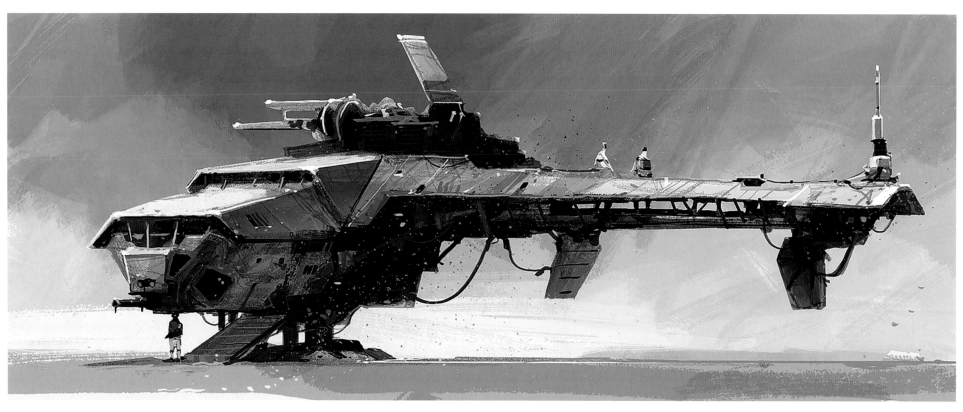

▲ **HAULER ROUGH VERSION 04** McQue

▼ **HAULER VERSION 16** McQue

"QUADROTOR" — IMPERIAL CARGO LIFTER / DROPSHIP.—

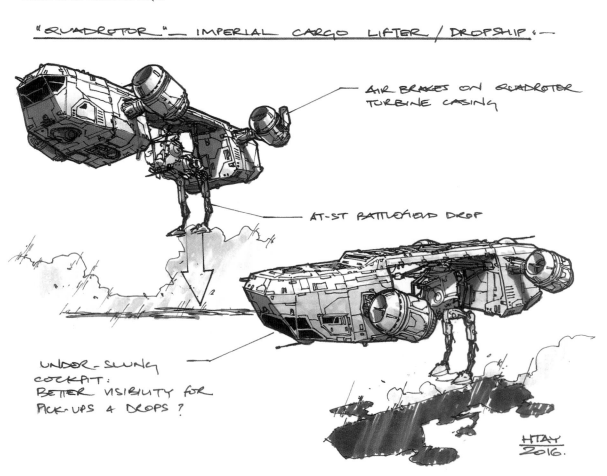

AIR BRAKES ON QUADROTOR TURBINE CASING

AT-ST BATTLEFIELD DROP

UNDER-SLUNG COCKPIT: BETTER VISIBILITY FOR PICK-UPS & DROPS?

HTAY 2016.

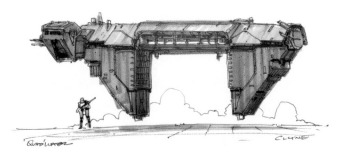

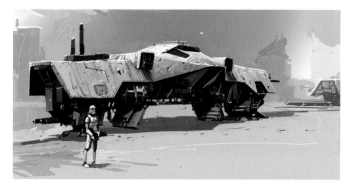

▲ **HAULER SKETCH VERSION 02** "The Sikorsky CH-54 Tarhe helicopter is funny looking. All of the middle is empty because that's where they put the cargo; that was an influence on those early versions. But it ultimately couldn't be like the Sikorsky because the when the train car blows up, it had to be far enough away so that the train doesn't take them out as well." Clyne

◄ **CARGO LIFTER VERSION 1E** Htay

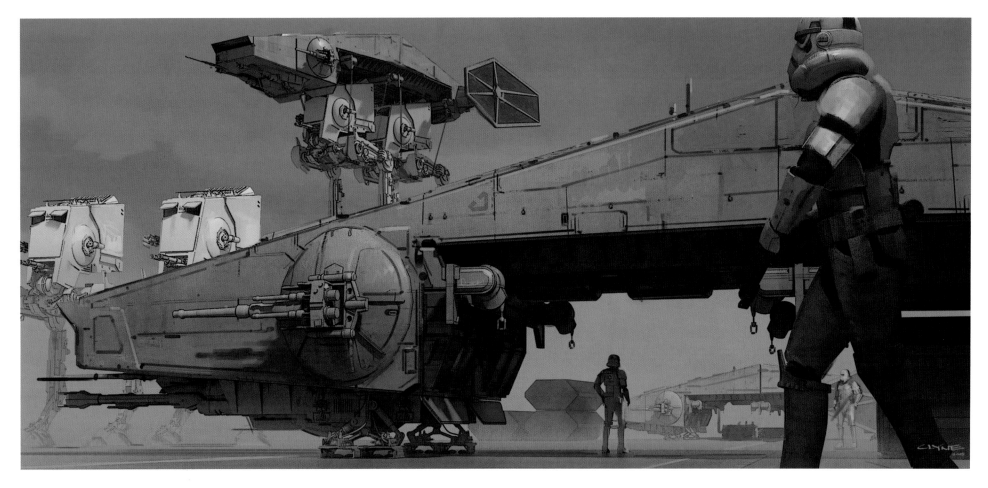

▲ **QUAD EXTERIOR 01** "Then I pitched this next one, which is essentially a flying garage. You have this open cavity that you can load anything into, and then it takes off to the battlefield." Clyne

▶ **HANGAR CORELLIA VERSION 1A** Tenery

▼ **AT HAULER VERSION 4B** Jenkins

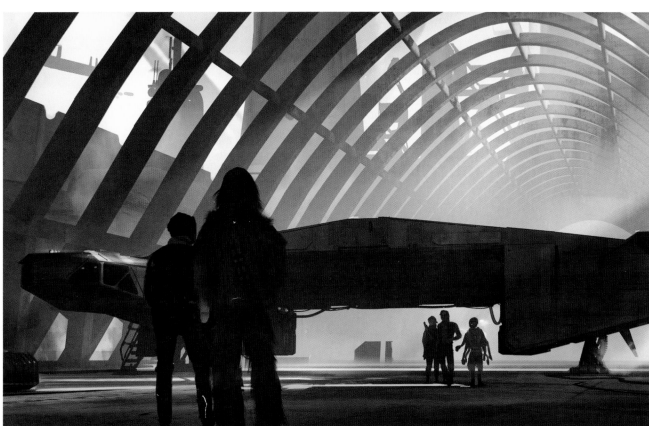

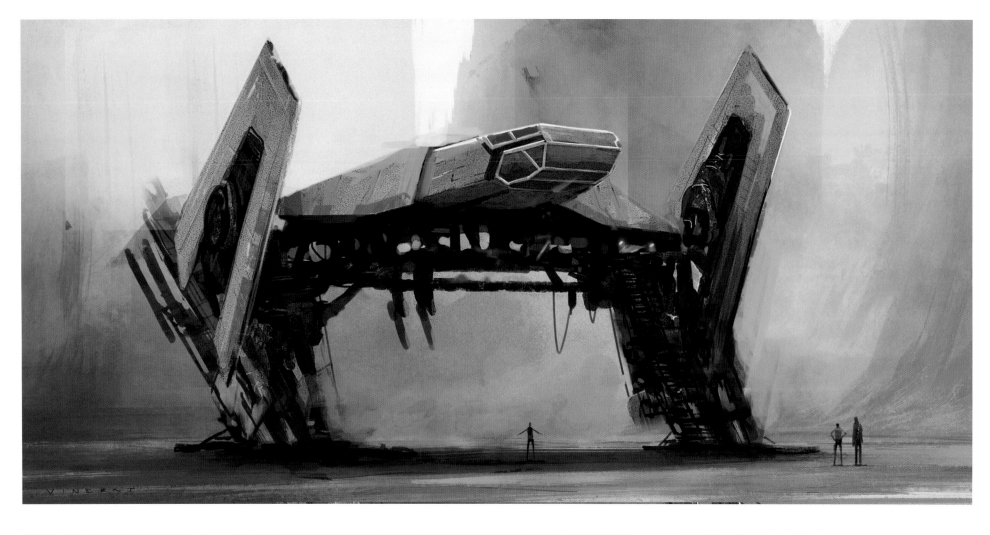

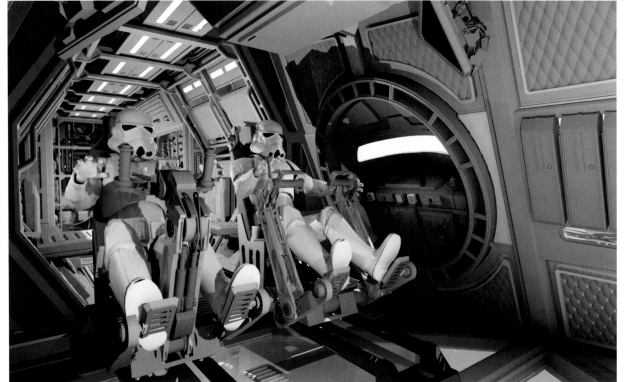

▲ **CHUNKY LANDED VERSION 9C** Jenkins

◄ **FRONT COCKPIT VERSION 1D** Oliver Carroll

"When we started building the interior, I wanted to put a camera right between the two pilots because there was all of this play in the story of Rio piloting. He could see straight down, in between the two seats, like a crane. But I wanted to make sure that you could see the train car physically below him. There was some concern that they wouldn't be able to see out of the sides. But I love that on all of the Imperial stuff, there's very little glass. It's all closed off, armored. They're kind of a closed-off society. Rebels have a lot of glass. They're more open." Clyne

▼ **HEIST VERSION 5A** Tenery

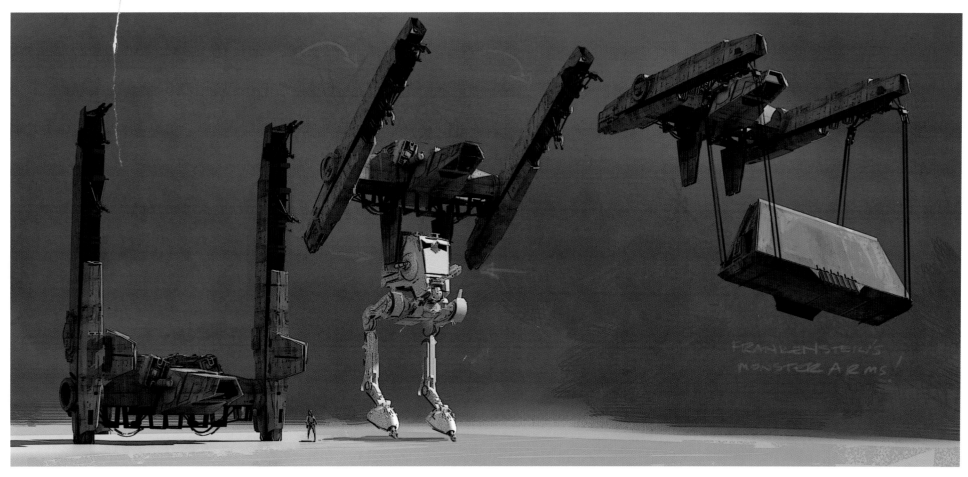

▲ **H SHAPE VERSION 05** "Finally, I sent this. It was like a flying crane. It has these two arms, which I pitched to them as being like Frankenstein's monster's arms, out in front at a ninety-degree angle. I was playing with the idea of having paddles that could pick up an AT-ST and drop it in, but also having these big crane arms, which would allow us to have cabling. Cabling was important for picking up the train car, because you will see it swing and smash against the rocks." **Clyne**

"I came up with this idea that when it lands, the arms go straight up—an homage to Kylo Ren's shuttle or the shuttle *Tydirium*. I remember being in a meeting with forty people about the Hauler, and producer Simon Emanuel was like, 'Doesn't this look too much like Kylo Ren's ship or some of the other shuttles?' And I was like, 'Simon, that's exactly what I want to hear!' You want to feel like it fits in with the vernacular." **Clyne**

"The AT-hauler, our sky-crane? So much of its design is based around the cladding that was established in *Empire* on the AT-AT. We're just trying to keep that vibe going, since these are the pioneer vehicles." **Lamont**

▶ **HAULER MODEL** Paul Marsh

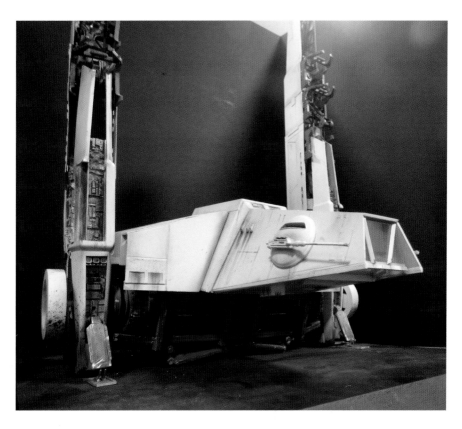

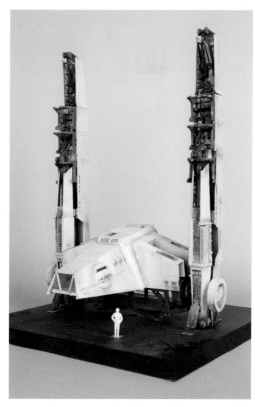

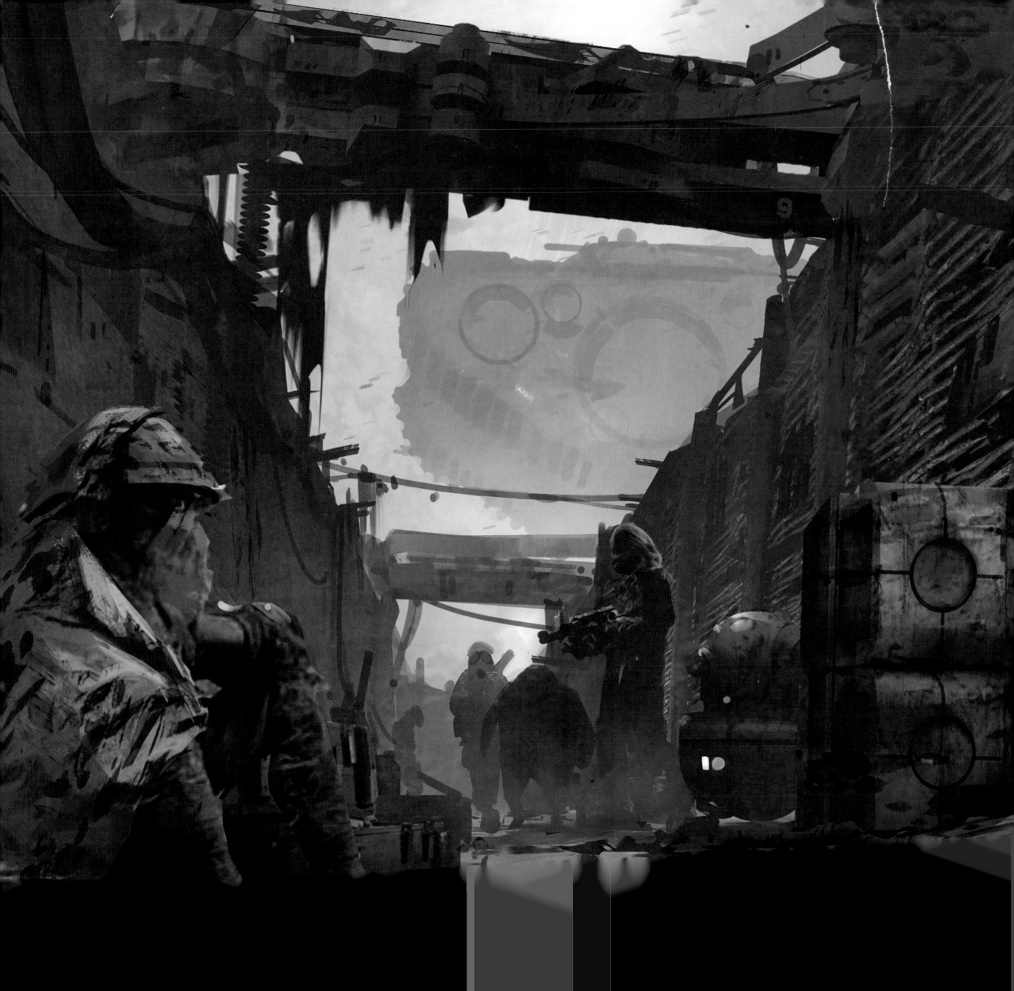

Mimban

After serving as a supervising art director on *The Force Awakens* in 2014 and co–production designer, alongside Doug Chiang, on *Rogue One*, production designer Neil Lamont (*Harry Potter and the Sorcerer's Stone*, *War Horse*, *Edge of Tomorrow*) revisited the *Star Wars* galaxy once more for *Solo*, with almost no break between projects. "I officially started on *Solo* on January 4, 2016, two weeks after finishing *Rogue One*," Lamont said. "I quickly went out for a week to Los Angeles to link up with James Clyne and meet the artists who had already been working on the project for six months or so. It was a little bit of a whirlwind tour but good to get into it. James is massively talented and could do this by himself. Fortunately, James had time at Pinewood and Doug also had a lot of time here on *Rogue*. But they were only able to stay in the country for a certain amount of time. So it's been a pretty similar process to *Rogue One*."

Upon returning to Pinewood Studios outside of London, Lamont enlisted the expertise of his fellow *Rogue One* veterans in the formation of the production-side art department. Lamont recalled, "Working with many of the same artists as *Rogue One* felt like a natural next step. Will Htay and Jon McCoy were just finishing up some stuff in post on *Rogue*, so it was great to be able to roll them, alongside Matt Allsopp and Vincent Jenkins, straight back onto *Solo*. No matter what you do, you develop an understanding with the people you work with. And they understand *Star Wars* on a deep, fundamental level. We are five to ten years prior to *Rogue One*, so it's not that huge a leap."

Quickly, Lamont and team realized that, in spite of *Solo* starting almost exactly in the middle of the twenty-year span between *Revenge of the Sith* and *A New Hope*, they would not be splitting the aesthetic difference between the two films. "It's really retro-*Rogue*, not future *Revenge of the Sith*. Instead of looking back at what the *Star Wars* production team was doing in the mid-seventies, we are looking at real-world shape and texture reference from the mid-to-late sixties to early seventies; that general vibe. And the colors of the psychedelic era are a huge thing for this film. We've also referenced classic sixties and seventies sci-fi films like *The Andromeda Strain* and, of course, *2001: A Space Odyssey*—exactly the same as we did on *Rogue One*."

In the winter of 1978, assistant art director Michael Lamont drew elevations of the rebel snow trenches of Hoth (among many other set drawings) for their eventual construction on the tundra of Finse, Norway the following year. Almost four decades later, his nephew Neil Lamont (Peter Lamont, Neil's father, is also a production designer/art director with a storied six-decade career) was tasked with realizing an analogous set in the Imperial battle trenches of Mimban. "Mimban is referencing World War I: Stanley Kubrick's *Paths of Glory*, *All Quiet on the Western Front*, and stuff like that," said Lamont. "Above ground, it was always going to be Somme-like: the battlefields of France and Belgium, pitted with craters and the detritus of battle. But adding in the trenches, you get to that point where it's just too on the nose. It's something that you have to be very cautious of with concept art. Concept art purveys a feeling, not a final look. We always knew we weren't going to be using wattle and wood down there in building the set. We had to inject the *Star Wars* aesthetic."

Han Solo's first encounter with Chewbacca, in a makeshift Imperial cell on Mimban, was filmed in a pre-shoot, without the full cast and crew, on Pinewood's B Stage from February 6 to 10, 2017, and several additional days the following week. As soon as the Corellian spaceport set was struck on 007 Stage starting February 27, the Mimban trench set was raised in its place for main unit photography on April 5, struck overnight to become the airfield from April 6 to 8, and then quickly transformed the subsequent week into the muddy Mimban battlefield, which included a full-scale crashed AT-DT, this film's new Imperial chicken walker, for shooting from April 18 to 21.

◂ **TRENCH WARFARE VERSION 1A** Tenery

"To get our *Star Wars* aesthetic into the trench set, we agreed, 'Let's make our trenches deeper. Instead of only having them six feet high, let's double the height.' And we get multiple uses out of 007 Stage. That was actually second unit director Brad Allan's idea, 'Why don't you put your trench on 007? At least you can build against one wall.' It took an outsider to say that. We've created quite a good trench system for them to do half a page of dialogue in. They will shoot it cleverly enough that the audience will be convinced that it's half a mile long." **Lamont**

HATB ROUGH 002

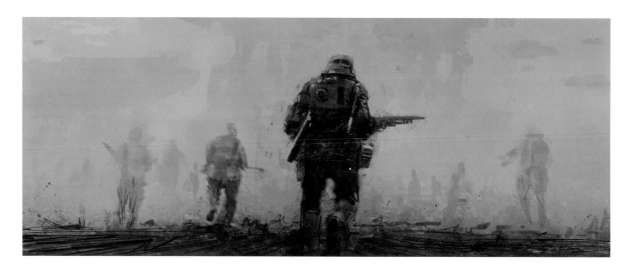

◄ **BADLANDS ROUGH** McQue

"Mimban was something we worked on pretty early in the process, but it kept on being pulled out of the film and then pushed back in. Mimban's sole purpose is to introduce our team: Beckett, Val, and Rio." Clyne

▼ **TANK LINE VERSION 2A** Dudman

"In the UK, I had an opportunity to show our filmscape to [ILM executive creative director and original Star Wars trilogy special effects guru] Dennis Muren, who was there for a week. One of his notes was, 'Do we need to see another AT-ST walker? Is there another way we can approach it?'" Clyne

▲ **TRENCH BATTLE VERSION 01** "There is a bit of a trench warfare feel in the original three movies, especially with Hoth in *Empire*. The idea of a trench in general is a very *Star Wars* design theme. What if we took it even one step further in the *Paths of Glory* direction, playing with mud and the real distress of war? Early on, we were talking about color palette, and I pitched, 'What if it was very desaturated, almost black and white, with the exception of a little bit of red on their armor? How far can we go with it?' Looking at the rushes, you really don't see much color, other than the little bit of red on their arms. It's a wonderful palette, or lack thereof, to play with." Clyne

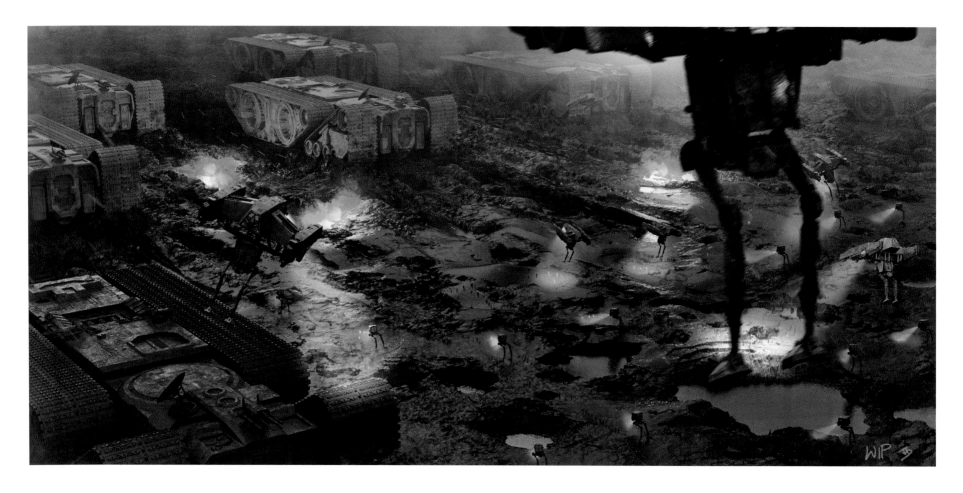

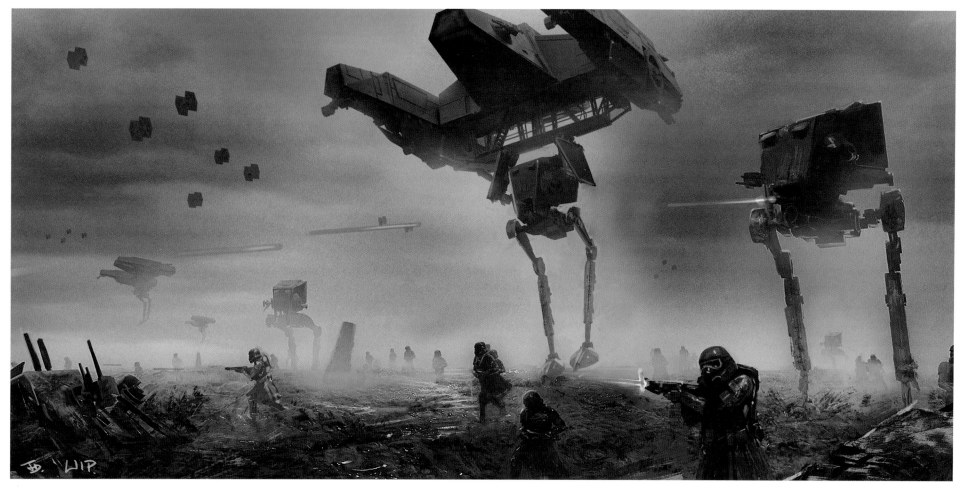

▲ AT-ST DROP VERSION 1B Dudman

▲ TANK DEV VERSION 7A Tenery

▲ TANK DEV VERSION 10 Tenery

▲ TANK DEV VERSION 2A Tenery

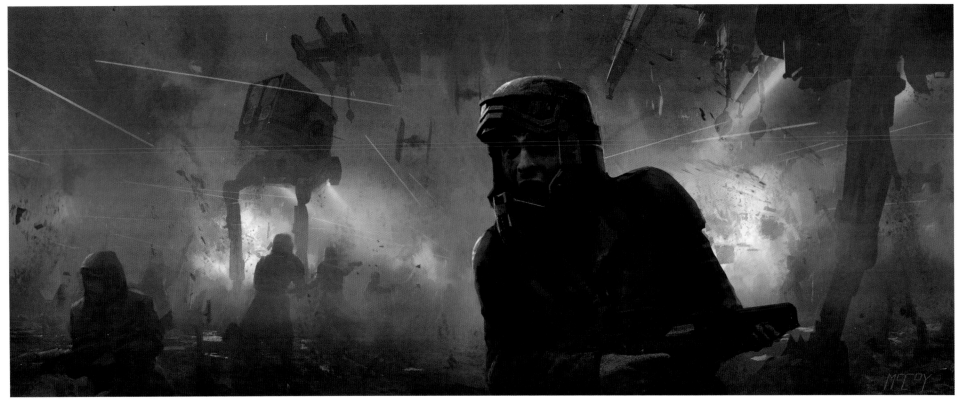

▼ **CHICKEN WALKER MODEL** Alex Hutchings

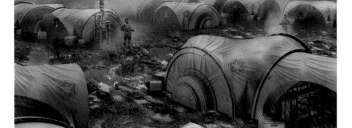

▲ **MIMBAN ENCAMPMENT VERSION 1A** Chris Caldow

"As a prolonged ground-war camp, the Imperial depot at Mimban is more like the Vietnam War than World War I. They've been there for a long time. Mimban is a very dangerous place, potentially the end of the road for Han. That's how they set up Beckett as his mentor: He saves Han's life. Throughout the film, Han returns the favor multiple times." **Lamont**

◄ **CHICKEN WALKER VERSION 1A** "I proposed this sketch on the right, where I referenced a German Flak 38 gun that I found in a book and put it on two legs. It's Brutalist, a little nonsensical. I kept on saying to the art department in the UK, 'Don't be afraid to make it mediocre looking,' [laughs] because out of the mediocre comes something that, to me, feels real. War machines don't always feel like the coolest, badass, designed-by-Ferrari thing. They are just machines—very basic and simple. It's something they really nailed in those original *Star Wars* movies. What is the even more basic version of the basic AT-ST? The head of an AT-ST is very much just a gun platform to begin with, so it really was riffing off of that and boiling it down. I love thinking on that level: Here's something the Empire used but shelved because they came up with something better." **Clyne**

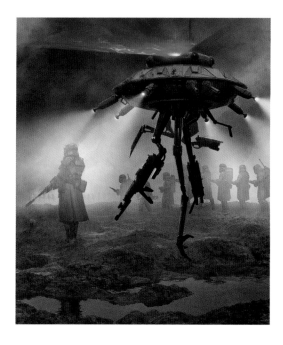

▲ **PROBE DROID VERSION 1B** Dudman

▼ **BATTLEFIELD VERSION 01** Dudman and Clyne

"I had this idea that there would be these big shapes, obscured by fog, slowly rolling in the distance. Maybe they drop these big tanks down and have AT-STs come out of the tanks, really showing the strength, might, and scale of the Empire." Clyne

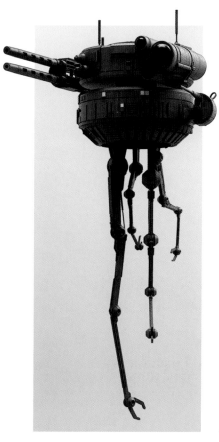

▲ **VIPER DROIDS VERSION 2A** Dudman

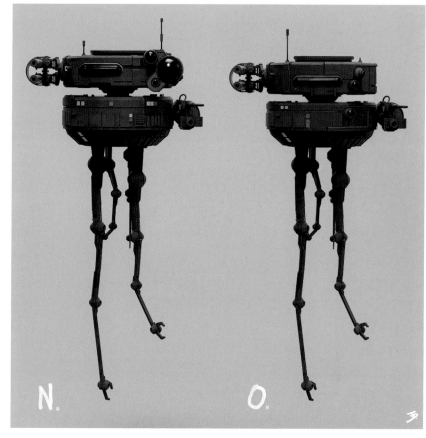

N.

O.

▲ **VIPER DROID OPTIONS VERSION 17** Dudman

▶▶ **BATTLEFIELD VERSION 01** McBride

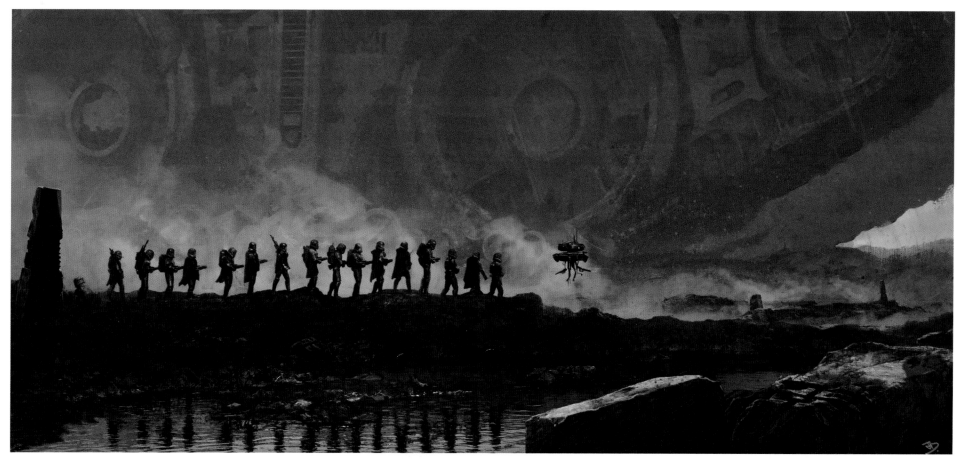

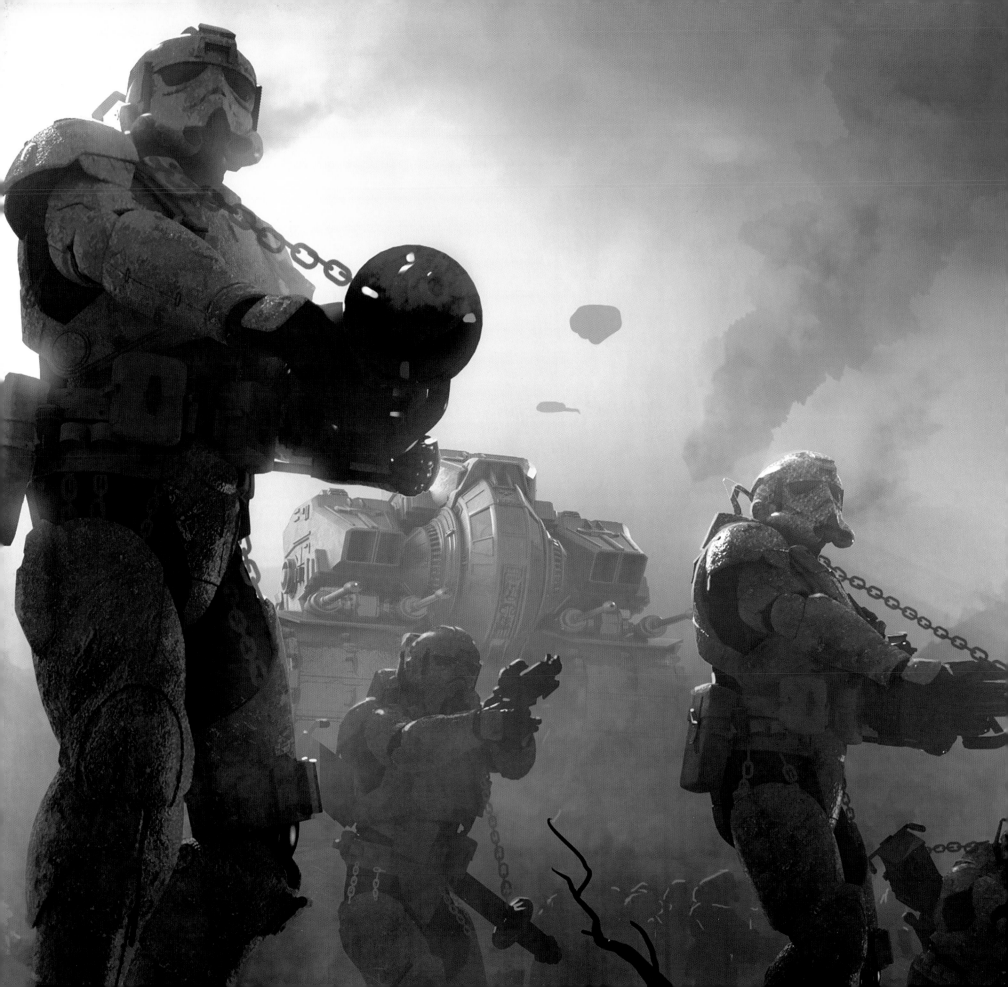

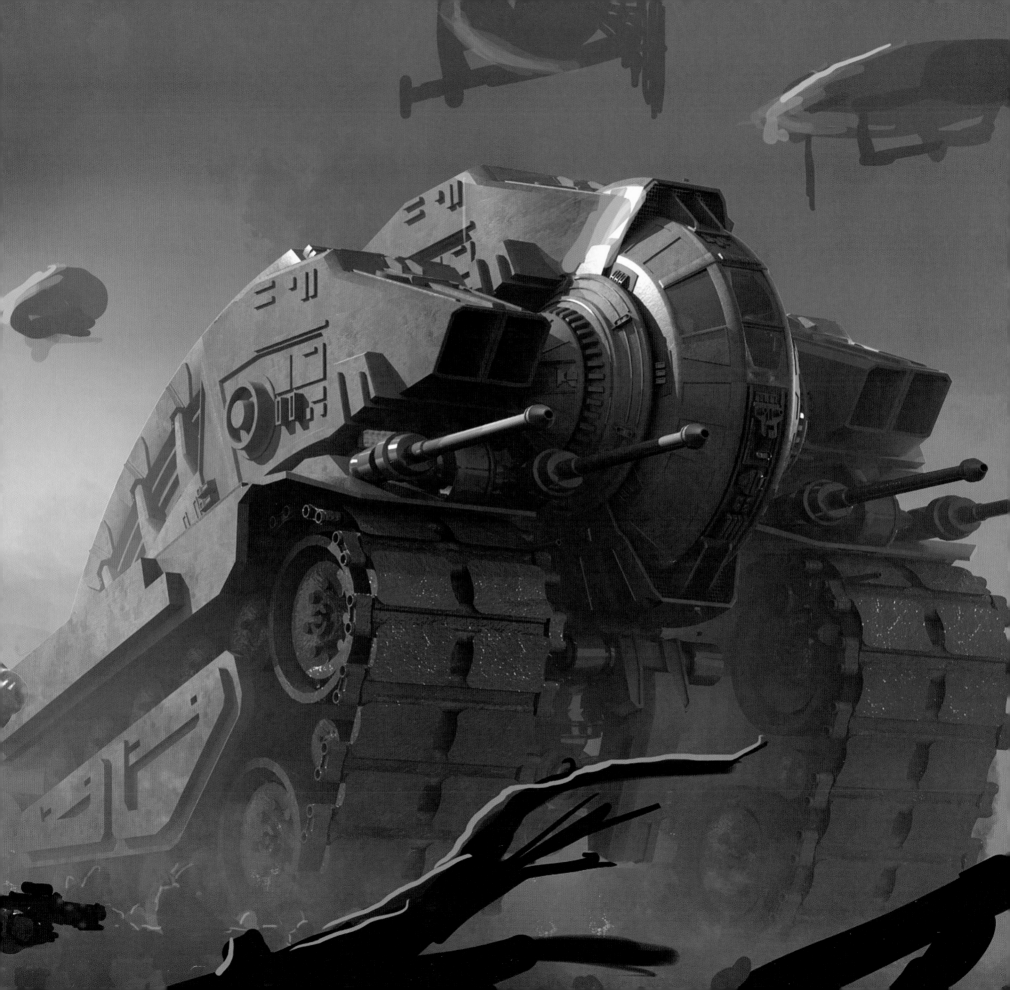

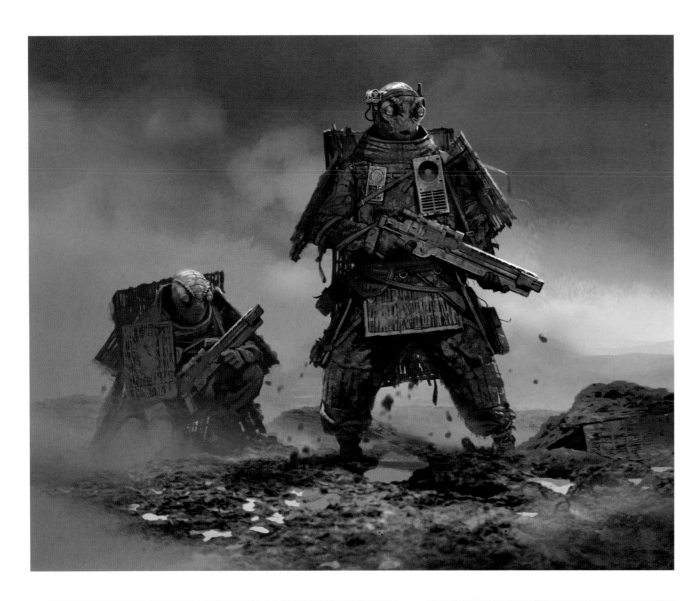

▲ **ALIEN 01** Manzella

"A concept that got a lot of traction in the early days was that the surface of Mimban would be treacle-like and aquatic in nature. Think *Creature from the Black Lagoon*: reptilian, alligators, those sorts of things. Mimban was very monochromatic, only having very small amounts of color. Fiery red for the Mimbanese seemed to fit with the design of the soil. There was a secondary requirement to their design: This is the first time Han ever kills anybody or anything, the first time he steps over the line. We wanted some level of humanity, sympathy, or connection between the audience and this character. This is extermination, ethnic cleansing, isn't it? The Imperial troops, obeying orders, are moving in and getting rid of the indigenous population. There were many different versions of the design, but the one that was chosen fit the bill the most." Scanlan

◄ **MIMBANESE TROOPER VERSION 2A** Brockbank

"Han lands on this planet during the Battle of the Somme. All hell has broken loose. He doesn't even know what he's fighting for or whom he's fighting against, and neither does anybody else. It has overtones of the tunnels in Vietnam and the Viet Cong's ability to pop up out of nowhere in a moment, assassin-style, and take out the troops. The Mimbanese are able to move subsurface, but the one thing that will give them away is their blowhole because they need it to breathe." Scanlan

"Early on, someone had expressed that the Mimbanese warriors might be these mud creatures that come out of the ground. Japanese shapes inspired a silhouette that was a big rectangle on the back. Then we thought, 'Oh, that could be part of their disguise. It helps make them look like the surface of the ground.'" Dillon

"We got these great samples of this lovely woven raffia from a tiki bar supplier, who had nice ends from rolls of bamboo. So we bought some of that. Each suit of armor lasted about five minutes on set before needing to be replaced [*laughs*]. Everything was covered in the gray clay mud of Mimban. We kept at it, adding elements to make them more and more menacing. We wrapped strapping on the faces and flashlights for the sides of the heads." Crossman

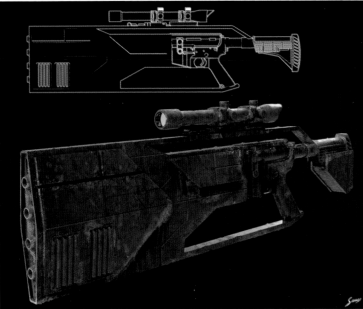

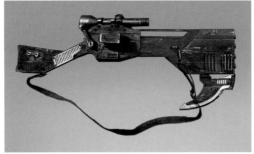

▲ **MIMBAN GUNS VERSION 03** Savage

"The native Mimbanese blaster is what we are calling the 'haddock gun,' a big flat gun. It's inspired by a Madsen light machine gun, a really unusual weapon. The Norwegians and Germans used it until 1942, so it's exactly the right period. But with this big heavy body, it's like the grandfather of all submachine guns. We dress it up, but this fantastic stock makes the gun." Wilkinson

◄ **MIMBANESE GUN VERSION 02** Savage

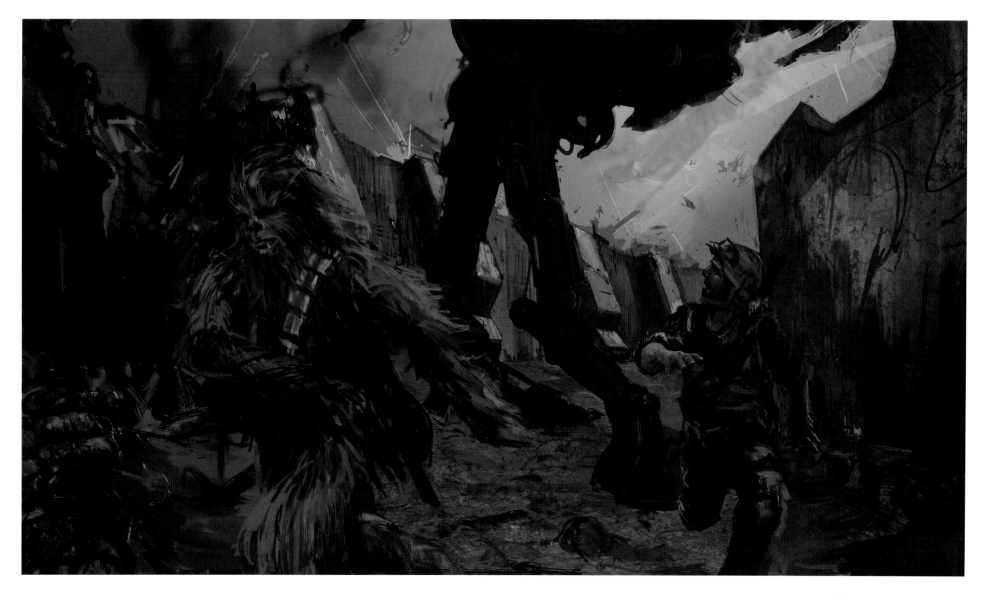

▲ **CHEWIE MEETS HAN VERSION 04** Sole

▶ **CHEWIE SHIELDING HAN VERSION 01** McBride

▽ **MUD BATTLE 04** "I did this Pietà sketch. I always imagined a moment where Han has been knocked out and Chewie picks him up and gets him across enemy lines or something." Clyne

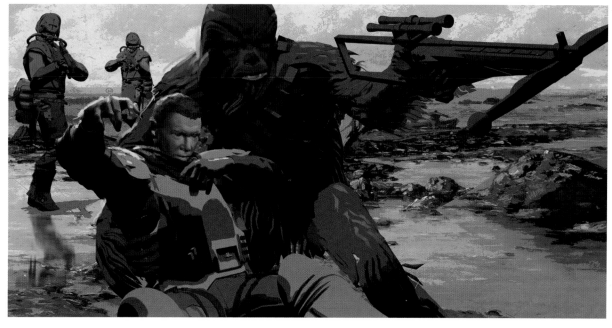

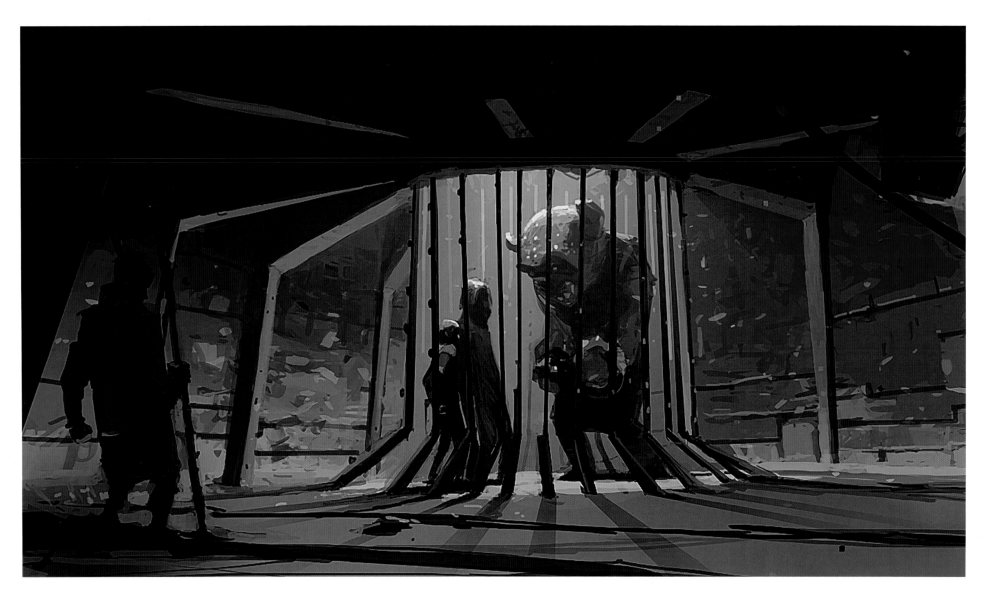

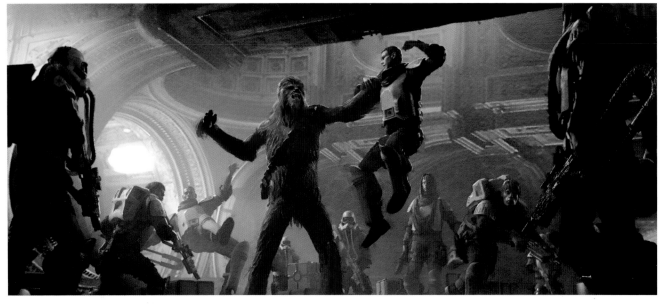

▲ **PRISON CELL VERSION 01** McQue

In a slight variation on Han and Chewie's "meet cute" from Lawrence Kasdan's 2013 "Harry and the Boy" story notes, drafts in late 2015 to early 2016 found the pair bonding on the battlefields of Mimban, fighting for the Empire and then fighting each other. Locked up with an alien cellmate even larger than a Wookiee, the fast friends soon work together to make their escape, chained together at the ankle.

◄ **HAN AND CHEWIE BRAWL VERSION 03** "I tried a Western bar fight between Han and Chewie, brawling in a bombed-out building on Mimban while the rest of their Imperial regiment scrambled to get out of their way. Perhaps their platoon was holed up, like the squad in *Saving Private Ryan*. I loved the idea that Han would be scrappy enough to take on a Wookiee, fighting dirty to match Chewie's size and strength." McBride

▶ "I had ten minutes with Alden Ehrenreich [Han Solo] in some temp costume, taking photos of him in a headlock with Joonas Suotamo [Chewbacca]. I'd have my artists paint on top of it. It was great because then the studio and Kathy could see a one-to-one: what our movie is going to feel and look like, even though it was months before anything was shot." Clyne

▲ **CHEWIE REVEAL VERSION 1A** Dudman

▼ **CHEWIE HEAD FIGHT VERSION 2A** Dudman

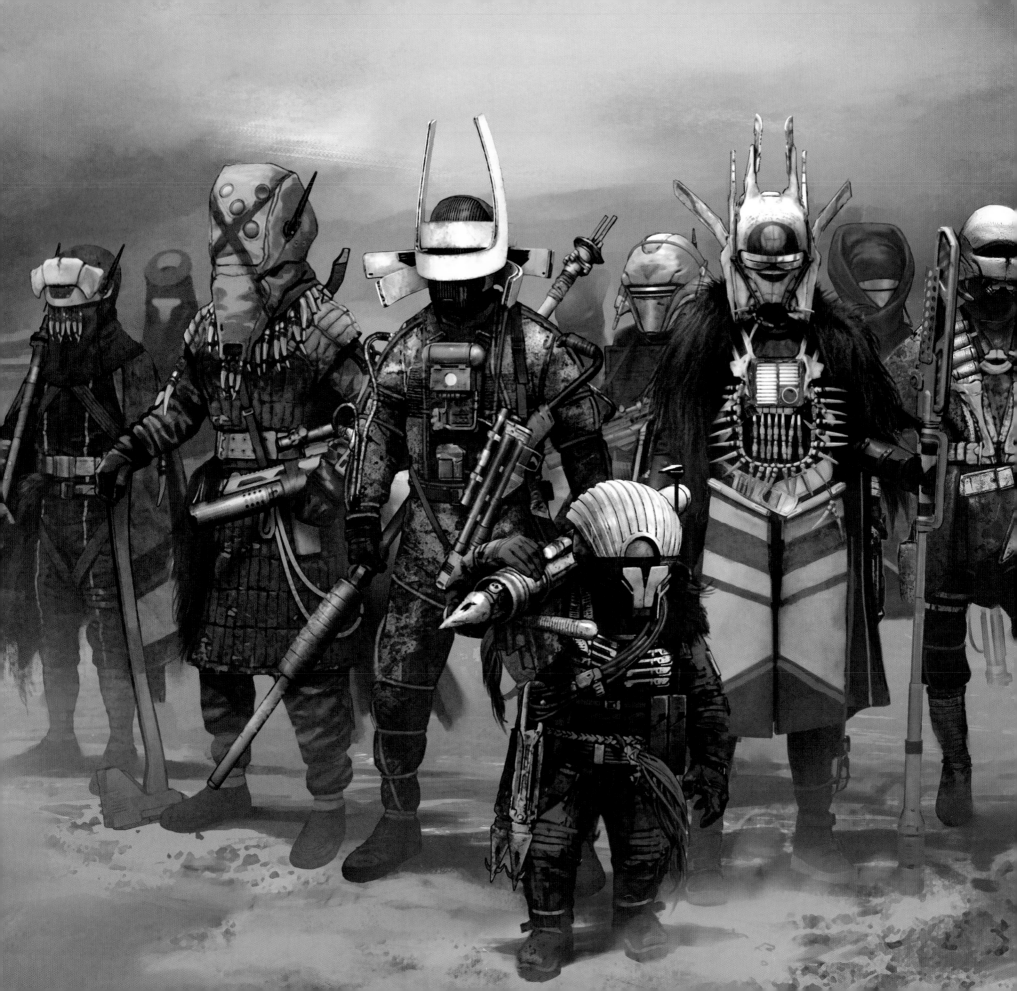

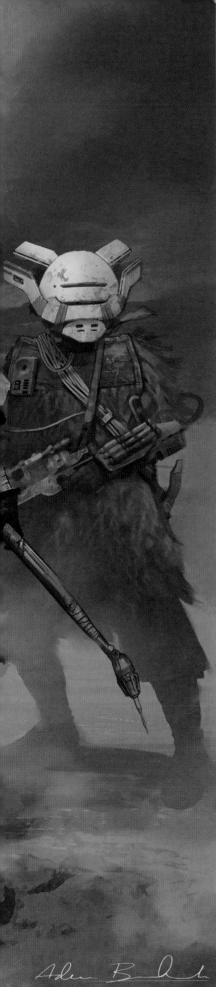

Enfys Nest

Rival gang leader and perpetual thorn in Mattias Beckett's side, the enigmatic Enfys Nest and her marauding Cloud-Riders' role in the narrative was locked in early drafts of *Solo*. But her look was completely left up to the art and costume design teams. "I was thinking about how we can give Enfys her own identity and uniqueness," James Clyne recalled. "In listening to the discussions about punk rock, I wondered, 'How else can we see *Star Wars* differently?' I pitched, 'What if Enfys Nest is the leader of a biker gang? And instead of ships, she flies around in these cool *Easy Rider* hogs?' I didn't know what they looked like, but culturally speaking, it felt right. So I put together some imagery."

"We were also playing off of Native American and café racer culture. British kids created these souped-up, stripped-down sixties and seventies motorcycles to go from café to café in. And obviously America has its own biker culture."

Production designer Neil Lamont said, "We were bouncing off of samurai films like *Ran*, with regard to the red flags on their speeders. We bring in a lot of influences from Kurosawa.

Himalayan prayer flags were another influence. Everything beyond the Empire has this essence of tranquility and the frontier, but also faith. It's very important to hit those notes."

The mix of Native American and North American outlaw motorcycle club aesthetics mesh neatly with the project's overall Western filmic themes, particularly regarding the wild western worlds of Vandor and Savareen. But the long history of subjugation of indigenous peoples, both globally and more specifically in the Americas, and sensitivities around cultural appropriation of Native American symbology and dress were concerns the filmmakers were very conscious of. "We have to be sensitive around aboriginal cultures," Clyne reflected. "But I think there's something to be said about tribal cultures being a big part of the *Star Wars* universe. There's the main population of starship-faring beings, some tribal like the Wookiees and some not. And then there are other cultures that are a little more primitive, like the Sand People, Ewoks, or Gungans."

The creation of a mask for Enfys Nest that could sit side by side with iconic *Star Wars* helmet designs like Darth Vader, the stormtrooper, and Boba Fett proved to be an immense challenge for Glyn Dillon and David Crossman in the costume department. "The Enfys Nest helmet design process went on for at least a year," Dillon remembered. "The weird thing is that the finished design isn't that far from some of the earliest designs. It's one of those things where you go 'all 'round the houses' and come right back to where you started. We experimented with all sorts of things, but we eventually came back to that alien bone-mask idea."

As with the yearlong search for Kylo Ren's mask design during production of *The Force Awakens*, which unintentionally generated by-product designs for Captain Phasma, the Guavian Death Gang helmet, the First Order fleet engineer helmet, and the Knights of Ren, cast-off drawings for Enfys Nest's helmet likewise did not go to waste. "All of the design work that we did on her fed into her gang," said Dillon. "Whatever was rejected for her could work for her Cloud-Riders."

◄ **ENFYS GANG GROUP VERSION 5A** Brockbank

"For Warwick's suit, we discussed the aesthetic of Adam Ant. So we added a hussars' cavalry jacket, with piece of tech bone to the front so he's got that vaguely Romantic detailing, with drops of fur hanging from various places, and with a mini-fur collar. The whole film is all about rock stars, the bands we grew up loving." **Crossman**

"The piece on the front of Warwick [Davis]'s Weazel helmet is based on an object I found at Pinewood Studios. The props department has shelves and shelves of all of these amazing metallic bits and pieces in the vehicles section. We are allowed to go in there and pick and choose any little bits that might be useful for costume. This piece was some sort of handle for an aircraft door, red and green in that 'Y' shape. When Adam Brockbank was brought on board, I asked, 'Can you put this on some helmet?' First, it was on the Pyke Syndicate guards. Then we did some versions of Enfys Nest with it on her helmet. In the end, it ended up on one of the Enfys helmets that didn't get chosen, and we thought, 'That could maybe be Warwick's.'" **Dillon**

alien skull used as mask

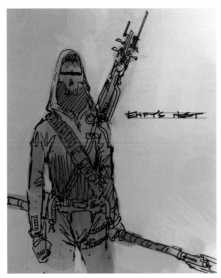

EHFY's NEST

▲ **ENFYS SKETCH VERSION 01** Tkocz

▲ **ENFYS SKETCH VERSION 01** Clyne

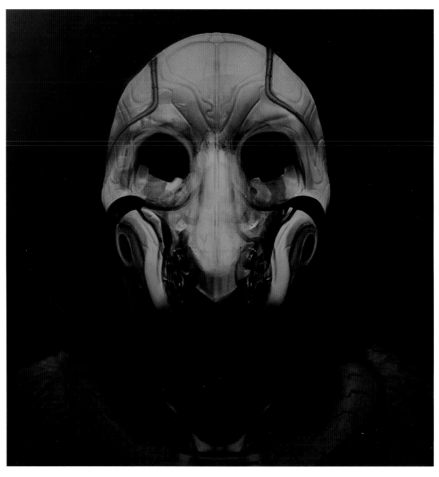

▲ **NEST VERSION 01** Manzella

▼ **ENFYS VERSION 11** Clyne

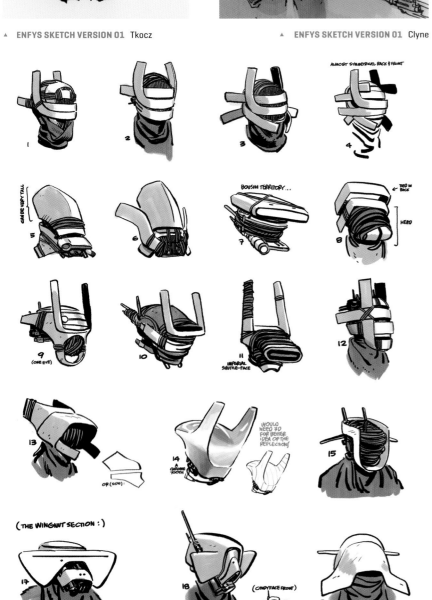

ALMOST SYMMETRICAL BACK & FRONT

BOUSH TERRITORY...

TIED IN BACK

HEAD

WOULD NEED 3D FOR BETTER IDEA OF THE REFLECTION

A CHROME TOOTH

OR (SO?):

(ONE EYE)

IMPERIAL SHUTTLE-FACE

(THE WINGNUT SECTION :)

(CINDYFACE FRONT)

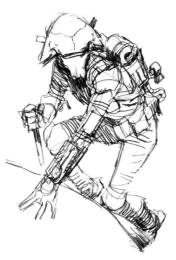

▲ **ENFYS SKETCH VERSION 02** Dillon

◄ **HELMETS VERSION 1A** Zonjić

"Tonči did a nice batch of helmet shapes in a beautiful black and white. There's so much value in even one page of Tonči's ideas: You can start pulling the individual designs out. We made a few of those as prototypes, and a couple were used on set as gang helmets." Crossman

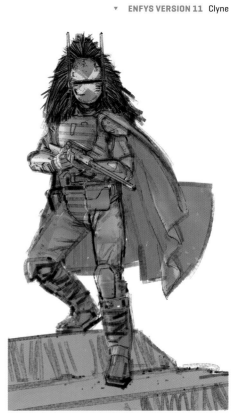

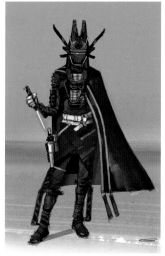

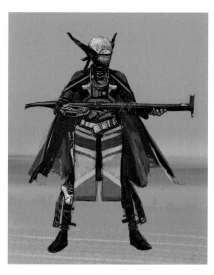

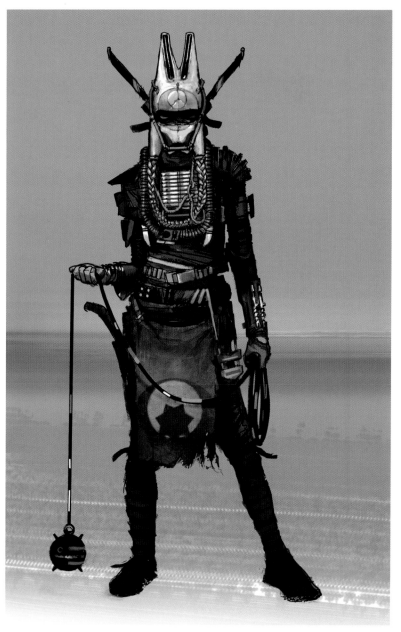

▲ **ENFYS VERSION 3C** Dillon

"Early on, I found reference of a Japanese dolphin skull, painted black and lacquered. They had done all of this amazing gold calligraphy on it," Dillon recalled. "It was beautiful. That was a very early inspiration for the helmet. That idea came around again, and we ended up inscribing a poem on the skull." The poem on the final Enfys Nest helmet design, penned in stylized Aurebesh (the most common written language in *Star Wars*, first introduced in *Return of the Jedi*), translates to, "Until we reach the last edge, the last opening, the last star, and can go no higher."

▶ **ENFYS FLAIL BALL VERSION 01**

"The mask didn't have to look too much like a human skull, more like an alien skull. It went in all kinds of different directions, tribal things. We wanted to get that balance of tech and organic material right." Dillon

▼ **NEST BALL VERSION 2A** Dillon

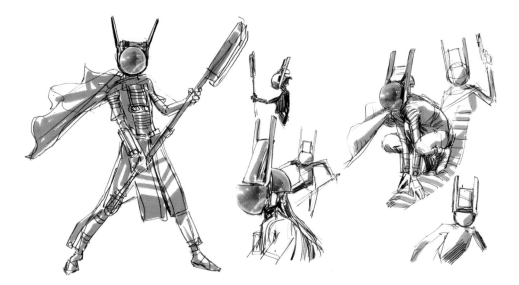

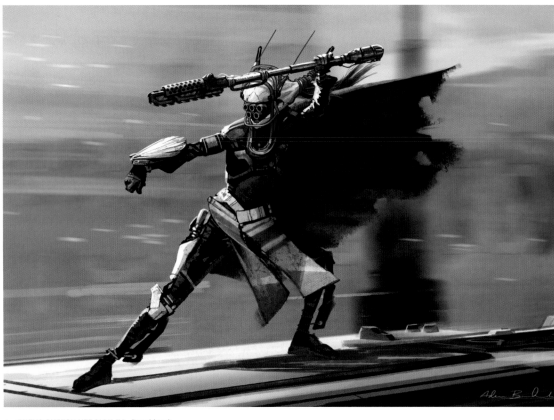

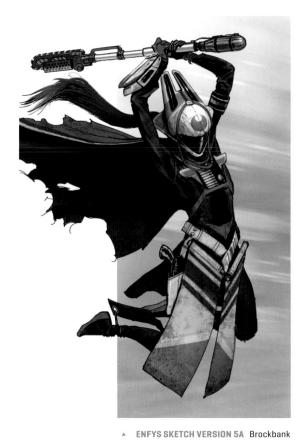

▲ **ENFYS SKETCH VERSION 4A** Brockbank

▲ **ENFYS SKETCH VERSION 5A** Brockbank

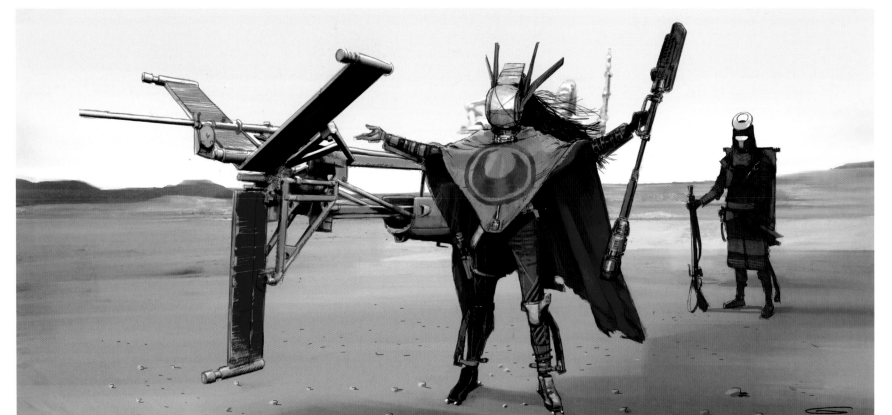

▲ **ENFYS BIKE VERSION 4A** Dillon

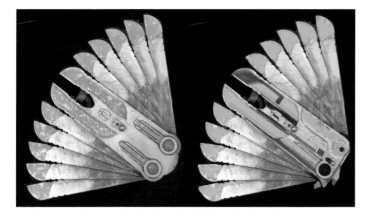

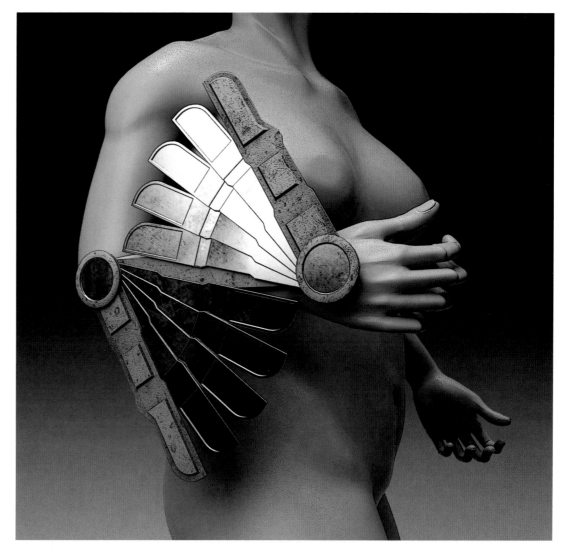

▲ **ENFYS VAMBRACE VERSION 1A** Dillon

▶ **GAUNTLET VERSION 02** Savage

"Brad Allan loved the idea of Enfys having a shield, but I wanted to steer away from the things you see in other movies, especially with *Wonder Woman* coming out this year. The way Enfys fights has a dramatic, martial arts feel about it. In a martial arts movie I saw years ago, there was this amazing scene where a female character fights with two fans; I thought it had a really nice elegance. So that was the idea, something that was really subtle. We crafted the shield blades and Glyn Dillon incorporated the design into her helmet, so it carries through. They ended up with some nice beads and lashing in the design. Her gang is on the road and has to adapt to what's available." **Wilkinson**

▼ **CHAINSAW PIKE VERSION 08** Savage

"The initial idea was that it was a cutting sword. It eventually became an electric-bladed chainsaw. On the hero prop, the chain actually runs around. It's lightsaber-ish without treading that ground. Potentially, it has an equivalent power to a lightsaber, like the taser blade that the stormtrooper fights Finn with in *The Force Awakens*, but you would never say that this was a Jedi weapon, by any stretch of the imagination. The difference is that the taser blade, the Praetorian Guard weapons from *The Last Jedi*, and the fusion cutter or Enfys's staff all have a man-made energy source versus lightsaber energy, which is powered by naturally occurring crystals." **Wilkinson**

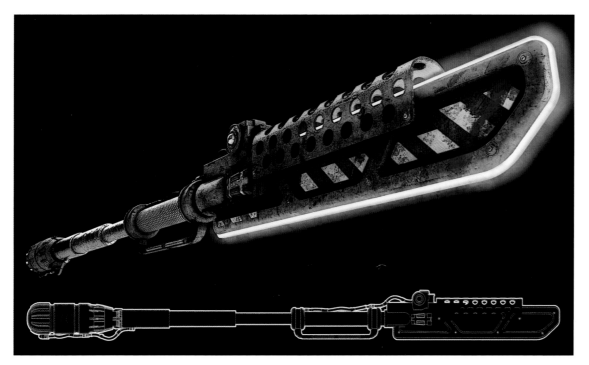

▼ **CHAINSAW PIKE CHARGE VERSION 09** Savage

"At one point, the club end of the staff was going to pop out. But now we have a light source coming out, a surge of energy that she can stun opponents or propel herself with." **Wilkinson**

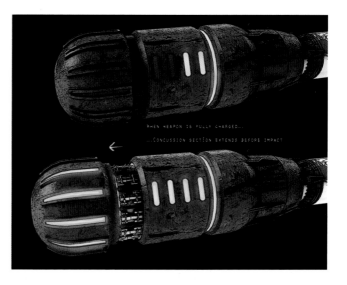

WHEN WEAPON IS FULLY CHARGED...

...CONCUSSION SECTION EXTENDS BEFORE IMPACT

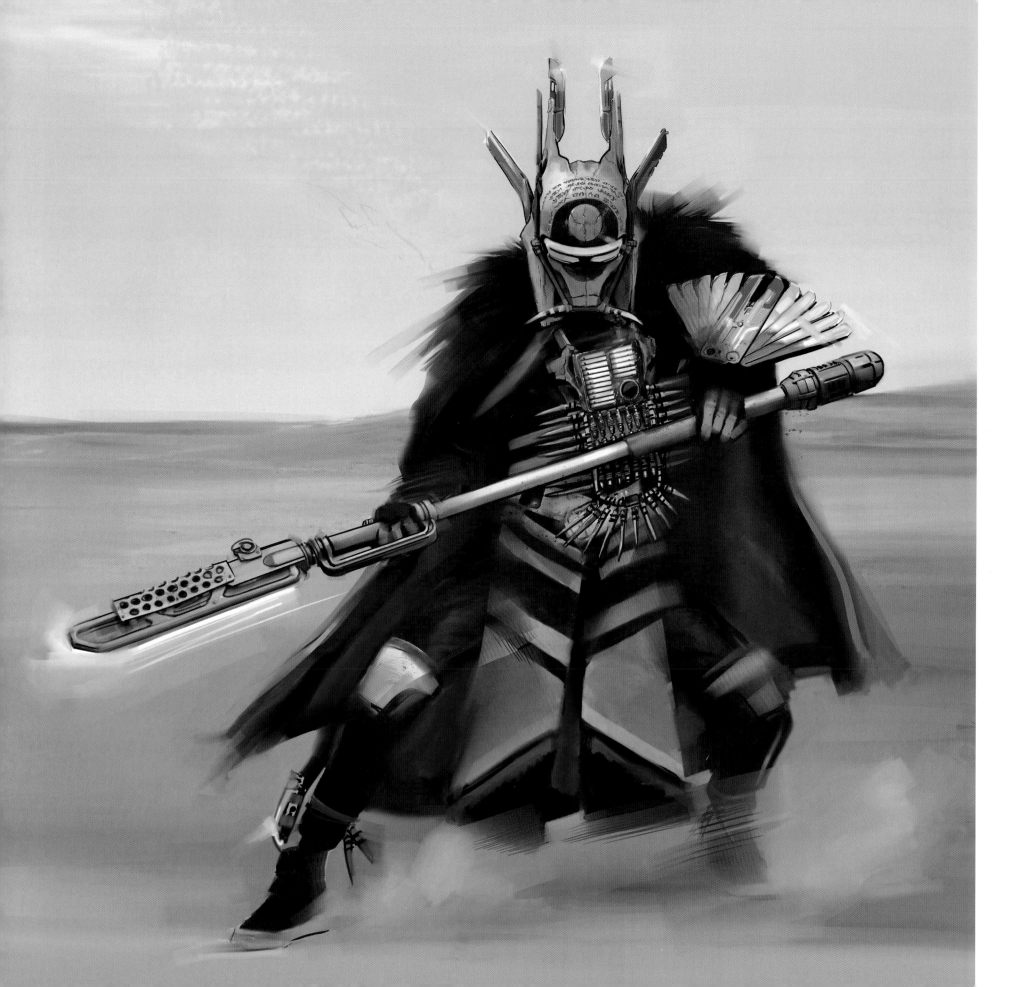

▲ **PIRATE 04** Lunt Davies

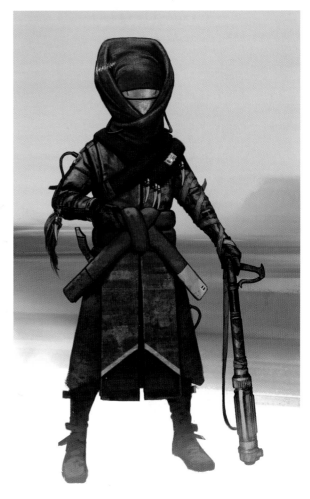

▲ **SIDEKICK 14** Manzella

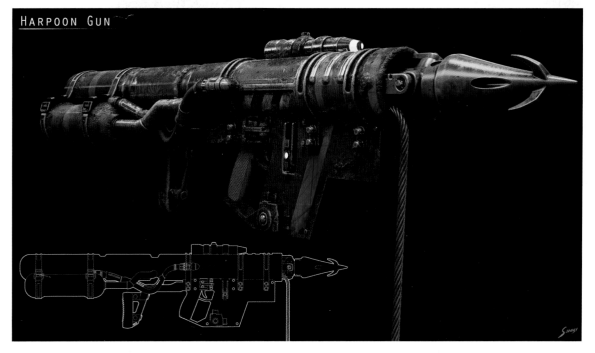

HARPOON GUN

▲ **NEST GANG 21** Brockbank

◄ **ENFYS VERSION 02** Dillon

"Glyn found the chromed glasses from *Cool Hand Luke,* which is the inspiration for Enfys's eyepiece. The mixture of the bone and chrome is nice. The helmet is not completely organic." Crossman

▶ **HARPOON GUN VERSION 02** Savage

"Enfys has a harpoon gun that mounts on the side of the skiff. I think Warwick Davis is going to use that. It's a huge gun that goes on his shoulder, like a missile launcher or a bazooka." Wilkinson

▲ PIRATE 11 Lunt Davies

▲ SIDEKICK 26 Manzella

▲ PIRATE 03 Lunt Davies

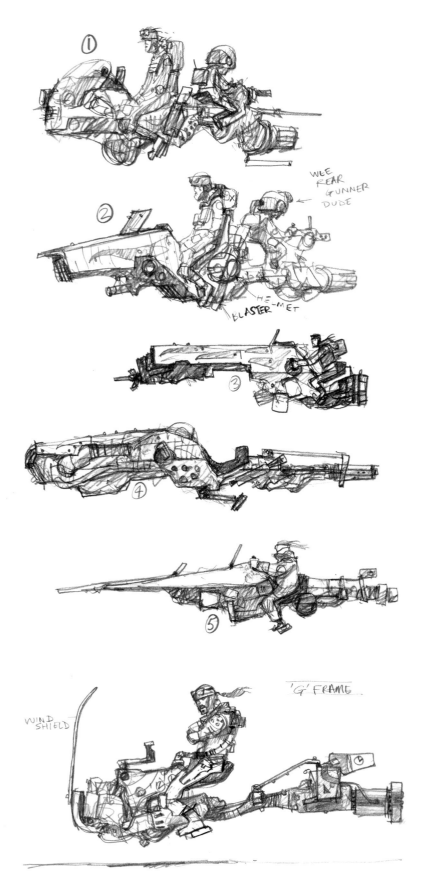

▲ NEST BUMPER CARS VERSION 03 McQue

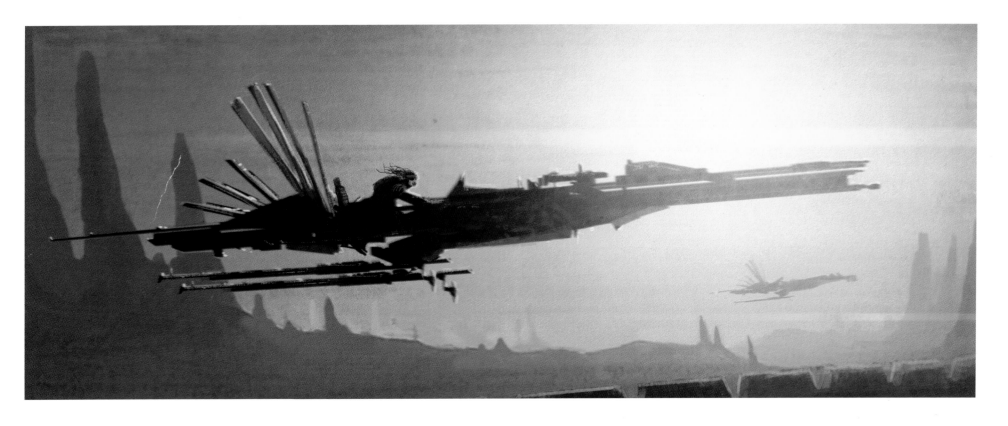

▲ **ENFYS SPEEDER VERSION 1A** Jenkins

"Initially, we wanted to feel a tribal nature to the Nest gang. Tribal colors, tribal inferences with regard to feathers or flags or decals, natural materials, etc." **Lamont**

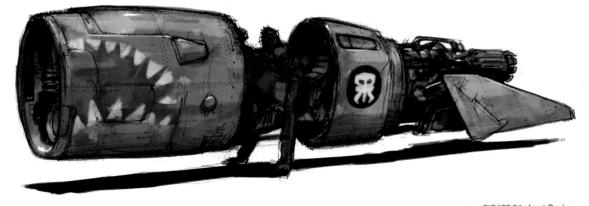

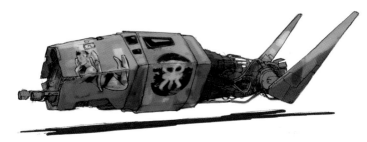

▲ **PIRATE 05** Lunt Davies

▲ **PIRATE 6A** Lunt Davies

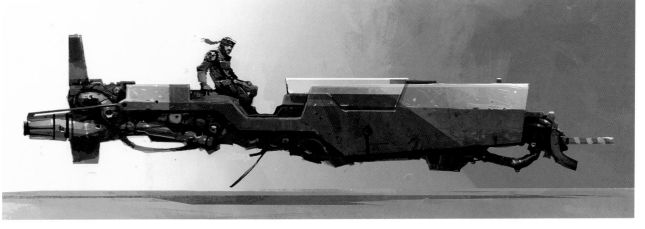

▲ **SPEEDER VERSION 04** McBride

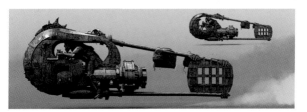

▲ **NEST BUMPER CARS VERSION 20** McQue

▲ **SPEEDER VERSION 05** McBride

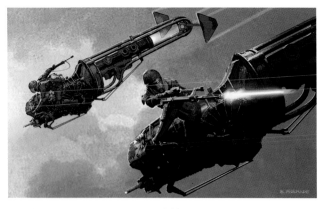

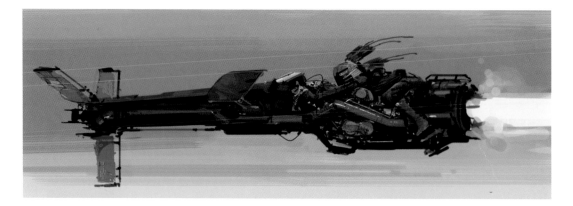

▲ **NEST BUMPER CAR VERSION 01** McBride

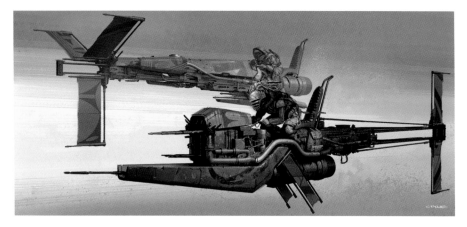

▲ **ENFYS SPEEDER VERSION 01** Clyne

"There's a little bit of samurai, a little bit of Kurosawa in the flags. I am constantly trying to go back to the well that George would be pulling from. The speeders can be any configuration as long as they share those red flags. That way, you know they are unified." Clyne

◄ **ENFYS SPEEDER VERSION 01** "We were laughing about how far we can push the ape-hanger handlebars. Bikes like that had what we called 'banana seats' as kids. I put a banana seat in there, and they laughed at it. But Enfys Nest's bike still has a big banana seat on it. I wanted to add almost a homemade quality to the Nest speeders, which became a big part of their aesthetic. The idea is that they all share one big garage. That the speeders all look unique in spite of shared parts makes the producers happy. The challenge is to try to keep your toolbox as small as possible and see how creative you can get." Clyne

▼ **ENFYS SKIFF 03** Ellis

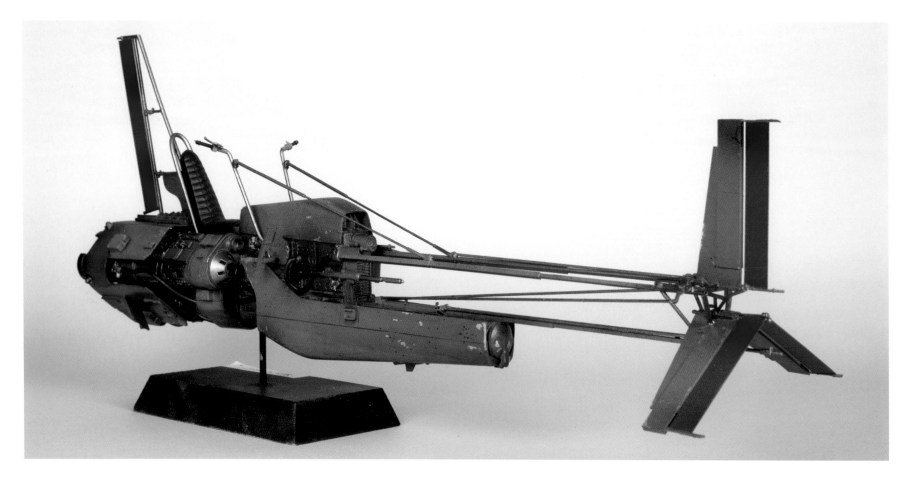

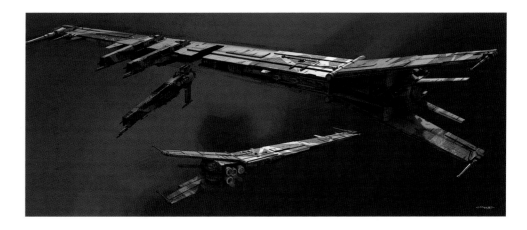

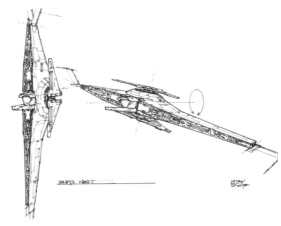

▲ **BUCKSHOT EXTERIOR 04** "This one got a lot of traction. It's got an unexpected way of flying. We needed some background ships on Fort Ypso for the LED display outside of Dryden's yacht window, so I threw the *Buckshot* in with twenty others. You might see it flying off on the LED, a bit of an Easter egg within an Easter egg [*laughs*]." **Clyne**

▶ **BUCKSHOT EXTERIOR 03** "I proposed this idea that Enfys Nest had her mothership [called the *Buckshot*], and out of the mothership would come these motorcycle speeder ships. That got some traction for a while. I was directly taking a B-wing and kit-bashing it, but also playing with a lot of shapes. Those little pods would open up and fire out these speeders. For the train sequence, this thing would show up. 'Oh boy, we know who that is.' But now they show up on the speeders. We don't quite know how they get from planet to planet [*laughs*]." **Clyne**

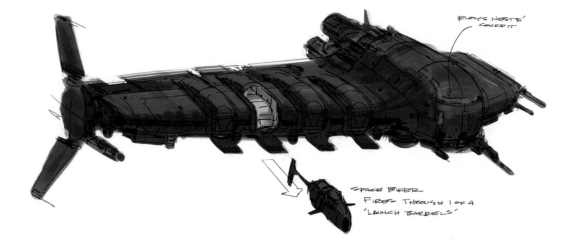

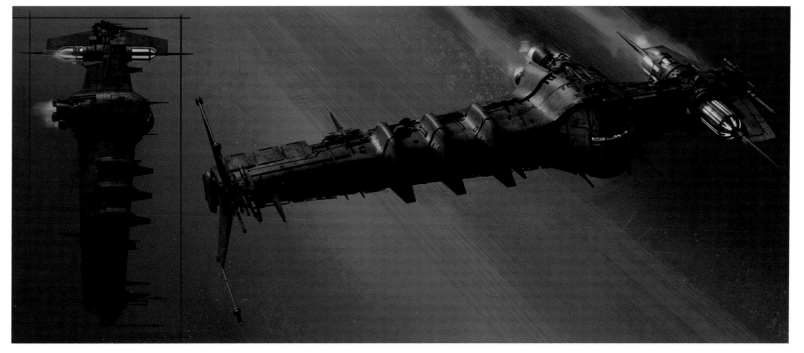

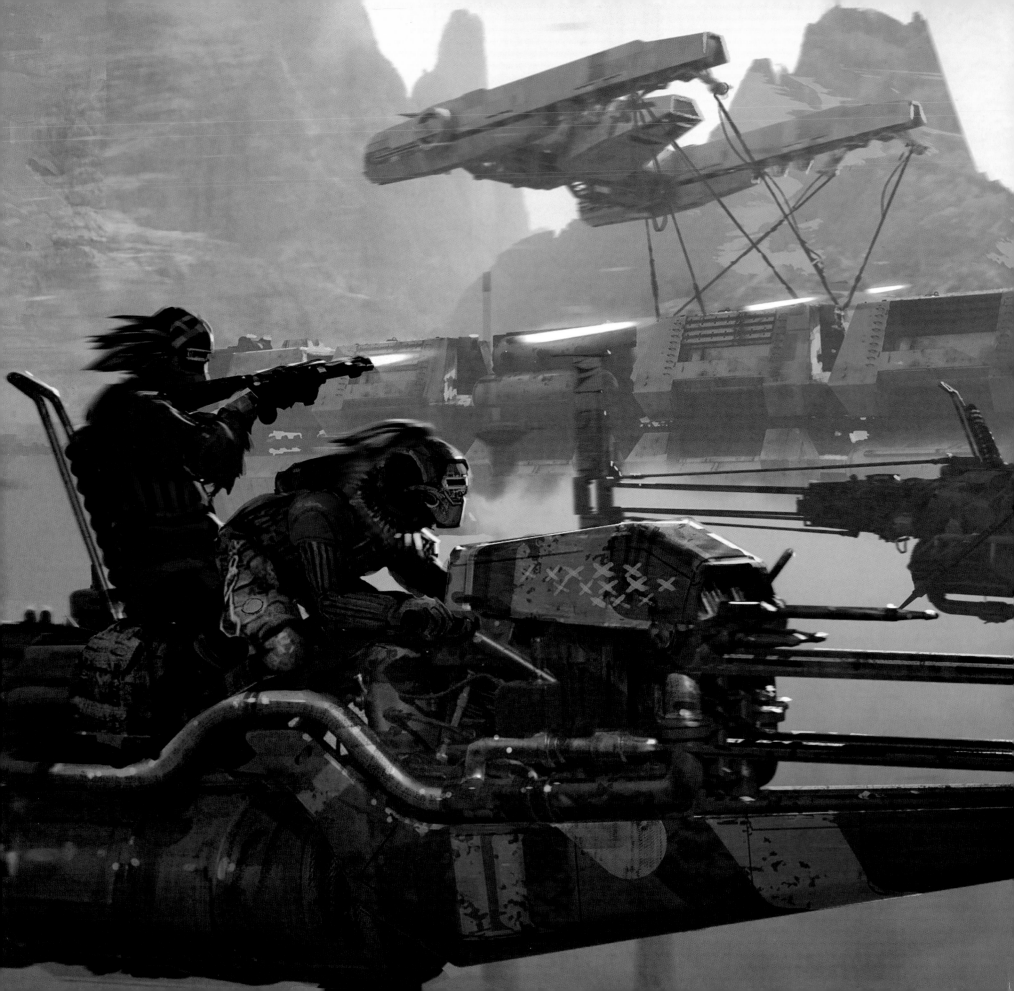

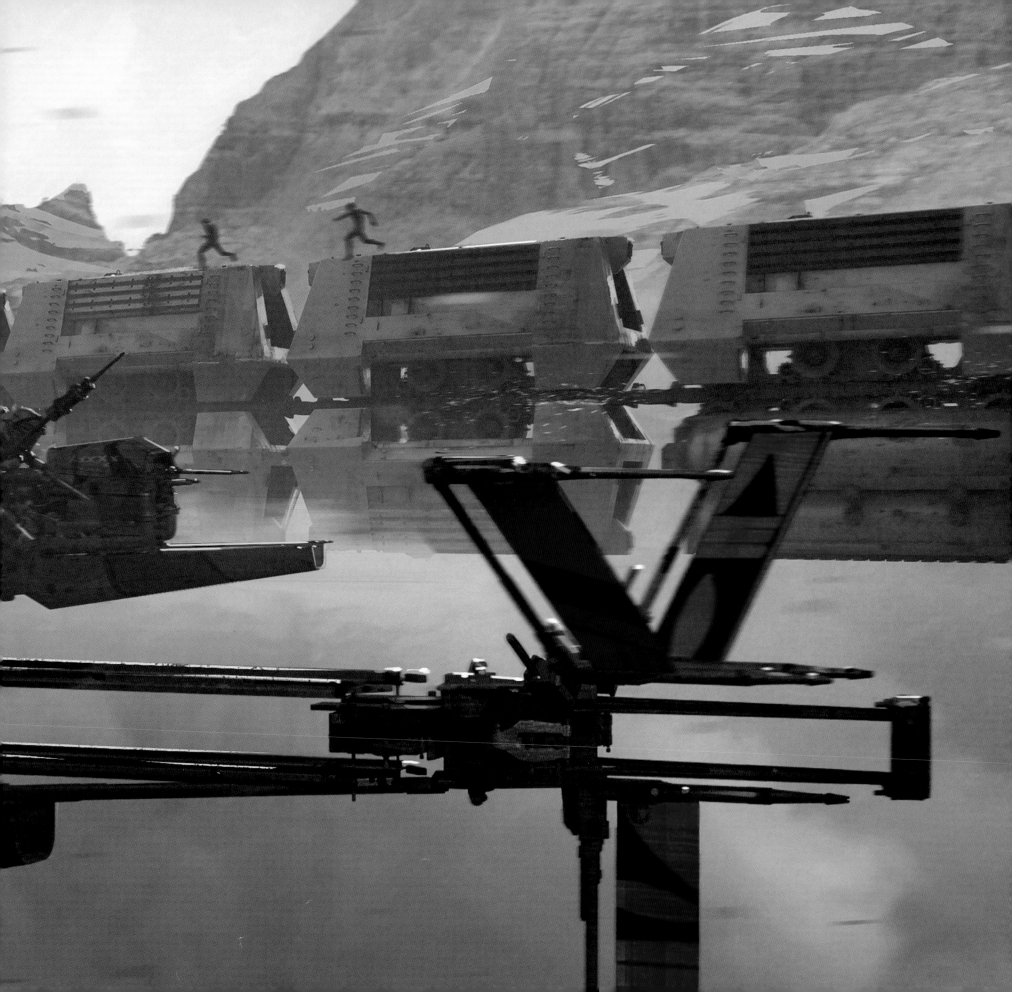

Dryden Vos and the Crimson Dawn

Moviegoers were first introduced to the morally gray side of the otherwise clearly delineated *Star Wars* universe of good and evil—Rebellion and Empire, Jedi and Sith—with the "wretched hive of scum and villainy" that is Mos Eisley spaceport, more specifically the freighter pilot, bounty hunter, and extraterrestrial-stuffed cantina where farm boy Luke Skywalker and Old Ben Kenobi first encounter a smuggler named Han Solo and his first mate, the Wookiee Chewbacca. After an initially dizzying and, following the gruesome murder of Luke's adoptive aunt and uncle, ultimately sobering forty-five minutes of *A New Hope*, George Lucas's vignettes of cavorting alien barflies (and barmantises) accompanied by John Williams's "space jazz" provided a blast of fresh air, becoming an instant and unforgettable highlight of the film. The scene was also easily and delightfully recognizable to anyone who has ever set foot in a dive bar. Crime lord Jabba the Hutt, Solo's occasional boss and impatient benefactor, first mentioned in that nutty *Star Wars* bar, would not be seen until 1983's *Return of the Jedi* (though he was later digitally added to a deleted scene with 1997's *Star Wars: A New Hope Special Edition*).

But *Star Wars* has never seen a crime lord quite like the *Crimson Dawn*'s Dryden Vos [Paul Bettany]. In comparison to the gloomy dungeons of Jabba the Hutt's repurposed stucco palace on the edge of Tatooine's Dune Sea, Dryden Vos's luminous starship yacht, which serves as his mobile headquarters, is positively dripping with luxury. But Vos and the *Crimson Dawn* were not always so itinerant and well-appointed.

"Taanab being the central location for the second half of the movie was a huge element of our original script," Jon Kasdan recalled. "Larry and I felt it made sense for Dryden and Enfys to share a planet so that they're conflict seemed rooted in something tangible, a battle over finite resources." Taanab was first mentioned in *Return of the Jedi* as the site of a battle in which General Lando Calrissian bragged about pulling "a little maneuver." Clyne continued, "So Taanab started as a planet but, about six months in, it became Dryden's ship, based on a conversation we had. I mentioned this Russian vodka tycoon who had pulled up to the Santa Monica pier in this gleaming-white, pristine yacht. At the time, it was one of the world's largest yachts. The boat that came out of the back of the yacht was the biggest boat I had ever seen. So I said, 'What if Dryden flew around in the big, elaborate, ostentatious, over-the-top yacht?' It allowed him to be mobile. He could show up at Fort Ypso and, at the end, Savareen."

Although reminiscent of the war profiteers found in Canto Bight's seaside city, as seen in Rian Johnson's *Star Wars: The Last Jedi*, the lavishness of Dryden's yacht is fundamentally quite different. "The yacht people were meant to be more fun-in-the-sun, afternoon party—way less formal that the Canto Bight casino," David Crossman said. "It has that mixture of slightly menacing gangsters with decadence." The yacht interiors are also somewhat analogous to *The Empire Strikes Back*'s Cloud City. "Seeing the full set made me think that Lando might have been influenced by the wealth and clout of Dryden Vos to implement that into Bespin architecture," Clyne mused.

The yacht interior set and their Easter egg–filled curio displays also provided a golden opportunity for returning set decorator Lee Sandales and his team, including concept artists Savage and Chris Caldow, to shine. "The private study is where Dryden houses his collection of 'trophies' from around the galaxy and some objects are referenced directly from the extended Star Wars universe, procured and plundered from defeated enemies," Sandales said.

The yacht's main deck was shot on S Stage at Pinewood Studios from August 5 to 8, 2017. The set was then converted to Dryden's private study, to cover its presence on both Vandor and Savareen, for shooting on August 30 through September 2 and September 11 to 14.

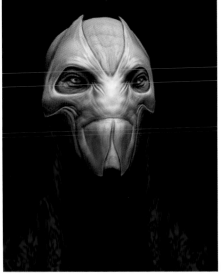

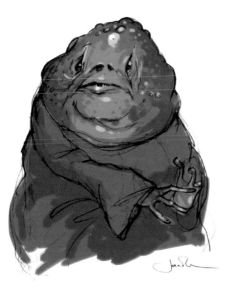

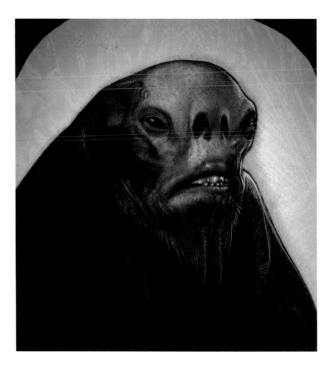

▲ DRYDEN VERSION 2A Manzella

▲ DRYDEN VOS 10 Lunt Davies

▲ CRIME BOSS 10 Manzella

"Dryden and his world were very loose in our minds: 'Let's just keep playing with this and see what we come up with,' with no real central focus. The other aspects of the scene needed to gel before one really knew what Dryden might be." Scanlan

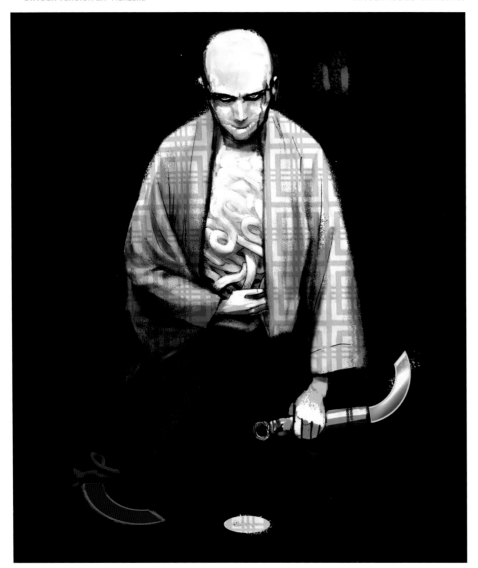

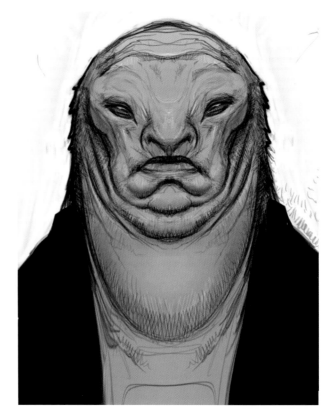

▲ CRIME BOSS 19 Manzella

▲ CRIME BOSS 05 Manzella

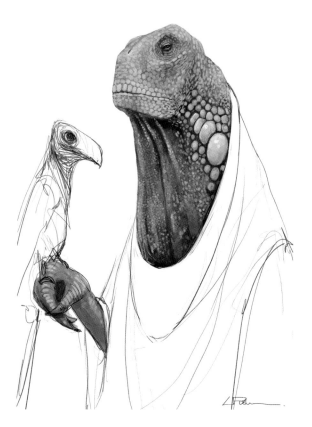

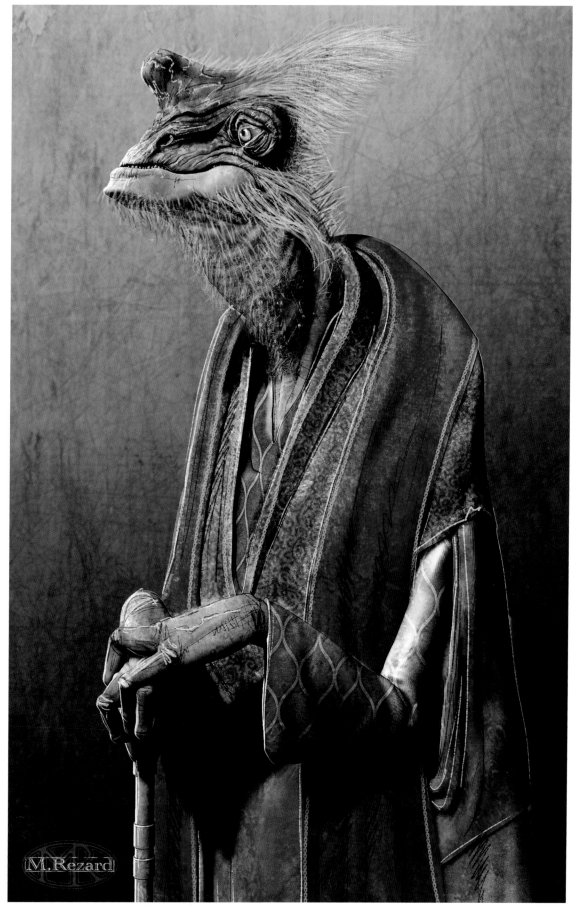

▲ **DRYDEN VOS 04** Lunt Davies

"Dryden Vos was both a dinosaur and a bird, at one time. But the 'love triangle' in Han's mind, that Qi'ra might have feelings for Dryden or that they may have had a relationship, started to inform the design. The idea of her going to bed with a reptilian bird [*laughs*] started to cross the line. Dryden became majestic, handsome, and more in line with someone that Han would feel some jealousy, envy, or threat toward." Scanlan

▶ **VOS VERSION 1A** Rezard

▼ **GDFT VERSION 1A** Manzella

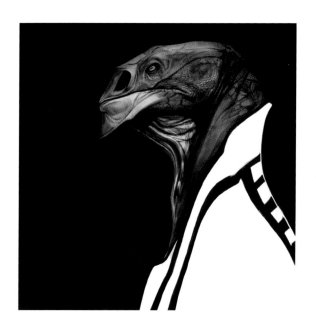

▲ **DRYDEN VOS 25** Lunt Davies

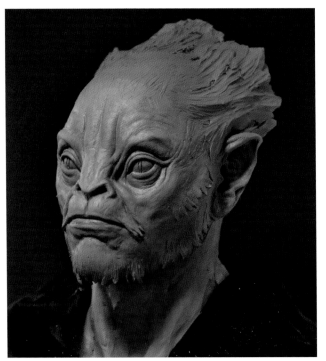

▲ **DRYDEN 03** Louis Wiltshire

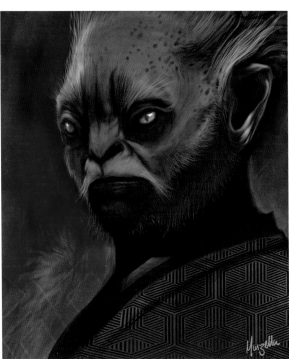

▲ **DRYDEN VOS 67** Lunt Davies

In January 2017, Scanlan's creature team and the filmmakers briefly dabbled with the idea that Dryden Vos might be a Lasat, an alien species first introduced via the character of Garazeb "Zeb" Orrelios on *Star Wars Rebels*. (Zeb's design was inspired by 1975 Ralph McQuarrie preproduction sketches for Chewbacca.)

◄ **DRYDEN VOS COLOR VERSION 1A** Manzella

"It was *Beauty and the Beast*, an area that's been done to death. It's a really tough one. You inevitably end up with something wolflike or bearlike. Opposites often attract, but there are limits. Ivan Manzella came up with quite a simple design sketch, quite graphic-based, that struck a chord. 'There's something in this. This guy has got the look. He's sending the right messages.' We decided the best thing to do was to get into 3-D and start sculpting." Scanlan

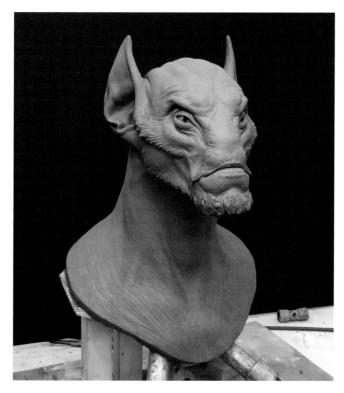

▲ **DRYDEN 17** Wiltshire

▲ **DRYDEN 04-06** Zonjić

"You'll notice that Tonči's Dryden Vos designs were drawn on a neutral gray figure because we were biding our time, waiting to see what Dryden was going to be: a human or a cat or something else. So that was the basis to apply to whatever physical form Dryden took." **Crossman**

▶ **DRYDEN VERSION 07** "With Dryden we wanted to do something dramatic but also with a formality. This was a powerful man who courted politicians as well as the darker underbelly of society. His shirt collar become known as the 'stealth collar' due to its resemblance to the angular B-2 bomber." **Dillon**

"Dryden is a rare example of putting a couture costumed character into Star Wars. As leader of a criminal gang, the character lead us toward affluent and powerful dress. There is a simple but bespoke elegance to his suit, which has a grown-on cape so that it appears as one garment. The fabrics are luxurious—Saville Row wools and silks for his shirts. Paul Bettany was ideal to convey this bespoke-tailored menace to perfection, so we were lucky." **Crossman**

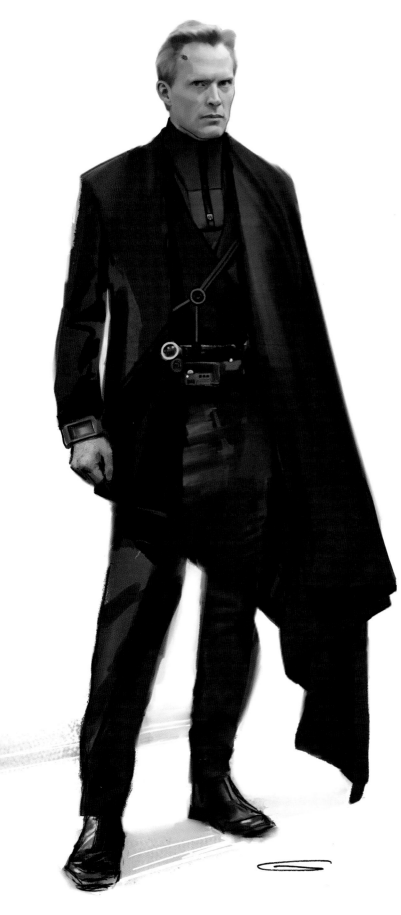

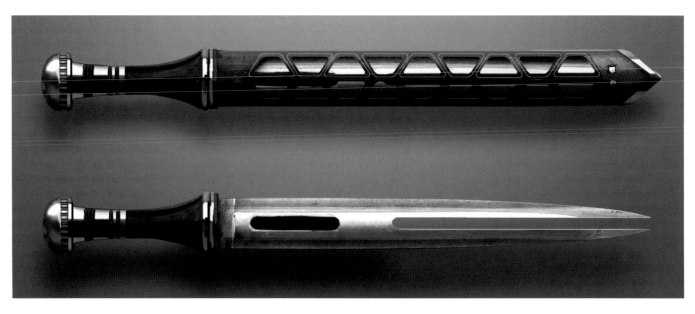

▲ **DRYDEN'S WEAPON 09** Savage

"Early on, we did some research and made a reference board full of ideas. And there are very similar real-life things to Dryden's blades: brass knuckles and double-bladed or curve-bladed knives, like the karambit. I was afraid it was going to be too on the nose. Some of the knuckle knives are really vicious looking." **Wilkinson**

▲ **SHORT SWORD 03** Chris Caldow

"It evokes a more classical sword, Dryden's collection consisting of more ancient weapons. I threw this at one of our concept guy, Chris Caldow, 'Can you come up with three or four designs?' This was one of the designs that he came up with. It has this fantastic negative space. It's almost like a tuning fork. It lends itself to having an energy field in between the tines, like a Jacob's Ladder climbing arc. We put a metal decoration on the inside, which you can just see when the light is kicking off the sword." **Wilkinson**

▼ **DRYDEN'S KYUZO PETAR VERSION 01** Chris Caldow

"Dryden's blades look amazing when they are lit up. We did it right at the last minute. Again, it's that man-made energy weapon type." **Wilkinson**

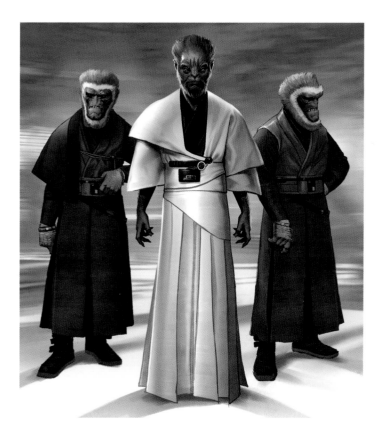

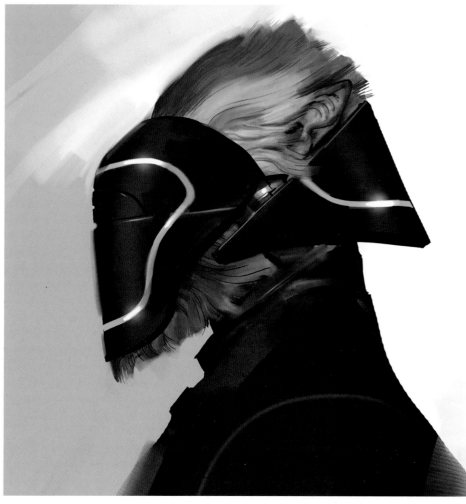

▲ **DRYDEN AND GUARDS VERSION 2A** Brockbank

"We started to think about what the voice might be, how the lip might lift up, just generally getting into the character: Who they are and how they act in order to drive the design of them a little further. And the guards are slightly Disney-esque, I suppose. Why not? That's not necessarily a negative. You want to engage with them. There's humanity in them. With primate characters, you tend to look into their eyes, don't you?" Scanlan

▶ **MAVERICK 013 VERSION 1A** Manzella

"Dryden's guards are definitely primates. Internally, our conversations would be, 'There's an intelligent one. There's a dumb one. There's the physical one. There's the more articulate one.' But generally, they are bodyguards. They know what their role is. Ivan Manzella came up with this drawing of an enforcer." Scanlan

"Dryden's enforcers are the high-end SWAT team, attired like a rich man's private militia. They look good as well as being deadly." Crossman

▲ **DRYDEN THUG ELITE VERSION 4A** Dillon ▼ **DRYDEN THUG VERSION 24** Dillon

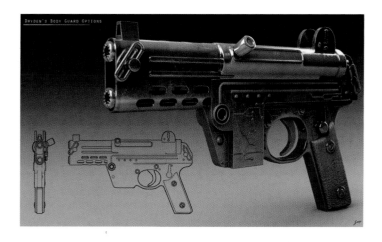

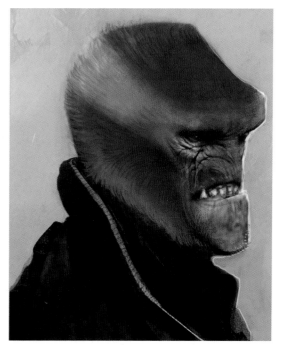

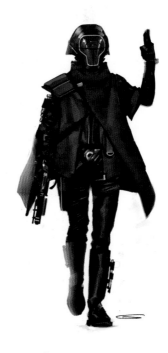

◀ **ENFORCER BLASTER VERSION 06** Savage ▶▶ **DRYDEN'S PARTY VERSION 1A** Brockbank

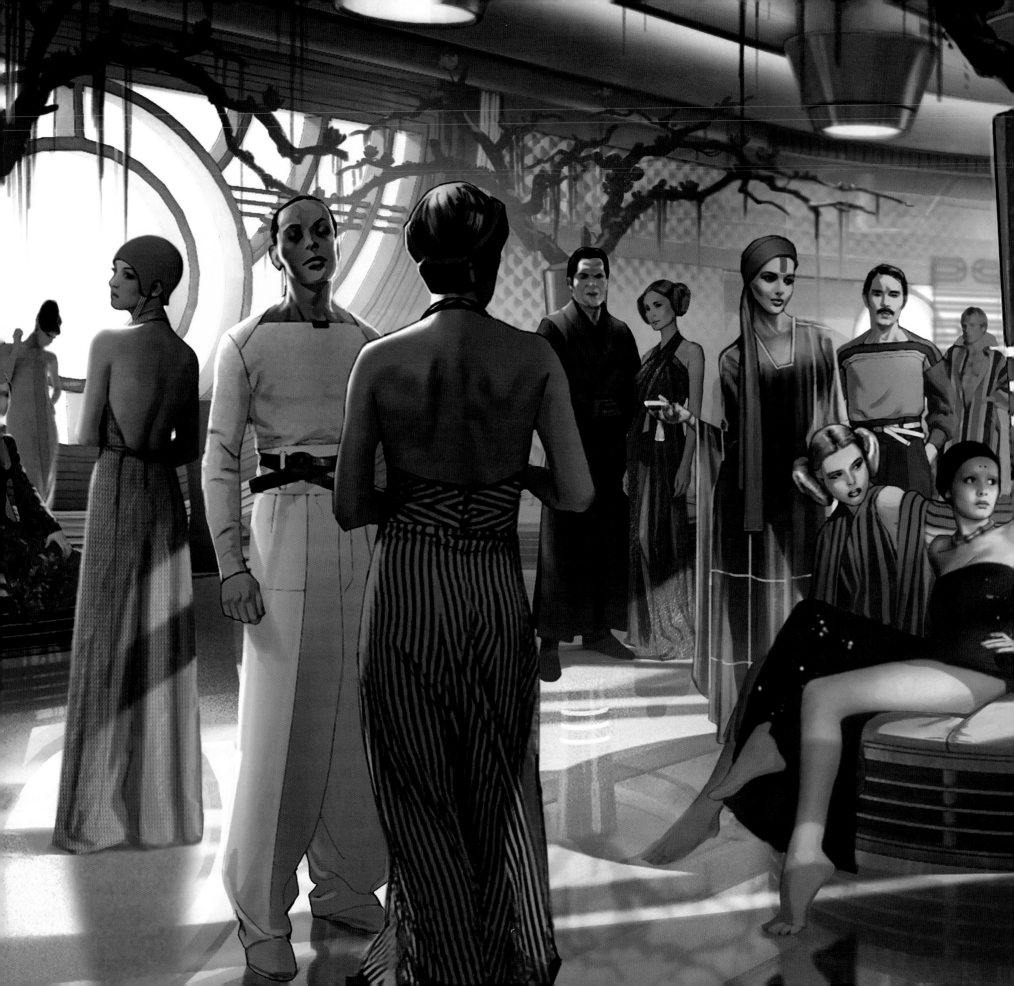

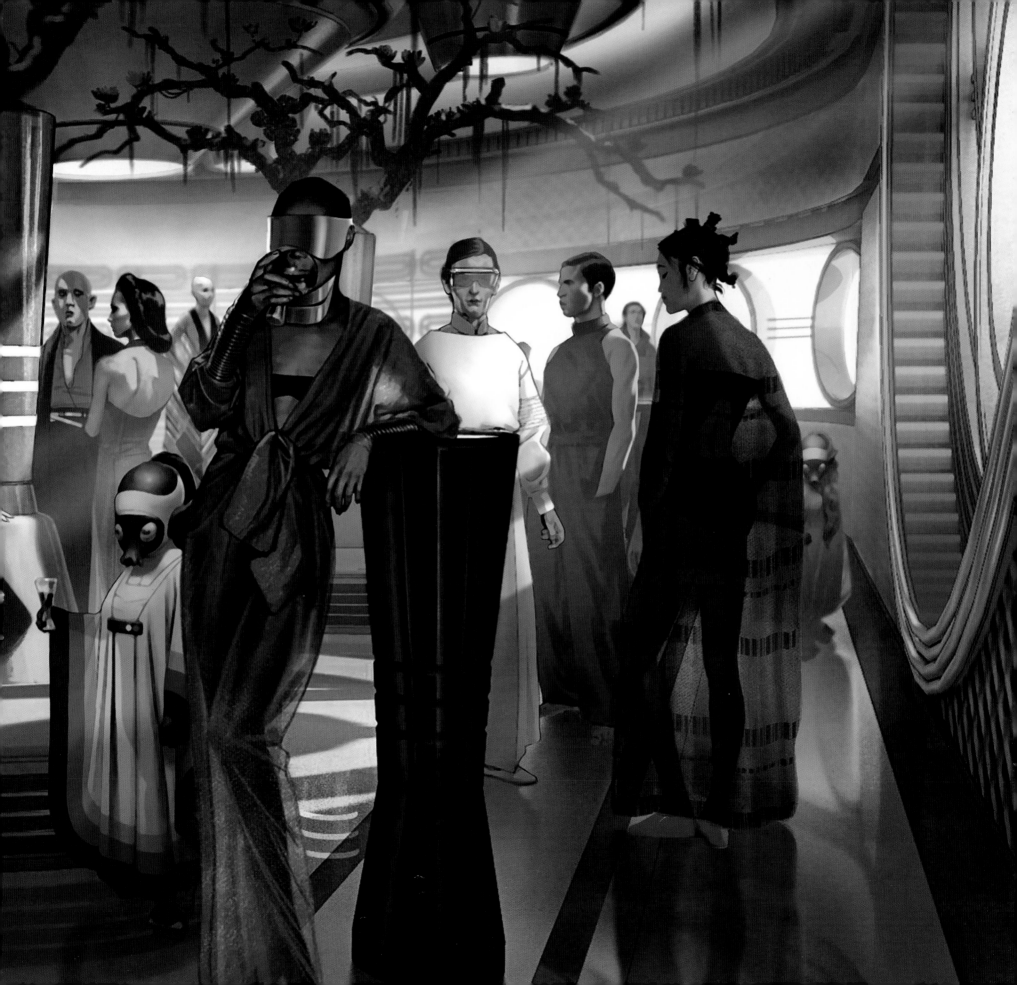

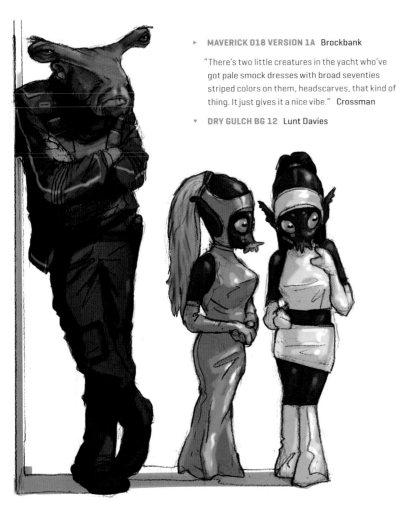

▶ **MAVERICK 018 VERSION 1A** Brockbank

"There's two little creatures in the yacht who've got pale smock dresses with broad seventies striped colors on them, headscarves, that kind of thing. It just gives it a nice vibe." Crossman

▼ **DRY GULCH BG 12** Lunt Davies

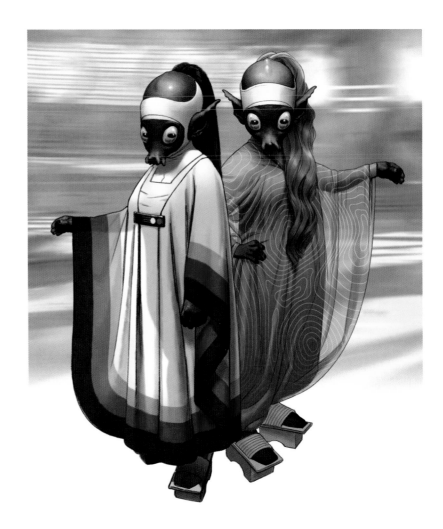

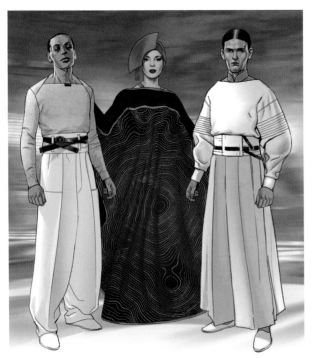

▲ **YACHT GUESTS VERSION 1A** Brockbank

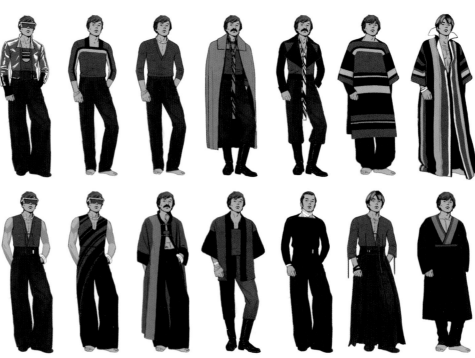

▲ **YACHT GUEST SKETCHES 01** Brockbank

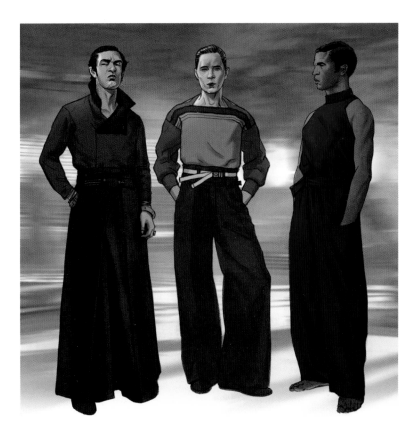

▲ **YACHT GUESTS VERSION 2A** Brockbank

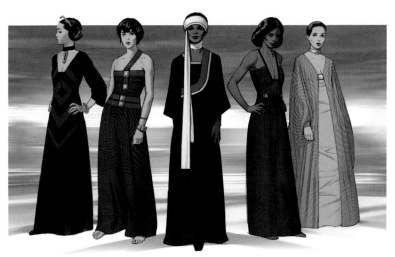

▲ **YACHT GUESTS VERSION 3A** Brockbank

"We were looking at Twiggy—that *Vogue* magazine feeling of the early to mid-seventies with more prints, more color, trying to make it a bit more vibrant. At one point, there was a swimming pool, so we were doing people in *Star Wars* swimwear and various robes. Then there are local bribed bureaucrats hanging around, sexy girls, and all that kind of thing. We also looked at Studio 54 for inspiration. We did specific prints for some of the creatures, like Margo." **Crossman**

▶ **MAVERICK 026 VERSION 1A** Brockbank and Lunt Davies

"Originally this was a sketch for Qi'ra, but when it was picked as a general background alien, she became Margo, the door woman/maître d' on Dryden's yacht. Her design is based on flinty chalk-stone nodules." **Lunt Davies**

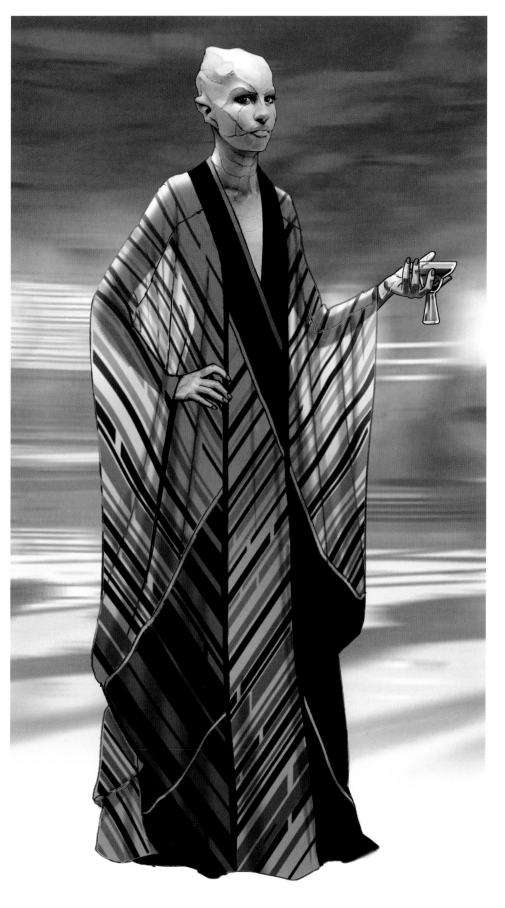

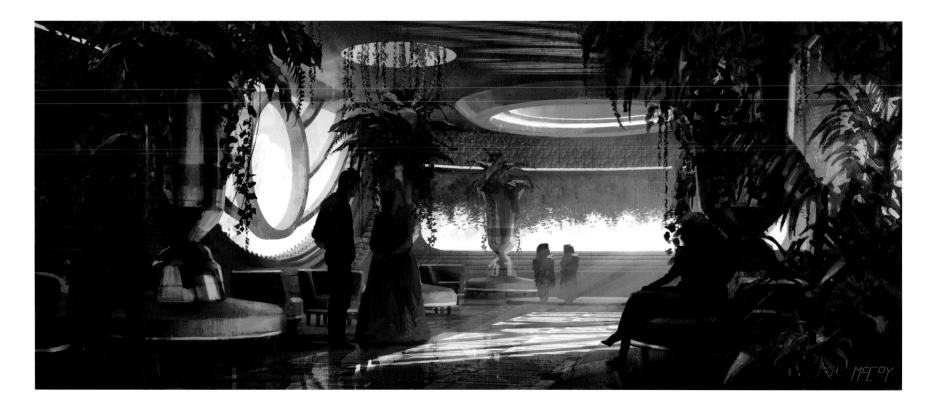

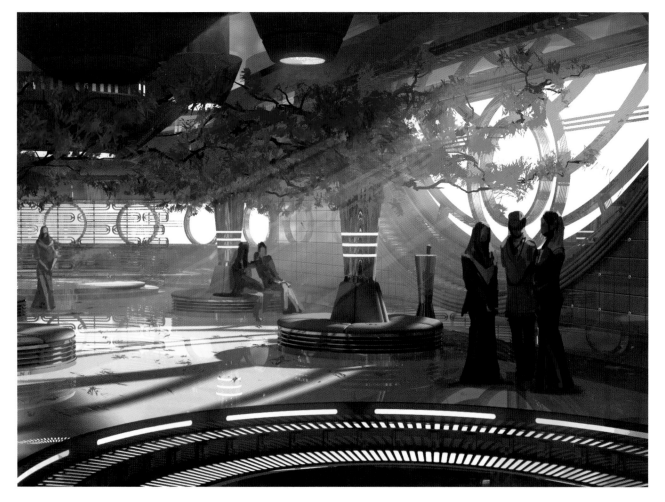

DISPLAY STAND TRIBAL
BREAKAWAY

DISPLAY STAND ANCIENT TECH

DISPLAY STAND MYSTIC
BREAKAWAY

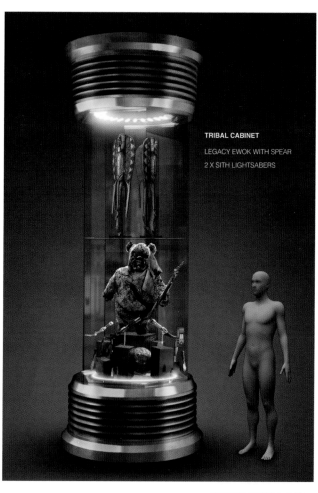

TRIBAL CABINET

LEGACY EWOK WITH SPEAR

2 X SITH LIGHTSABERS

DISPLAY STAND JEWELS

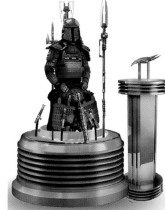

DISPLAY STAND WEAPONS
INCLUDING SWORD & KUZO PETAR

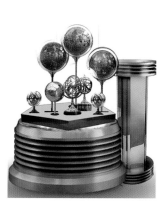

DISPLAY ARMILLARY

▲ **DISPLAY CASE 04** Caldow

▲ **STUDY DRESSING PLAN VERSION 1A**
Sikking and Chris Caldow

"The Jewel and Mystical cabinets are extravagant displays of wealth and contain the blue Jewel of Yavin and the Dancing Green Goddess of Godo. These sit alongside a display of precious ancient weapons at the center of which is a Mandalorian suit of armor." **Lee Sandales**

"The Tribal display evolved from finding inspirational artifacts at auctions and antique fairs. These items are shown alongside researched elements from the Star Wars archive of rare and unique items from across the galaxy, reinterpreted by concept artists within the set decorating department." **Sandales**

▶ **METEOR YACHT DESK B** Chris Caldow

"The central desk, which represents the administrative seat of his power, is a bespoke piece of furniture. The stone base, that Dryden has plundered from the Sith temple of Exar Kun, is made from polished obsidian and decorated with carved hieroglyphs representing spells that protected its former home." **Sandales**

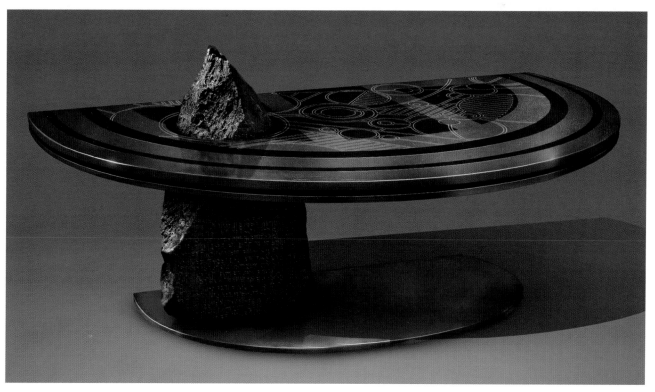

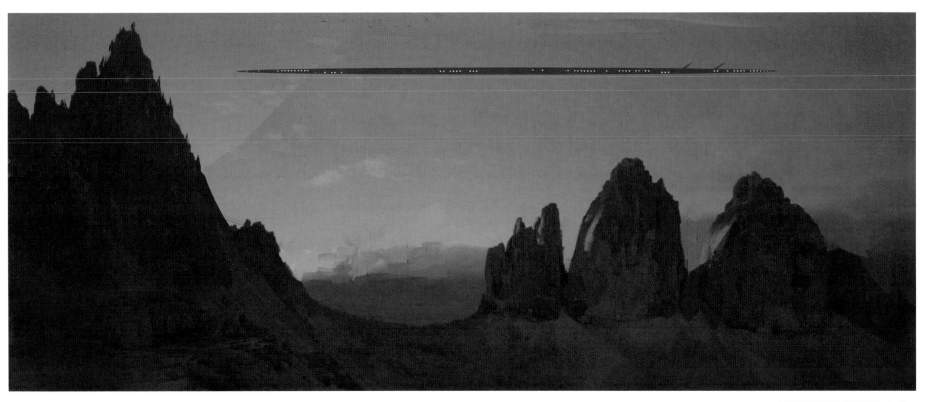

YACHT EXTERIOR VERSION 3A Tenery

▲ DRYDEN SHIP VERSION 1A Jenkins

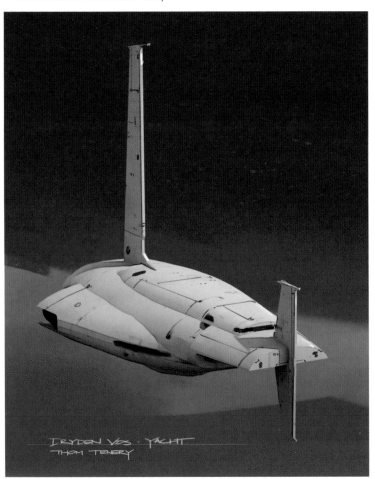

DRYDEN VOS · YACHT
THOM TENERY

UPPER DECK
- LOUNGE
- PRIVATE STUDY

ELEVATOR SHAFT

MAIN DECK
- COCKPIT
- ENGINE ROOM
- GUEST QUARTERS

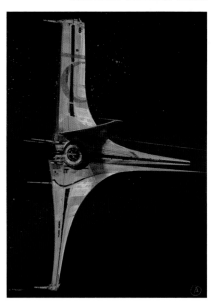

▲ **VOS SHIP 07** "Illustrator John Berkey is such a big influence—not only his style but his aesthetic too." **Clyne**

◄ **VOS SHIP 08** "It's a flying skyscraper with the penthouse as the boss's lair. I was looking at Jabba's sail barge for this design. That seemed like an elegant shape, derived from a pirate ship. We were influenced by the Frank Lloyd Wright realm of art deco, which seems very appropriate for *Star Wars*, including the Marin Civic Center." **Clyne**

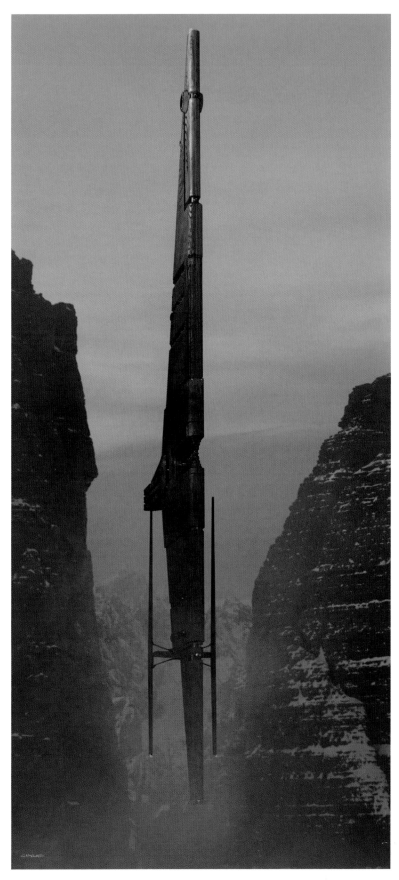

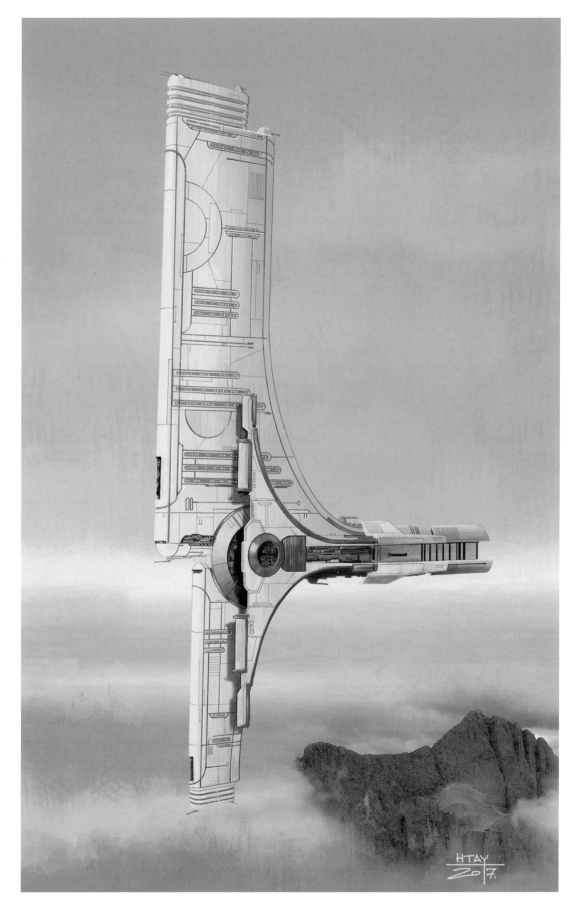

▲ **VOS 3 CHIMNEYS VERSION 05** Clyne

▶ **YACHT VERSION 8E** Htay

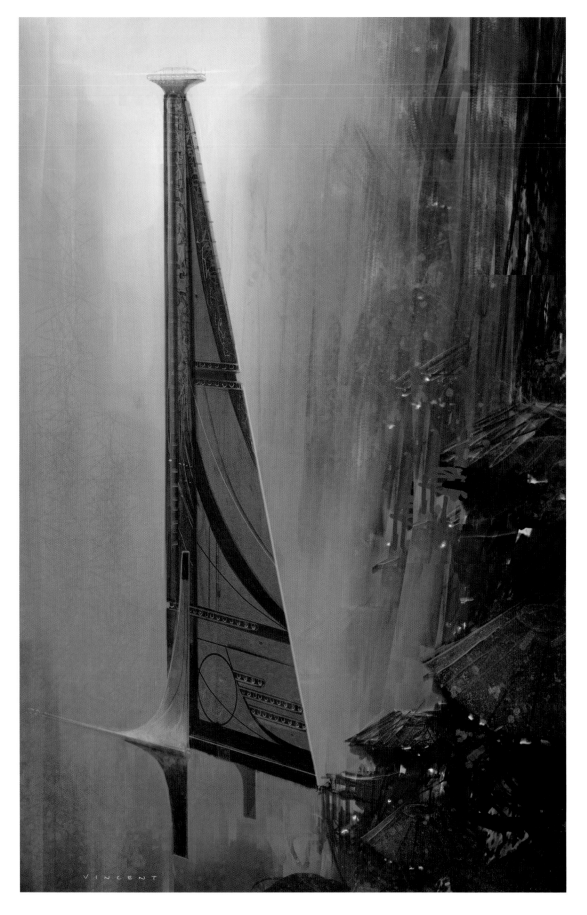

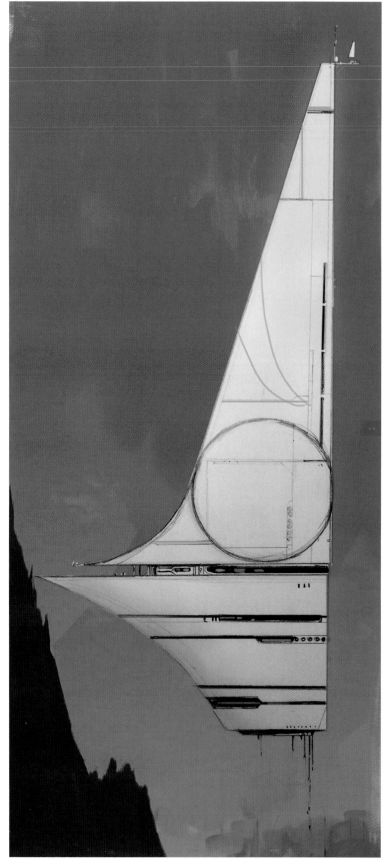

◄ **YACHT DESIGN VERSION 22** Jenkins ▲ **YACHT DESIGN VERSION 17** Jenkins

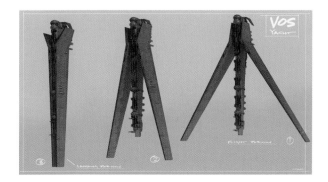

▲ **DRYDEN YACHT VERSION 31** Clyne

A preliminary design for Dryden Vos's yacht found inspiration in Bela Lugosi's collar in Tod Browning's 1931 classic *Dracula* film. The yacht's interior sets were greatly influenced by the art deco aesthetic and were designed six months prior to the exterior, as the final vehicle exterior would be rendered in CG by ILM and therefore had much less pressing deadlines.

▶ **VOS YACHT VERSION 32** Clyne, Htay, and Northcutt

▼ **DRYDEN YACHT VERSION 25** Clyne

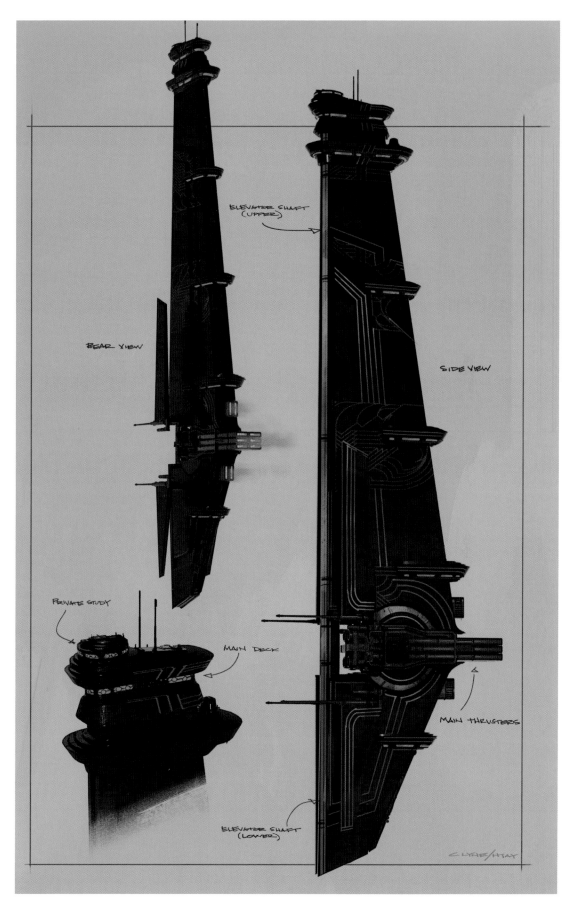

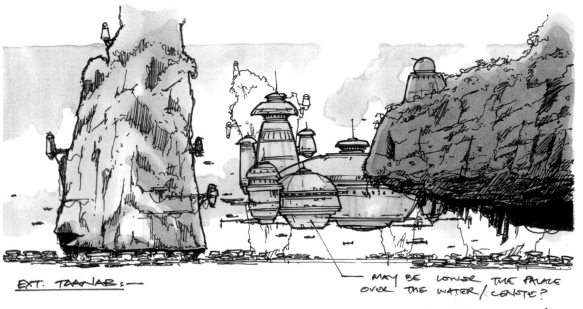

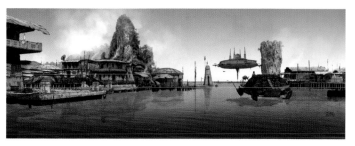

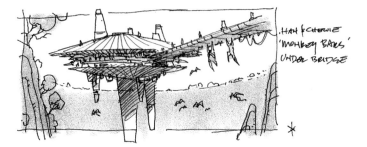

EXT. TAANAB:—

MAY BE LOWER THE PALACE OVER THE WATER / CENOTE?

PALACE NESTLED BETWEEN ROCKS OVER CENOTE. SHANTY TOWN MOORED AROUND ROCKS.

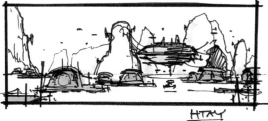

HTAY 2015.

▲ TAANAB VERSION 1B Htay

HAN & CHEWIE 'MONKEY BARS' UNDER BRIDGE

▲ CRIME ISLAND VERSION 01 Clyne

"At first, Taanab was a floating city. And they had this idea that there would
be a shootout on the deck of this floating city that would slowly careen
and the whole world would capsize, which was kind of fun. So Taanab was a
combination of the current Dryden's yacht and Savareen." Clyne

◄ TAANAB SKETCHBOOK 1J Htay

▼ TAANAB 01 Clyne

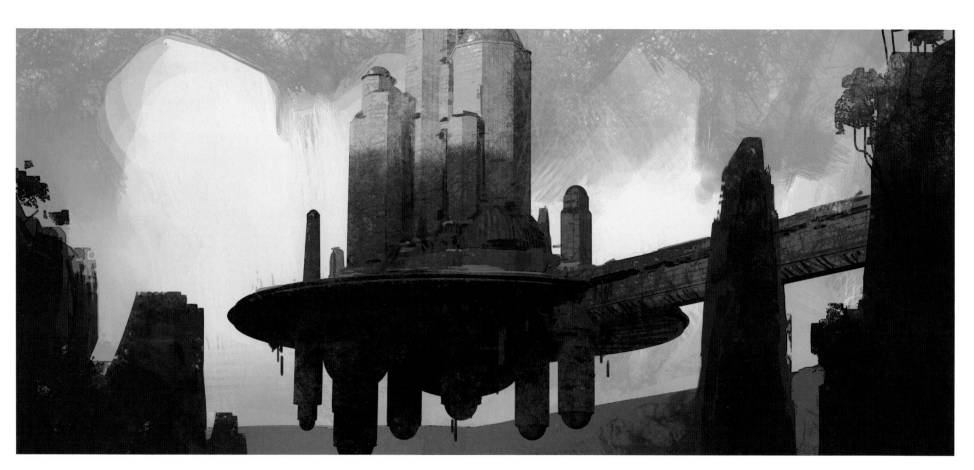

▸ **VOS CONCEPT VERSION 1A** "That piece certainly does feel like a James Bond villain's lair, which was some of what they were hinting at. One idea was cenotes in Mexico, underground water wells or caves that break open and these big tubes form. In Episode III, the sinkhole world of Utapau that Obi-Wan journeys to is kind of like a cenote. This was a little play on that." Clyne

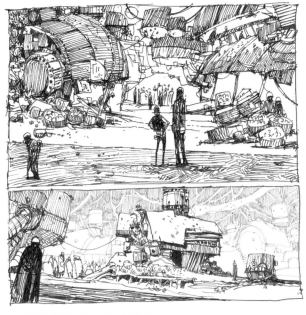

▴ **CRIME ISLAND VERSION 06** McQue

▸ **LODGE VERSION 2B** Mullins

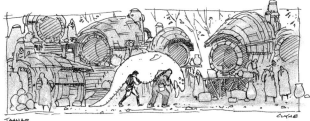

▴ **CRIME ISLAND VERSION 04** Clyne

▸ **VOS LAIR VERSION 1A** Allsopp

"Early on, we were doing a lot of Taanab iteration. Some of the influence has made it into Fort Ypso. But this was obviously more of a jungle climate. Early on, it was not just doing artwork but saying, 'Hey, what if we went to Thailand? What if we went to Indonesia?'" Clyne

"Sir Edward James, this British poet ex-pat who moved to Mexico, had a bunch of money and was obsessed with the culture. This was north of Mexico City, right in the rainforest. And he spent five million dollars in the sixties and seventies building this surrealist sculpture garden. It feels really *Star Wars* and perfect for Taanab. 'What if we went here?'" Clyne

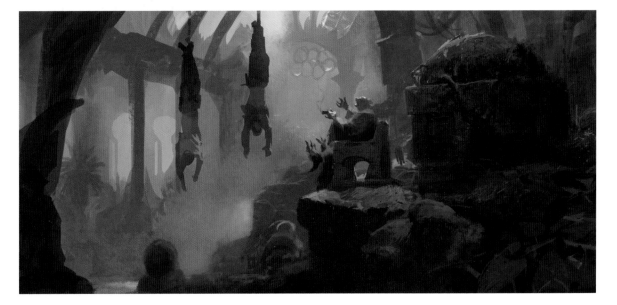

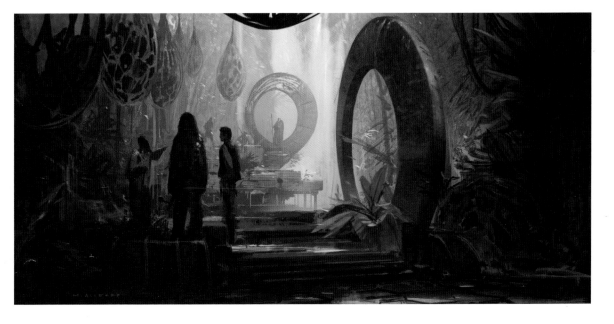

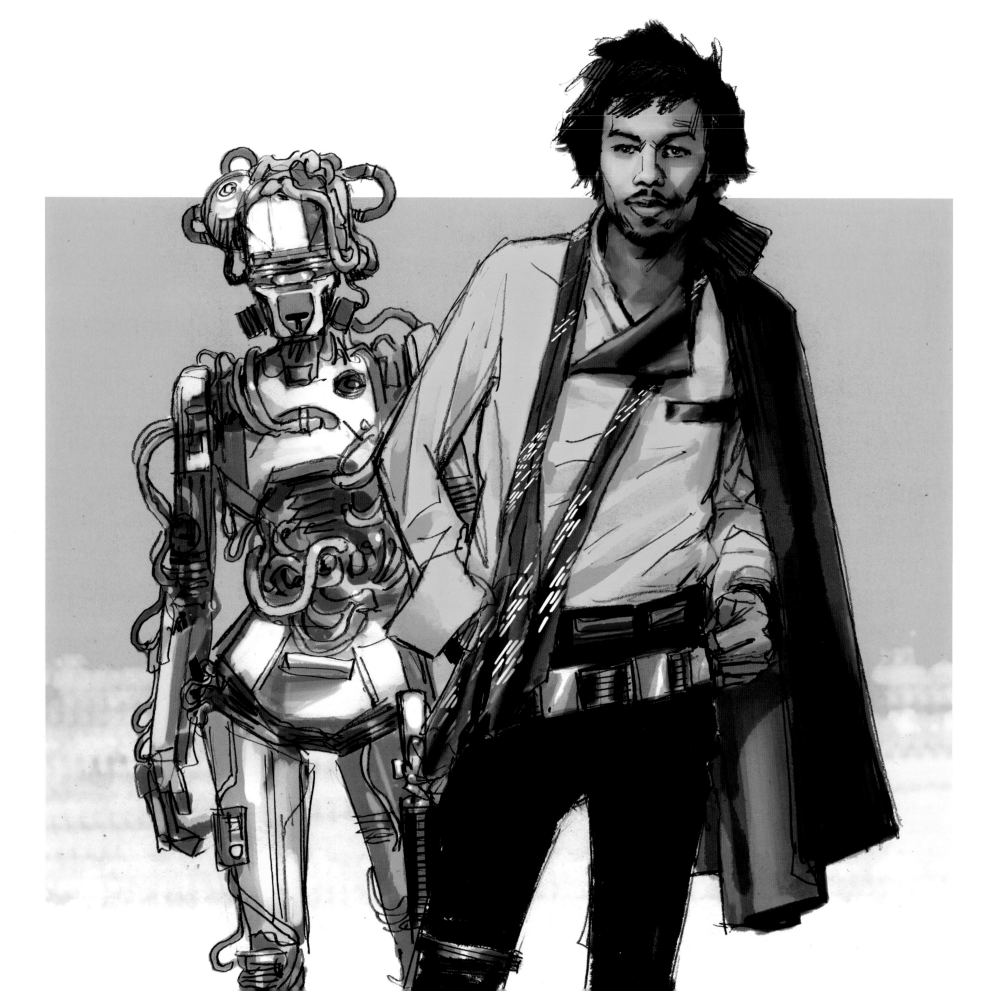

Lando Calrissian

As director Rian Johnson expressed in his forward to *The Art of Star Wars: The Last Jedi* (Abrams, 2017), what makes a design feel "*Star Wars*-y" is "something elusive that everyone has their own instinct for" but is almost impossible to articulate. After working on three films in the franchise, James Clyne understood that dilemma full well. "It's an easy thing to get stuck in," Clyne said. "On *The Force Awakens*, we spent a year trying to understand what it means to be in the *Star Wars* timeline thirty years past *Return of the Jedi*. But I think there's some necessity to make sure that we are tracking what it means to be a *Star Wars* movie more generally. What does Dryden Vos look like? What does Director Krennic look like? When you are creating new aspects of the *Star Wars* universe, there's almost nothing to bounce off of."

Bringing his learned sense of the *Star Wars* aesthetic to bear on *Solo* was vital to Clyne's role as design supervisor. "I spent most of my days at Pinewood sitting with art directors and set designers saying, 'Well, this is cool but how do we make it a little more *Star Wars*–centric?' Don't get me wrong; a ton of them had worked on *The Force Awakens* and *Rogue One*. They were off and running. But I created this mantra, '*Star Wars* doesn't live in the future. It lives in the past.' People inevitably think, 'It's *Star Wars*. It's science fiction.' They want to do something sleek and futuristic. But I would constantly be saying, 'Let's look at this German flak gun or a Luftwaffe fighter from the early forties.' That's our world, not the world of *Minority Report*."

◄ **LANDO VERSION 14** "The pattern on his scarf is an Easter egg: I took a still from *A New Hope* where Luke is swinging across the chasm with Princess Leia and adjusted the levels so it was dark and the pill lights on the Death Star were hard white. Donald Glover really knows how to wear this kind of outfit. It's Lando on his way up, isn't it? His costume is still a bit rock 'n' roll and young, but you can tell that he has a pride in the way he looks. We all know where he's heading." **Dillon**

In defining the look of Lando Calrissian's legendary Corellian YT-1300 freighter the *Millennium Falcon* years prior to its first appearance in *A New Hope*, Clyne found inspiration in a film released almost a decade prior to *A New Hope*. "Everyone was saying, 'The *Falcon* is just going to be cleaner and simpler.' But nobody knew what that meant," Clyne remembered. "One thing I really latched onto was Harry Lange." A spacecraft designer for NASA (the United States' National Aeronautics and Space Administration) alongside famed aerospace engineer Wernher von Braun, Lange segued into the film industry after meeting author Arthur C. Clarke, who introduced Lange to director Stanley Kubrick. Lange was hired by Kubrick to design space program–accurate sets, costumes, and props for *2001: A Space Odyssey* (which also employed future Chewbacca creature designer Stuart Freeborn in the creation of its apelike hominid tribe). More than a decade later, Lange served as an art decorator and set decorator on *The Empire Strikes Back* and *Return of the Jedi*.

"I started digging into a couple of the recent 'Making of *2001*' books and looking at the interiors from the film, knowing that they were a direct influence on everybody that did anything for *Star Wars*," Clyne continued. "*2001* is still an influence! It's this monster of a movie that somehow got it right, that somehow predicted the future. Going back to the well of what came before us, I pitched the padding and the white color that Harry Lange designed for *2001: A Space Odyssey* for our *Falcon* interior. I even did a whole Harry Lange document for *The Force Awakens*. I love how Rick Heinrichs [production designer on *The Last Jedi*] called it 'Harry Lange-uage.' That's fantastic."

"To me, all of that has been like archeology. I always wanted to be a paleontologist or an archaeologist when I was a kid, based on the movies I grew up with. The research you do as a concept artist is like going to a site and digging, finding what works."

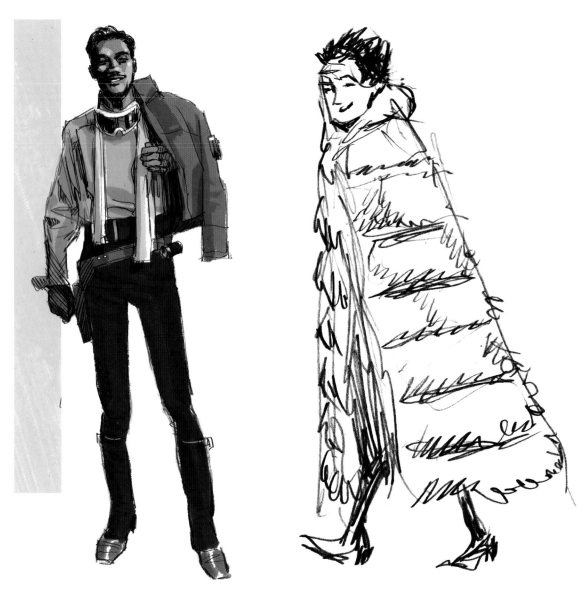

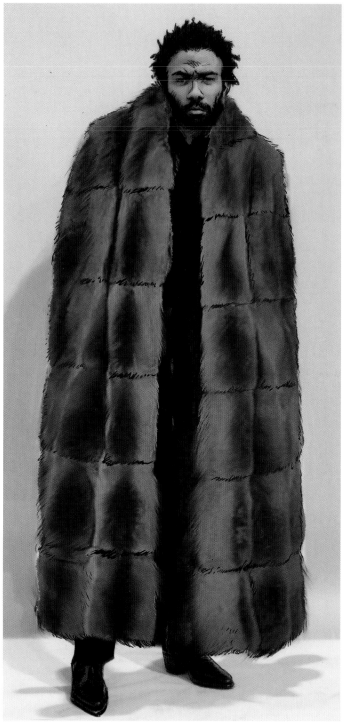

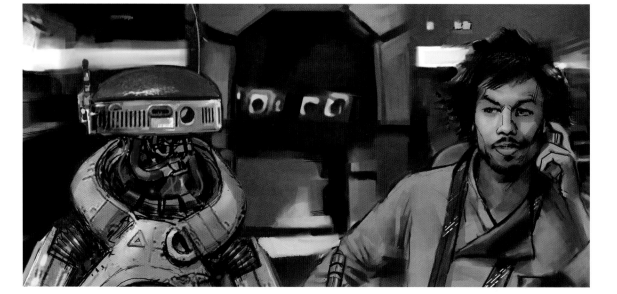

▲ **LANDO SKETCH VERSION 01** Crossman

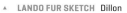
▲ **LANDO FUR SKETCH** Dillon

▲ **VANDOR LANDO VERSION 1A** Dillon

◄ **LANDO L3 FALCON VERSION 1F** Dillon

"Lando [Donald Glover] was inspired by Jimi Hendrix and a bit of Marvin Gaye in the collar. That Lando concept that Glyn did of the yellow shirt with the black cape was one of the early concepts that never really changed. That design held its ground for over a year. We made the shirt in a sand-washed silk, very soft and flowy. We did exaggerated cuffs lined in black, which are held in a rakish way and stay open most of the time." Crossman

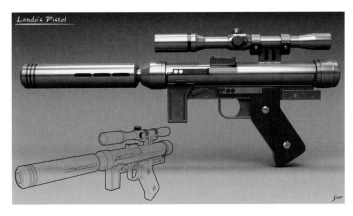

▲ **LANDO PISTOL 01** Savage

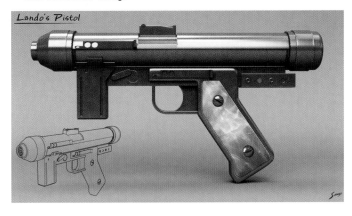

▲ **LANDO PISTOL 02** Savage

"Lando's blaster had to be your typical bling-y, show-offy gangster gun. We ended up using the same finish that we put on Qi'ra's gun: a polished aluminum. We kept the mother-of-pearl grip, which can be found on fancier real-life gun grips. It definitely has a little of the seventies, polished-chrome, disco vibe to it. Because we were going to such extremes on the decorative finish, I said, 'It would be really nice if it were recognizable, an Imperial gun.' This was originally the stormtrooper sidearm, built from a Rexim-Favor submachine gun. But we reduced the whole thing by thirty percent because he's such a petite character." **Wilkinson**

▶ **LANDO NEW CAPE VERSION 11** "We wanted to do something colorful like a Star Wars version of a Hawaiian shirt. So in the same way with the pattern on his scarf, I looked to the original trilogy for inspiration and particularly to the Art of Ralph McQuarrie book. In that, I found some great drawings he did of some spaceship-type skiff, that had very bird-like wings. So I used that and created a little scene with two suns over some water and we used that as the repeat pattern." **Dillon**

▼ **CARD RIG VERSION 04** Savage

"The Lando card rig runs on a little screw drive. Originally we had it on a roller so you could physically see it. But that made it so big, and with the tight-fitting shirt, it didn't work. On the last version we did, we went down to a bike shop and bought a bike. Someone off-screen is holding the bicycle brake [laughs]. When you release the brake, the cable comes out. We went back to the early days of special effects." **Wilkinson**

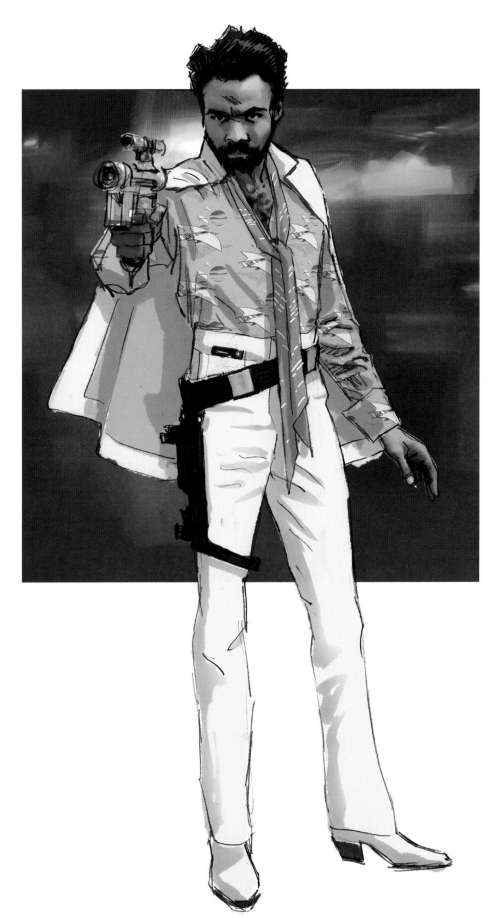

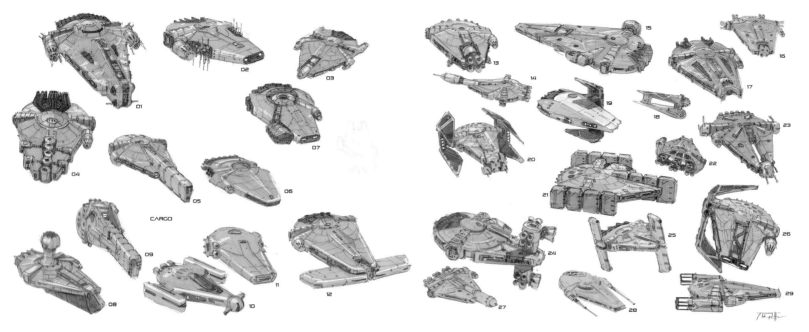

▲ FALCON 006 Faulwetter

▲ FALCON 007 Faulwetter

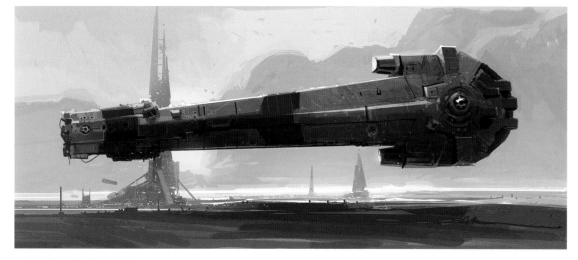

▲ FALCON VERSION 01 McQue

▲ LONG NOSE SKETCH Clyne

▼ LANDO'S FALCON VERSION 04 "We were playing with a lot of designs, ridiculous ideas like, 'Are there two cockpits, where one is a gunner?' It was actually symmetrical, at one point. One of the things that really did stick was the triangular front end." Clyne

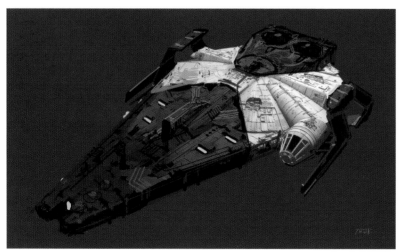

▲ FALCON 004 Faulwetter

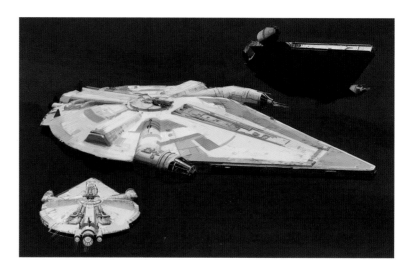

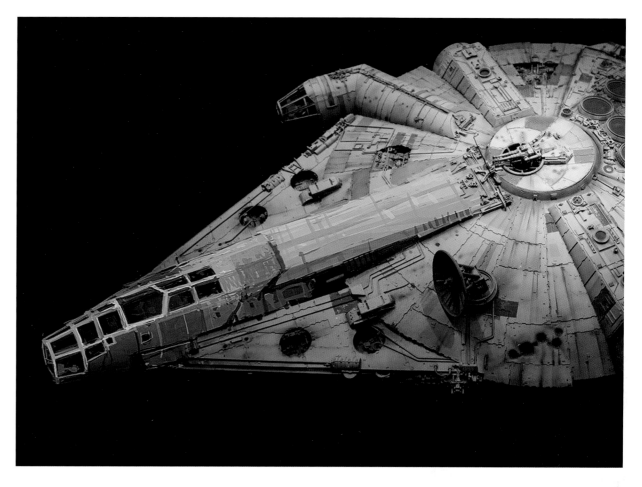

▲ **JOE JOHNSTON SKETCHING THE PIRATE SHIP** Photographer unknown

"The *Millennium Falcon* was the scariest thing to have to revisit. One of the first things I did was reaching out to you, 'What can we find of anything related to Joe Johnston's *Falcon*?' And you sent me this Joe Johnston drawing, which I had never seen before. The history of the *Falcon* was that it originally was the blockade runner shape. George wanted to get away from that after seeing the similar Eagle Transporter in *Space: 1999*, and then it magically turned into this beautiful saucer with the asymmetrical side cockpit. That Johnston drawing is the only transitional art I've seen. The side view and back is almost the blockade runner. It's like they simply put a saucer on it. You can see how the mandibles were there but the cockpit fits into the negative space." Clyne

▸ **FALCON ROUGH VERSION 01** McQue

▾ **MF MUSCLE VERSION 12** Tenery

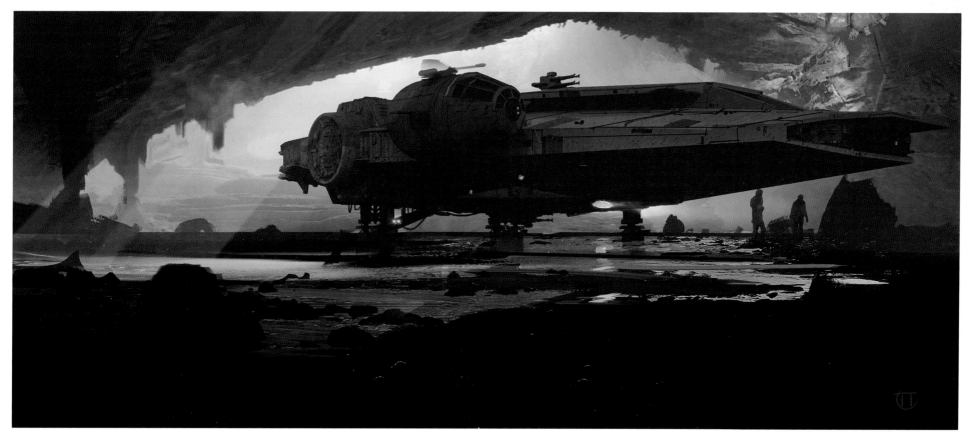

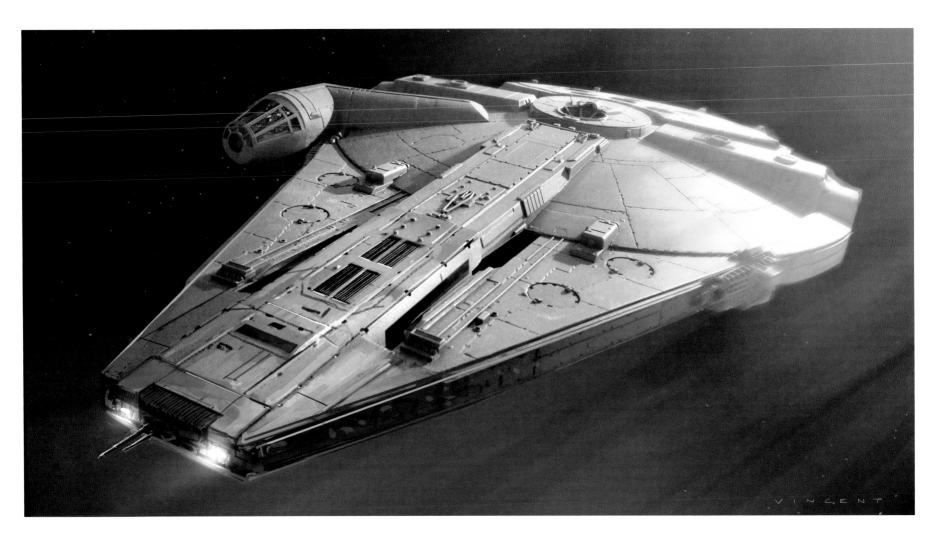

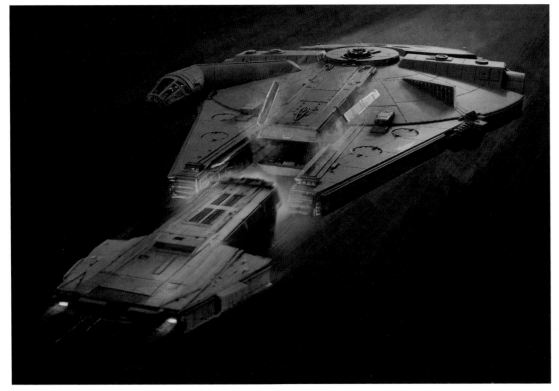

"We started to work with the physical model-maker guys. We bought ten 1:48 scale *Falcons* and started to build a shell over them because story-wise, Lando's ship is cleaner and has this beautiful shell over it. Every day we built about five iterations of these *Falcons* as a tool to show what it could be. We could hold it in our hands, look down low on it. We could put a lipstick camera on it. We even got into proposing all of the different part lines and scoring. For the exterior graphics, they wanted to mimic the scomp link that Artoo-Detoo jacks into which has some of that Harry Lange feel." Clyne

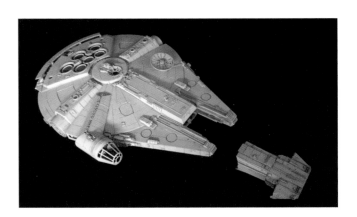

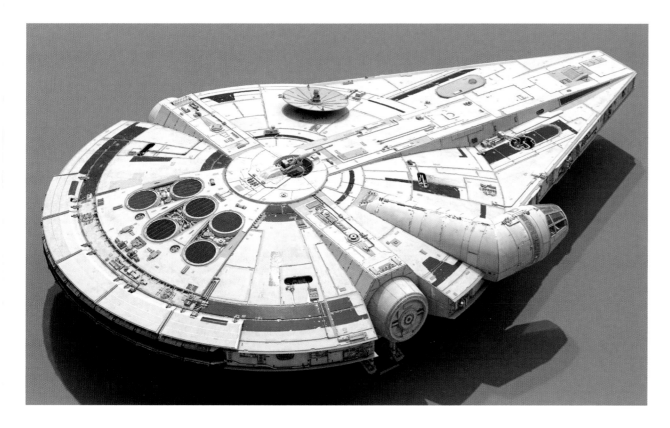

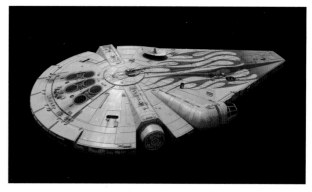

▲ FALCON PAINT 10 Clyne

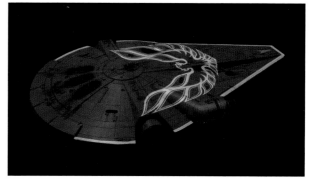

▲ FALCON PAINT 11 Clyne

▲ **FINAL FALCON STRIPES** Clyne and Masa Narita

"There are all of these little Easter eggs on the final design, like the Corellian pill-shaped islands, since it's built on Corellia. Ralph McQuarrie's *Falcon* hatch is far simpler and not as greeblied. I even did a Ralph McQuarrie *Falcon* gun, which is just a single turret. Han's like, 'I've got to get a little more heat up here [*laughs*]. I'm getting chased more these days.' The cannon is also a note to Lando's elegance. He's not so much of a fighter; he's more of a lover. So I love this idea that it's not as heavily armed." Clyne

▶ **FALCON MODEL** Marsh

"We referenced a photo of the *Falcon* under construction, loving the smooth surface of it all, even though it was just plywood." Clyne

"The biggest pitch that I gave was Ralph McQuarrie's version of the *Falcon*. The gak band was a lot cleaner. It was very slick. Even the radar dish was bigger and pointed up. You don't have to do much or say anything when you show a Ralph piece. 'Done.' In a way, this design is an homage to Ralph McQuarrie and his *Falcon*." Clyne

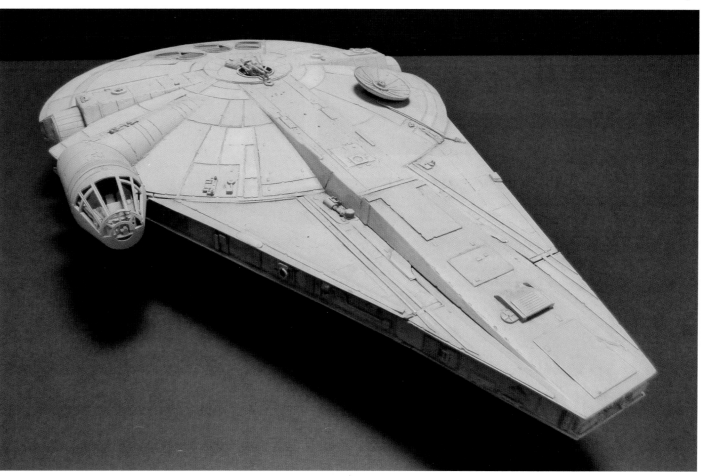

▲ POKER ALICE VERSION 01 Lunt Davies

▼ DROIDS 04 Lunt Davies

▼ N5-G8 VERSION 3 Lunt Davies

▲ L3 VERSION 16 "Originally, she was a political activist. She still has that activism, but initially, it was more about that than anything. Then the idea was that she came with the *Falcon*, as a ship's cook or a copilot all rolled into one. So we were doing designs based on the *Falcon* design. Over time, she got more independent and felt that she shouldn't be a slave in any way. But she was also a great navigator." Dillon

"L3-37 was a huge undertaking, as BB-8, K-2SO or any of the new droids are. They have so much personality. It's not like just designing a ship, a gun, or something. You're designing a personality." Clyne

◀ N5-G8 VERSION 25 "Over the course of the process, we were encouraged to explore ideas such as that L3 was old; falling apart; her femininity; had rebuilt herself; didn't care about her appearance; was embarrassing to Lando; or should potentially contain the *Millennium Falcon* navigation computer as a prominent feature. In a period of where she was going to be some embarrassing old tech, we referenced old beige computer monitors from the seventies and eighties." Lunt Davies

▲ **DROID 03** Dillon

"Everyone was searching around for what L3 should be for a long time. There were so many lovely designs by Glyn and everybody. There were hundreds." **Crossman**

"The biggest issue, more than anything, was having an actress play the role in a semi-practical suit. We spoke about the implications of having to put a person in a suit and using sections removed later by green screen. That drives your design very distinctly. If you throw that out the window, like we did with K-2SO, your horizons become much broader." **Scanlan**

▶ **L3 IN FALCON VERSION 1A** Brockbank

▼ **L3 SKETCH 08** Savage

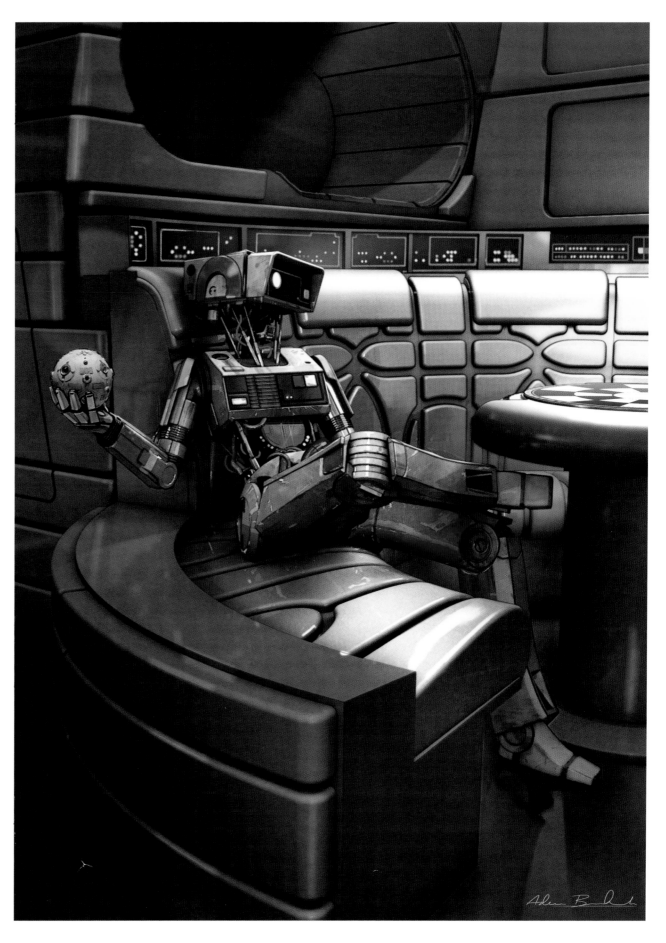

▲ **L3 NEW HEAD VERSION 01** Dillon

▲ **L3 ROUGH 08** Chris Reccardi

▲ **L3 VERSION 12F** Clyne

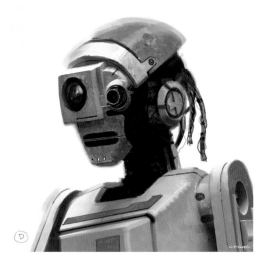

ⅅ

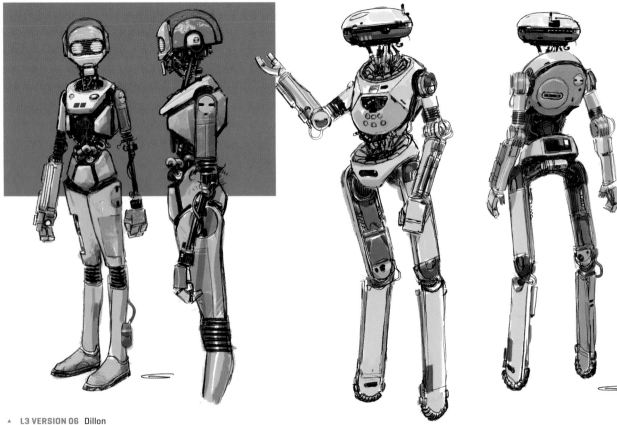
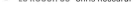

▲ **L3 VERSION 06** Dillon

▲ **L3 VERSION 12P** "What stuck was that she is somebody who really doesn't want to be told what to do. She's somebody who wanted her own rights and is for droid rights, in general. Serving that story enabled us to take it this more astromech kit-bashing idea. Her shoulders are almost exactly like Artoo-Detoo's. This one got pretty close, with the eye of an astromech kludged onto more of a humanoid head." Clyne

◄ **L3 LATEST** "When they were still thinking of her having come with the *Falcon*, there was a concept where her head is a bit like a hamburger shape. That came from thinking about the story of George Lucas on a flight from London, coming up with the hamburger-shaped *Falcon* with an olive coming out of the side. And that led to thinking, 'Maybe that's not a hamburger, but the dome of an astromech.' Then we started using pieces of an astromech in the chest. That gave legs to the story that L3 is a self-made woman, literally and figuratively. What if she was an astromech but gave herself legs and a voice? That change was really close to the deadline, but it really helped." Dillon

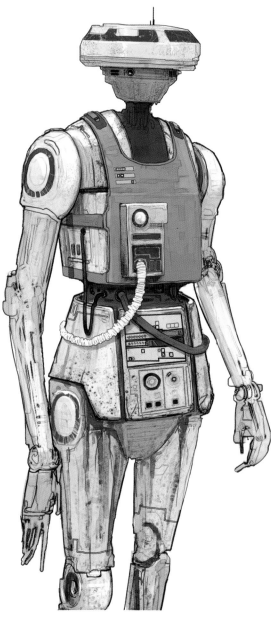

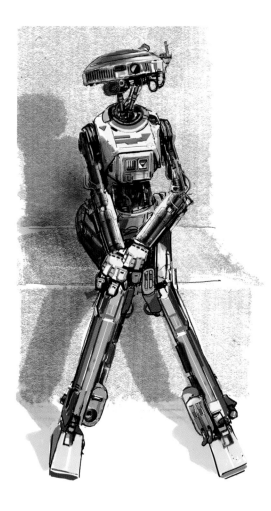

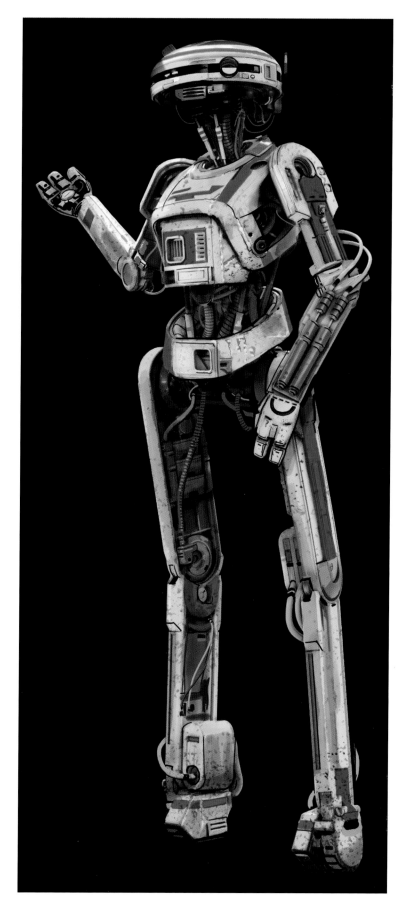

▲ **L3 VERSION 5A** Fisher

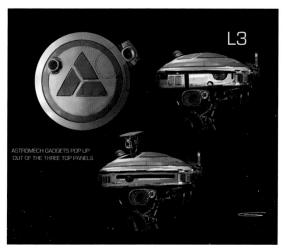

ASTROMECH GADGETS POP UP
OUT OF THE THREE TOP PANELS

▲ **L3 VERSION 29** Dillon

"It's fair to say that L3 is a mixture of lots of people's contributions to try to answer the questions of not only what she looks like, but also where she sits technologically. Old Atari machines, the Honda robot, even the classic English teasmade automatic tea machine of the sixties and seventies are very much part of her visual. And then Glyn and the guys took her forward to create the practical elements that we see in the film." Scanlan

◀ **HEAD PATTERN VERSION 09** "Maybe she worked as an astromech waiter in some bar, some menial job. When droids would get into fights in the alley out the back, she would take their parts, building legs for herself. Astromechs famously don't have a voice, outside of the beeps and boops, so she gave herself a microphone mouth like the medical droid on Hoth." Dillon

▶ **L3 LAST PASS VERSION 23** "HOD [Head of Department] modeler Pierre Bohanna's department has built about four L3s. Three of them are worn by Phoebe Waller-Bridge. Her hands can interact with other characters. Until viewers find out how it's done, it will be a bit confusing. When you take Phoebe's head and neck away and replace it with wires and innards, then that can look quite CG. But then she's interacting with characters in such a real way. It will be a really interesting mix. We've seen some tests of it, and it looked great—so fingers crossed." Dillon

Vandor

The path that the eponymous protagonist of *Solo* finds himself on is, by design, quite different from other *Star Wars* heroes. Luke Skywalker starts on a backwater planet, far from a theoretical "bright center to the universe"; is soon gobbled up by the "technological terror" of the Empire, the Death Star (ultimately falling into the literal and metaphorical "belly of the beast," a trash compactor); and finally arrives in the lush idyllic jungle world of Yavin 4. As described in *The Art of Rogue One: A Star Wars Story* and affirmed by Neil Lamont, "*Rogue One* started and ended in a beautiful place, Jyn Erso's journey going in a circle"—from the Erso farm on Lah'mu to the tropical paradise perverted by the Empire's war machine, Scarif.

"Han's journey is more of a line," Lamont continued. In keeping with the Western themes established in the project's earliest days, that line represents "the journey across America into the frontier, traveling east to west. That all was part and parcel of the vibe of *McCabe & Mrs. Miller* and that whole frontier-ism." James Clyne recalled, "There was a lot of discussion about westward expansion, manifest destiny, and this Americana of planting down in the East Coast but eventually making your way to the West Coast. It's a very Western kind of trope. It's the story of America."

That journey would also self-referentially follow the path of the nascent American film industry: from inventor Thomas Edison's kinetoscope, developed in Fort Lee, New Jersey, and the Kaufman Astoria Studios and Edison Studios in the New York boroughs of Queens and the Bronx, respectively, to the establishment of the classic Hollywood studios in sunny Los Angeles, away from Edison's restrictive (and litigious) East Coast production patents. Likewise, Han Solo's hero's journey starts in the seaside industrial city of Corellia, representing "New York, maybe in the twenties, in the Depression, at the beginning of the movie industry," according to Lamont.

But no realm in *Solo* better exemplifies that voyage across America than the mountainous Vandor, a stand-in for the snow-capped Rocky Mountain range that divides the North American continent. "It's all about westward expansion, and the Rockies being an obstacle to that westward expansion," Clyne stated. "We were looking in places like Chile, Patagonia, and the Dolomites, a place that looks like the Rockies but doesn't feel like Hoth or any other *Star Wars* world. That feeds into our western motif. This idea quickly became something that was not only beautiful but also obtainable in that the Dolomites are in Italy, not too far from London."

Lamont recalled, "One of the first things we did in mid-July 2016 was go to the Dolomites with James, cinematographer Bradford Young, and VFX Supervisor Rob Bredow. Even on my first trip with Mark Somner, our location manager, I knew the Dolomites were Vandor. It's just phenomenal." Clyne remembered, "We scouted for two days, eight hours a day in two helicopters. It was a beautiful landscape. Automatically, we thought this was the right place. It felt so *Star Wars*. Then you throw a train into the mix, and it becomes very unique and feels very right for our movie."

The three-room interior of the Fort Ypso saloon was shot from March 6 to 10 on Pinewood Studio's A Stage, with a reshoot on April 10 and additional pickup filming on August 7 and 8. Main unit photography shifted to Monte Piana in the Sexten Dolomite mountain range, near the film production's base camp in Belluno, Italy, for scenes prior to and following the train heist on Vandor. Upon returning to England, the campfire set shot in the Dolomites was re-created on Pinewood's L Stage, for close-ups of the Rio creature performance and dialogue that was difficult to capture on location, from June 13 to 14. The approach to the impound lot where the *Millennium Falcon* is first revealed was photographed on Pinewood's south lot August 9 through 11, not far from the outdoor locales where Domhnall Gleeson gave his Starkiller Base speech in *The Force Awakens* and the Jedha City set once stood for *Rogue One*.

◄ **MOUNTAINS EXTERIOR VERSION 23** "It's Han seeing another world for the first time—away from Mimban, away from the horrors of war: a world that has beauty and color, atmosphere and oxygen." **Clyne**

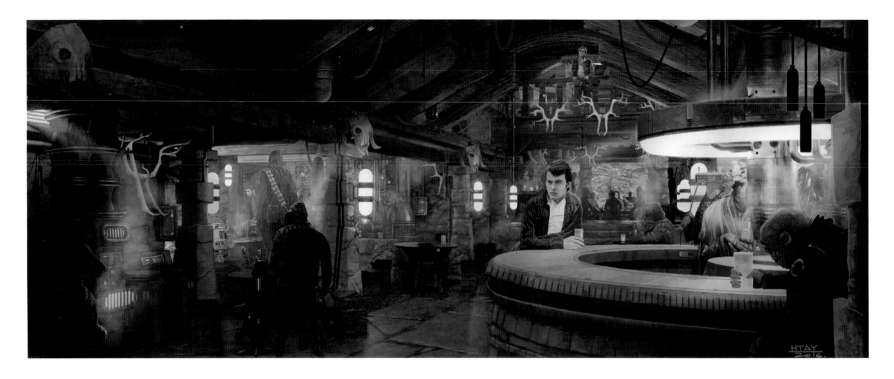

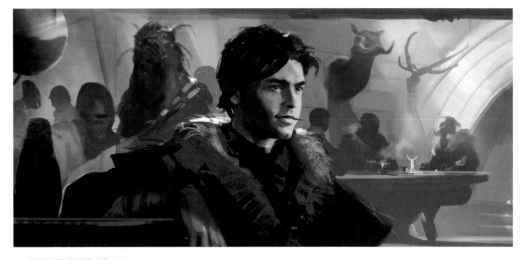

▲ STORY BEATS 07 Allsopp

▲ FRONT ROOM VERSION 3C Htay

"I looked at the drawings of *Star Wars* art director Norman Reynolds of the Tatooine bar to understand the size of that room. I thought, 'OK, that's the size of that room. Let's not overdo it.' There's a specific Indian temple where I saw the reference for the double column. It's unusual. And then Tom Whitehead, one of our art directors, started to draw the set. 'Tom, let's get some more wood into the set. Let's think about making the tops of the columns in timber.' And he showed me sort of this Japanese aesthetic, which is great for *Star Wars* and that rebel, frontier vibe." **Lamont**

"The lodge was inspired by paintings and image research of nineteenth-century American saloons, eighteenth-century French country lodges, and a buying trip to India. Wood was the primary material in the set, reflected in the use of wooden furniture. The bar was constructed from reclaimed timbers, set against a backdrop of a moonshine distillery with optics made from aircraft flame cans - a direct reference to the bar in Mos Eisley." **Sandales**

"Continuing the endless music vibe, the barman is based on Frank Zappa [*laughs*]." **Crossman**

▲ VALACHORD VERSION 1B Savage

▲ STORYBOARD PAINT 2 Mullins

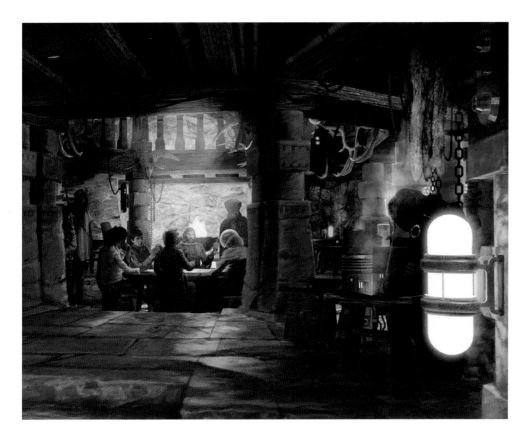

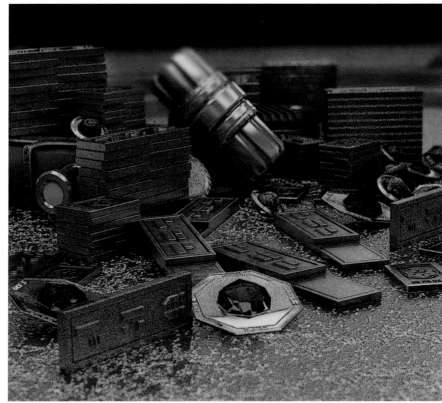

▲ **COIN PILE VERSION 4A** Savage

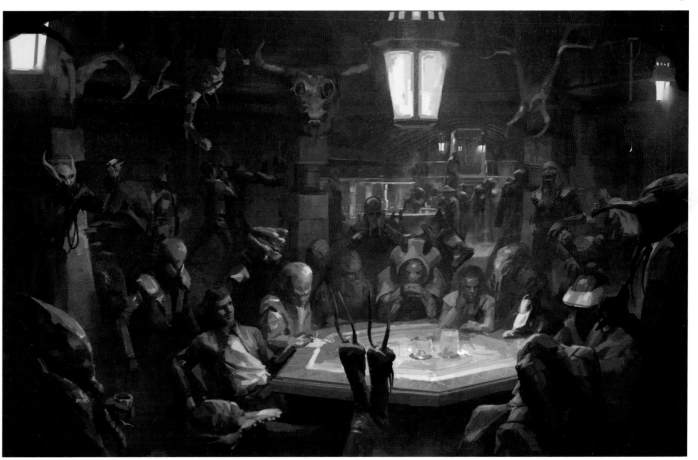

▲ **BACK ROOM VERSION 3C** Htay

"The yacht and saloon sets have to be worlds apart. Han's come back down to earth with a little bump. In previous scripts, the saloon was always called 'the haberdashery.' We wondered, 'Was it more of a general store, more of the Hudson's Bay Company?' That led us down certain routes. We referenced how log cabins are finished, internally. With the wood in the saloon, you think, 'Where would it come from in the Dolomites?' But I could get my head around that and say it's from the lowlands or whatever." Lamont

▸ **SABACC TABLE VERSION 27** McCoy

"Gas powered lighting was designed, a direct reference to the early Victorian lighting used in the bars of the Wild West. Working with Bradford Young, our director of photography, the lamp light added an inviting warmth to what is otherwise a cold harsh environment." Sandales

▸▸ **BACK ROOM VERSION 1B** Brockbank

"This is definitely a showcase moment, more so than any other scene that we've had so far. We are around a table, and these guys are playing cards with human actors. We've got to respond accordingly. There are *Star Wars* ingredients, just like there are James Bond ingredients. If there's not a sexy girl in James Bond, it's not a James Bond film. That's just the way it is. It's great. It's *Star Wars*. We are at a table with aliens playing cards for the *Millennium Falcon*! It doesn't get better, does it [*laughs*]?" Scanlan

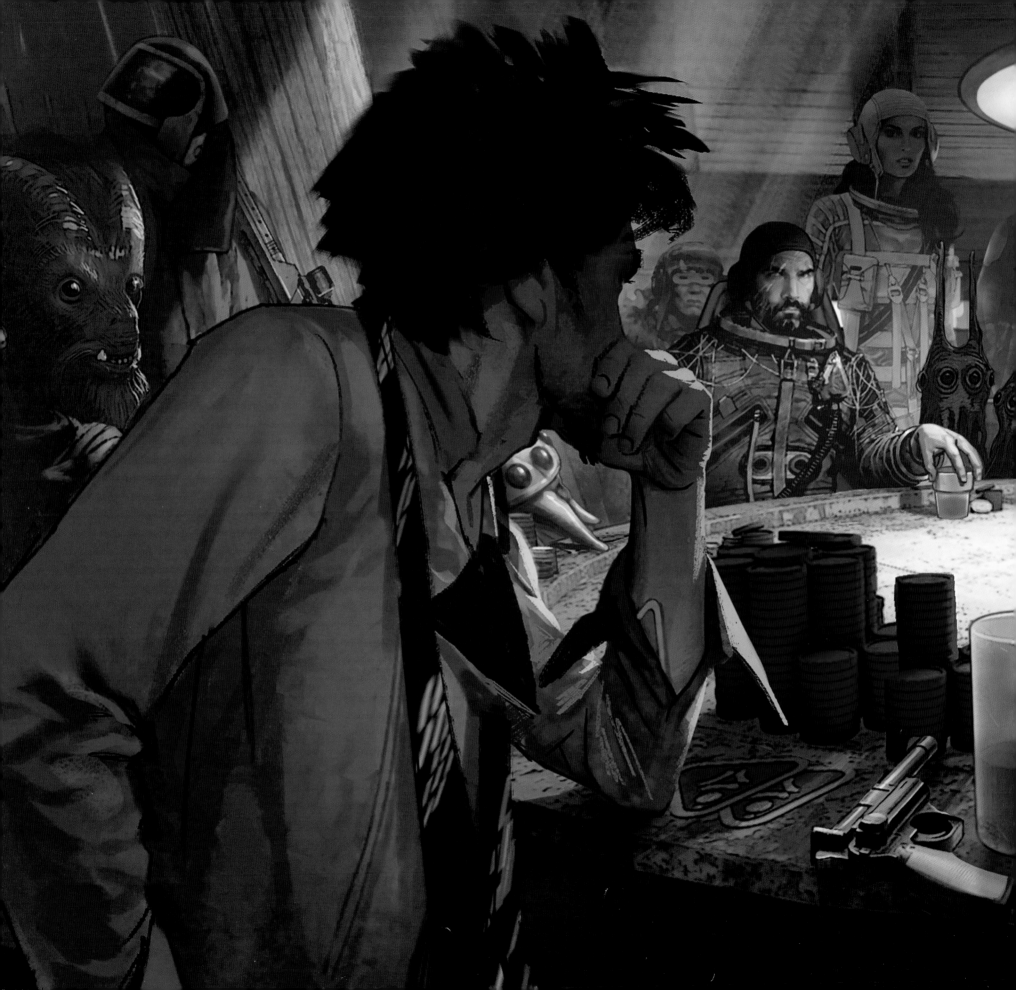

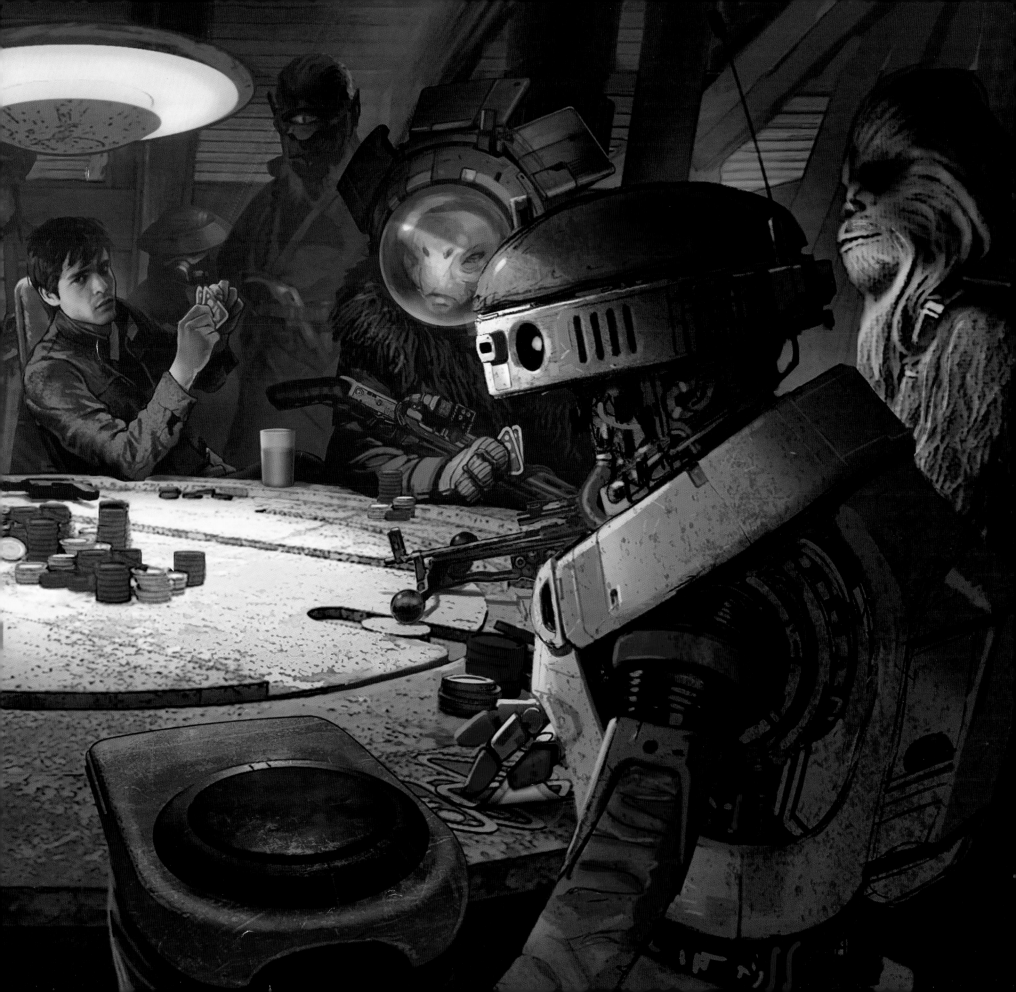

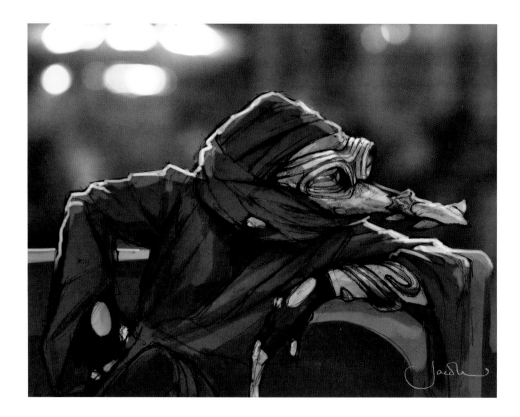

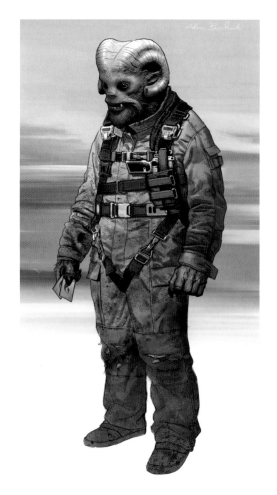

▲ **MAVERICK 002** "Nicknamed 'Crocamole,' this design draws on the long snout of a crocodile or caiman combined with the tooth arrangement of a sawfish. Unlike either of these real-world creatures, however, his lower jaw reciprocates at high speed, turning his snout into a lethal hedge trimmer-type saw." Lunt Davies

◄ **MAVERICK 001** "We did a lot of group concepts referencing Caravaggio and Caravaggisti gaming scenes while also referencing Western and frontier styling, plus fifties pulp sci-fi for some of the alien designs. The latter was a deliberate attempt to give the look a retro feel compared to *A New Hope*. The thinking was, 'If this film had been made ten years before *A New Hope*, what would the designers have then been referencing and been influenced by?' You can probably see the application of this ethos at the card table most clearly in Ivan Manzella's M004, M007, and M009." Lunt Davies

"I've always liked the idea of a creature having to wear their own life-support system, with a visibly different color gas or liquid within the glass bubble of their helmet. She started as a he, and I saw her as a powerful warlord or smuggler boss. The plates that spread out over her back and shoulders are reminiscent of a Native American war bonnet." Lunt Davies

▶ **MAVERICK 006** Brockbank and Fisher

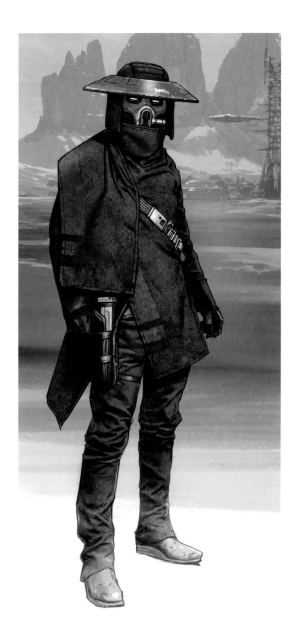

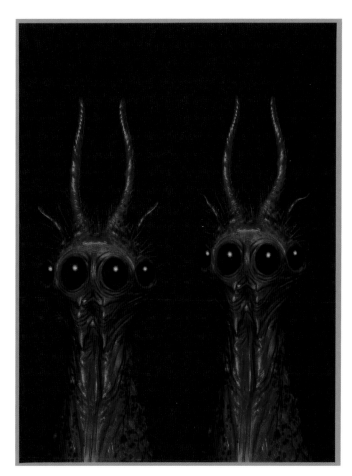

▲ **MAVERICK 007** Manzella

▲ **MAVERICK 009** Manzella

▲ **MAVERICK 003** Brockbank and Lunt Davies

"He started as a concept for Enfys Nest, but he was used as the dealer in the card game, with his scrimshaw bone mask becoming leather." **Lunt Davies**

▶ **MAVERICK 005** Rezard

"We're not breaking new ground with the six-eyed guy, but we are beginning to take more ownership for the future of the films. In a creative and an emotional way, Rian says goodbye to the past and heads to the future in *The Last Jedi*: 'OK, it's time for us now to take what George has given us and left us and try to take ownership of it—take it to where it needs to be four or five films from now.' So the sabacc table seemed like a good opportunity to say, 'They will have seen *The Last Jedi* before they see *Solo*. And wherever we can, we have to start giving the audience more sophisticated animatronics.' This is the next level, if you want to call it that." **Scanlan**

▲ **MAVERICK 004** Manzella

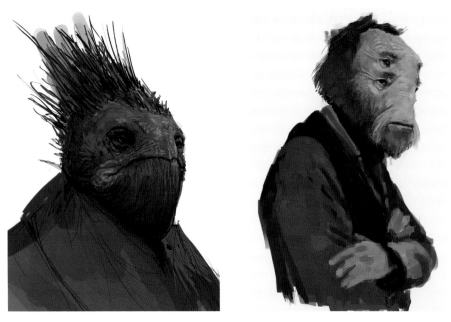

▲ **MAVERICK 015 VERSION 1A** Fisher ▲ **MAVERICK 016 VERSION 2A** Fisher

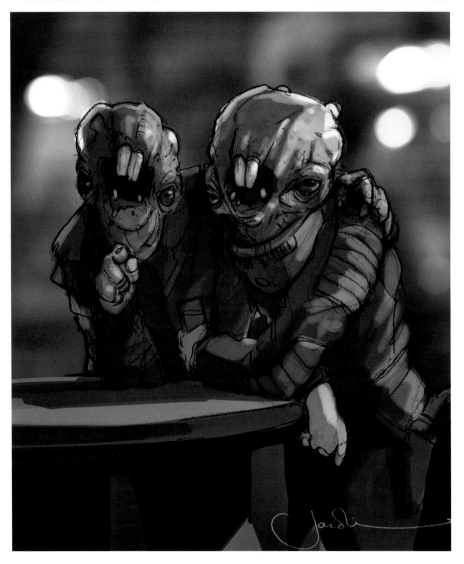

◄ **MAVERICKS 10 AND 11 VERSION 1A**
"These two are deckhands on leave, both drunk, disheveled, derelict barflies based on mole rats. Their ugly faces and uglier opinions are best avoided." Lunt Davies

▲ **MAVERICK 12 VERSION 1A** "I really wanted to create a female character that didn't conform to the obvious (and even subtly overt) sexual stereotypes that often occur in sci-fi and fantasy design." Lunt Davies

▲ **BATTLE DROIDS 21** Lunt Davies

▲ **BATTLE DROIDS 02** Lunt Davies

▲ **BATTLE DROIDS 6B** Lunt Davies

▲ **BATTLE DROIDS 05** Lunt Davies

▲ **BATTLE DROIDS 09** Lunt Davies

▶ **BACK ROOM VERSION 3F** Htay

The initial source of inspiration for the Fort Ypso saloon's droid fighting pit was several pieces of 2013 concept art by Iain McCaig, originally intended for Maz Kanata's castle in *The Force Awakens.* "We wanted two droids that, with the addition of weapons, had been repurposed for fighting: an imposing super-gladiator against an apparently weaker foe," Jake Lunt Davies recalled.

"I wanted them to play more from Lando's point of view, watching L3 in that droid-fight room and him getting a bit tense with her because he's doing so well in the card game. That's why we have that little entrance from the back room." **Lamont**

"It was just an excuse to hit Warwick Davis with hammers, really. That was my feeling. If I can convince him to get in a small suit and hit him, why not? No—again it's a lovely little moment of storytelling, isn't it? It sets up the whole droid revolution for later in the film, and L3's role in all of that." **Scanlan**

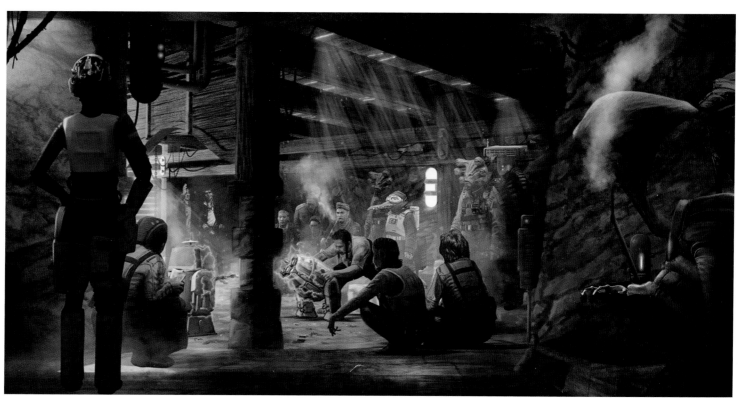

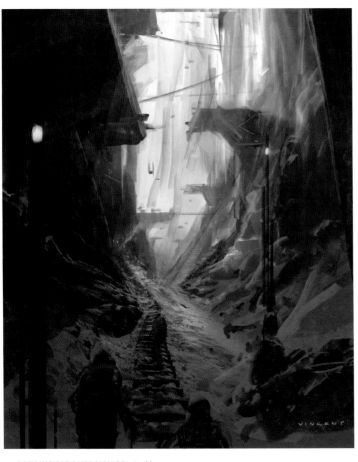

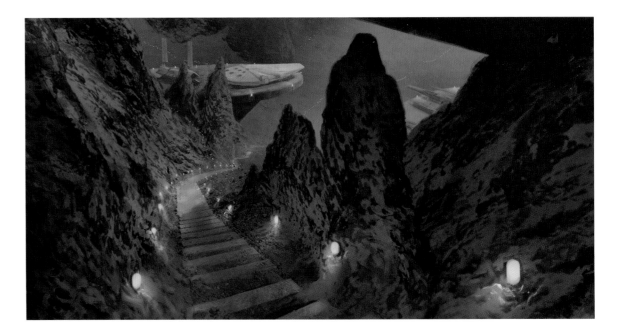

▲ **LANDING PADS NIGHT VERSION 23** Jenkins

"We put a stone arch over the steps so the characters can walk through it on their way down to the fence and not reveal the *Millennium Falcon*. Next, we look back up at a digital extension on the steps as if they've come down from a great height. And then *bang*—there's our new, sleek version of the *Falcon*." **Lamont**

▼ **FALCON UNDERSIDE VERSION 2B** Jenkins

"We were thinking of shooting the impound lot at Longcross Film Studios on the tank slopes (exteriors of the *Millennium Falcon*, as well as the library tree and Canto Bight casino for *The Last Jedi*, were shot at Longcross). But it was only going to be shot for one night, so we had to come up with something quite simple and pragmatic. Instead, we ended up producing our impound lot set within our Kessel environment, then striking the impound around the *Falcon* and recoloring it to become Kessel. It's a real cheat. We're working with the darkness [*laughs*]." **Lamont**

▲ **LANDING PADS VERSION 22** Jenkins

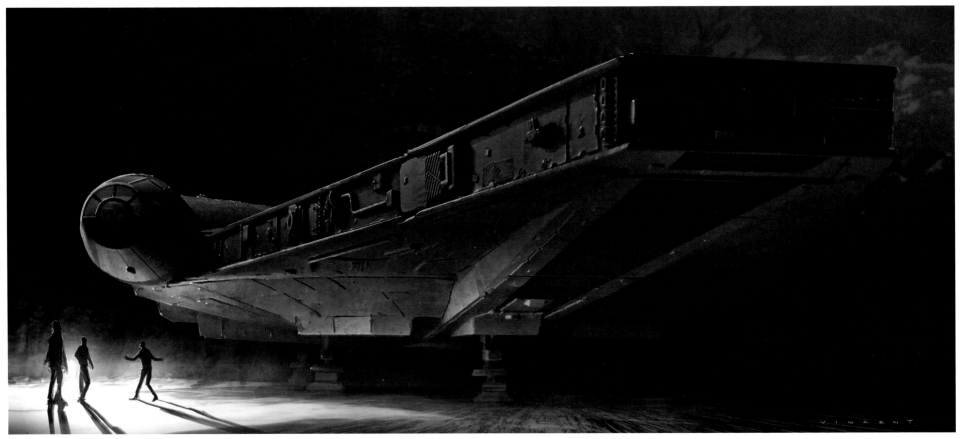

▲ **LODGE ROUGH VERSION 12** McQue

▲ **LODGE VERSION 05** McQue

▲ **LODGE VERSION 01** McQue

▶ **HUNTING LODGE VERSION 01** Clyne

In the earliest days of the visual development of Vandor, Fort Ypso was a single-structure hunting lodge in arid lowland location, far from the mountains where the train heist transpired. "I kept on putting antlers on everything." Clyne recalled. "That old lodge-y ramshackle vibe felt right to explore. We looked at using the Canary Islands as a location for Fort Ypso, which evolved into Savareen. It's fun to see these weird mutations that happen in the process."

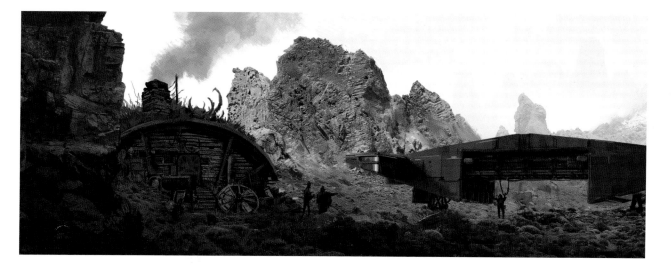

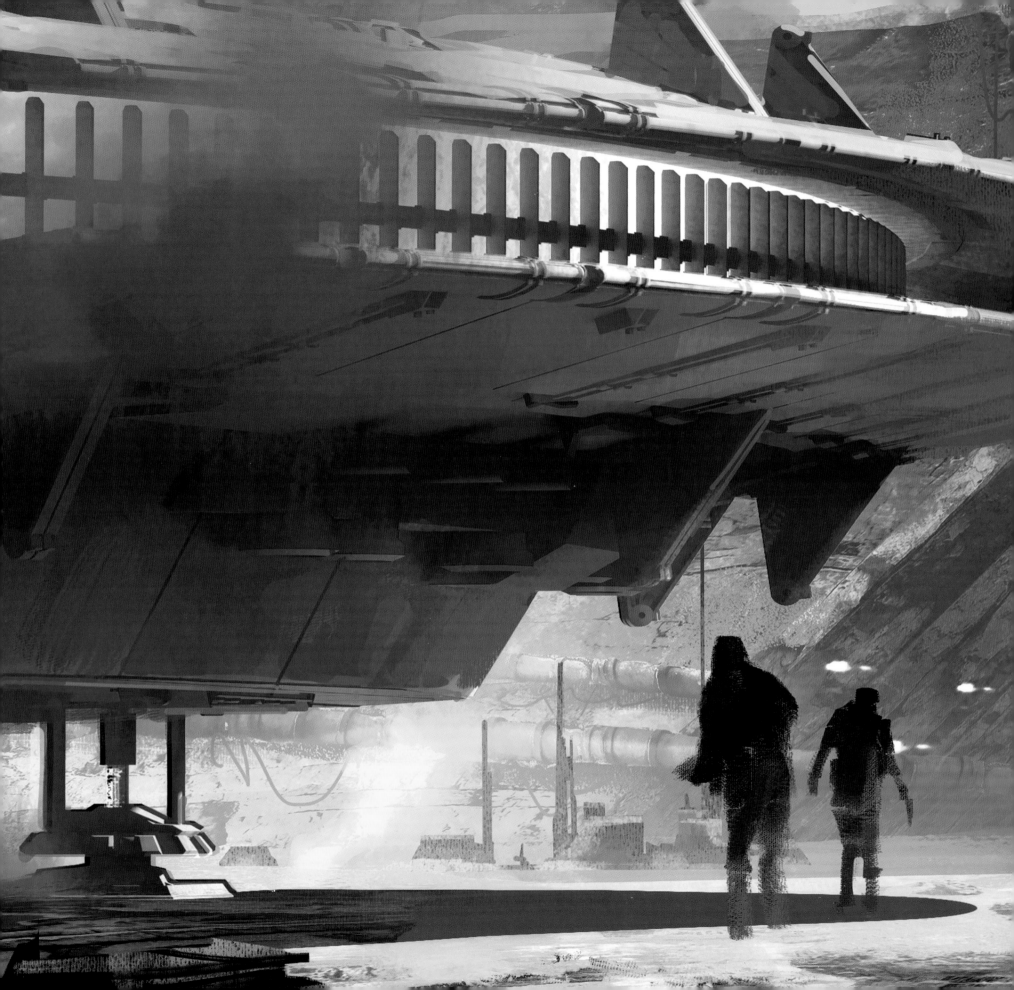

The Pyke Syndicate

Well-versed *Star Wars* fans will immediately recognize Quay Tolsite, the Pyke Syndicate's site administrator for the mines of Kessel, as the same dastardly Pykes that first appeared in the animated *The Clone Wars* television series in its fifth-season episode "Eminence," in which former Sith Lord Darth Maul recruited criminal factions like Black Sun, the Hutt Clan, and the Mandalorians of Death Watch to his "Shadow Collective." From their gloomy homeworld of Oba Diah, the alien Pykes controlled the flow of spice, an illicit and addictive substance, from the spice mines of Kessel in the Outer Rim to Core Worlds like Coruscant via the famous Kessel Run.

Creature effects supervisor Neal Scanlan said, "We liked the existing design but wanted to put a spin on it, making it worthy of a two hundred million dollar *Star Wars* film. We wanted to make the design a little more coherent. So the guys sketched away."

The true origin of Quay and the Pyke Syndicate was known only within Lucasfilm: an alien originally sketched by concept artist David Hobbins in April 2007. *Star Wars* creator George Lucas plucked the design out of dozens (this one, in particular, a design for an alien Jedi) to represent the Pykes, asking for eyestalks that came out of its bulbous head to be removed and replaced by what were then its nostrils, giving it an odd fishlike appearance. The Pyke's head and costume design was honed in mid-2009 by *Star Wars* comic book and concept artist Doug Wheatley. Oba Diah, aspects of Kessel, and the Pyke Syndicate's role in the spice trade were all delineated and designed at that time as well.

That same Pyke creature design was carried over into development of an unproduced LucasArts video game called *Star Wars: 1313*, centering on Coruscant's criminal underworld. In mid-2012, LucasArts concept artist Colin Fix further refined the Pykes, leaning into their fishiness by adding a crab-like armored carapace to the back of their long craniums. Simultaneously, the Pykes were being ushered into *Star Wars: The Clone Wars* for their January 2013 debut by Lucas and creative director of Lucasfilm Animation Dave Filoni.

The Pyke Syndicate control room in the Kessel mines was shot from August 1 through 3, 2017, on Pinewood Studio's L Stage.

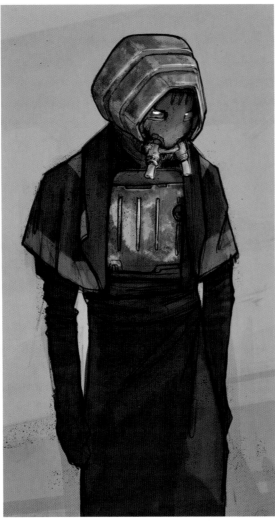

▲ JEDI CONCEPT 06 David Hobbins

▲ PYKE 06 Lunt Davies

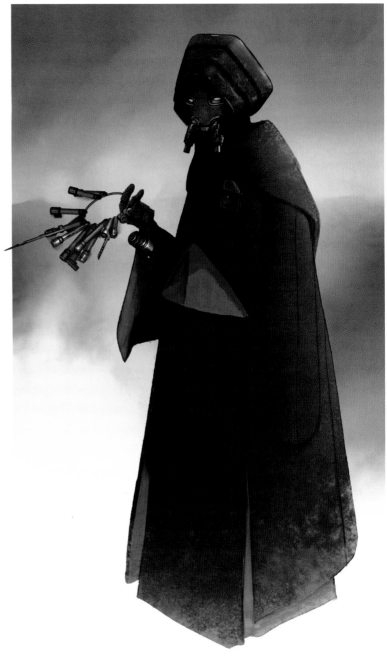

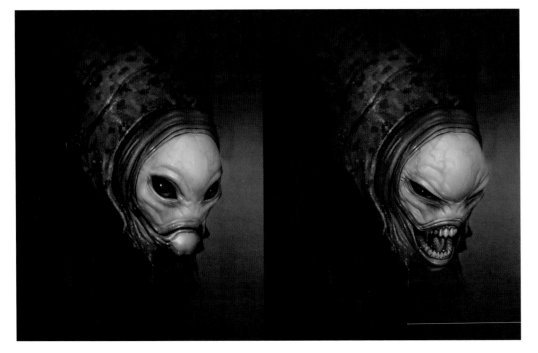

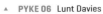

▲ QUAY TOLSITE VERSION 1E Brockbank

"Jake designed the Quay that's in the film now. Dee Tails, who is the performer inside, is great. The performance has a feeling of the informant Huggy Bear from *Starsky & Hutch*. He moves in a certain way [*laughs*]." Scanlan

"I remember thinking about the triangular shapes of the Kessel tunnels, and wanting to include that motif in the costume. So I did this cutout piece on his stomach in a triangular shape. Inside that space is that *Star Wars* mucky-looking oily gak. The overall figure was black, but we tried greens and reds, and then landed on yellow for the inserts, encrusted in the yellow dust of Kessel. His gloves are a bit like Two Tubes's gloves in *Rogue One*. I remember the script saying that the Pyke language sounds 'disgusting.' So he's a bit creepy, a bit sinister. You don't quite know what he is. Is he alien and part machine? I just wanted him to feel discomforting." Dillon

◄ PYKE HEAD Fix

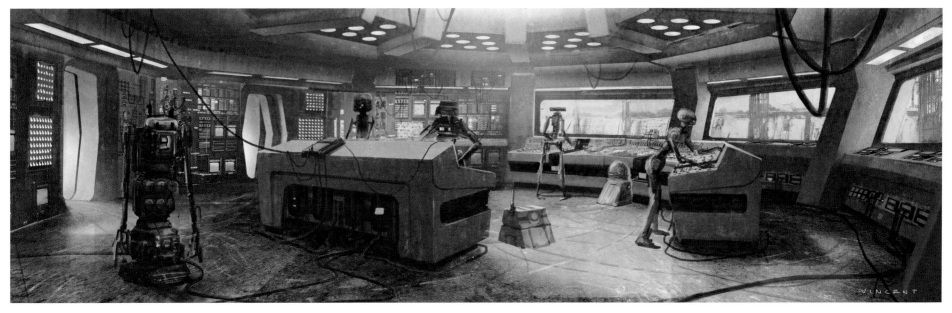

▲ **CONTROL ROOM VERSION 1A** Jenkins

▲ **DROIDS VERSION 11B** Lunt Davies

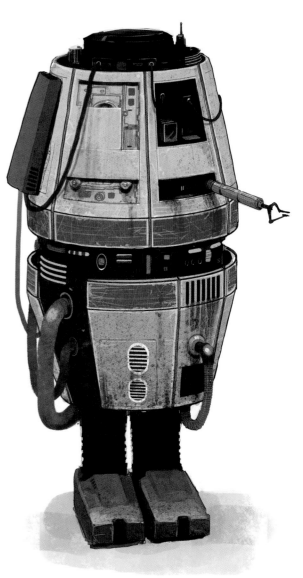

▲ **DROIDS VERSION 12A** "For the control room, we used a variety of droids picked from different sources. Some were rejects from the early days of L3 exploration; others were designed specifically for the scene. We also concepted scenes of droids being driven into the ground as they worked in the mines, the fear that See-Threepio expresses in *A New Hope*." **Lunt Davies**

◄ **KESSEL DROID VERSION 1A** Brockbank

"Some of the four humanoid droids for the mine ops center were *Rogue One* L3 ideas that were rejected—but they suited the mines. Our workshop loves making droids. They're a bench build now. You can take the basis of the droid and start adding pieces and playing with it." **Dillon**

▸ **DROIDS VERSION 14A** Fisher

"DD-BD is the droid that L3 liberates. And again, Warwick plays her. There was one design in particular that was taken forward. Others were close to the mark, and for that reason they were still valid for additional droids." **Scanlan**

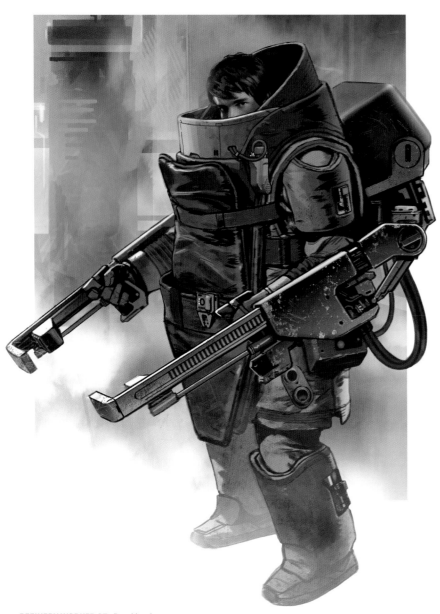

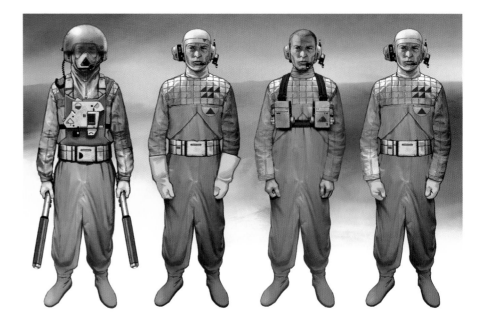

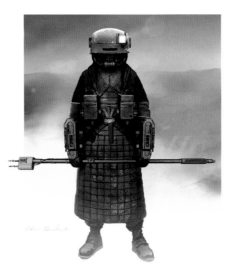

▲ **KESSEL SUPERVISOR VERSION 2A**
Brockbank

"The mine workers look nice and sinister.
Those headphones go around the back in
a similar way to Lobot's headgear. Maybe
that's where Lando got the idea from
[*laughs*]." **Crossman**

◄ **KESSEL GUARDIAN VERSION 1F**
Brockbank

"We didn't want the Pyke guards to be
instantly recognizable as humans, so we
tried to scale them up and keep all of the
proportions big. Their helmets are not
human-shaped. They sit flatly on their
head. It could be a hammerhead alien
under the helmet." **Crossman**

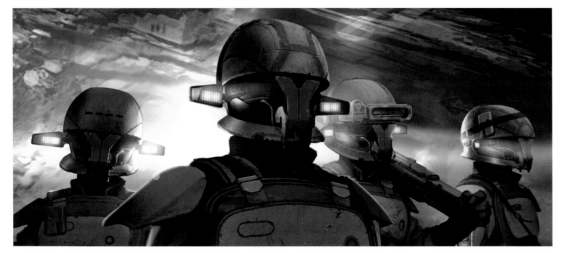

▲ **PYKE HELMET LIGHTS VERSION 01** Brockbank

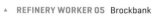

ELECTRO STAFF

▲ **ELECTRO STAFF VERSION 1A** Savage

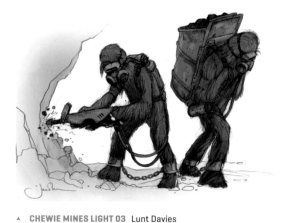

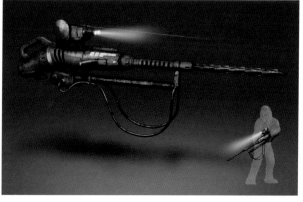

▲ **CHEWIE MINES LIGHT 03** Lunt Davies

▲ **COAXIUM EXTRACTOR DRILL A** Chris Caldow

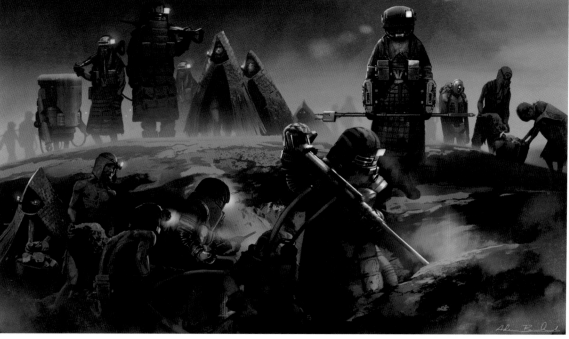

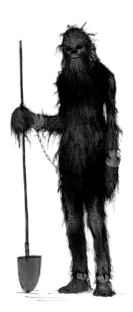

▲ **WOOKIEE MINER 02** Fisher

"We did an early experiment where we went freestyle on the Wookiee's portraiture. The sculptors and I were looking at them one day, and I said, 'I don't like them. They're not Wookiees to me. They're something else,' because all Wookiees are drawn out from Chewie in my world. So we took a cast of the Chewie head and used his bone structure and the proportionality of his face in order to create our emaciated mine Wookiees. It's worked really well. Somehow, his personality is still in them. And for that reason, you look at them and go, 'They are right. That's what I imagined.'" Scanlan

▲ **KESSEL COLLECTION VERSION 1B** Brockbank

"We did designs for slave workers, as well. They're like Japanese folk rain-capes for foul weather, made out of wicker. We made them a whole head-covering thing with a light inside so they can be some form of protection from the endless dust of Kessel." Crossman

▶ **WOOKIEE COLORS 02** Lunt Davies and Fisher

"These are Luke Fisher's original illustrations over which I worked color options, hair loss, and wounds. The objective of these was to create variations that would be distinctive from each other and Chewie plus also displaying the hardships of toiling in the mines. We deliberately chose thinner, tall actors to enhance the emaciated look of the slave Wookiees in comparison to Chewie." Lunt Davies

"We didn't want them to feel like Chewie clones. Wookiees come in different colors, like cats and dogs do. It was incredible how majestic Chewie looked when we got these four guys lined up and Chewie joined them. Joonas looked absolutely fantastic next to his counterparts! It's funny how you respond. You feel very sorry for the slaves, but at the same time, you'll see how empowered Chewie is as a character. It defines Chewie as an alpha Wookiee." Scanlan

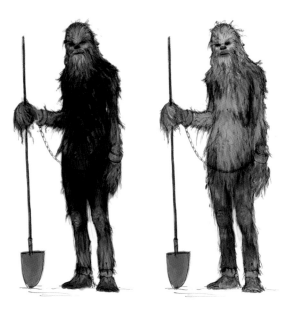

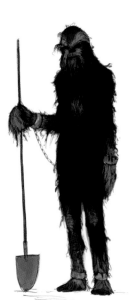

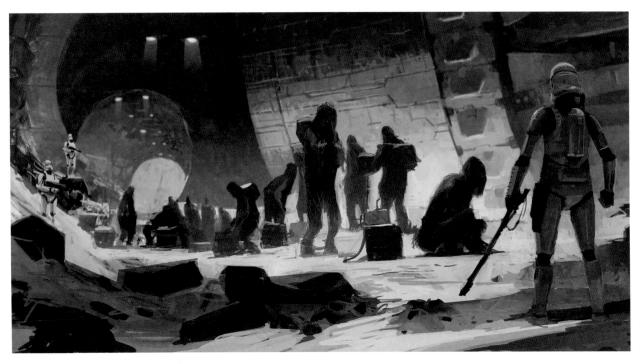

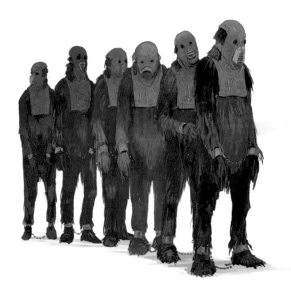

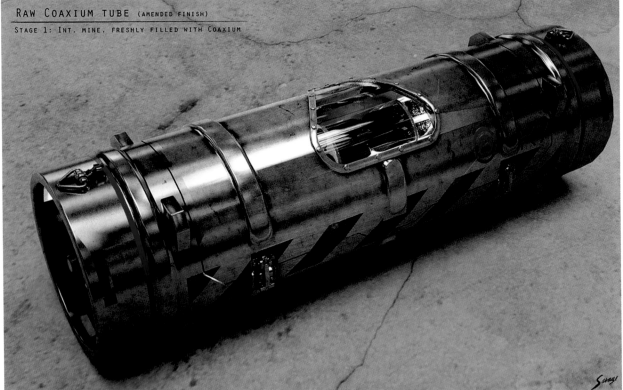

RAW COAXIUM TUBE (AMENDED FINISH)

STAGE 1: INT. MINE, FRESHLY FILLED WITH COAXIUM

"I reasoned that the mine owners would have a generic design of protective headgear that could easily be adapted to fit a multitude of different head shapes, and that we could use this to generate the appearance of different species." Lunt Davies

"I started working on the unrefined coaxium container when I was still finishing up on *The Last Jedi*. My thought was that it had to be industrial. There are three different stages of corrosion. When we get to level three, it needs to literally look like it's going to explode. You know when you wet the pages of a book and they fan out? We tried to get that look in metal so it looked like it was slowly expanding and peeling back. We got to the silver and gold color because I thought it looked like a Western bank vault door that contains something really precious." Wilkinson

"The first thing that we dealt with was the graphic on the coaxium canister, the ticking time bomb of the film. We had to show, graphically, that the coaxium is deteriorating, going from being quite calm and gentle to almost ready to explode, on the journey through to Savareen. In the script it says 'seventy-eight degrees,' but we can't show that. We've spent a lot of time on *Solo* making the graphics look old or out of focus or have echo or have dirt on them, just generally not feel like a graphic that you would see on an iPhone or a laptop." Booth

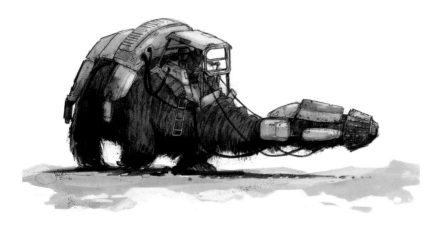

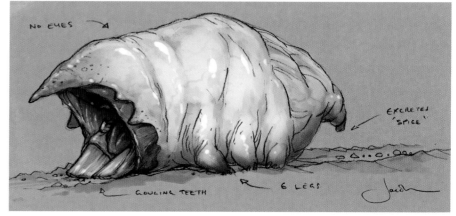

▲ **BEAST 01** Lunt Davies

"Luke and I worked on developing the mine beast, with both of us coming together to take the machine-snouted grub version further before Luke's design won out. The brief was to make the creature big and slow, but filling the tunnel so that the only escape was ahead of it." **Lunt Davies**

▸ **MINE BEAST 11** Fisher

▾ **KESSEL CREATURE VERSION 04** Allsopp

In early drafts of the *Solo* screenplay, an "elephant-sized naked mole creature" with a giant drill on its face, called a "wapota," is spooked by the riot instigated by L3-37 and DD-BD. As Han and Chewie make their escape, slowly pushing a hover-sled full of unstable, unrefined coaxium, the lumbering mine beast follows behind, leading to the "slowest foot chase ever."

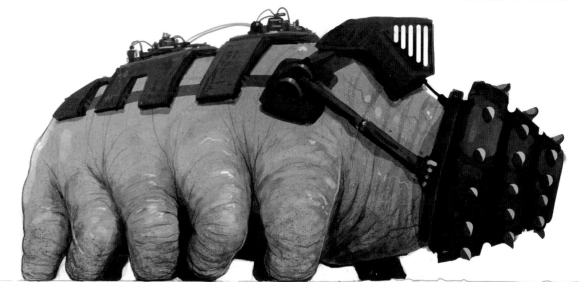

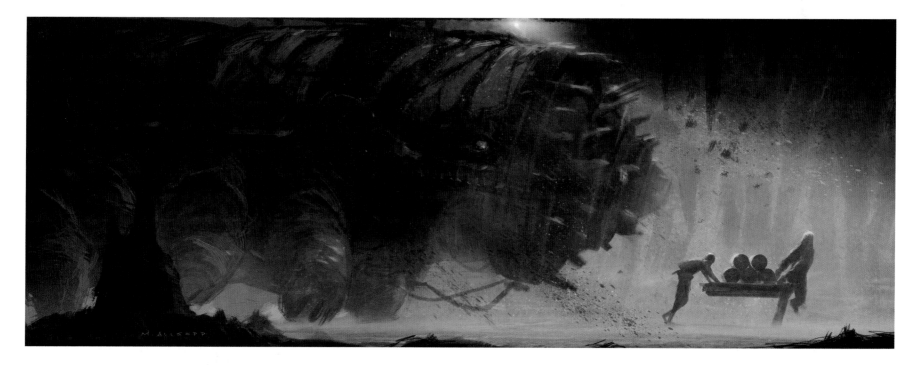

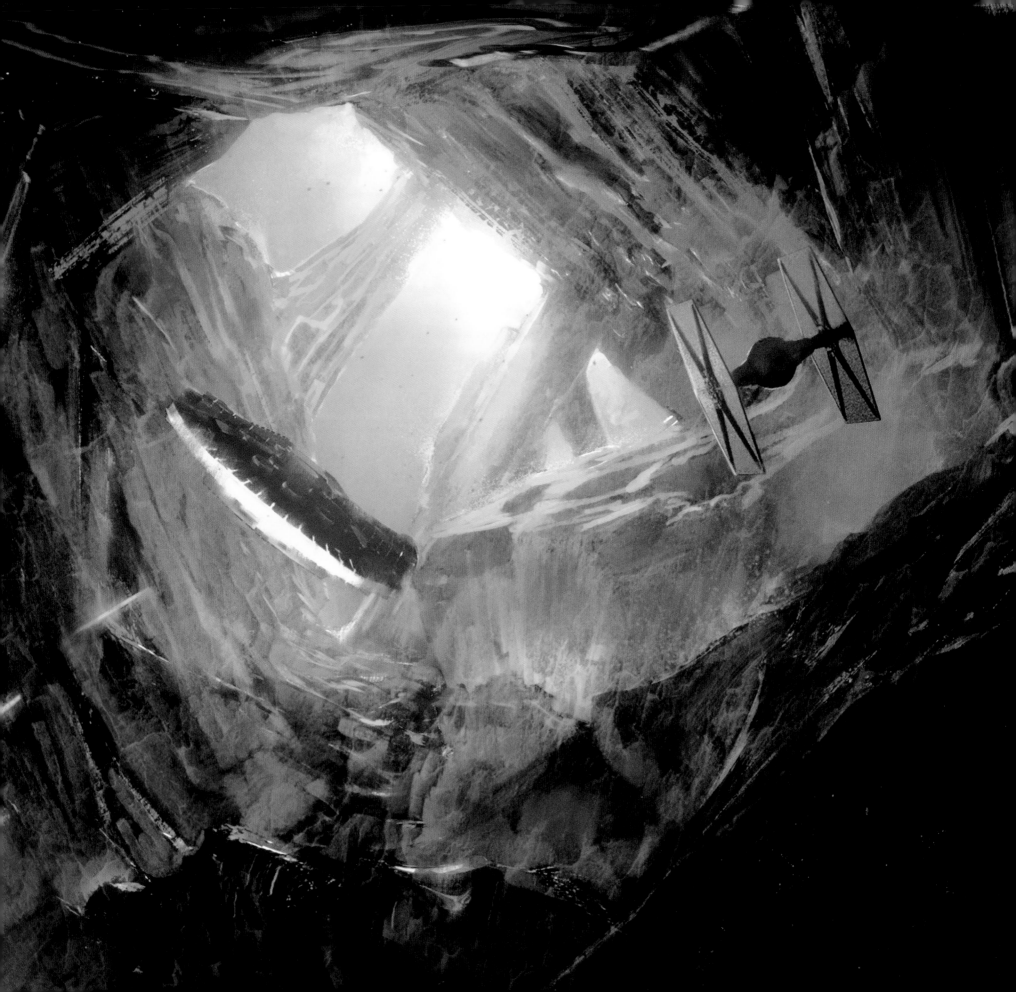

Kessel

Also returning for their fourth successive *Star Wars* film with *Solo* were computer graphics supervisor Andrew Booth and his BLIND LTD. team, but they were surprised to discover that leveraging off of their experience from the previous three films—especially *Rogue One*, which is set in a similar time period between *Revenge of the Sith* and *A New Hope*—would not bear fruit. Booth recalled, "*The Force Awakens* was very future-focused thinking, in terms of what the graphics could look like, but we also had to be respectful of the past. *Rogue One* was definitely playing in that arena of the original *A New Hope* from 1977. When we came to do *The Last Jedi*, the fact that we had been to the future and been to the past really informed what we did. Approaching *Solo*, I originally thought, 'Oh, it's like *Rogue One*.' And I was wrong in that estimation."

Solo's computer graphics were rationalized and realized in terms of real-world decades, not splitting the difference between the original trilogy and prequel aesthetics. "If you imagine that *Rogue One* was 1976/1977, what we've done with *Solo* is gone back to the mid-sixties," continued Booth. "When it comes to sixties film references, we are definitely talking about *2001: A Space Odyssey* and, as with *Rogue One*, *The Andromeda Strain*. Obviously, George Lucas's *THX 1138* was an inspiration to us, in terms of the fidelity of the image and his use of bold, simplistic graphics that told the story. But what did computers look like in the 1950s or '60s? What was computer art like then?"

Booth referred to art made by the fathers of computer animation, including John Whitney, whose son John Whitney Jr. was a consultant for *Westworld* (1973), and Ben F. Laposky, who in the early 1950s "did really beautiful computer art, photo-graphed with a 35mm camera, which is how you get that really beautiful fidelity. There's a thing which we call 'echo,' almost a smoky trail that follows a moving graphic. You've got the flicker in there, as well." Booth continued, "Everyone thinks computing or computer graphics is quite a modern thing. But this is over sixty years ago. People were actually creating fine art out of a computer then, whereas people today don't necessarily think of doing that."

"Then we started looking at the displays of that time," said Booth. "SAGE was an Earth-observing satellite that we got some videos of. It looks almost like radar. They had all of this amazing technology and one of the first things they did was a drawing of a pin-up, like the nose art on a World War II plane, which I thought was very human. Space program graphics from the late sixties were much more the graphic language that we really wanted, in terms of simplistic, bold, vector-style graphics, generally on a cathode ray tube [CRT], very old school. The more that we got into this, the more we realized that we couldn't use the computer."

Booth recounted that, "The process on the classic *Star Wars* films was hand-drawn cell animation, so we started drawing what the coaxium canister graphics may look like, also wrapped in with Harry Lange. It felt like the way to go. Normally, we would do this in Adobe Illustrator or Photoshop, completely precise. This time, we actually hand-drew it, scanned it in, and then created the graphic. What this gave us, which we loved, was a handmade aesthetic. That has been our credo ever since. It's got to feel like it's handmade."

Alongside the coaxium canisters, Kessel's computer and security monitor–filled operations center became a showplace for Booth and BLIND LTD.'s 1950s, retro-graphic sensibility. Han Solo and Chewbacca's journey through Kessel's tunnels and caves would be captured and displayed, both in-universe and to filmgoers, through era-appropriate closed-circuit television [CCTV] cameras and CRT monitors, with their inherent flicker, dirt, and fuzz.

The *Millennium Falcon*'s measured arrival and hasty depar-ture from the landing pad just outside the Kessel mines were shot from July 11 to 17 on Pinewood's backlot. July 11 was also the day that *Star Wars* creator George Lucas, his wife Mellody Hobson, and family visited the *Solo* set, touring the "clean" *Fal-con* interior on C Stage, posing for photographs at the holo-graphic chess board and chatting with longtime *Star Wars* actor Warwick Davis, who, as a preteen, made his acting debut in 1983's *Return of the Jedi*. Han Solo and Chewbacca's journey through the maze-like mine tunnels was shot from September 18 to 20 on E Stage which, in mid-2014, housed the Resistance base interior for *The Force Awakens*.

 ◂ **ICE RUN VERSION 6A** Dudman

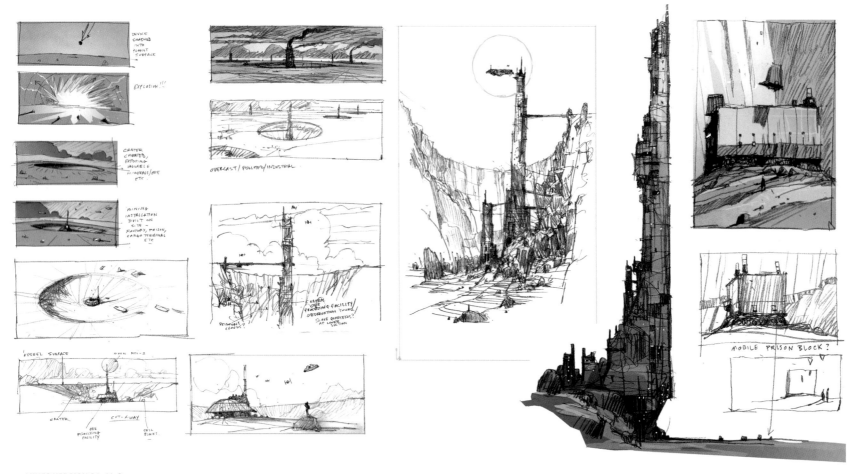

▲ **MINES VERSION 01** McQue

▲ **KESSEL RUN VERSION 05** Justin Thompson

▲ **MINES VERSION 01** Clyne

▲ **KESSEL PLANET VERSION 9A** Northcutt

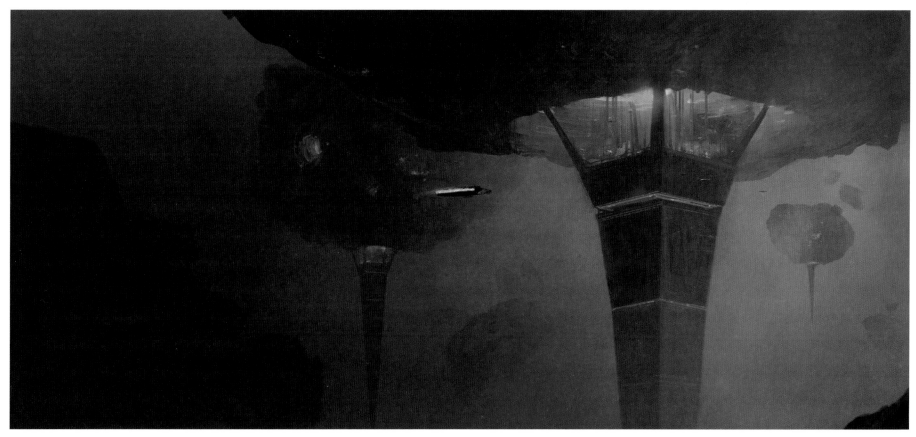

▲ **KESSEL 02** Allsopp

▼ **MINES VERSION 05** Tenery

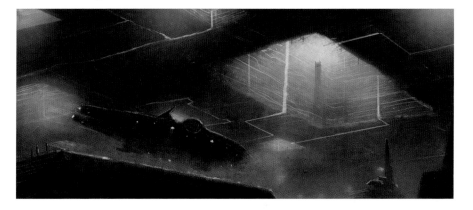

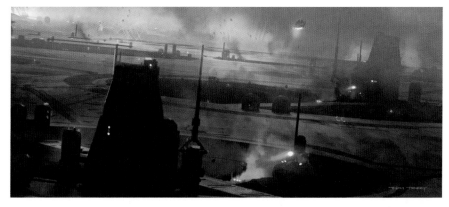

▲ **INSIDE MINES VERSION 5A** Jenkins

▶ **KESSEL MINES VERSION 2A** Htay

"Originally, we looked along an open-cast copper mining area in Spain. There are a lot of copper mines out there. In Rio Tinto, we found a very interesting disused mine with great scope that we could have used." **Lamont**

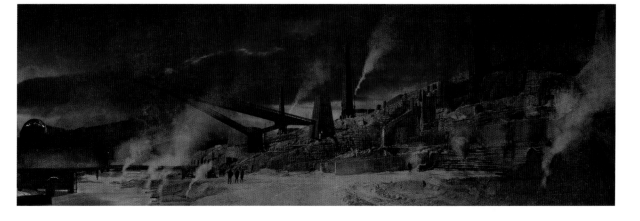

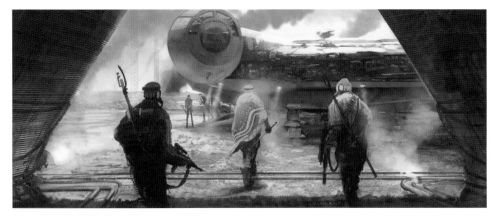

▲ FALCON GREETING VERSION 9A Jenkins

▲ KESSEL CONCEPT VERSION 06 Northcutt

◄ LANDING AREA VERSION 1A Htay

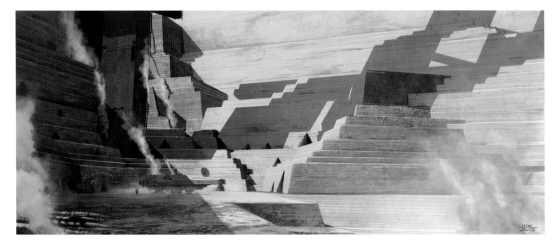

"In Dallol, Ethiopia, there's this incredible sulfurous poison pool that sparked a lot of the ideas for Kessel. They even wanted to bring a camera and shoot there, as a miniature world. But the mechanisms in the camera would melt, due to the amount of toxicity coming off of those lakes." Clyne

"We'd be in a meeting, and I'd bring up triangles or yellow. I'd look over to Neil and he'd just roll his eyes [laughs], thinking, 'That will eventually get kicked to the curb.' Honestly, those two things are very memorable. People will remember what Kessel looks like, for better or for worse. It's kind of ballsy, but sometimes you have to do something a little out of the box." Clyne

"James and Vincent Jenkins worked for quite a long time on triangular tunnels, which I've always kicked and bucked against. But you can always turn a triangle on its point or break it down, as we will." Lamont

▼ KESSEL LANDING PAD VERSION 06 Northcutt

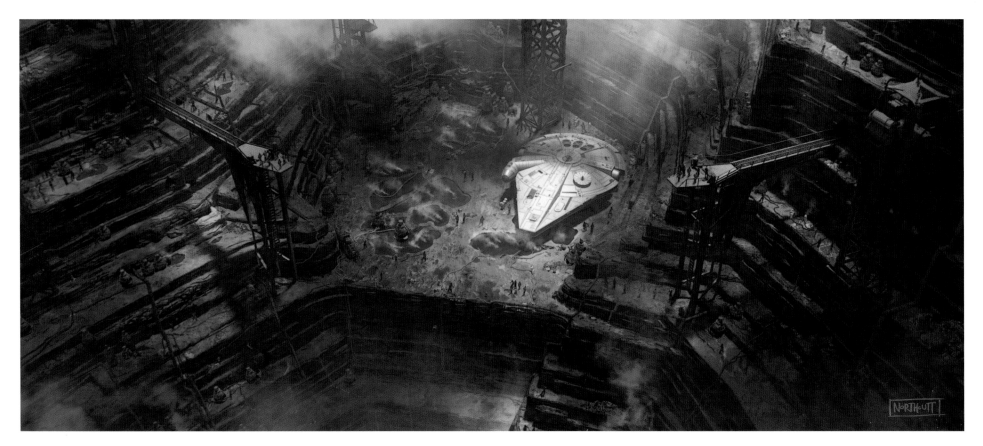

▲ PACKHORSE 008 Lunt Davies

▲ FREE THE DROIDS VERSION 7D Jenkins

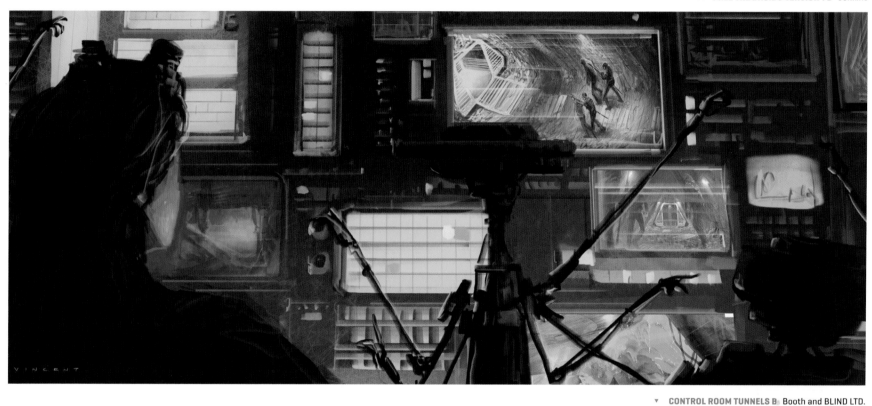

▼ CONTROL ROOM TUNNELS B Booth and BLIND LTD.

▲ SECURITY MONITOR VERSION 6A Jenkins

"The control room is very simple, very late-sixties. There's a Soviet control room we used as reference and a control room at Fawley that's the same color, the same vibe, and the same details. That's what we're saying is Kessel/Pyke red oxide primer." Lamont

"We originally thought that Han and Chewie's adventure to find the coaxium was going to be played out in a schematic, so the plans of the Death Star felt like a very obvious reference. Now we are discussing CCTV through security cameras. We can then process the footage and make it feel like it was from the sixties or seventies. Then we can play it back and record it with an Arri ALEXA 65mm digital camera. Even though we are in the twenty-first century, where you can do almost anything from a visual-effects perspective, the fidelity and the reflections, and the light that emits from a monitor, is very difficult to replicate in post." Booth

▲ CONTROL ROOM TUBE A LOOP Booth and BLIND LTD.

"We actually referenced *Westworld* (1973) for the mining control center, only because they have some really cool triangle graphics. The whole point of Kessel is that it's triangulated, so we riffed on that." Booth

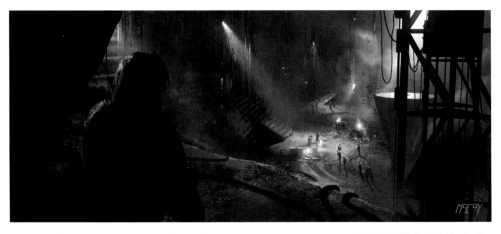

▲ **RUNNING THROUGH THE MINES VERSION 10** McCoy

▼ **WHICH WAY VERSION 6B** Jenkins

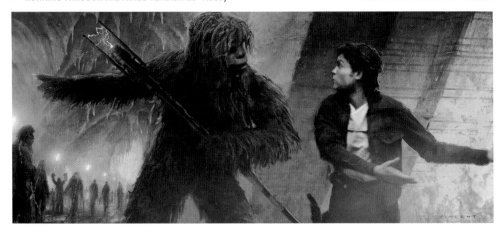

▼ **COAXIUM STORAGE VAULT VERSION 2A** Htay

▲ **KESSEL MINES VERSION 06** Faulwetter

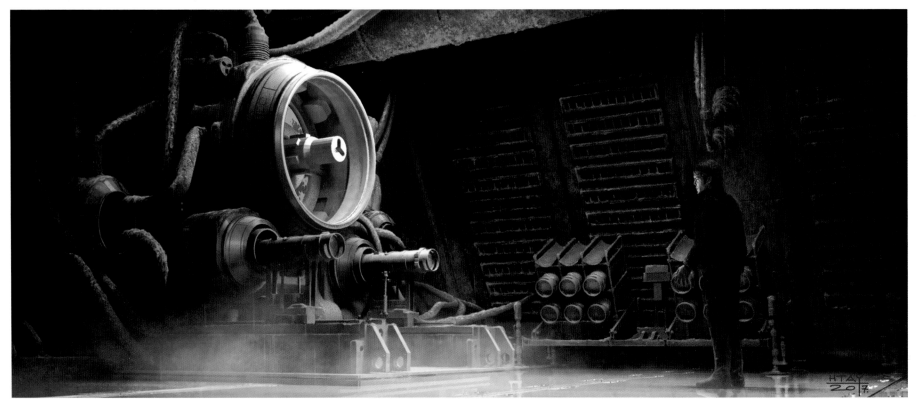

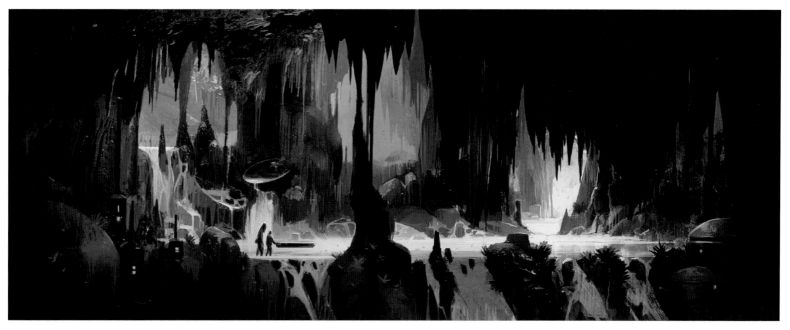

▲ **CHASE VERSION 05** McQue

▲ **WALK TUNNEL VERSION 1D** Jenkins

▼ **LANDING PAD VERSION 1D** McBride and Clyne

▼ **KESSEL FALCON VERSION 01** Faulwetter

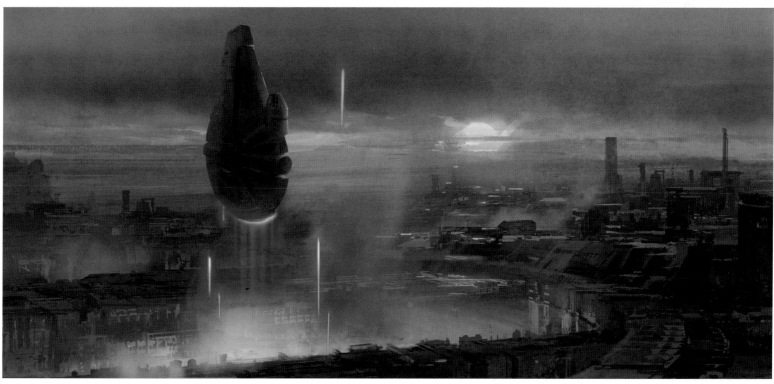

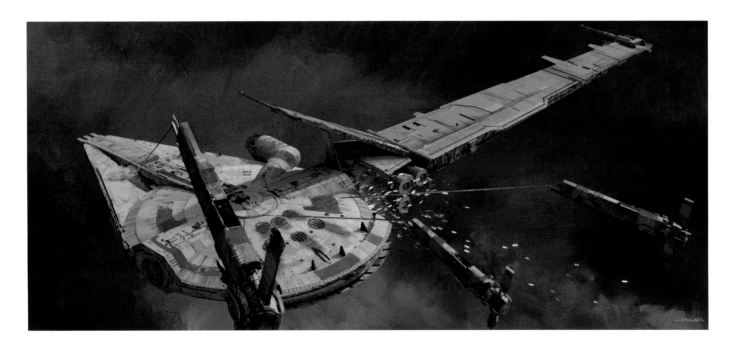

◄ **KESSEL RUN VERSION 01** "Enfys Nest's *Buckshot* was going to have a big moment in the Kessel Run. She catches up with them and harpoons the *Falcon* to slow it down, collaring onto one of the docking ports of the *Falcon*. But now, all parties converge on Savareen, the O.K. Corral." **Clyne**

▼ **ESCAPE POD VERSION 1A** **Htay**

"They kept the Episode VIII escape pod location vague, but we're being very direct about where our *Falcon* mini-ship is. You go through a removable pad on the little bed behind the holochess bulkhead seat. Our pod ejects from between the mandibles. So it will have a tunnel similar to the tunnel to the *Falcon*'s cannons." **Lamont**

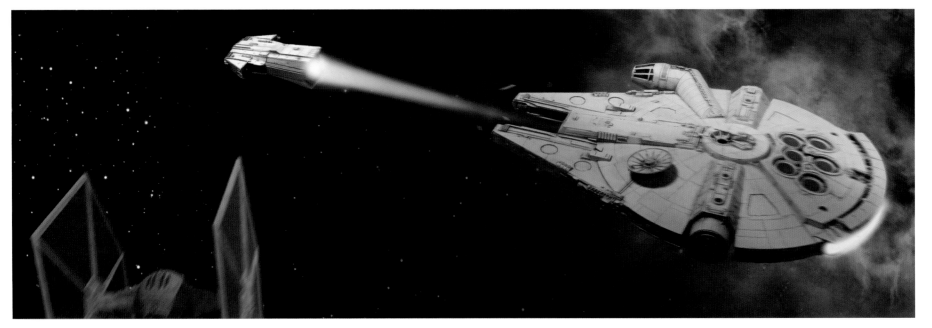

▼ **KESSEL RUN MAP VERSION 03** Chris Voy

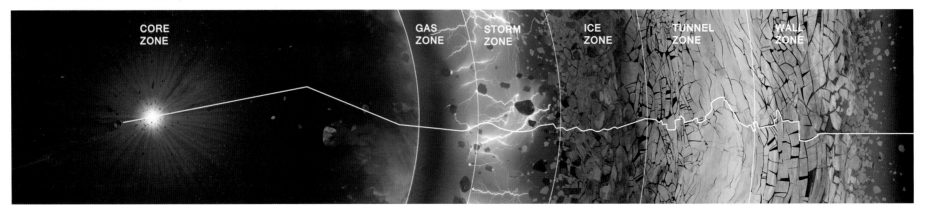

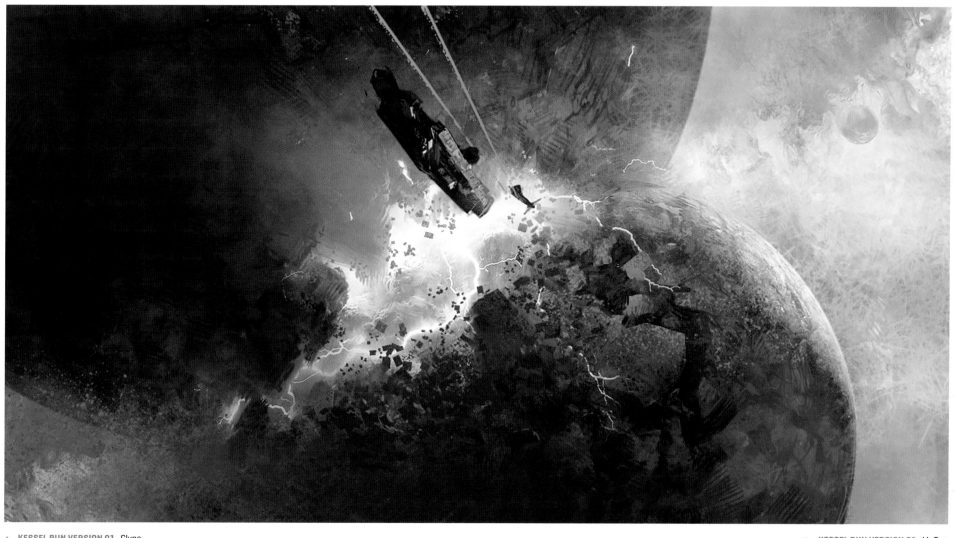

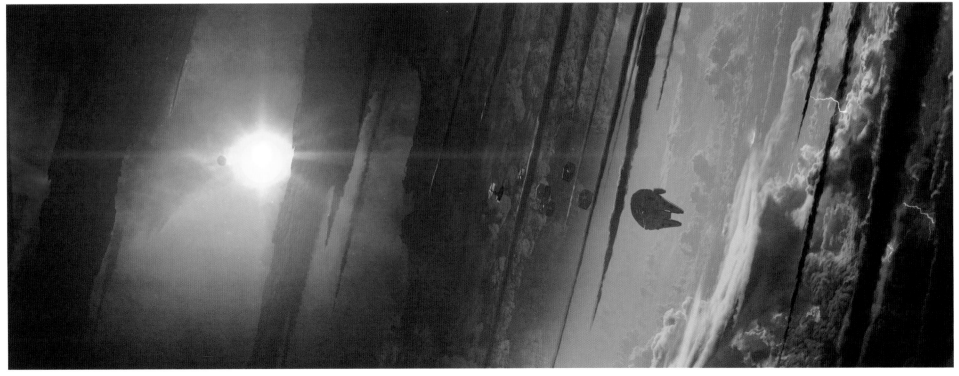

▲ INTO THE MAW Voy

▼ BUOY OPTIONS VERSION 4C Voy

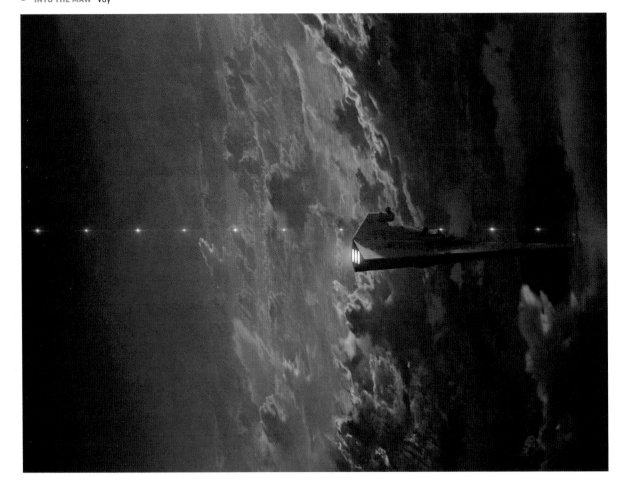

▼ KESSEL ENTRANCE VERSION 01 Zavala

▲ MAW ENTRANCE VERSION 2A Voy

▶ CLOUD TUNNEL B Voy

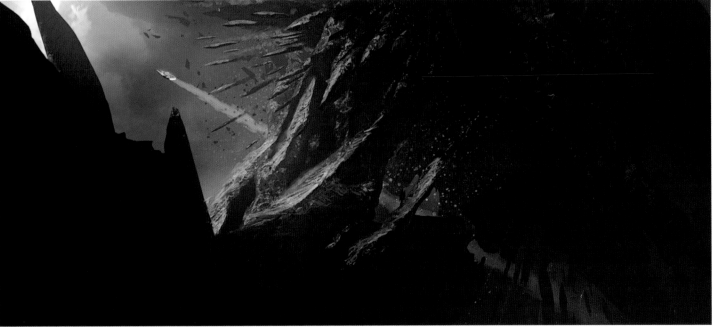

▲ **ICE CAVES VERSION 1B** Faulwetter and Clyne

"The carbonbergs have always been in the
Kessel Run. There's some reference I found
of shards, obsidian-looking shapes. The
carbon is a little foreshadowing to carbonite
on Bespin. 'Something smells fishy around
here.' Kessel was just an open world that
we were trying to fill, with some success
and some not. And I thought, 'What if this
world is so big that small moons are being
slammed into each other?'" **Clyne**

◄ **CARBONBERG VERSION 1B** Dusseault

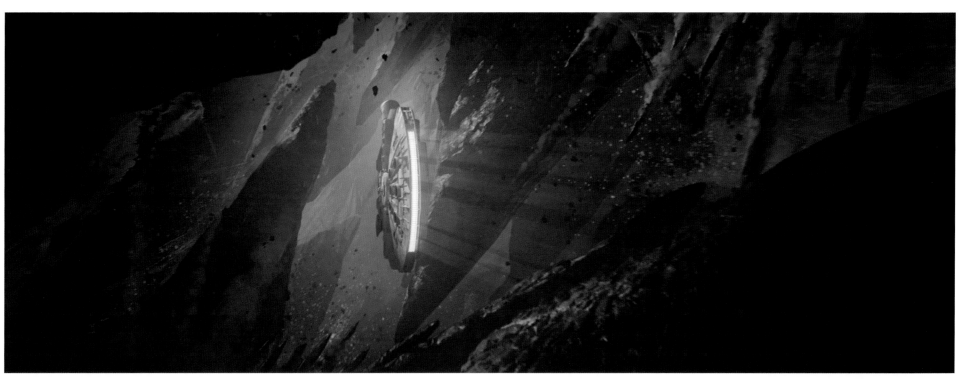

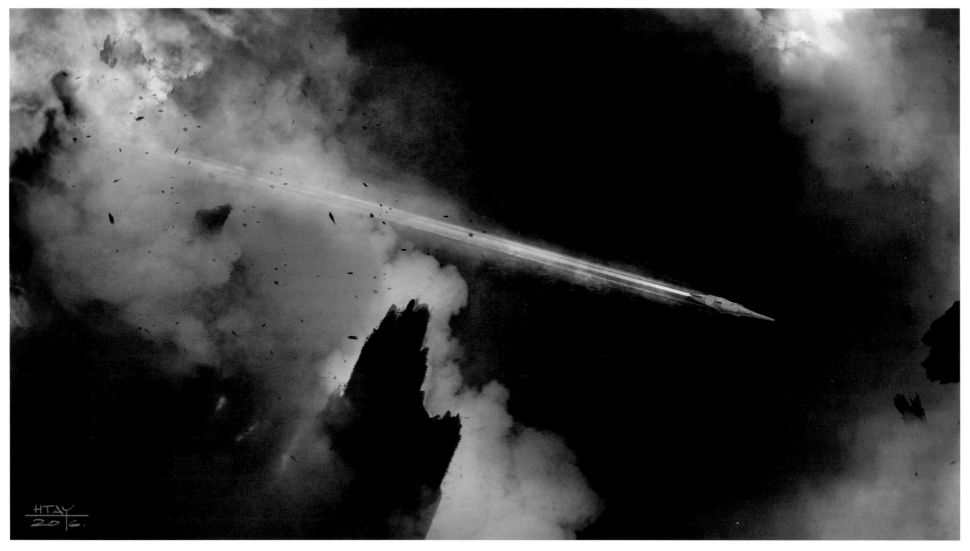

▲ **KESSEL RUN VERSION 5A** Htay

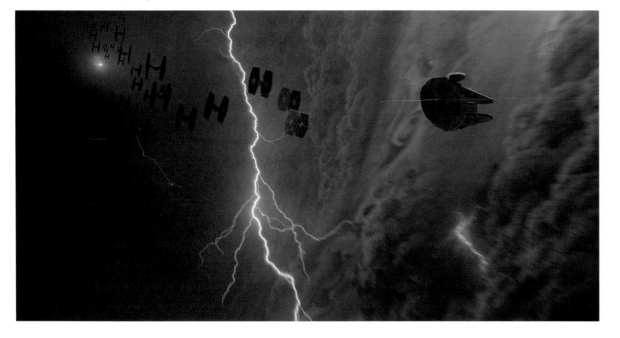

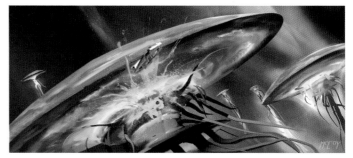

▲ **JELLYFISH FLY THROUGH VERSION 1G** McCoy

"The jellyfish in the Kessel Run, again, came from throwing dumb ideas out in a meeting," Clyne recalled. "I literally opened my sketchbook and pitched, 'What if the *Falcon* had to fly through a jellyfish?' [*laughs*] 'Yeah. All right. OK.' But we come back and, 'There's a jellyfish in the presentation.'"

◄ **INTO THE MAW VERSION 1E** Voy

▲ SPACE MONSTER EYE VERSION 4A McBride

▲ SPACE MONSTER TENTACLE VERSION 9B McBride

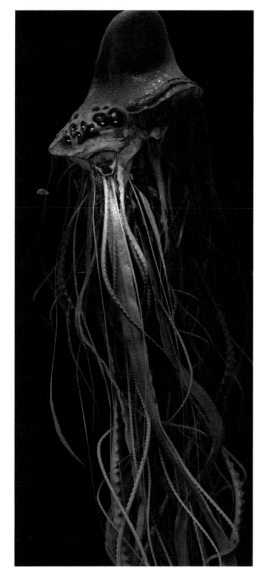

▲ SPACE MONSTER VERSION 15 McBride

▲ GRAVITY VERSION 2A Clyne

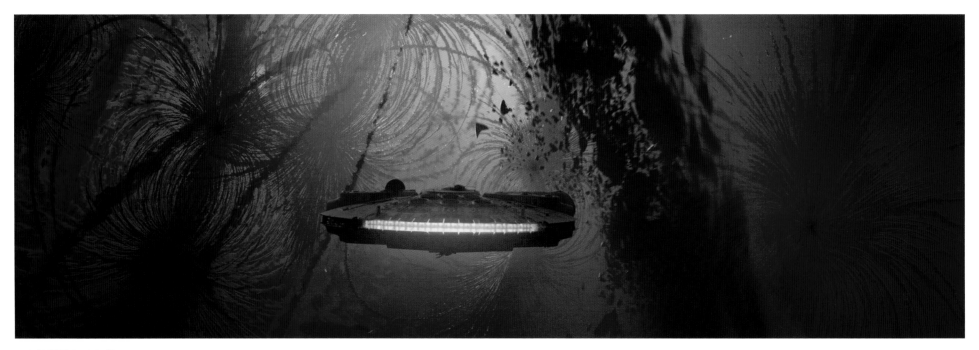

▲ **MAGNETIC FIELD B** Htay

▲ **GRAVITY WELL 02** "This was the first image that started to get close to the idea of the gravity wells. I think it's something that Rob Bredow pitched: these interesting magnetic fields with arcing and returning lines. It's a beautiful look." Clyne

▲ **GRAVITY WELL VERSION 08** Northcutt

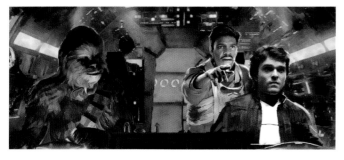

▲ **FALCON COCKPIT VERSION 1G** Clyne

▲ **LANDO FALCON INTERIOR 06** Clyne

▶ **MAELSTROM VERSION 07** Faulwetter

"Han drives the *Falcon* through the Kessel Run and, progressively, pieces rip off of it and expose the *Falcon* that we all know and love." Clyne

▶▶ **PLASMA FOREST** Voy

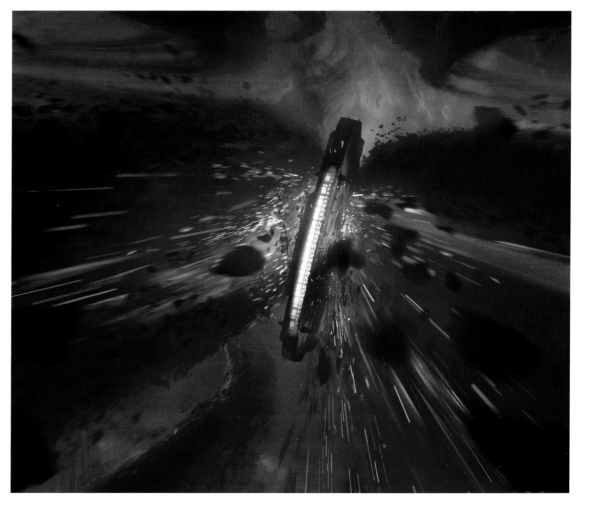

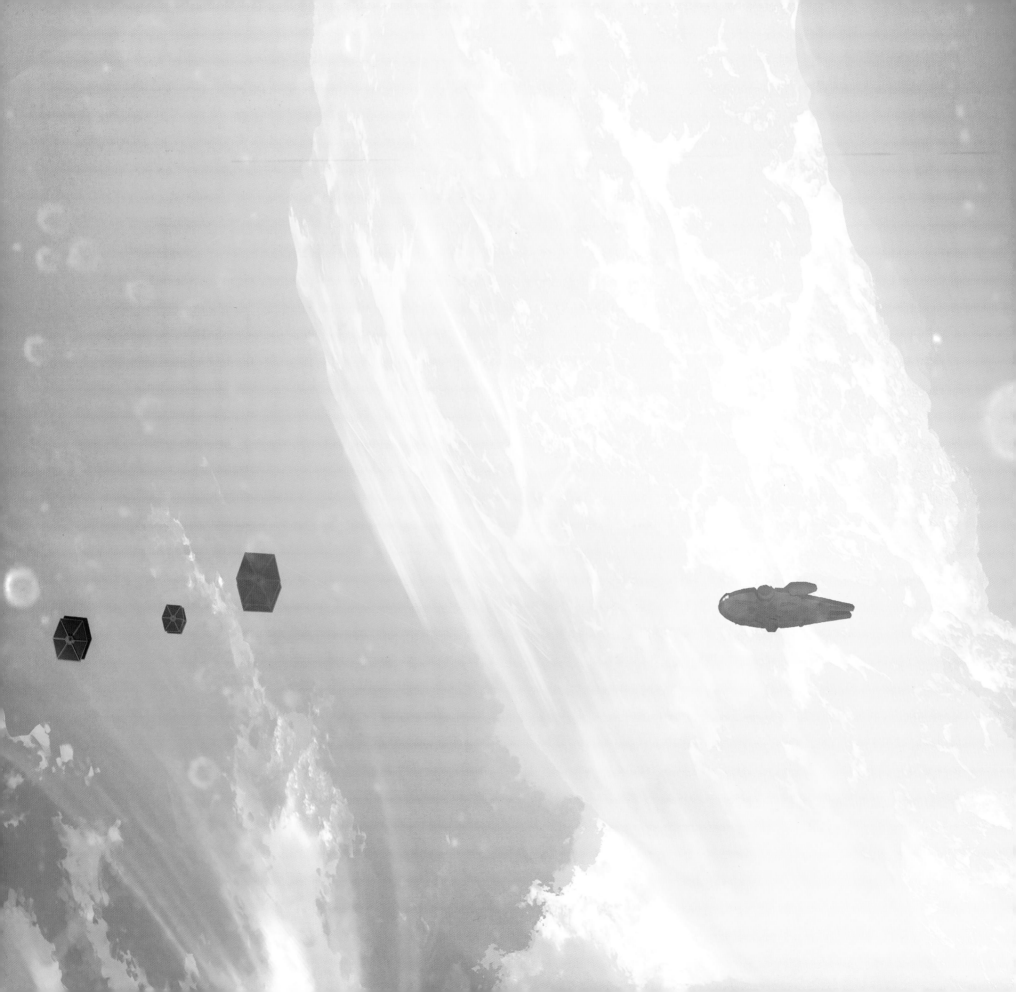

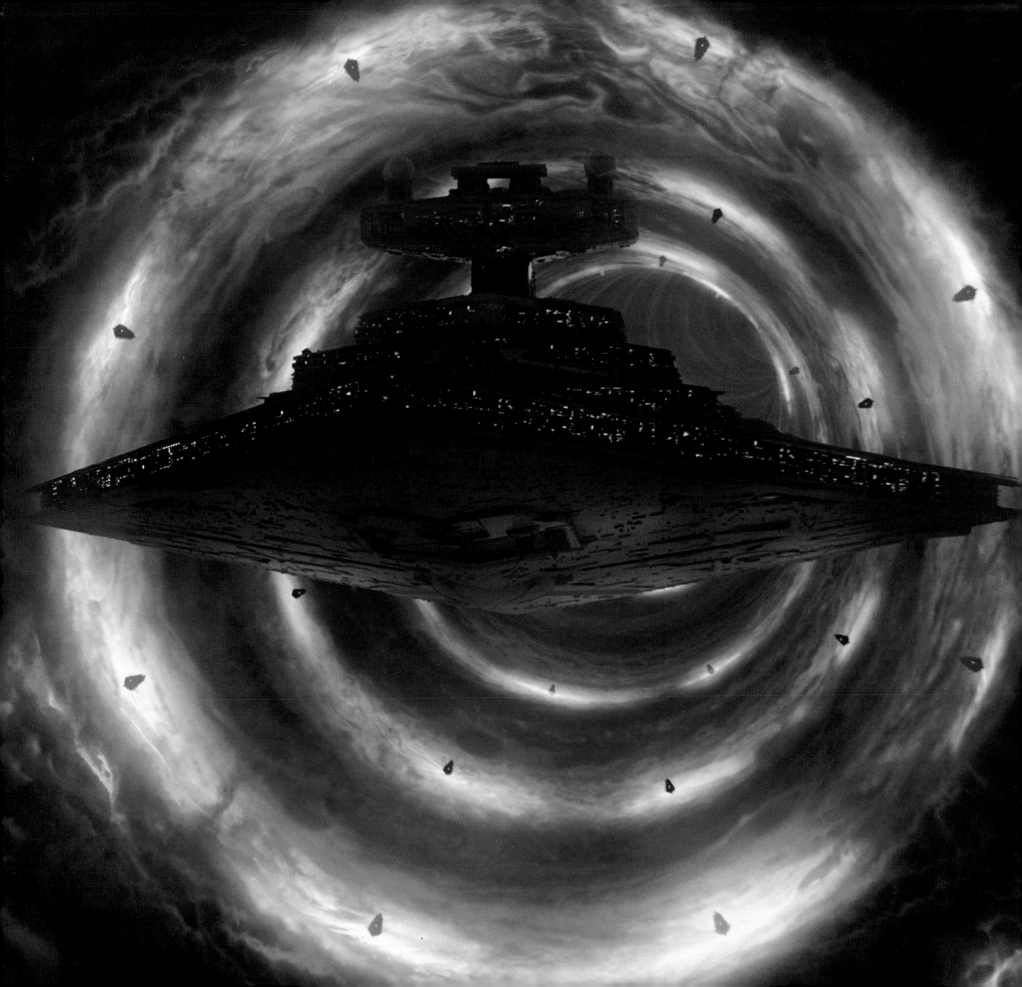

The Empire

Solo will be the first *Star Wars* film not to center on the galaxy-wide war, nor on the conflict between the Jedi and Sith Orders. The superficially clear delineations between good and bad, as represented by the schism between light and dark, Empire and Rebellion, Skywalker and Vader, don't exist in the *Star Wars* criminal underworld. Denizens of that world—smugglers like Han Solo, bounty hunters like Boba Fett, and crime lords like Jabba the Hutt—dwell within shades of gray, occasionally shifting allegiances to one side of the galactic war or the other, as the need dictates. More often than not, they only look out for themselves. As Han Solo makes it abundantly clear to Leia Organa in *A New Hope*, "Look, I ain't in this for your revolution, and I'm not in it for you, Princess. I expect to be well paid. I'm in it for the money!"

Imperial presence in the film, however, was a foregone conclusion, as *Solo* takes place after Emperor Palpatine's Order 66, which led to the near-extinction of the Jedi at the conclusion of the Clone Wars. The heavy hand of the Empire grips even the farthest-flung corners of the galaxy, as evidenced by the invasion of Mimban and Imperial presence on Vandor and Kessel. The coming rebellion will broaden their reach even further, into the Outer Rim worlds of Tatooine, Scarif, Lothal, and beyond.

In general, the costume, prop, and art departments leaned heavily into both their experience re-creating original trilogy Imperial designs for *Rogue One* (and its cache of reusable costumes and weapons) and a five- to ten-year devolution/deconstruction of those same designs. For starships, Lucasfilm design supervisor James Clyne sought inspiration from an oft-overlooked source. "The work of Colin Cantwell is like a treasure that hasn't really been exposed enough," Clyne said. Cantwell was one of the very first concept artists hired by George Lucas in late 1974, just prior to Ralph McQuarrie's employment, for *A New Hope*, then titled *Adventures of the Starkiller, Episode I: The Star Wars*. Cantwell, who had served as the photographic effects artist for Kubrick's *2001: A Space Odyssey*, drew and built prototype models for the X-wing, Y-wing, T-16 skyhopper, TIE fighter, Star Destroyer, *Millennium Falcon*, landspeeder, and sandcrawler, even coining the names "X-wing" and "Y-wing."

"Colin Cantwell was the guy slightly before all of it," Clyne recalled. "We're the guys slightly before all of it. So there's a Colin Cantwell ship in our movie. What better way to pay homage to him than to turn his design into one of our ships. The design just looks so *Star Wars*, but in its infant stage. It's more 'sixties aspirational,' with a Space Race feel, than the final seventies vehicle designs. I'm hoping that all comes through in the work."

Scenes of Beckett, Han, and Chewbacca's battle with the Empire and Enfys Nest aboard the conveyex were shot from March 13 to 21, 2107, at Pinewood Studio's Q Stage, dominated by the massive gimbal arm upon which the train car set twisted and turned through Vandor's mountains. Val's nail-biting traversal across the conveyex bridge was shot by *Solo*'s second unit the week of June 12, 2017.

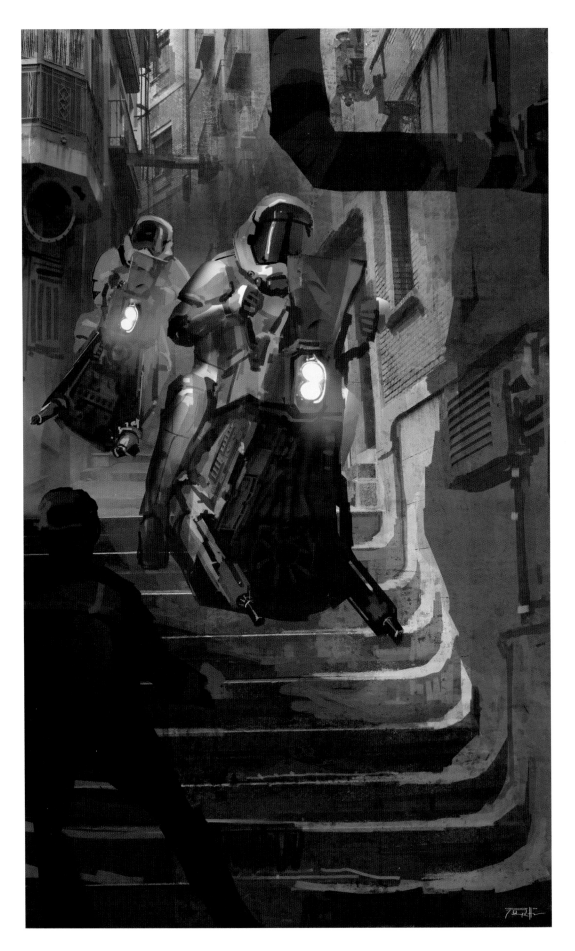

▲ **BIKE TROOPER 01** "This was an idea I had at one point, thinking about not only the era before Episode IV, like the sixties and seventies, but digging into George's era, which is *THX-1138*. What if the *THX* police were the first version of the stormtrooper? What would be the next evolutionary look? So I did a quick paint-over of one of the *THX-1138* cops for reference." Clyne

◄ **TROOPER CAR ALLEY VERSION 01** Faulwetter

▼ **SPEED TROOPER** "The speeder cop is a bit like the scout trooper, with britches instead of armored thighs. The white stripe on the britches were very 'motorbike cop.' And obviously, they make it easier for him to sit on the motorbike as well. The chest plate is all new. The back lower bit is part of the Death Trooper armor, except it's white. So we mixed things up." Dillon

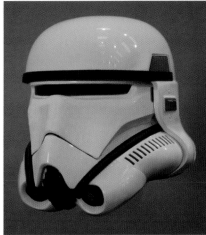

▲ **CLONE CLASSIC VERSION 08** Dillon

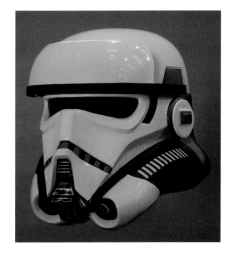

▲ **SPEED TROOPER** Dillon

▶ **CORELLIAN HIGHWAY PATROL VERSION 2A**
"We weren't thinking of the television show *CHiPs* at all [*laughs*] for the Imperial speeder cop. Honestly, that was all that we were pushing around for a while. We thought it was too on the nose, at first. It's always good fun to do stormtrooper variations." Dillon

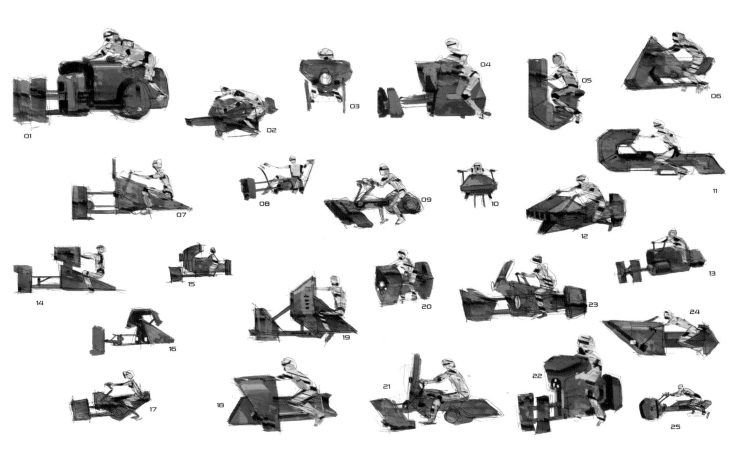

▲ **TROOPER CAR VERSION 01** Faulwetter

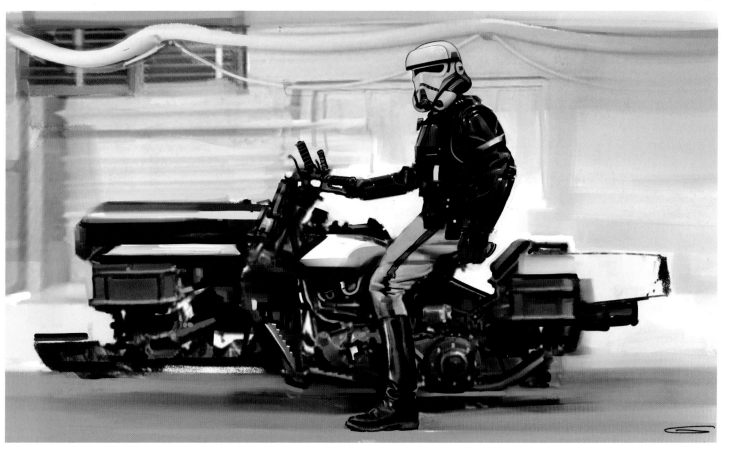

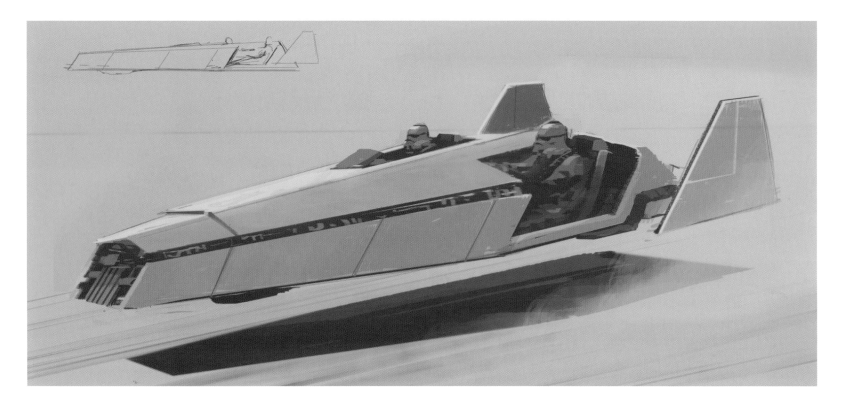

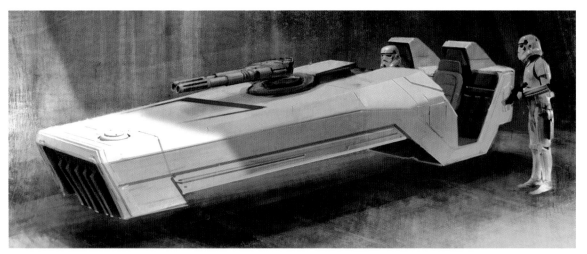

▲ **TROOPER CAR VERSION 5A** Clyne

◄ **IMPERIAL CAR VERSION 2A** Jenkins

"The big debate on the cop speeder was whether it was going to be another car or another bike. I was on the side of it being a car. It just felt more realistic to have just cars in the chase rather than cars and motorcycles. It seemed a little more *Cannonball Run* to me. And producer Simon Emanuel was always pitching the bike. So we had this ongoing friendly debate back and forth. Simon eventually won out, and rightfully so." Clyne

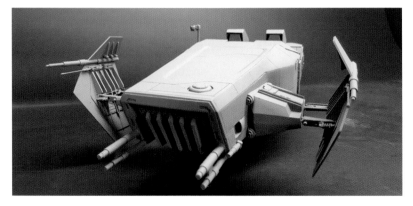

▲ **SPEEDER MODEL 24** Hutchings

▲ **RADAR LOOP** Booth and BLIND LTD.

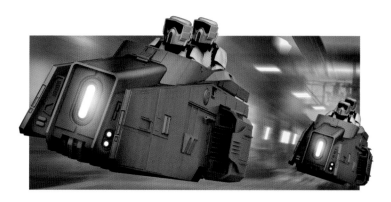

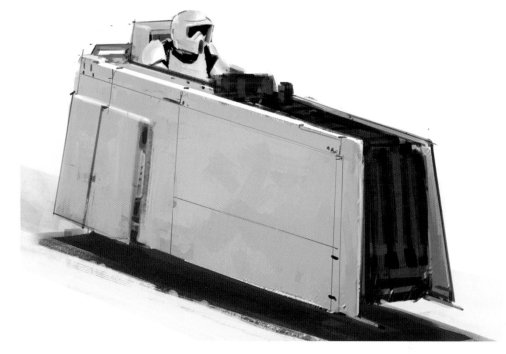

▲ **TWO SPEEDERS VERSION 03** Julian Caldow

▶ **TROOPER SPEEDER VERSION 1A** "We circled around it a lot and eventually arrived at this, a very simple slab. Again, we went to the simplest shape, kind of reminiscent of Rey's speeder but an Imperial version, really Brutalist. Funny enough, on a flight from Fuerteventura in the Canaries, I did this sketch with my finger in iPhone Notes [*laughs*]. This was the fifth version. You should see the other four. It got a lot of traction. Everyone laughed when I said I just did it with my finger." Clyne

▼ **TROOPER SPEEDER VERSION 14** Clyne

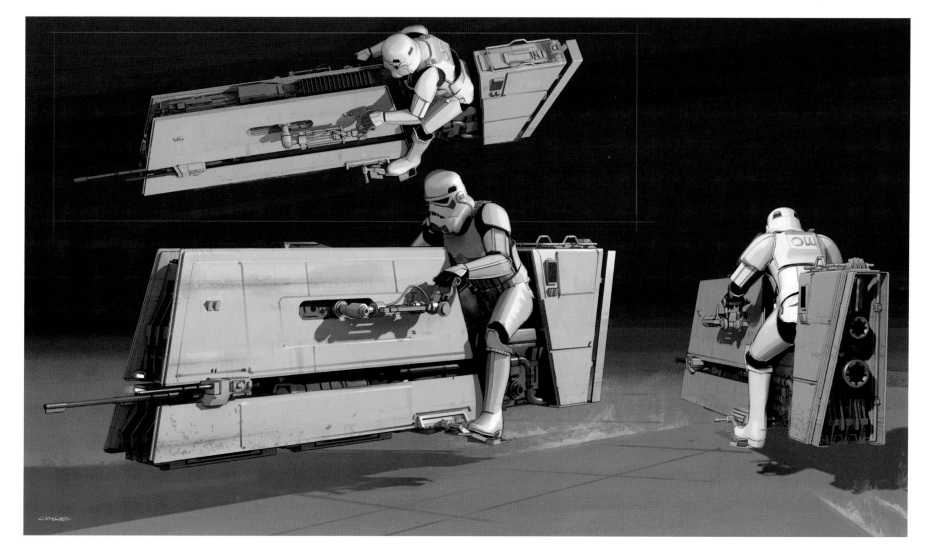

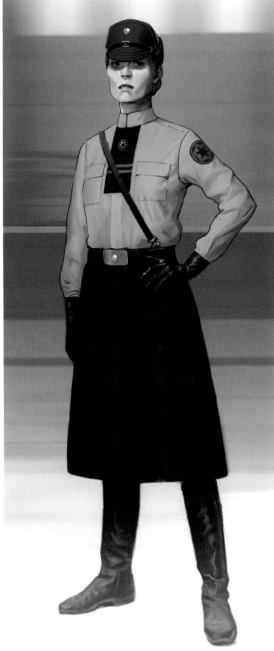

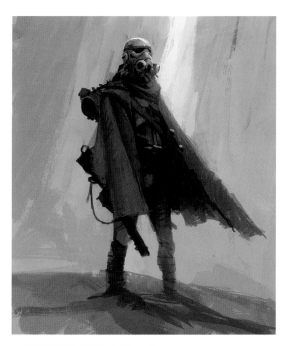

▲ GAS TROOPER VERSION 1A McQue

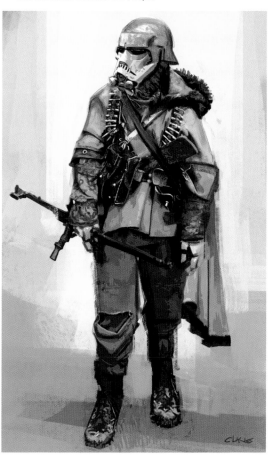

▲ MUDTROOPER VERSION 1A Clyne

▶ CLASSIC MUDTROOPER VERSION 01 "The 'muddy
trooper' is like a stormtrooper with an extra piece of armor
on the helmet, a brow-plate, and the big cape." Dillon

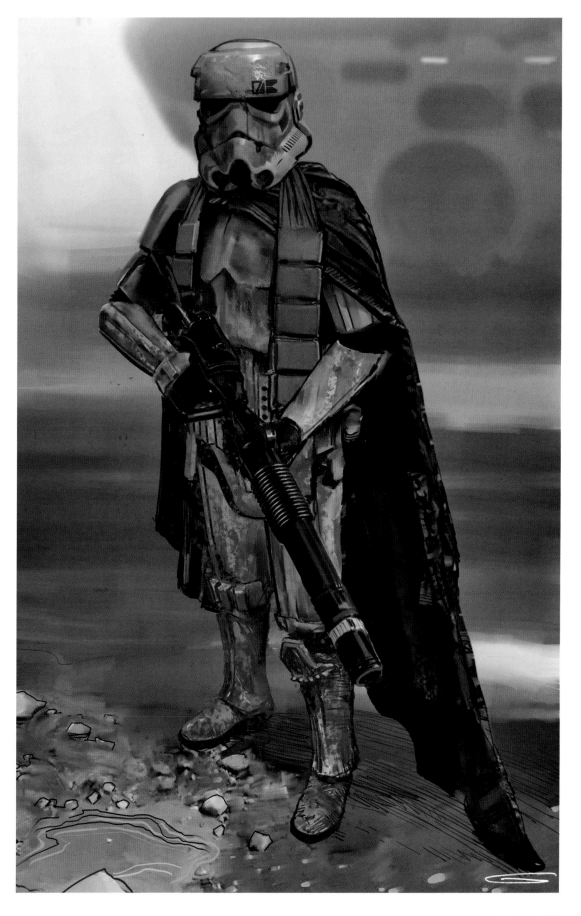

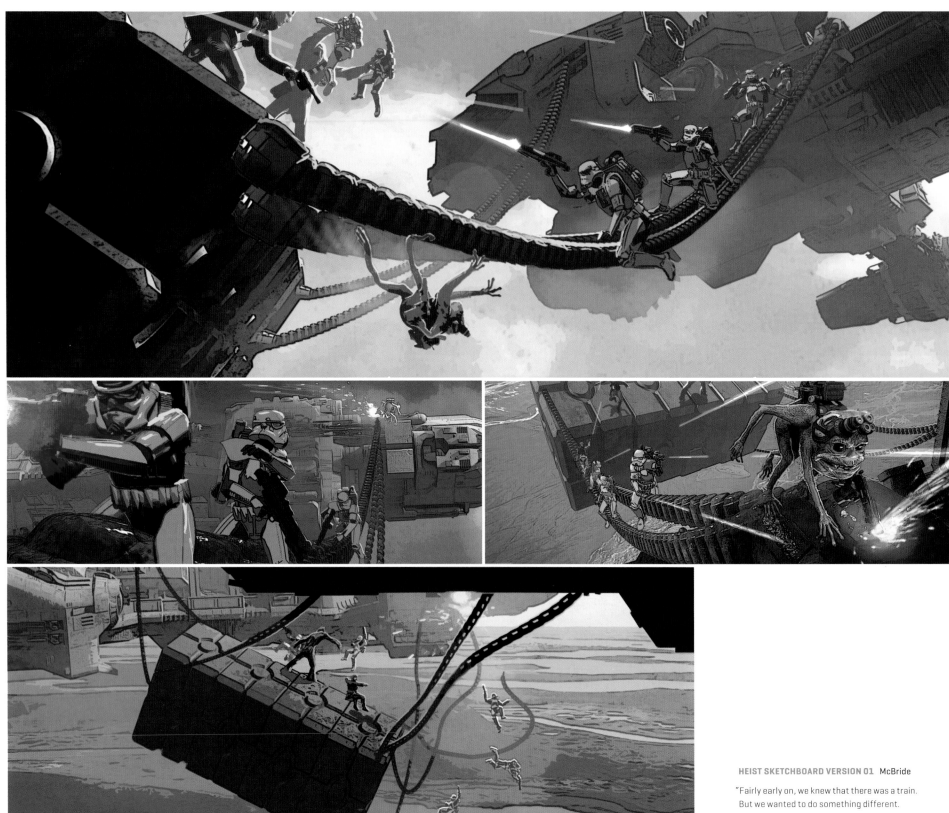

HEIST SKETCHBOARD VERSION 01 McBride

"Fairly early on, we knew that there was a train. But we wanted to do something different. Again, I went back to *Butch Cassidy and the Sundance Kid* for inspiration. But how do we bring it into a *Star Wars* world? Does the train rotate or something? Some of the early reference was heavily armored, pre–World War II German trains." Clyne

GUNNER CAR

PORT FOR CANNON

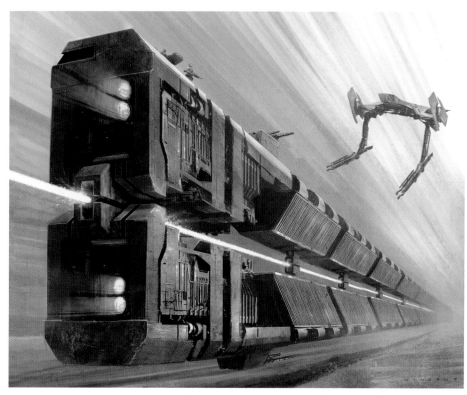

▲ **TRAIN ESTABLISHING 05** "I pitched this idea that the train has a top and a bottom, and the track runs through the middle of it. We knew we wanted the train to do some kind of roll. But I wanted a counterbalance. We were still trying to figure out if it works. Is it too much? So I put it in VScout, an ILMxLab virtual reality volume, to look at it. They've been providing and offering up VScout since *Rogue One*, for designers and artists to look at their spaces in VR as a development tool." Clyne

▶ **TRAIN DEV VERSION 5A** "A more physical track mechanism had the added benefit of providing all kinds of sound effects opportunities and the grittiness of a lived-in universe like *Star Wars*." Tenery

"A lot of us railed against the laser line track. We would have seen this technology again somewhere else in *Star Wars*. A laser is blaster bolts or the lightsaber; let's leave it at that. That's how we came to a train that had to drive or claw its way along this tank tread or motorcycle drive-chain." Lamont

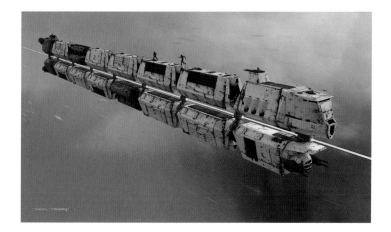

▲ **TRAIN ESTABLISHING VERSION 03** Clyne

▲ **TRAIN DEV VERSION 6A** "The initial design brief for the Imperial train had the cars moving along a laser track in an over/under stacked configuration that twisted through turns like a DNA strand. Some of the reference that kept floating to the top was of the rhomboidal British Mark I and V tanks from World War I, along with some of the weirder Nazi tanks and armored transports from World War II. As a result, we slowly gravitated toward designs that felt more muscular, heavily armored, and tanklike." Tenery

▶ **TRAIN CAR DEV VERSION 3A** Tenery

"The directors were wondering, 'Can you jump from car to car?' And in VScout, I was like, 'If I can get anything done today, I need to know if I can jump from this car or not.' The xLab guys were scared because no one had run in the volume before! So I just started from one end of the room, and there was this guy on the other end who was going to catch me if I fell. So I ran and jumped from car to car, and I made it. I was like a virtual stuntman." Clyne

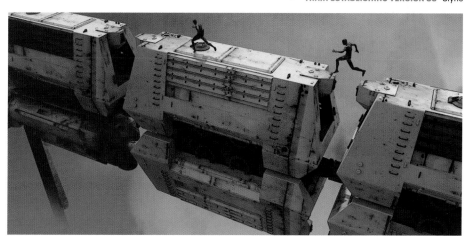

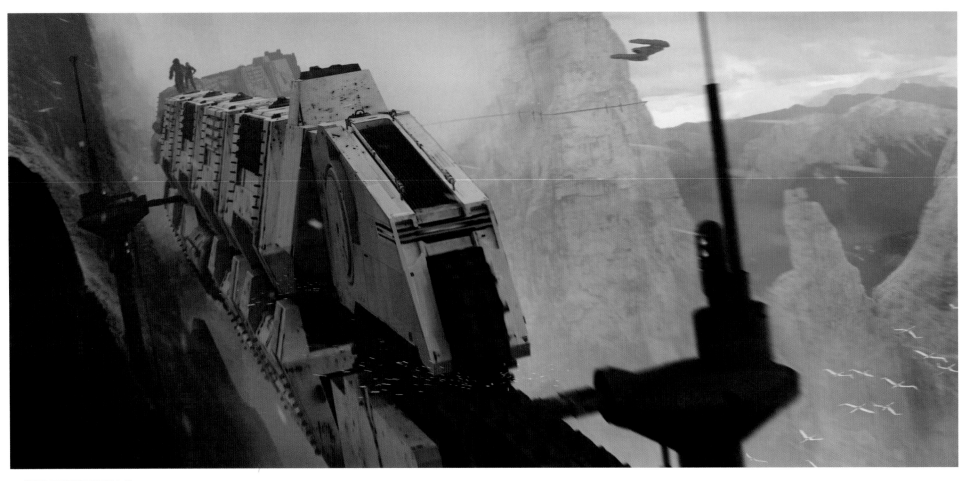

▲ **HEIST SHOT VERSION 1A** Tenery

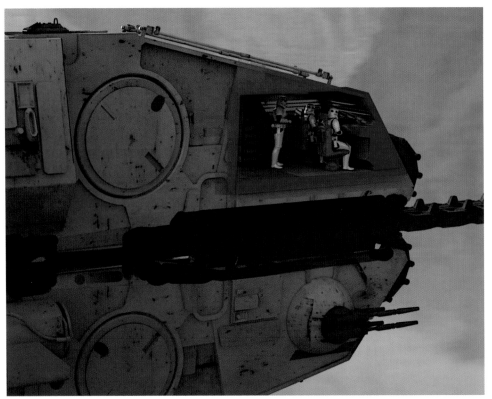

◄ **COCKPIT INTERIOR VERSION 6A** "The engine car was heavily inspired by AT-AT and AT-ST 'heads'—in this case, stripped down, unadorned, and slightly streamlined. I thought of the cockpit design as something preceding, but in the same family as, an AT-AT. I was aiming for something a bit more tactile and busier, but that would recall the very brief over-the-shoulder shots we saw in *The Empire Strikes Back*." Tenery

▲ **PYLON BASE VERSION 1A** Tenery

"We've got one carriage. Can we make it generic enough so we are able to maintain a decent flow for shooting and not get lost in the miasma of continuity of which car we are on? To translate that is quite difficult. What do we do with the aging? We make the aging neutral. We don't make it directional. There were a lot of things we had to think about." Lamont

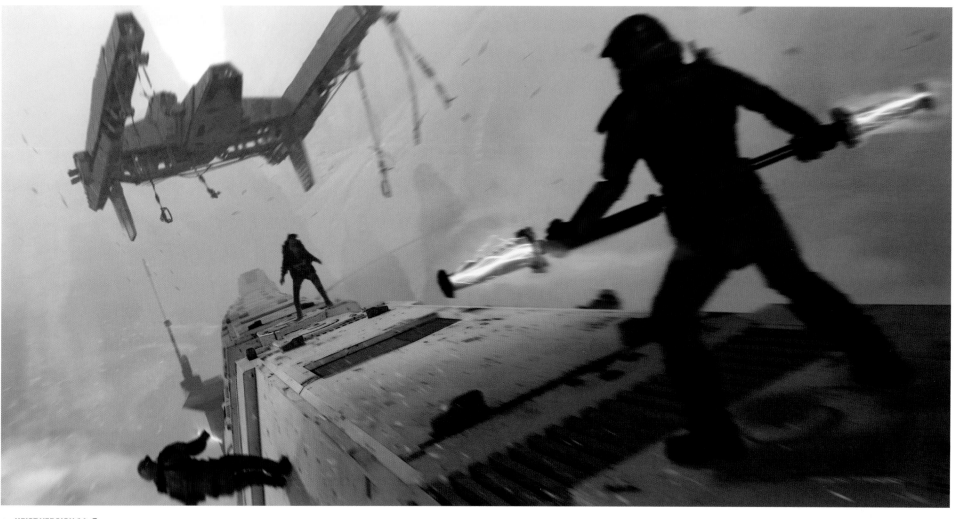

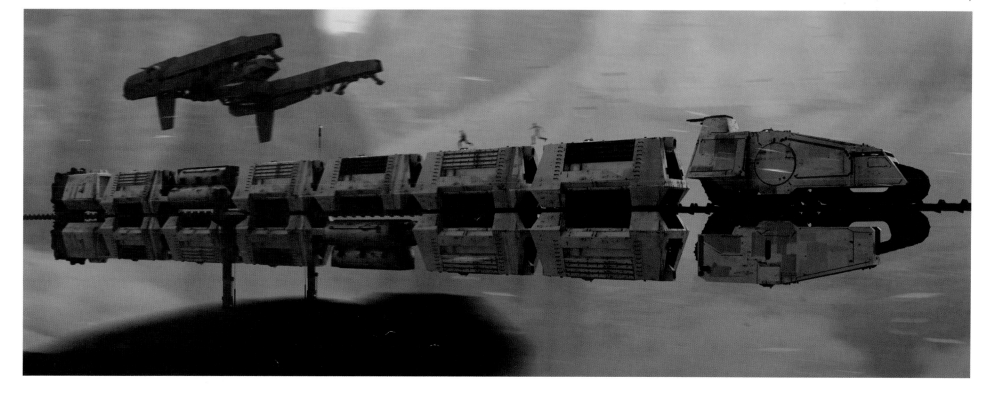

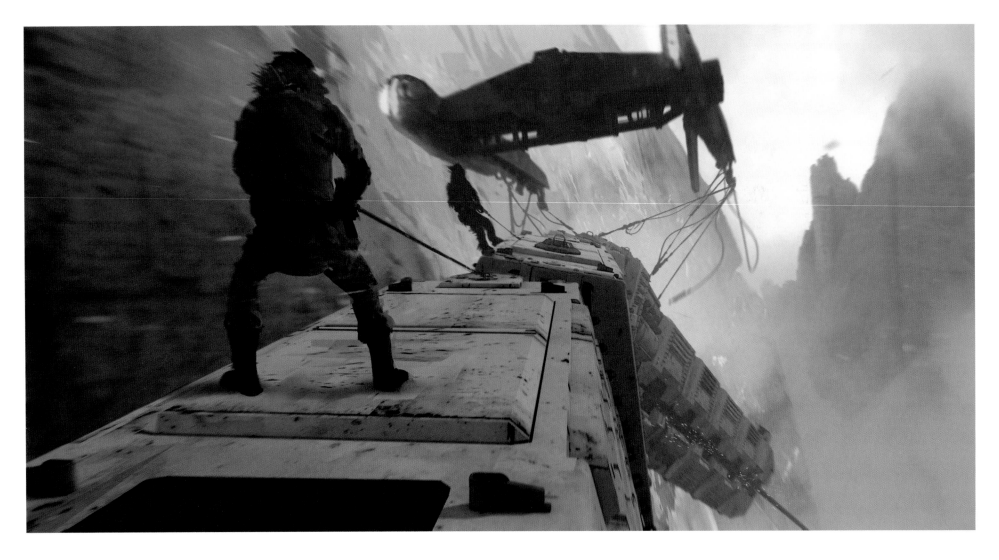

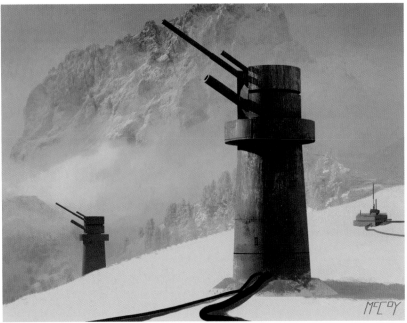

▲ GUN TOWER VERSION 01 McCoy

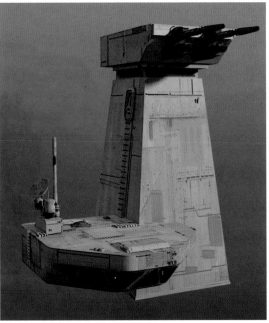

▲ SECURITY TOWER VERSION 2A Tenery

"Our carriage is basically built from MDF [medium-density fiberboard] on a steel frame that special effects had built, because it attaches directly into their monster gimbal that allows it to rotate from left to right but also go up and down through its length, which is phenomenal. It's a beast." Lamont

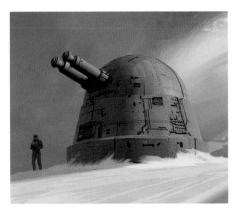

▲ GUN TURRET VERSION 12 Tenery

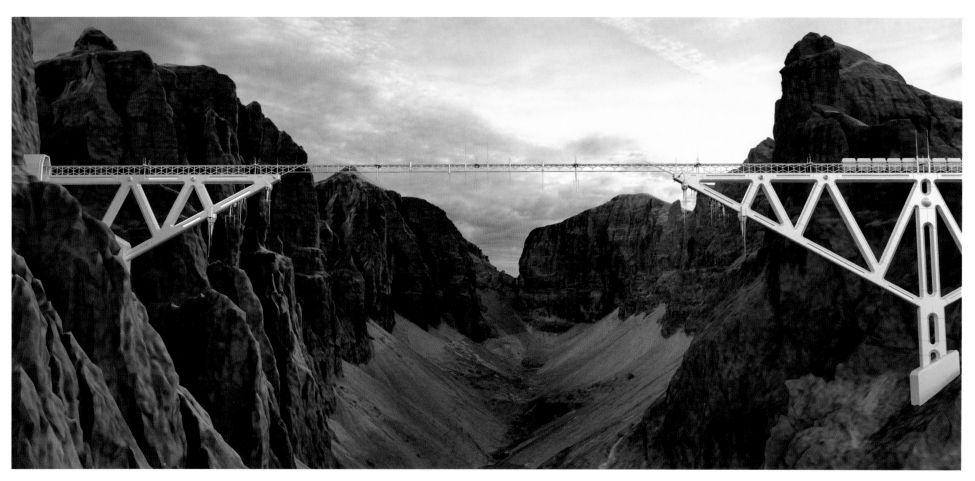

▼ **TRESTLE PROBE DROIDS VERSION 1A** McCoy

▲ **BRIDGE LAYOUT VERSION 9H** Mark O'Kane

▼ **BRIDGE MODEL** Matt Naish

"That's the bridge for Val during the train heist. She hides under here from the droids. I think it will be on a stage because everything in the train sequence has been shot interior." **Lamont**

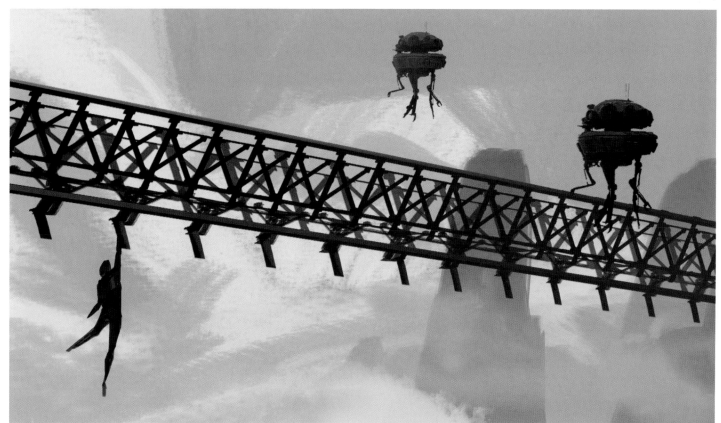

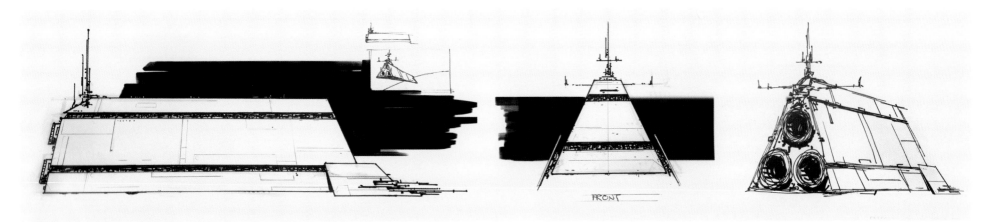

▲ **IMPERIAL BULK CRUISER VERSION 3A** Jenkins

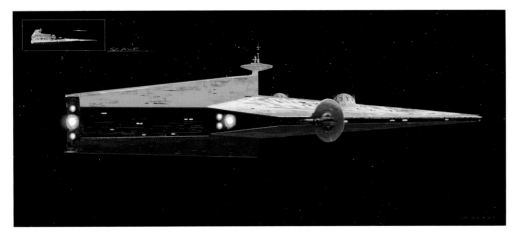

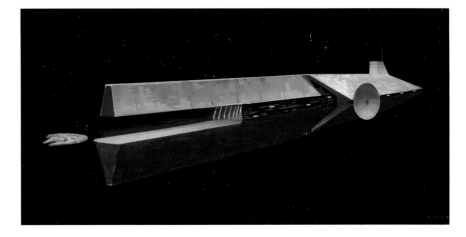

▲ **CRUISER VERSION 3D** Jenkins

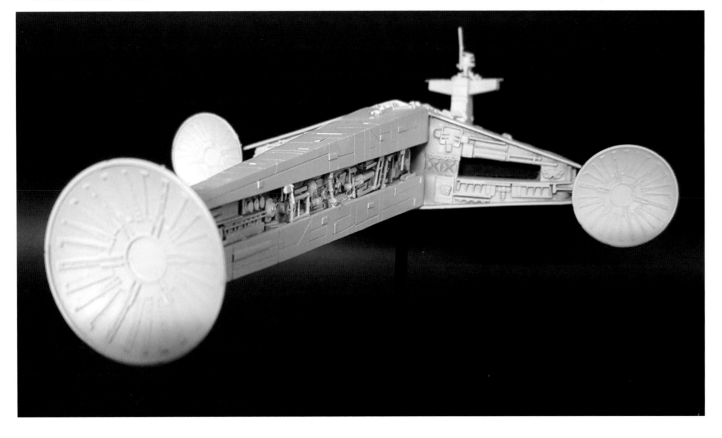

▲ **MOUTH VERSION 4A** Jenkins

"In the script, it was just another Imperial ship, a tractor beam ship. The *Falcon* gets pulled into it." Clyne

◄ **CRUISER MODEL** Hutchings

"This was another, 'Guys, the research we are pulling is one of the very first design pitches for the Star Destroyer by Colin Cantwell.' So it just worked out perfectly. We built a little physical maquette. And I've been art directing the CG model here at ILM, bringing resolution and fidelity to it." Clyne

▼ **CRUISER MODEL DOCKING BAY** Hutchings

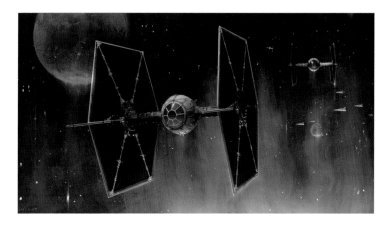

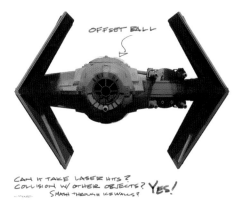

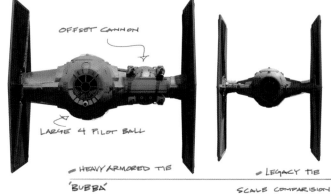

OFFSET BALL

CAN IT TAKE LASER HITS?
COLLISION W/ OTHER OBJECTS? YES!
SMASH THROUGH ICE WALLS?

OFFSET CANNON

LARGE 4 PILOT BALL

HEAVY ARMORED TIE
'BUBBA'

LEGACY TIE

SCALE COMPARISION

▲ **OLD TIE FIGHTER VERSION 01** Jenkins

"Again, I was showing Colin Cantwell's models. But the story need changed from an early TIE to a TIE fighter leader. And we felt like this design was too simplified to be a leader." Clyne

▼ **PROTO-TIE VERSION 5F** "I proposed a ball gunner TIE on *The Force Awakens*. It finally made it in, but in a slightly different iteration. I'm even having the modeler put two seats in the driver's area. You can fit maybe even four pilots in there. It's much bigger than a standard TIE. We are going to have *A New Hope* TIE fighters, as well. But then this guy will be leading the way." Clyne

▲ **PROTO-TIE VERSION 5E** "The original TIE fighter is so beautiful and so simple, so I thought, 'I need to give it a personality to sell it.' If this is the TIE fighter leader, I started calling it the 'Bubba TIE.' It was an SUV version of a TIE fighter. Most TIE fighters take one hit and they are obliterated. What if this could take a hit? It's the Terminator of TIE fighters." Clyne

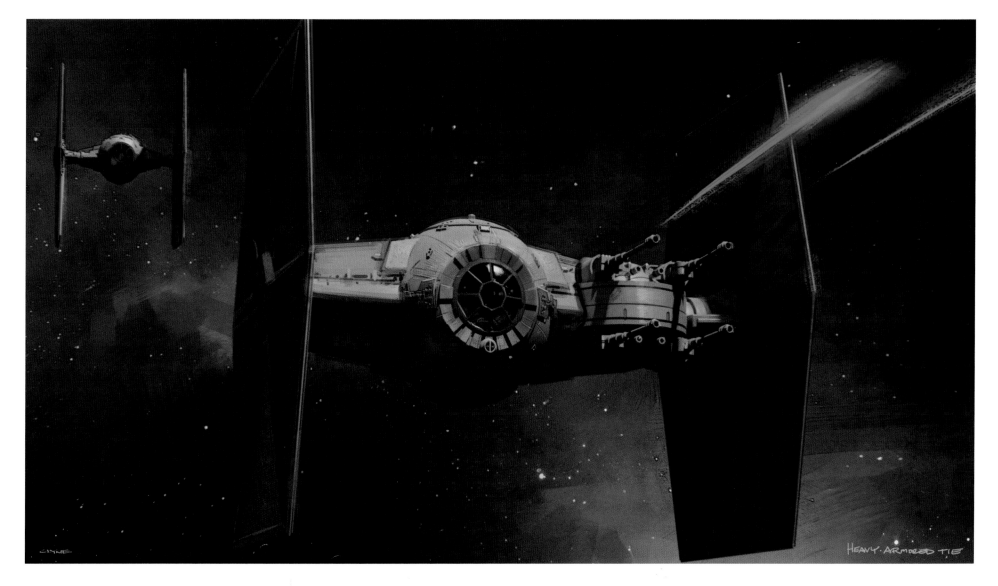

HEAVY ARMORED TIE

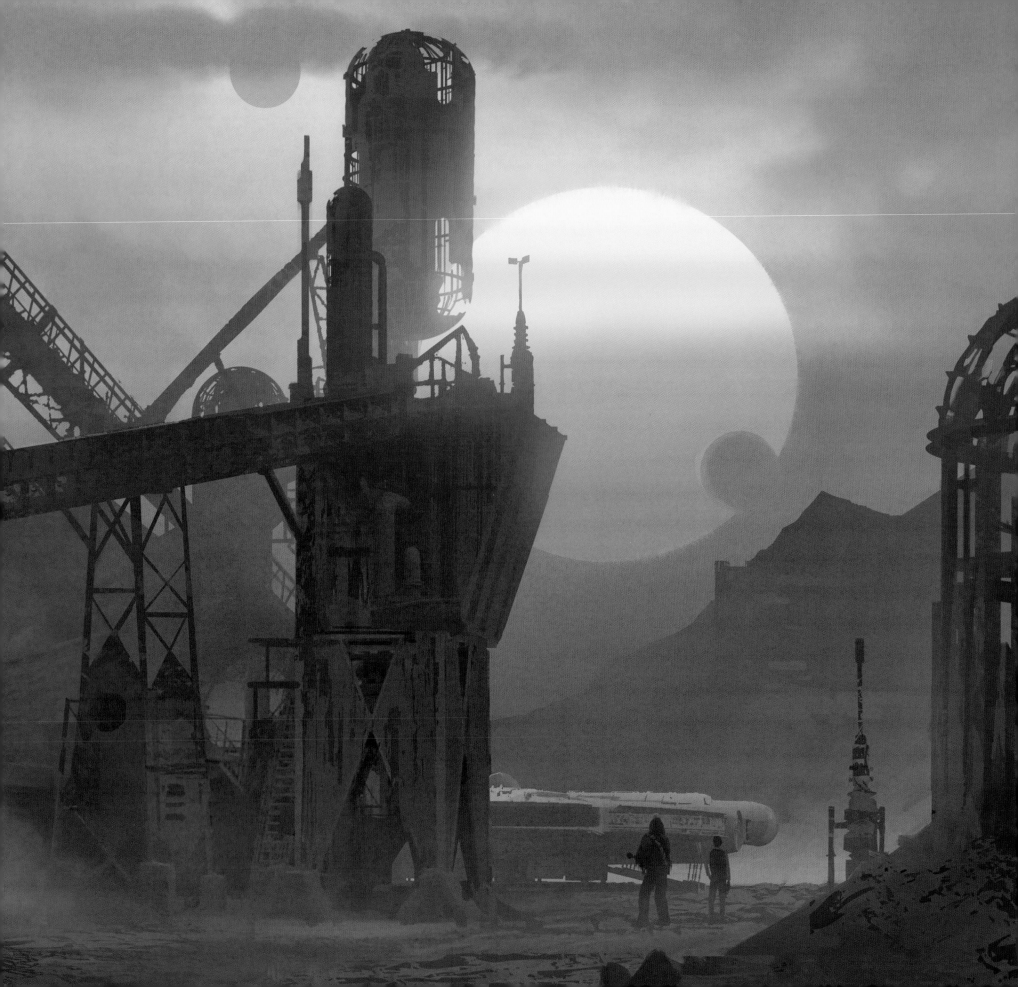

Savareen

At the conclusion of *Solo*, all of the main characters—including Han, Chewie, Qi'ra, Beckett, Dryden Vos, and Enfys Nest—converge for a final showdown over the priceless case of refined coaxium on the barren world of Savareen, a crucible where loyalties will be tested and truths will emerge, some enlightening and others heartbreaking. Savareen also represents the end of the road for both Han Solo's and the audience's symbolic journey across America: Southern California, a place where the desert meets the sea, the end of the continent and the birthplace of the modern film industry.

According to James Clyne, "We began referencing the painters Frederick Church and Albert Bierstadt: this Yosemite Valley, Ansel Adams kind of approach. They were some of the first European artists to come and paint the American West and bring it back to the colonies and Europe. At one point, we were thinking it would all be on stage with green screen. But the hope was that we would go somewhere real. Abu Dhabi was in play at one point. We even scouted some of those Spaghetti Western locations in Spain as a possible Savareen." Spaghetti Western films of the 1960s, such as director Sergio Leone's "Dollars Trilogy" starring Clint Eastwood as the "Man with No Name," were primarily coproductions between Italy and Spain, often utilizing inexpensive and nearby shooting locations in the Tabernas Desert of southeastern Spain, the driest region of Europe, representing the American Southwest.

Neil Lamont recalled, "We also looked at Namibia and that coastline there, which is extraordinary. We would have gone there just to shoot plates [background elements for visual effects shots]."

Ultimately, a shooting location briefly considered for the Vandor hunting lodge became the home for Savareen. "At the time, it was debatable whether Savareen was going to be a jungle, like Taanab, or more of a sandy dune," Clyne continued. "But I like that we now end on the most Spaghetti Western world. It's going to feel like the most desolate, Outer Rim world in the film." Lamont said, "The great thing about finding Fuerteventura, this amazing location in the Canaries, is that we can go there and shoot it live, getting it all 'in the can.' We're not massively far from the UK, either."

"Fuerteventura is very long island," explained Lamont. "The narrowest part of the island, from coast to coast, east to west, is a band of sand. And that sand goes all the way down to the water. It's really quite unearthly with a lot of its own natural characteristics. And those Savareen scenes will take place at the 'magic hour' [at sunset, when the light is golden and low on the horizon]. We're shooting in the morning, having a long siesta, and then shooting in the late afternoon."

Solo's main unit relocated to the Jandía Natural Park on Fuerteventura, the second largest of the Canary Islands, on May 27, 2017, for a location shoot that lasted from May 30 to June 9, 2017, returning to England on June 10. While on the Fuerteventura, cast and crew stayed in the small resort town Costa Calma at the boundary of Jandía's parkland.

▲ DISTILLERY VERSION 7B Lunt Davies

▲ REFINERY IDEA VERSION 44 Jenkins

CORE HEATS UP

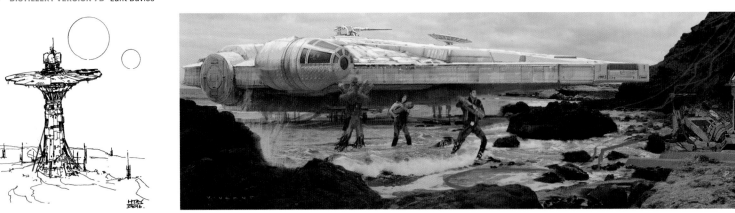

▲ SAVAREEN SKETCHBOOK VERSION 1C Htay

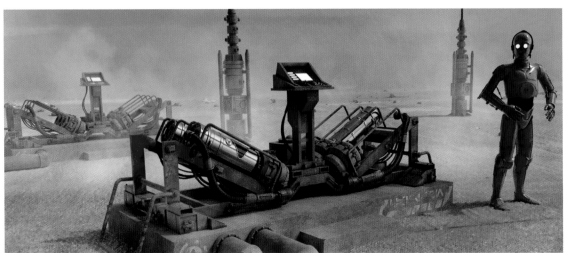

▲ LANDING PAD VERSION 1B Jenkins

"With Savareen, we are in a cowboy town. We're in *High Noon*, Spaghetti Westerns, with the church at the top of the village being the refinery." Lamont

◀ COAXIUM RIG VERSION 99 Savage

▼ SAVAREEN ARCHITECTURE VERSION 1C Htay

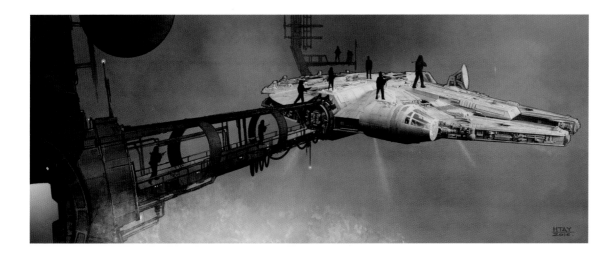

▲ **SAVAREEN REFINERY VERSION 1A** Htay

"For a long time, we had the refinery hanging off of a cliff wall, with the *Falcon* docked on it through its docking ring. And it looked so cool." **Lamont**

▶ **SAVAREEN VERSION 22** "I was playing off of these standoff motifs of an old refinery. It's an old moonshining facility, essentially [*laughs*]. What do those structures look like?" **Clyne**

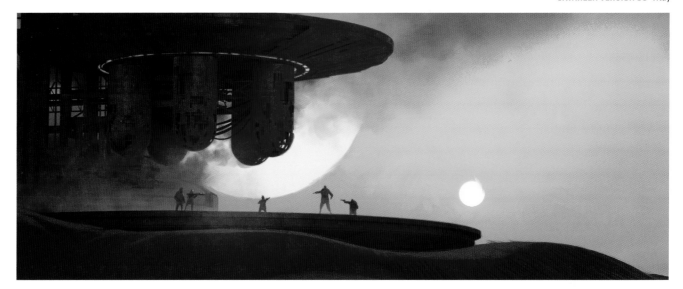

▶ **STANDOFF VERSION 2B** Htay

Once more, the *Solo* art department found inspiration in the work of Ralph McQuarrie, specifically a painting for *The Illustrated Star Wars Universe* book, published in 1995. "Bespin—Floating City Ruins" depicted a rusted cityscape, with distinctive skeletal domed silos, perhaps a reflection of the derelict floating city inhabited by an alien tribe that George Lucas wrote of in his November 28, 1977 *The Empire Strikes Back* treatment. "Those tall McQuarrie silos were an influence and his work is so inspirational," Lamont said. "You just have to use it. It's like he created the directory for *Star Wars*, and there's nothing new, shape-wise, that you can think of because it's already been drawn. All we have to do is plagiarize it some way, shape, or form." Or, as Clyne succinctly put it, "You show *Star Wars* directors a little McQuarrie and it's in the movie."

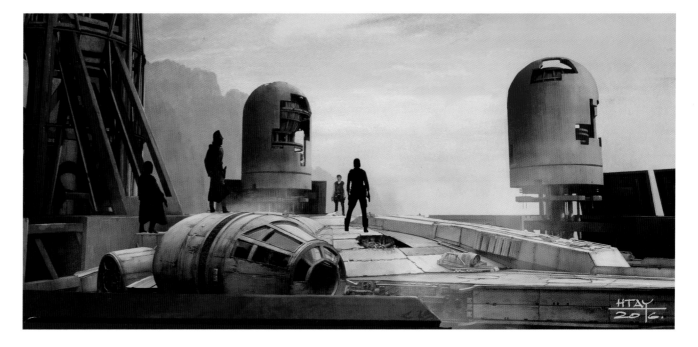

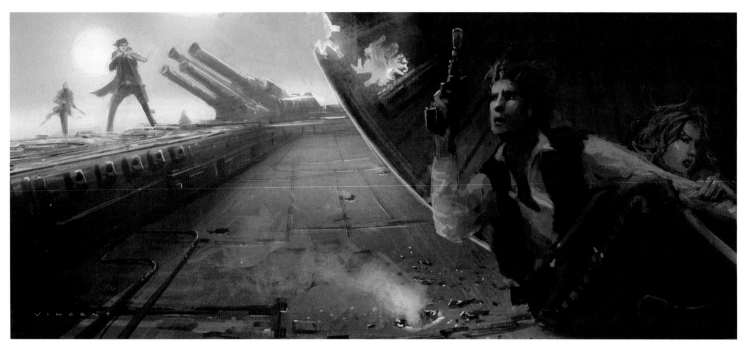

▲ **FALCON STANDOFF VERSION 27** Jenkins

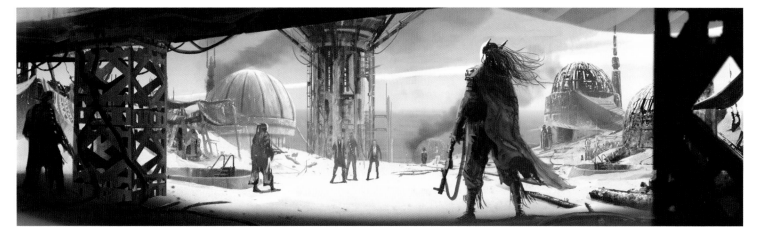

▲ **APPROACH VERSION 8C** Jenkins

▼ **DISTILLERY VERSION 11** Clyne

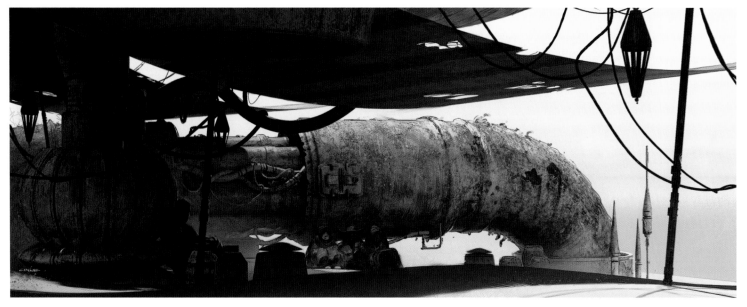

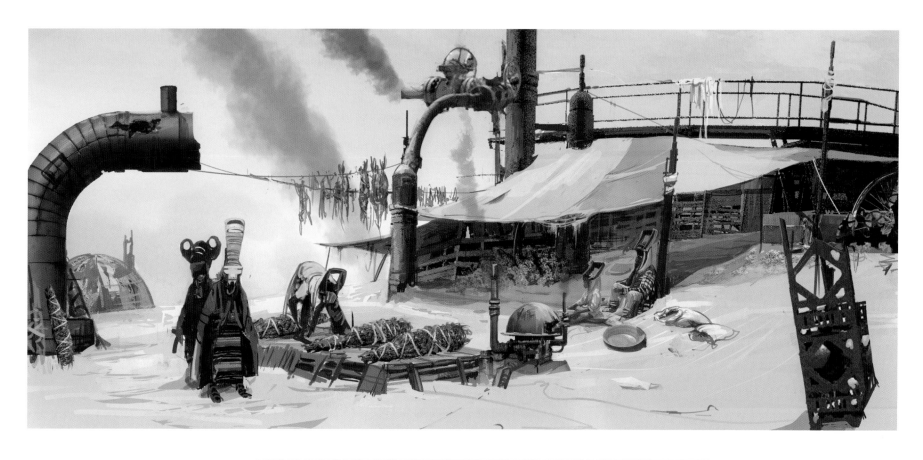

▲ SAVAREEN CULTURE VERSION 4D Sole

"None of this Fuerteventura location build is preexisting. It was a completely naked site. We are trying to say that the refinery is still working. So we are putting these big cylinders into the ground, excavating inside them, running pipes into them, and having ladders that come out of them so the Savareenians can appear. We have masses of room to play with. That's the great thing. You can film in the middle. Or you can film on the other side. And, as a viewer, you don't need to know exactly where you are." Lamont

▸ LOCALS VERSION 11 Brockbank

"If you look at any reference of indigenous people anywhere in the world, they often have clothing that they produce themselves, which often bears strong colors. You'll see a tribe with strong red stripes, like the Maasai people of central Africa. Even in the folk costumes of Eastern European cultures, you'll often see these strong primary colors. So we were trying to get a nice strong palette for the Savareenians that reflects that idea. Originally, the whole group on Savareen was on Vandor. In the original picture, they are very wintery. Now, there's a warmer climate version of them with bare legs and blankets wrapped over simple clothing. We've had around sixty blankets woven specially. We picked all of the yarn to try to keep the colors as vibrant as possible." Crossman

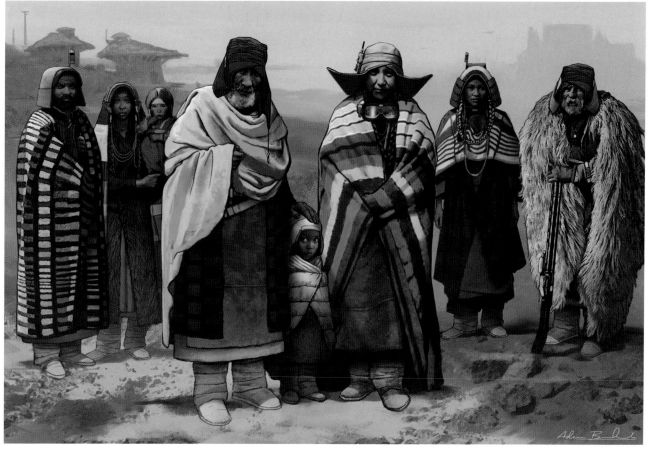

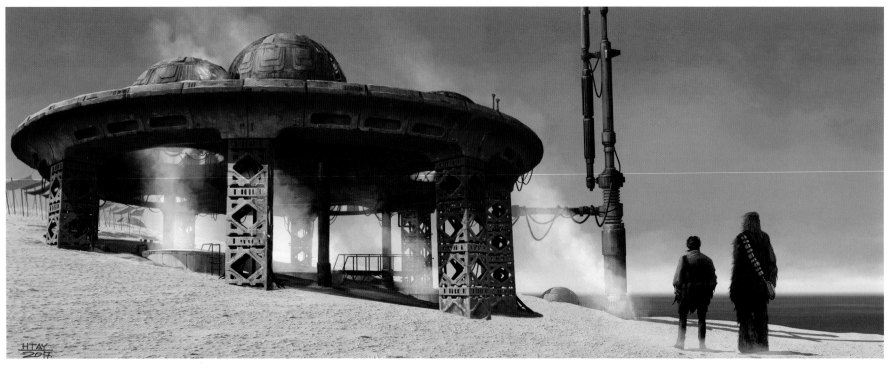

▲ **SAVAREEN MAIN STRUCTURE VERSION 1C** Htay

▼ **FIRE RESCUE VERSION 25** Jenkins

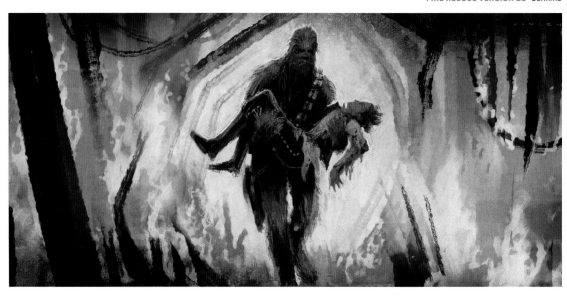

▼ **VOS SHIP SAVAREEN VERSION 1A** Clyne

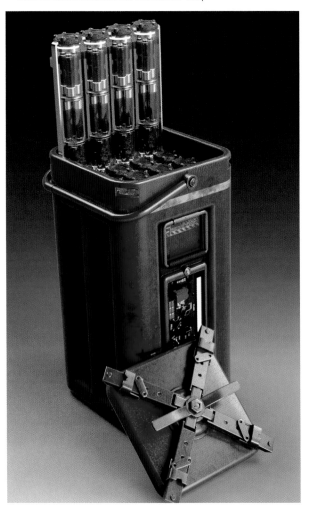

◄ **CARRYING CASE 16** Savage

"The refined coaxium canister was actually a beautifully made case that we found for carrying fantastically expensive drill bits. I thought, 'That's a great starting point.' So the prop canister is based on that real canister, but we made it bigger because Chewie was going to be carrying it. It works because it's based on something that exists, and it's a very simple industrial design. It's also made for a purpose similar to how it's being used in the film." Wilkinson

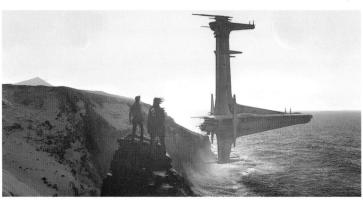

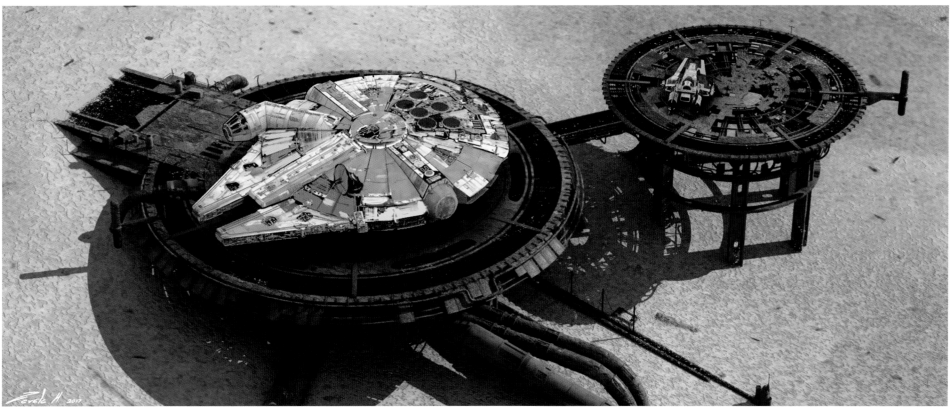

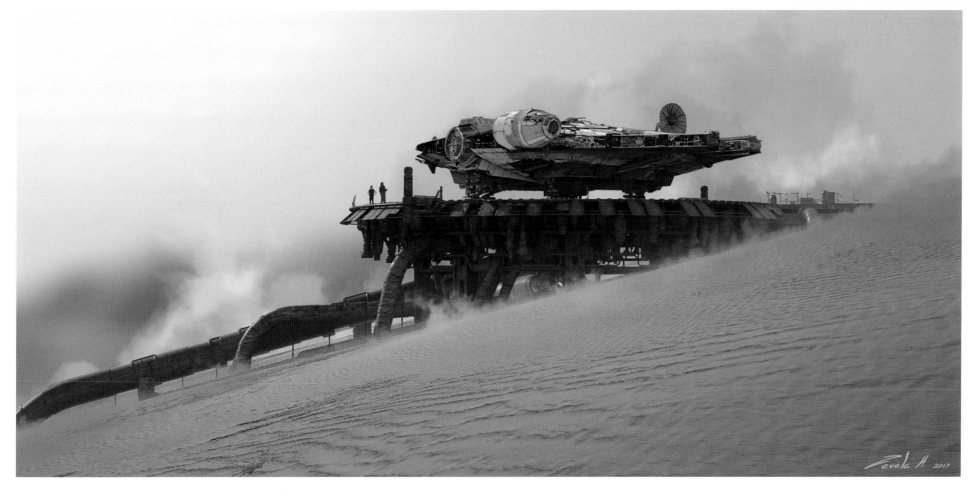

▲ **COLOR SCRIPT** "I did a color key for the entire movie. We talked about going from a pretty monochromatic, which is parallel to Han Solo himself originally being this monochromatic character, then becoming more colorful as the story progresses. The monochrome awfulness of cities like Corellia during western expansion or the Industrial Revolution is pretty Dickensian too." Clyne

"Rob Bredow showed us the color map from an animated film. And it's like, 'Oh my God, look at that! This is phenomenal! OK, fine, what is our color map for this film?' You break the film up into its six or seven environments, trying to head to a visual high the whole time. We're gradually honing everything that contributes to that palette. And that whole color range of the film starts informing every department, hugely. It was an incredibly clever thing to do." Lamont

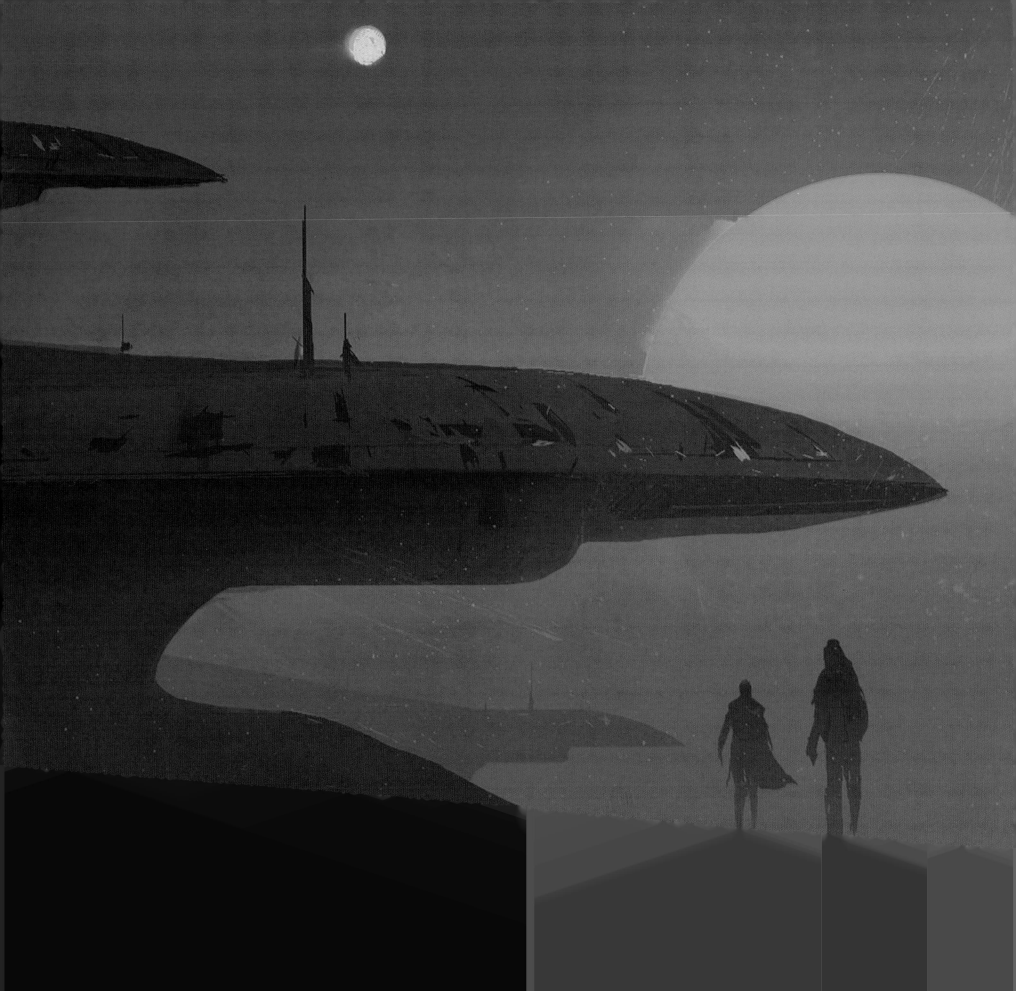

Coda

For production designer Neil Lamont, working on *The Force Awakens, Rogue One*, and *Solo* was not just carrying on the Lamont family legacy, but a throwback to his very beginnings in the British film industry. "I was eighteen when I worked on *Return of the Jedi*, as an art department assistant. I had just finished *For Your Eyes Only* with my dad, his first film as a production designer. An art department assistant basically makes tea, gets lunch, and makes sure that everybody is happy. I missed so much, being a young kid running around. Of course, I had seen both *Star Wars* films by then and enjoyed them. But I have to say that now I am a major fan. I love it. I still love going down to props and being taken through a show-and-tell. And we're lucky to have a really good group of people, youngsters especially—the late-twenty-to-thirtysomethings who are channeling *Star Wars* twenty-four hours a day."

Mirroring the generations of *Star Wars* filmmakers collaborating on *Solo*, "Trying to create a family is what all *Star Wars* movies are ultimately about," Jon Kasdan realized. "Han tries to find emotional, personal connections throughout the movie. First with Qi'ra on Corellia, then later with Beckett's gang, then again with Qi'ra, and ultimately ends up forming a lasting bond with the most unlikely candidate (to his thinking)—the big Wookiee. But even though he ends up with Chewie, Han gets his heart broken in big ways. And the scars of those betrayals and abandonments inform his personality going forward. This is where Han's cynicism comes from. That's the story we wanted to tell."

The experience on *Solo* was also particularly meaningful for design supervisor James Clyne, "I feel like this movie,

more so than any in my career, has been really personal for me, just by the virtue of being a part of it for so long." Ultimately, Clyne would spend more than two and a half years on the project.

Crafting the first film in the franchise that both pushes the limits of tone and genre (humor and the filmic Western, respectively), and that tells a story far, far away from the wars of *Star Wars*, deepened the crew's investment in the project. "Getting to the next level has got to be our goal, collectively, within Lucasfilm and ILM, whether we are talking about it openly or just feeling it," creature effects creative supervisor Neal Scanlan stated. "We are in the place that Dennis Muren, John Dykstra, and all those guys were when they first got involved in *A New Hope* with George. We can add something to the *Star Wars* stories and their future legacy that could be quite fresh, unique, and exciting to an audience, purely by using the best tools around us. I talked to Rob Bredow and the filmmakers, and we've all got our hearts in the right places."

"You're almost creating impressionistic dreams within the *Star Wars* universe," computer graphics supervisor Andrew Booth mused. "I agree with George's assessment that *Star Wars* design should not call attention to itself. There is so much for the audience to take in. For those five to ten moments in each of these films that there is a screen and it's in focus, there are hundreds of layers of time and thought. I think that's quite exciting, because it's the purest form of each person's discipline on screen. That's why the films are such enriching experiences. That's also why you can see them over and over again. That inherent richness within the *Star Wars* universe means you can look at it from many angles. It's boundless."

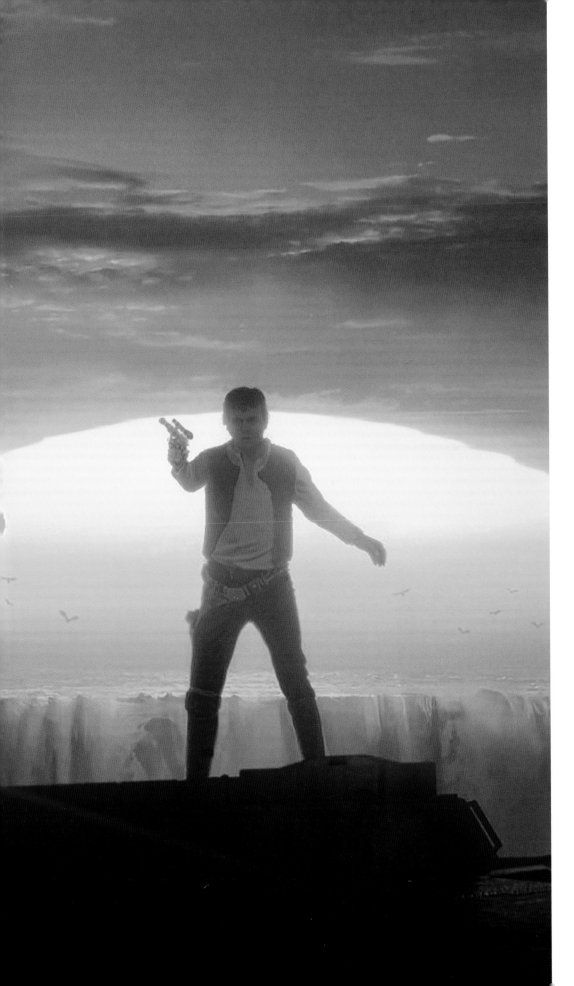

Acknowledgments

To my father, Joseph Szostak, who fostered my childhood love of film, the arts, and *Star Wars*, and who would have loved to have seen the further adventures of Han Solo and Chewbacca.

To my family, Barbara Ambruster, the Szostak clan: Martin, David, Grace, and Leo, and friends, Lila Atchison, Sean and Sarah Dicken, Mike Bates, Shawn Hunter, Matt Davis, Chris Wales, and Tina Fossella, for their abiding support and encouragement.

To George Lucas, Kathleen Kennedy, Lawrence and Jon Kasdan, Ron Howard, Chris Miller, Phil Lord, and Jason McGatlin, without whom none of this would be possible.

To James Clyne, Neil Lamont, and all of the *Solo* department supervisors and artists who took the time to share their stories with me.

To Frank Parisi, Michael Siglain, Troy Alders, and Sammy Holland in Lucasfilm Publishing, Rayne Roberts, Pablo Hidalgo, and Matt Martin in the Lucasfilm Story Group, Brian Miller, Newell Todd, Gabrielle Levenson, Bryce Pinkos, and Erik Sanchez in Lucasfilm's Asset Team, and Doug Chiang, Genna Elkin, and Jennifer Hsyu in the Lucasfilm Art Department, for their diligence, patience, and thoughtful counsel.

To Jonathan Rinzler, for seeing something in me that I didn't see in myself.

To Eric Klopfer, Liam Flanagan, Gabriel Levinson, and Denise LaCongo at Abrams, for turning my crude layouts and scrawlings into something worthy of this great film legacy.

Phil Szostak

▲ **ART DEPARTMENT NAMEPLATES** Photo by Vincent Jenkins

◄ **LANDING PAD STANDOFF VERSION 6B** Clyne

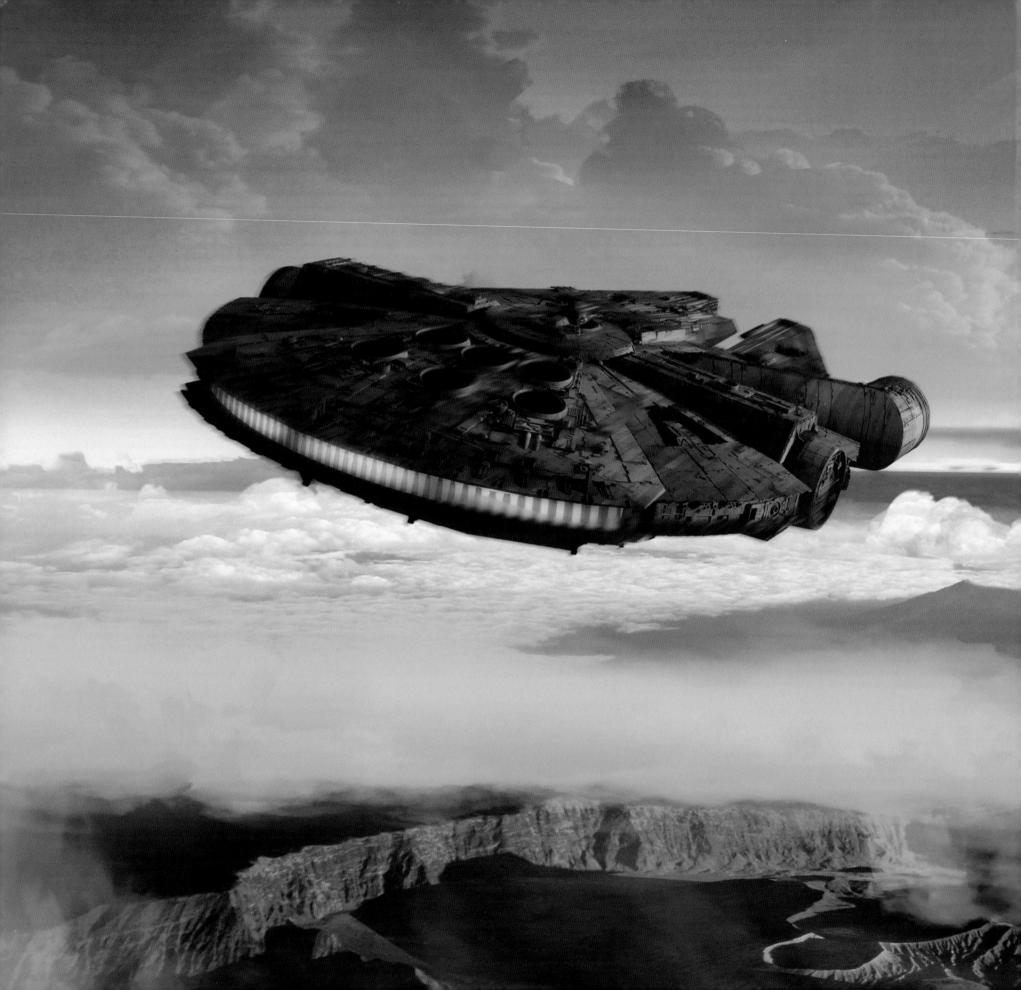

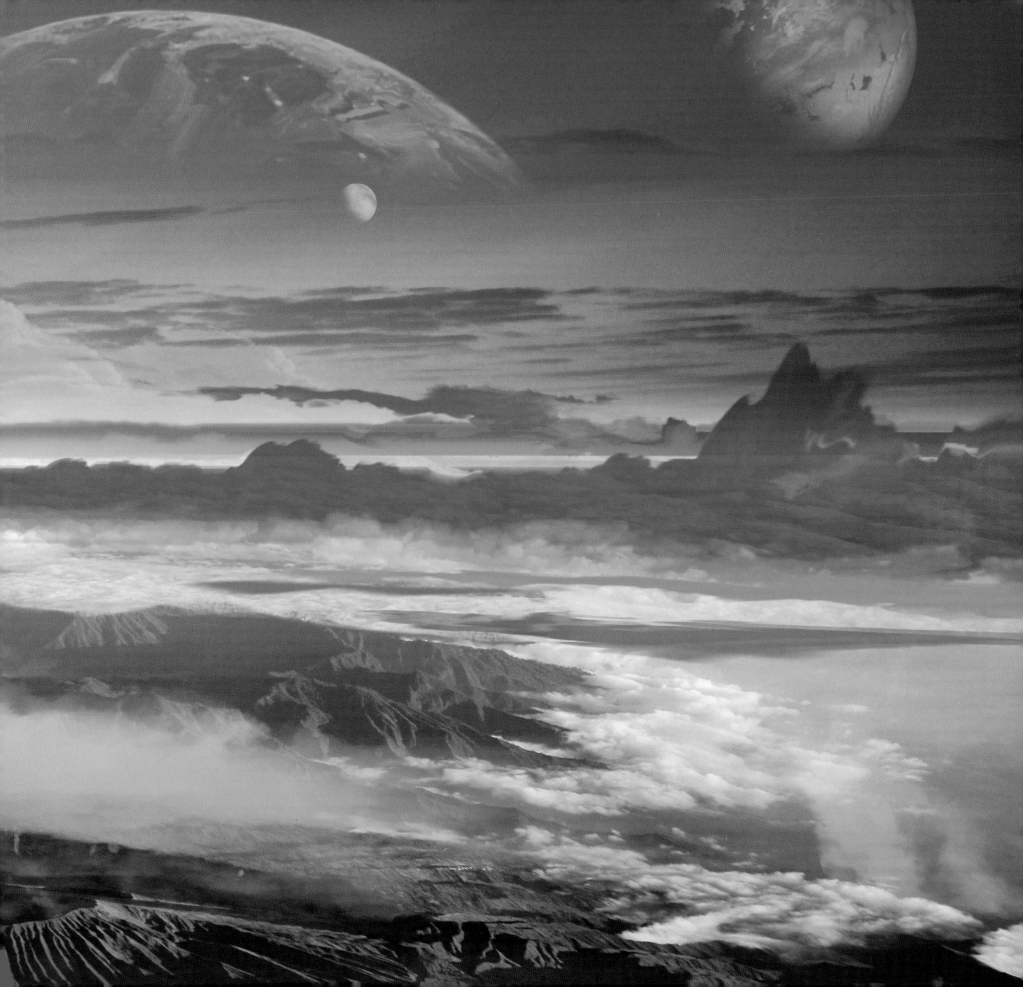

For Lucasfilm Ltd.

Senior Editor Frank Parisi

Creative Director Michael Siglain

Art Director Troy Alders

Assistant Editor Samantha Holland

Asset Group Steve Newman, Newell Todd, Gabrielle Levenson, Erik Sanchez, and Bryce Pinkos

Story Group Pablo Hidalgo, Matt Martin, and Rayne Roberts

For Abrams

Senior Editor Eric Klopfer

Designer Liam Flanagan

Managing Editor Gabriel Levinson

Production Manager Denise LaCongo

Pages 252–53 **OUTRO VERSION 2A** Tenery

Pages 254–55 **END SCENE VERSION 02** Jenkins

Page 256 **DICE HANDOVER VERSION 01** Sole

Case **INTO THE MAW** Voy

Library of Congress Control Number: 2017945118

ISBN: 978-1-4197-2745-0

© & TM 2018 LUCASFILM LTD.

ABRAMS The Art of Books
195 Broadway, New York, NY 10007
abramsbooks.com

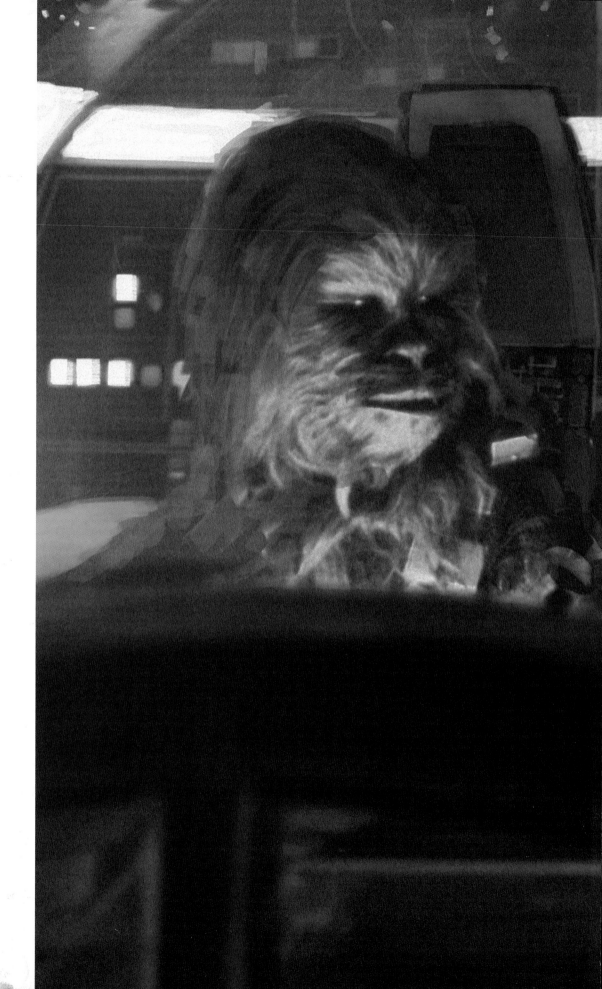

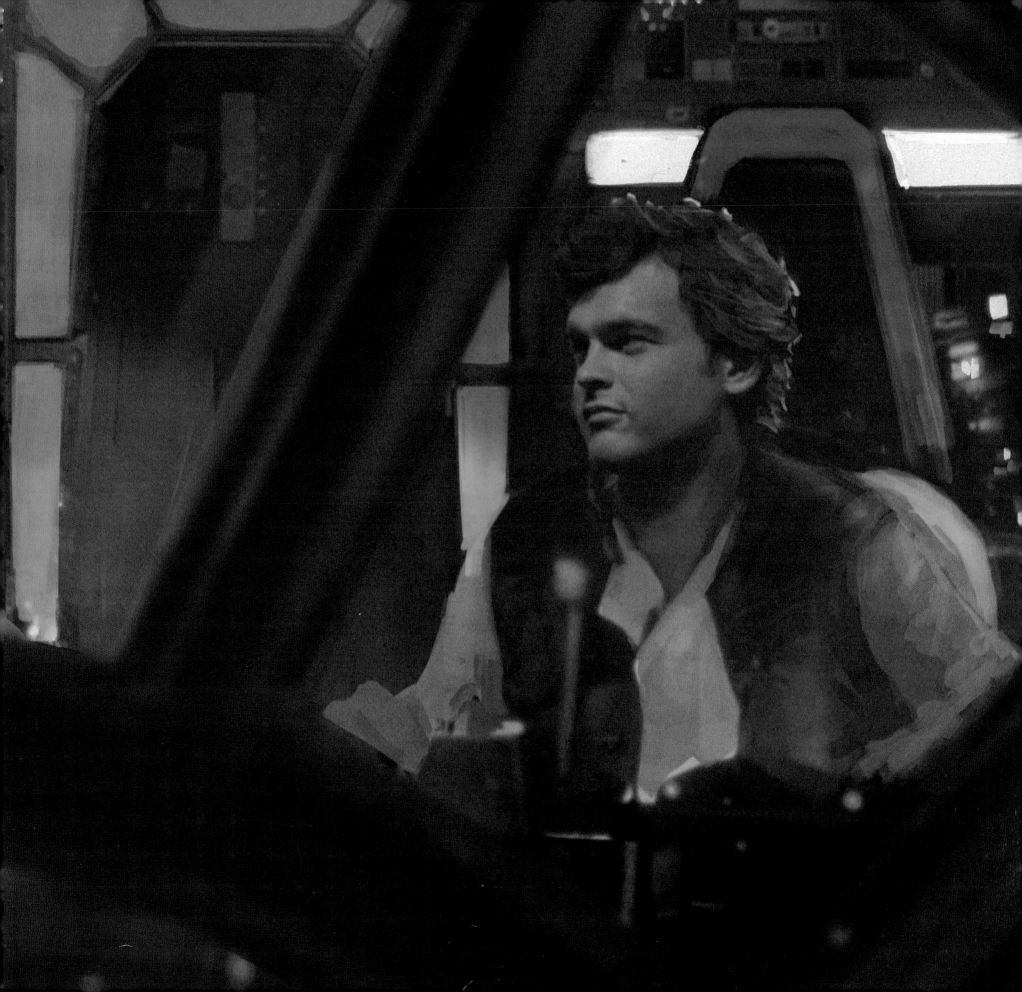

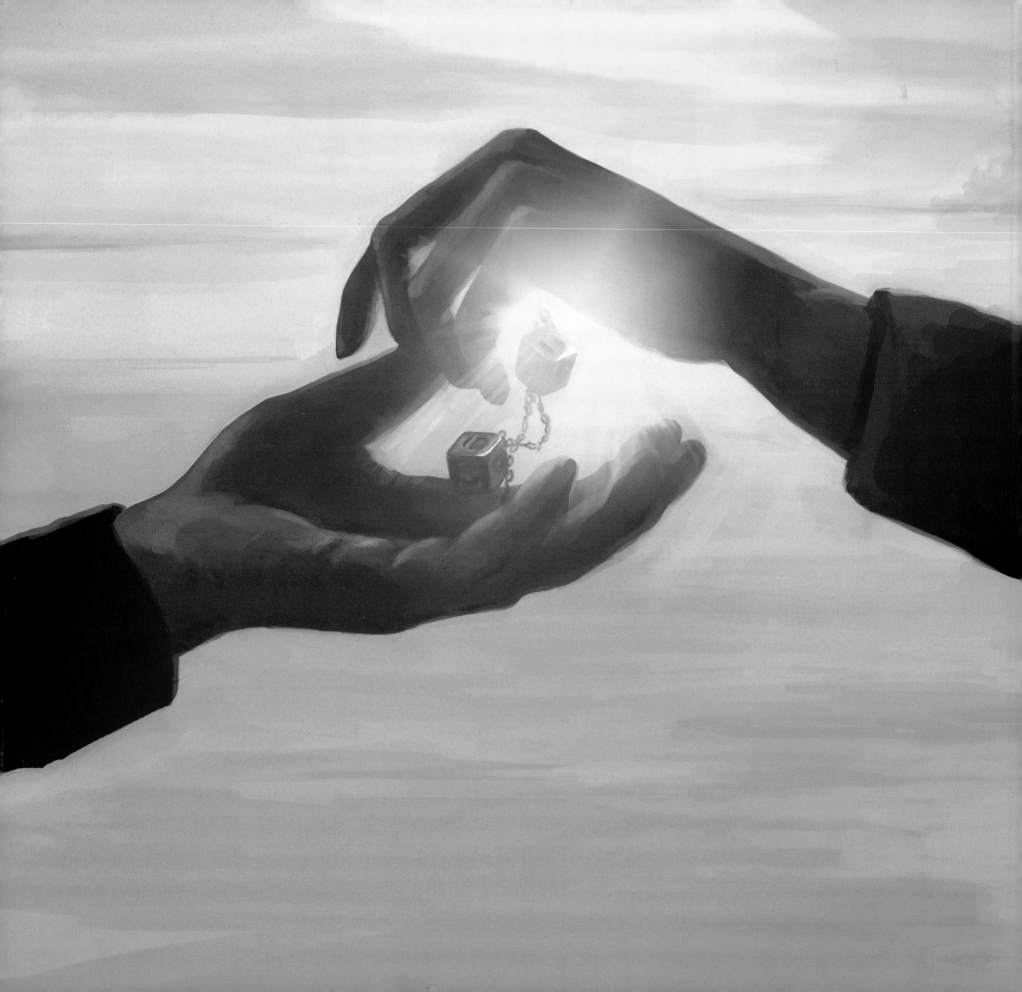